OUT OF THE VOLCANO

Portraits of Contemporary Mexican Artists OUT

Smithsonian Institution Press · *Washington and London*

Margaret

Sayers

Peden

V OF THE OLCANO

Photographs

by Carole

Patterson

This book was edited by Lorraine Atherton and designed
by Linda McKnight. Sponsoring editor Amy Pastan con-
tributed materially to the advancement of the project
throughout. Kathryn Stafford was the production editor.

Library of Congress Cataloging-in-Publication Data
Peden, Margaret Sayers.
 Out of the volcano : portraits of contemporary Mexi-
can artists / Margaret Sayers Peden : photographs by
Carole Patterson.
 p. cm.
 Includes bibliographical references.
 ISBN 1-56098-060-5.—ISBN 1-56098-061-3 (pbk.)
 1. Artists—Mexico—Interviews. 2. Arts, Mexican.
3. Arts, Modern—20th century—Mexico. I. Title.
NX514.A1P4 1991
700'.92'272—dc20
 91-11772

British Library Cataloguing-in-Publication Data is available.

97 96 95 94 93 92 91 6 5 4 3 2 1
∞ The paper used in this publication meets the minimum
requirements of the American National Standard for Per-
manence of Paper for Printed Library Materials
Z39.48-1984. Printed in Hong Kong by South China Print-
ing Company.

CONTENTS

We dedicate this book to

Bill and the Tan-Tara-A Twelve and to My parents and to Don
m.s.p. *c.p.*

ACKNOWLEDGMENTS

One source of support and encouragement is foremost in our minds. Simply put, this book would not exist were it not for the generosity of FRIENDS OF THE ARTS OF MEXICO. We especially want to thank Miguel Angel Corzo, President of the Foundation. Without their continuing interest and nurturing, our idea would never have made its way out of the volcano.

Additional generosity was showed us by the HOTEL NIKKO MEXICO, our host for many weeks in Mexico. We are grateful to its Director General, Mark Wakuta, and to his assistant Susana Lozano B., who became a valued friend. The travails of many hours on site and in the darkroom were eased by superior material and equipment. A photographer's appreciation goes out to Ike Royer, President, Carmen Pacella, Vice President, and Veronica Cotter of ORIENTAL PHOTO DISTRIBUTING COMPANY and to Ernst Wildi, Technical Director, VICTOR HASSELBLAD INC. All photographs for this book were taken with Hasselblad equipment.

We are additionally indebted for support given us by the Smithsonian Scholarly Book Fund, and for the special contribution made by people who accompanied us through many pleasant and productive weeks in Mexico, individual thanks go to Eliza Peden Mitchell and Pamela Carmell and, for their encouragement and photographic help, Carol Bates, Donna Moore, and Tanya Moss, whose expertise surpassed the level of "assisting."

Friends on both sides of the Rio Grande lent their energies and enthusiasm to our work, facilitating interviews, sharing knowledge, acting as guides and drivers, listening, and heartening. Alejandra Regadas de Yturbe of the Galería de Arte Mexicano in Mexico City opened many doors. Mary-Anne Martin, of the Mary-Anne Martin Fine Art Gallery in New York, Jerry Brewster and Amy Beth Fischoff of the Brewster Gallery in New York, and Graciela Toledo of the Juan Martín Gallery in Mexico City all provided valuable assistance. The Tienda Michoacán in the Colonia Polanco of Mexico City offered us typical Mexican hospitality. The benevolence of a special friend, Betty Rea Proctor, sped us on our way toward a project that obsessed us for three years. Many other friends provided special inspiration, Sharon Crain, Rex and Lolly Marcum, Bill Clift, Elizabeth Revington Burdick, John Stubbs Brushwood, Domingo Aguilar, Barbara Azar Davis. To all of them, our warmest thanks. And finally, our heartfelt gratitude to Amy Pastan, who liked our work and ushered it into being.

INTRODUCTION

We really are different, we North Americans and Mexicans. We share a continent. We both acknowledge that as citizens of the New World at least our modern histories begin concurrently, with the historic encounter between the Old World and the New. Each of our countries was shaped by fluctuating tides of commercial, geopolitical, and cultural influences washing over us from Europe, obscuring or blending with civilizations that predated 1492. Our nations, however, despite being variant extensions of the long history of western civilization, remain more dissimilar than similar. Our differences begin with, but are infinitely more complex than, the fact that we speak different languages. If that were our only distinction, it might eventually be resolved, for we are increasingly exposed to each other's language, whether in the border and coastal states of the United States of America or in the tourist centers and sophisticated cities of the Estados Unidos de México.

When we say that someone does not speak our language, we refer to more than the language codes in which that person expresses himself. We mean that he does not understand us, and that we do not understand him. We mean that our traditions are different, our social structures, our ways of thinking. Things we North Americans (with apologies for having appropriated the continent) and Mexicans do not have in common are fundamental: legal codes, political structures, religious practices, educational systems, racial composition—the most basic influences that shape us as individuals and societies and determine our attitudes toward family and commerce and gender and gods, in short, our attitudes toward living and dying.

Anthropologists and sociologists on both sides of our shared border have written intelligent and thoughtful studies (some of which are listed under Suggested Readings at the end of this book) on our nations and peoples, grappling with questions I have barely touched upon. Their exposition—and common observation—illustrates differences so profound that we must wonder that we communicate at all. But we do. We must. We must, as neighbors, continue to attempt to penetrate one another's enigmas, driven by the awareness that every moment we share this threatened planet, the more necessary it becomes for us to learn to speak and understand one another's "language."

The arts offer a major avenue by which to approach one another in our halting progress toward mutual understanding. Art is that magical

phenomenon that is at once culturally specific and universal. Art speaks a lingua franca that allows us to transcend national patterns and to enter a society that otherwise seems imponderable. A magnificent painting, a great work of literature, a peerless performance, all are vehicles that can transport us into a foreign reality. Though we may not understand their every nuance and symbol, a photograph, a sculpture, or an architectural masterpiece communicate to us in a universal tongue that surpasses our diversity and binds us, if only briefly, in a common experience.

Such moments of communication are the goal of this book, which has been undertaken in the spirit of furthering cultural interchange. We North Americans have much to learn about every aspect of the lives of our nearest Spanish-speaking neighbors in a hemisphere in which English is a minority language. In this project, our Mexican friends, figurative machetes in hand and meeting us more than halfway, have slashed a corridor through the "cactus curtain" that rises between our two peoples and erected bridges to span the cultural arroyos that separate us. We must all travel those bridges ever more frequently.

Carole Patterson and I hope that Mexicans themselves will take pleasure in these lens-and-pen portraits of their remarkable compatriots. It is surprising that no similar profile of a culture has been compiled. There are books on individual artists, studies of specific literary figures and movements, but few examples of works that celebrate the spectrum of the arts in Mexico. This is particularly surprising, given that the arts seem to be more closely interrelated in Mexico than they are in the United States. Perhaps this circumstance is linked to the North American passion for specialization. Or one might argue that there is greater homogeneity in Mexican society, and among Mexican intellectuals and artists, than in our own. I think that is not the case. I suspect that

the sense of an arts community is more palpable south of the Rio Grande because Mexicans place a higher societal value on aesthetics than we. Mexican artists are rewarded—with respect, with broad recognition, and with concrete appreciations such as governmental posts and ambassadorial appointments. Mexican artists are not, as individuals or a group, isolated from their world or from each other. They know one another socially and interact intellectually. It is difficult at times to judge from an artist's surroundings the area in which he or she works. Each room in Gunther Gerzsó's beautiful home is filled with enough books for a public library, yet he is an abstract artist, not an author or academic. The walls of Emilio Carballido's home are crowded with paintings, although his vocation is centered in the theater, as author, director, and teacher. The interests of Mexican artists spread beyond their own genres. The poet Octavio Paz is one of Mexico's, indeed, Latin America's, major art critics. One of Francisco Zúñiga's monumental public sculptures is a tribute to a famous Mexican poem, *Suave patria* ("Beloved Land"). The novelist Carlos Fuentes was one of the earliest and most eloquent supporters of the art of José Luis Cuevas. Elena Poniatowska was but one of several authors who contributed a literary vignette for a series of graphics by Marta Palau. In turn, Leonora Carrington, years before, had illustrated Poniatowska's first novel. A Luis García Guerrero vase of flowers, inscribed with a friendly caption, glows from the wall of Margo Glantz's dining room. Francisco Toledo paintings worthy of a museum animate the living room of the poet Verónica Volkow. The chain of relationships is endless.

To a large degree, all divisions among the arts are artificial. At what point does the actor's gesture blend into dance? Does monumental sculpture fill or define architectural space? The arts in Mexico, however, are less distant from each other and from everyday life than in our own country,

and that sense of art as an everyday event is explicit in the incomparable crafts of Mexico, which have continued uninterrupted from the time when the ancestors of contemporary Mexicans felt the need to beautify utilitarian vessels and tools and adorn their persons. The most ordinary display of produce in a Mexican market provides an aesthetic experience. Mexican art exists on a circular continuum in which distinctions between art and craft, learned technique and innate expression, are often indistinguishable.

As we interviewed the artists in this book and experienced and appreciated their works, certain subjects and themes emerged repeatedly, attitudes and realities that typify Mexican culture. It may be of interest to note a few, to call attention to some of the more salient factors that shape that society. One of the most dominant entities in Mexican life and art is the Catholic church. As a physical presence, the Church presides over the central plaza, or *zócalo*, of every village and city. Its metaphysical presence is equally strong in the life of the mind and heart, whether as positive influence or negative reaction. One of the principal motivations for the Mexican Revolution (1910–1920) was to free Mexican society, specifically Indians and the poor, from the economic and moral oppression of organized religion. While many Mexicans today espouse the anti-Church principles of the Revolution, they are almost uniformly born, wed, and buried in the bosom of the Catholic church. One sees evidence of both religious protagonists and antagonists among Mexico's artists. True religious sentiments permeate the paintings of artists as diverse as Alfredo Castañeda and Nahum Zenil. The Virgin of Guadalupe, Mexico's own dark-skinned Virgin, is a unifying presence among millions of worshipers and a ubiquitous icon in all the arts. In his book-length essay on Mexican culture, Carlos Monsiváis unemotionally records the electric twenty-four hours of the celebration of December 12, the Day of the Virgin of Guadalupe. More negative portrayals of church and clergy are found in works such as Carlos Fuentes's *Death of Artemio Cruz* and Pedro Meyer's photographic portrait entitled *Quasimodo*. The very presence of so many satires of priest and church in literature and art denotes their pervasive influence.

In tandem with the Church, a second monolithic presence looms over Mexican life: a strongly centralized government. Since the Revolution, Mexico has been that contradiction in terms, a one-party democracy. Only in very recent elections have opposition forces succeeded in breaching the walls of the seemingly invulnerable fortress of PRI (the ruling Partido Revolucionario Institucional). Vicente Leñero's humorous account of his temporary involvement in the presidential campaign of 1988 is also a serious commentary on the regal powers enjoyed by Mexico's political elite.

Government in Mexico is the domain of men. That male power and its correlatives, potential for submission and oppression, permeate every level of society. One of its aspects is machismo. Machismo in the arts is perceptible in subtle and not so subtle ways. Publishers and critics have tended to be men, and although women constitute a steadily growing body of writers and critics, a male-only, clubby atmosphere continues to dominate Mexico's literary scene. Unintentional evidence of gender absolutism is found in such innocuous sources as a newspaper column that pretended to poll the "Most Cultivated of the Cultivated" among Mexican intellectuals, a list that included the name of one woman among some thirty candidates (an overwhelming majority of the fictitious votes favored José Emilio Pacheco). Even games are gender skewed.

The ultimate game in Mexico is death. Mexicans challenge death as a matador taunts a bull with his red cape. Contemporary Mexican society evolved from the clash and interaction be-

tween two death-oriented cultures. On the Spanish side, we need look no farther than the contemporary running of the bulls in Pamplona or the brutally bloody Christs of the crucifixes brought to the New World at the time of the Conquest. On the Indian side, we recall the often exaggerated but nonetheless factual stories of Aztec human sacrifice. While we North Americans go to elaborate measures to deny death, prolonging the fiction of life in death, Mexicans embrace death in their lifetimes. Fernando Gamboa's brief essay on the artistic tradition of the *calavera*, or skull, expresses the macabre humor also seen in the sugar skulls and skeletons sold on November 1, All Souls' Day—more popularly, the Day of the Dead.

Along with death, the most comprehensive theme to emerge in conversations with the artists and in their works is that of myth and magic. Inexorably, whatever one's prior convictions, one comes to believe that there is something magic in the air of Mexico. Incontrovertibly, that something is linked to the living presence of the mythic past, and it is one of the factors that most strongly differentiates our two societies. For five centuries, foreign observers have commented on the mystique of the New World; and of all Latin American countries, Mexico is most often singled out as the epitome of the wondrously real. Though not with specific reference to Mexico, Christopher Columbus's journals abound with awestruck descriptions of the new wonders of the New World: rivers, fruits, trees, fish, mountains, and, of course, peoples, some of whom he described as "loving their neighbors as themselves," along with others who were reported to have "only one eye" or "dog's snouts" and who "ate men." Columbus's overall reaction, however, remained one of enchantment: "I have not," he wrote, "praised it a hundredth part of what it deserves. . . . When one who has seen all this wonders at it so greatly, how much more wonder-

ful will it be to those who merely hear of it, and no one will be able to believe all of this until he sees it."[1]

In more recent years, André Breton, the father of French surrealism, called Mexico "the surrealist country *avant la lettre*." And the memoirs of Chilean Nobel laureate Pablo Neruda refer to Mexico as "the last magical country." "Every kind of magic," Neruda wrote, "is always appearing and reappearing in Mexico." He cites as examples the volcano that erupted before a peasant's eyes as he was working in the field, and the "frenzied search" for Cortés's remains—a hunt fueled by the legend that Cortés's skull is still encased in a helmet of pure gold. Neruda would have had no difficulty in adding countless stories of Mexico's hyperbolic geography and of its peoples, who live, simultaneously, in ages of orally transmitted history and high-tech communications. He might, for example, have cited inexplicable physical phenomena like the Green Wave, a fifty-foot wall of water that periodically, but only in March, April, and May, rolls onto the beach of Cuyutlán; inexplicable emotional states, such as those exhibited in passion plays in which the man performing the role of Christ may literally be nailed to the cross and occasionally killed; and an inexplicable randomness in life that resembles the laws of the French author Alfred Jarry's school of *pataphysiques*, in which the exception is the iron rule. This latter category of the regularity of the irregular in Mexico is boundless: street numbers that run both up and down within a distance of two blocks, skipping from 42 to 59 to 27; a telephone directory that subscribers strive to keep their names *out* of; breakfast trays that unfailingly arrive with a new and different combination of the same daily orders. It is perhaps those smallest details of everyday existence that most puzzle that North American visitor; as our hysteria in the face of nonfunctioning plumbing, our mania for buying elaborate packages of assorted screws

when only one screw is required, and our terror of foods that are not presented in plastic confound our Mexican neighbors.

"Magical realism," a term currently in vogue, would seem to describe many of the phenomena I have been describing. The term was coined by an art critic, appropriated for literary criticism, and eventually expanded to define a general mode of apprehending reality. Not all Latins, however, are happy with this designation, believing that it suggests they live in comic-opera kingdoms populated by levitating priests and gypsies with flying carpets. And it is true that the countries of the southern cone of Latin America—Uruguay, Argentina, and Chile, where European influences are strongest—are less likely candidates for magic kingdomhood than the more exuberant lands of Brazil, Central America, the Caribbean, and Mexico, with their large Indian and black populations.

Most specialists agree that Franz Roh coined the term, although the actual words, *Magisher realismus*, translated into Spanish as *realismo mágico*, may first have been used by a different German art critic, G. H. Hartlaub. The Cuban novelist Alejo Carpentier is mistakenly credited with making the term popular in Latin American literary criticism. Carpentier, who had refined his thoughts on what he considered to be the dominant style in Latin American writing, in fact used a subtly different phrase, *lo real maravilloso* ("marvelously," or "wondrously," "real"), which he proposed in an essay that appeared in 1949 as a prologue to his novel *El reino de este mundo* (*The Kingdom of This World*). Subsequent Spanish American critics, however, reverted to the art-derived term, *realismo mágico*, and with the publication in 1967 of Gabriel García Márquez's *One Hundred Years of Solitude* (the work of a Colombian author, but written in Mexico) magical realism was firmly established as a literary mode. From its prominence in Latin American literary criticism, "magical realism" again spread to include the art world from which

it had come and eventually crept into common parlance, where many North Americans came to accept it as a synonym for Latin American reality.

We might have been better served in understanding Mexico's magic had Carpentier's term been the one popularized, for Carpentier never intended for his wondrous reality to define only a fairy-tale world. When he wrote of "events more amazing than those invented by the surrealists," he was not referring to exotic invention but to the all too real reign of Henri Christophe in Haiti, a story, Carpentier said, that could have taken place only in the New World. "For what," he questioned, "is the entire history of America, if not the chronicle of a Wondrous Reality?" The advantage of Carpentier's "wondrous reality" over the more fantasy-charged "magical realism" is that Carpentier's term does not exclude anything that causes wonder or astonishment.

The confusion will undoubtedly continue, since the term is now applied to almost everything connected with Latin America. However one defines it, nonetheless, the reality of Mexico, its peoples and its arts, continues to attract those who step within the circle of its magnetic appeal. This fascination is what drew a North American writer and a North American photographer to undertake a profile of the arts culture of a nation in which an estimated fifteen thousand persons are active in the visual and literary arts alone. It is obvious from the numbers, as from the most cursory exposure to galleries and publishing houses and performing centers, that with time and fortune—and a touch of magic—this book could have become five. We regret sincerely the exclusion of those persons that time, geography, fate, and—in only one instance—unwillingness prevented us from interviewing. We celebrate, on the other hand, each of the remarkable individuals who do appear in these pages, warm, generous people who opened their homes and studios to us and allowed us to share their creative lives.

The actual interviews were preceded by careful research: polls of my Mexican and U.S. scholar colleagues, inquiries to Mexican friends made over twenty-five years of enchantment with their literature and crafts and fine arts, research in galleries in Mexico and the United States. Not least, we repeatedly questioned our subjects themselves. We crossed political and philosophical lines. Knowingly, we placed elbow to elbow ancient enemies as well as eternal friends. In searching for the best in the Mexican arts, our great advantage—countering our acknowledged status as non-Mexicans—was freedom from embroilment in the cliques and intrigues of the politics of Mexican art.

There are signs of more U.S. openness to the treasures of Latin America's contemporary arts. New York and Washington, D.C., for example, host increasingly visible Latin American book fairs. Major traveling exhibitions of Latin American art originating with the Bronx and Indianapolis museums in the eighties drew crowds in U.S. cities and abroad. And in 1990 a major exhibition of Mexico's visual arts opened at the Metropolitan Museum of Art in New York City. This stunning show was billed as the "Splendors of Thirty Centuries." "How many societies in this world," John McDonald, the exhibition coordinator, asked, "may boast of 3000 years of important contributions to the history of art?" This magnificent display of pre-Columbian, colonial, nineteenth- and early twentieth-century works was complemented by exhibitions of the most recent Mexican art arranged by a host of additional museums and galleries, among them, the Americas Society, the National Academy of Design, El Museo del Barrio, the International Center of Photography Uptown, and the National Arts Club. The streets of New York were filled with the tempos of Mexico's popular music and dances. Lectures and symposia focused on Mexican artists and Mexican society. The unprece-dented celebration of one nation's arts was a tribute to the riches of the Mexican tradition and the vigor of the living artists of Mexico.

It is our continuing hope that this book may provide still another bridge for promoting cultural interchange between our two nations—a bridge ever more traveled.

1992

Nineteen ninety-two is upon us, and with it, a profusion of celebrations marking the five hundredth anniversary of the moment most often referred to as the discovery of the New World. That designation reflects a myopic vision. Whatever history determines about the actual year in which the first Europeans made their way to our hemisphere, the indigenous peoples inhabiting it—at least those of them that have survived—cannot think of that undeniably major historical event as their "discovery." They were here all the time. Perhaps a more recent manner of referring to 1492 as the year of the Encounter between the Old and the New Worlds is a more accurate depiction.

Even though commerce and religion were the driving forces behind the exploration and colonization of our entire hemisphere, from their beginnings the areas we broadly classify as Latin America and North America developed in widely divergent ways. The Spanish-speaking conquistadores enlisted Indian peoples in their conquest, playing on internal conflicts to assist them in the overthrow of established power centers; they assimilated the peoples of the lands they appropriated for their empire. In contrast, the Dutch, English, and French who were the primary settlers of North America killed or drove from their lands the peoples they encountered. (There are, obviously, exceptions: some Indian tribes were involved in North American wars of westward expansion; the Spanish decimated the Indians of the Caribbean islands.) North American settlers brought with them a variety of religious beliefs, all of which were unaffected by and indifferent to the religious practices of indigenous Indian tribes. Spanish Catholicism, on the other hand, in large part because of the influence of the syncretic vision of the Jesuits, enveloped native theologies. While Indians were converted to Catholicism en

masse, the ancient gods were too firmly entrenched to die, and today one might still find on a village altar a pagan idol contained within the hollow body of a Catholic saint. Tribes to the north certainly held religious beliefs, but to the degree their religions survived, they remained separate from Christian doctrines, and whatever religious centers they may have had disappeared from the landscape. Spanish missionaries and priests, to the contrary, found monumental sites of worship central to millennial civilizations. To counter the influence of the old religions and to illustrate physically the dominance of Catholicism, Spanish American cathedrals were erected on the sites of, and built of materials torn from, ancient indigenous temples.

Another major difference in patterns of colonization was that in North America wives and children accompanied the colonists. The Spanish adventurers arrived alone, immediately confiscated Indian women, and thereby created a new race, the mestizos, who in Mexico now greatly outnumber their European and Indian progenitors. North America was settled under charter rule, a system that influenced the democratic direction the nation-to-be would take. The community was actively involved in governing, and desire for religious freedoms was often expressed as a will to sever relations with the mother country. At the time of Spanish expansion, in contrast, religion and governance formed an inseparable monolith, superimposed on a similar indigenous structure that Octavio Paz has described as pyramidal: one all-powerful ruler crowning a descending hierarchy of privileged priests and royalty, all in turn supported by huge masses of people bound in servitude.

There is good reason, therefore, to expect North and Latin Americans to approach 1992 with differing points of view. In celebrating the "discovery," we North Americans think of the beginning of an entirely new entity. Except for token, largely mythic tribute to figures like Pocahontas, and a dim sense that the Puritans were taught how to plant corn by the Indians and thereby survived to celebrate the first Thanksgiving, we exclude native influences from our vision of our past. We tend to picture our history since 1492 in terms of colonies established in New England and the Atlantic states and evolving into a federation that inexorably spread westward until it stretched from sea to sea, eventually including two extraterritorial holdings we could no longer "own" without embarrassment. (In this picture, we also conveniently overlook our wresting of the southwest from Mexico, a memory that is much more distinct in the Mexican consciousness.) We North Americans feel strong ties to our European forefathers—less and less, obviously, as we become truly pan-racialized—and we have little feeling of having been victimized by them. We, after all, won the war with King George.

In contrast, Mexicans live every moment of their lives in the presence of a highly visible indigenous past. The distinct dichotomy of their heritage—Spanish conquerors and conquered Indians—fuels a continuing quest for self-identity. Among the authors who have most insightfully explored the Mexican psyche are Octavio Paz and Carlos Fuentes. Both have written brilliantly on the question of Mexican identity. In so doing, both have found in the figure of La Malinche, the Indian woman seen to have betrayed her people by acting as Cortés's interpreter, a principal metaphor for the violence of the Conquest and subsequent "inferiority complex," to quote Paz, of contemporary Mexicans. In works such as Paz's *Labyrinth of Solitude,* a penetrating glimpse into the Mexican soul, and Fuentes's *Todos los gatos son pardos* ("All Cats Are Gray at Night"), La Malinche is pictured as a victim of Spanish rape, and her bastard son as the first "Mexican." Understandably, then, Mexicans continue to debate the effects of the Encounter.

As expected, reactions from individual artists interviewed for this book vary. Manuel Alvarez Bravo would have refused to be interviewed had he believed the book to be an exaltation of 1992. Marta Palau, who was born in Spain but moved to Mexico at the age of six, expressed a more positive reaction. "My father was a Republican, so he had to leave Spain. I was born in Spain, but really I'm Mexican, because this is where I grew up." Was she considering a specific project for 1992? "I would like to go back to the small town where I was born, and spend some time there, and work with all the materials of Spain, you know. I would like to do that." When the same question was put to José Agustín, his answer was much briefer. "No, it really doesn't interest me very much." The most surprising response may have been that from two Indian artists. Neither Germán Venegas nor Nahum Zenil had the least interest in what might be happening in 1992. That is not to say that there is not strong resistance among certain Indian groups to any celebration of the infamous anniversary of the destruction of pre-Cortesian cultures. That is a fact and must not be overlooked. But where one might have expected a commemorative work in the tradition of Siqueiros, Orozco, and Rivera, there was instead a total indifference that may in the long run be as strong a negation as a more overt protest.

Columbus never personally reached the shores of Mexico, anymore than he trod on land that is now a part of the United States. Whatever one's reaction to it, however, 1992 does mark the quincentenary of Columbus's landfall in the New World. Columbus's voyages have motivated a number of Latin American fictions. Among the most important are the posthumously published novel *The Harp and the Shadow* (1990; original Spanish, 1979), by the Cuban Alejo Carpentier, and *Dogs of Paradise* (1990; Spanish, 1983), by the Argentine Abel Posse. Classic among this genre is Carlos Fuentes's *Terra Nostra* (1976).

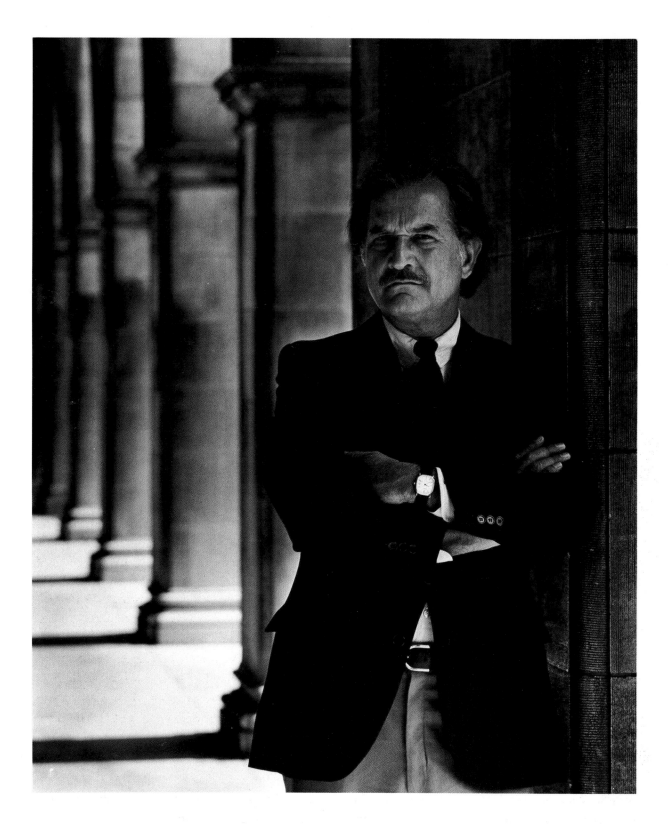

1. Carlos Fuentes

CARLOS FUENTES

Panama City · 1927

Carlos Fuentes is the Mexican artist best known in the United States. His broad recognition can be attributed to many factors, not the least of which is the abundance of his novels, short stories, and essays available in English, from his early novella *Aura* (1962) to his most recent narratives, *Christopher Unborn* (1989) and *Constancia and Other Stories for Virgins* (1990). Similarly important is his visible presence as an articulate spokesman and a commanding personality. He speaks elegant, British-inflected English and has, therefore, reached a much larger North American audience, through both television and personal appearances, than many other Latins. He is frequently consulted on questions of Latin American *and* North American politics. He has held visiting professorships in many North American universities, including Dartmouth, Harvard, and the University of Pennsylvania.

Fuentes's entire life has contributed to the cosmopolitanism that characterizes him today. Himself a diplomat in the seventies, Fuentes was the son of a diplomat and lived most of his childhood outside Mexico. He often recounts that he thought Mexico was an invented country that his father had made up to amuse him. Fuentes came to the United States in the early thirties, where he attended public school in Washington, D.C. It was there that he suffered a traumatic event that resulted in the birth of his nationalism and the death of his youthful innocence. On March 18, 1938, Lázaro Cárdenas nationalized the oil industry of Mexico. As a young Mexican who had never given much thought to such questions, Fuentes was rudely sensitized to his "otherness" by schoolmates who taunted him not for his personal characteristics but for the country of his origin. (Technically, it should be noted, Fuentes is not a native Mexican; he was born in Panama. This distinction sometimes arises in connection with his possible candidacy for president of Mexico. Only citizens born in Mexico may serve as president.) Washington newspapers were filled with stories about the "Reds" who had stolen "our oil." "I was an instant pariah. At that moment I knew I was not a gringo. I was a Mexican." That conflict of identities has fueled many of Fuentes's fictions and essays and at the same time has provided him with the omnicultural vision that makes him such an astute commentator on hemispheric and global affairs.

Fuentes is a cultural omnivore. One of his char-

acters in *Una familia lejana* (*Distant Relations*) sermonizes that Latin Americans must know more than anyone else. First they must know their own culture, and then everything there is to know about everything else. Fuentes practices what his fictional characters preach. He is encyclopedic in his knowledge of the arts. He is brilliant in the geopolitical field. He is relentless in pursuing any avenue of investigation. And he is blessed with total recall. One anecdote will illustrate his justly deserved assurance that he will not be betrayed by his knowledge or his memory.

In *Distant Relations* there is a passage in which a man who is disillusioned with nature constructs a garden of metal, imitating nature. Fuentes asked his translator to verify the literary source for this conceit, which he was sure was to be found in Goethe. The translator did not read German, but went to colleagues in the Department of Germanic and Slavic Studies and asked them. No, they thought, that certainly did not sound like Goethe. Absolutely not, one said; not in tune with his general world vision. Then the translator checked everything possible within her own limitations, that is, in English translation, and found nothing related to artificial gardens. In one of her regular exchanges with Fuentes, the translator reported her failure. The next time they talked, Fuentes reported *his* success. He had called a friend in Germany. The friend knew Goethe much better, apparently, than the academics did. The conceit does appear in Goethe; specifically, in one of his plays. Fuentes was content. "For a moment," he said, "I thought I might have forgotten."

In 1988 Fuentes received three literary prizes that testify to the breadth of his writing, as well as the surprising diversity of his admirers. From the Sandinista government in Managua, Nicaragua—before, obviously, those leaders lost the election—Fuentes received the Rubén Darío award, named after a highly regarded Nicaraguan poet who was the leader of what is considered to be the first literary movement indigenous to Latin America. It is the highest cultural award accorded by Nicaragua. The second award was granted in New York by the National Arts Club: its Gold Medal for Literature. And the third was given by the king of Spain, who conferred on Fuentes the coveted and lucrative Cervantes prize. The Cervantes prize struck a particular chord with Fuentes, for he has always felt a strong empathy with that father of the modern novel. During the year he was a Woodrow Wilson fellow at the Smithsonian Institution in Washington, D.C., working on a novel of his own, he wrote a brilliant essay on Cervantes and on reading the modern novel.

Fuentes is as dazzling in person as he is on paper, as the unseen writer, scholar, commentator. He is a mesmerizing lecturer. His energy is prodigious and his wit incisive, flashing, and totally intercultural. A quick glance at his *Cristobal nonato* (*Christopher Unborn*), the novel he considers his nod to Joyce—"Not *Ulysses. Finnegans Wake!*"—reveals Fuentes's ability, indeed glee, in punning in several languages at once. He has left a trail of one-line quotes through decades of interviews. On his arrival in Spain to film a project for the Smithsonian Institution, for instance, his peripatetic life became the subject of several quips. "I move, therefore I am," was his version of Descartes's time-honored maxim. He added that "like Paul Morand, I am going to ask in my will that my skin be made into a suitcase, so I can continue traveling." (Fuentes's close friend William Styron, who accompanied him on his trip to Nicaragua to accept the Rubén Darío award, compares Fuentes to

a shark: "The shark, you know, dies if it stops moving.") Fuentes is so talented a mimic that he could have been a professional entertainer, and fortunate after-dinner companions will find themselves enthralled by an endless store of imitations of the movie stars of Hollywood's golden age, the heroes and heroines of the films that, interestingly enough, are a shared influence among Latin authors of Fuentes's generation. He can repeat, perfectly, and with the identical gestures and phrasing, the dialogue of the closing scenes of every film he has seen, and he loves to astound North Americans with the names, from their own culture, of the film's director and minor character actors. Like any man with unrivaled talents, Fuentes is not without detractors. Confident of his place in history, he is little moved by controversy and dismisses criticism with a typical jest. "I love having critics for breakfast! I've been having them for thirty years in Mexico—just eating them like chicken and spitting out the bones."

Now Fuentes is involved with two projects worthy of his gargantuan abilities. He is preparing, for a British publisher, a history of the Spanish-speaking peoples, a task admirably suited to his gifts for synthesis and order. More immediate is the project sponsored by the Smithsonian Institution and the Spanish society overseeing events for the Quincentenary celebration. Fuentes is writing, filming, and narrating—in Spanish and in English—a five-part series entitled *El espejo enterrado* ("The Buried Mirror"). In the process of writing, Fuentes discovered that mirrors "buried to guide the dead in their voyage to the other world" had been found in Totonac tombs in the state of Veracruz—an example of the magic coincidence that occurs so frequently in Fuentes's Mexico. The first episode, "La frontera indecisa" ("Uncertain Frontier"), focuses on pre-Columbian

civilizations and the arrival of the Spanish in Latin America and the United States. The second, "La virgin y el toro" ("Virgin and Bull"), investigates Hispanic-Portuguese relations and the Iberian roots of Latin American societies. "En busca de El Dorado" ("In Search of El Dorado") portrays Spanish-Aztec and Spanish-Inca conflicts through the characters of Cortés and Moctezuma and Pizarro and Atahualpa. The last two episodes are "El águila y la serpiente" ("The Eagle and the Serpent"—the nationalistic icons seen on the Mexican flag), which explores the rich cultural heritage of Mexico as well as the watershed Revolution of 1910, and "500 años después" ("500 Years Later"), which profiles the nineteenth and twentieth centuries in the Americas up to the anniversary date of 1992.

The magnitude of Fuentes's undertakings is clear from this summary description. He has, however, spent a literary and political lifetime preparing for just such projects. His play *Todos los gatos son pardos* ("All Cats Are Gray at Night") and two of his major novels, *Terra Nostra* and *Christopher Unborn*, deal directly with the historical events of the Encounter. In the New World section of *Terra Nostra*, through the fictional saga of the first two Europeans to reach the New World, Fuentes relates the beginnings of the European presence and the decline of Aztec dominance in the land that was to become Mexico. The two characters are an old sailor named Pedro and the unnamed protagonist, who throughout *Terra Nostra* assumes many identities but here has obvious overtones of the god Quetzalcoatl, whom the Indians confused with Cortés. In "The Beyond," the unnamed man is separated from his elderly companion during the loss of their vessel in a gigantic whirlpool and washed ashore—the first man, as Fuentes tells it, "to set foot on the new world."

The Beyond

Was there ever a time, Sire, you looked death in the face? Do you know the strange new geography death offers to the passive eyes and stilled hands of the dead? With no proof except that of my own death, I imagine the universe of death is different for every person. Or is the uniqueness of our deaths also wrested from us by the nameless immortal forces of sea and slime, stone and air. Farewell to an age of pride; accept now the certainty that as the senses that served us in life are dead, a new sense with dusty eyelids and waxy fingers is born in each of us in death, awaiting only that moment to lead us toward white beaches and black forests.

I say white and black in order to be understood, but I do not speak of whiteness as we know it in life, the white of bone or sheet, or of the blackness of the crow or of the night. Imagine, if you can, Sire, their simultaneous existence; side by side, at once illuminating and obscuring, the white white because the contrast of black permits it, and the black made black because white lights its blackness. In life these colors are divorced, but when at the hour of death I opened my new eyes of sand, I saw them forever united, one the color of the other, unimaginable alone: black beaches, white jungles. And the sky of death obscured by swift wings: a flock of shrieking, brightly colored birds flew overhead, their number so great they darkened the sun.

I am recounting my first impressions upon dying, as vague and uncertain as my drowsy fatigue, but as precise as the certainty that I would not be astounded by anything I saw, for I was dead, and thus I was seeing for the first time what one sees on the littoral of death. I clung to such simple facts: I had met death in the sea and we had descended into its entrails through a deep tunnel of water; the speeding vortex had led us to the island of the dead, a curious place of vague outlines, a hazy impression of white beach, black jungle, and shrieking birds that cast the veil of their wings across a spectral sun. Phantasmal island, final port of phantasmal voyagers. All of this must be accepted as truth, my will was incapable of offering any opposition; so this was the contract with death, an inability to affirm, to better, or to transform. Final port, a reality without appeal.

Had I come to this bay alone or accompanied? The eyes of the dead voyager search for new and strange directions, Sire, for he has lost the compass of his terrestrial days and cannot tell whether far is near, or near, far. With the ears of death I heard intermittent breathing; with the eyes of death I saw I was approaching a beach, accompanied by mother-of-pearl shells washed toward shore by the waves and by a soft dew that bathed

both them and me. The dew was cool, the waters of the sea were warm, a green warmness warm as the water of a bath, different from the icy gray seas and cold blue waters I had known in life. I reached the shore of the other world with an armada of seashells that seemed to guide me toward the beach; my face was washed in the warm waves, I felt grainy sand beneath my hands and knees and feet; I was enveloped in crystalline green water, calm and silent as a lake.

I thought I had returned to life; I tried to shout; I tried to shout a single word: "Land!"

But instead of the impossible voice of a dead man I heard a bellow of pain; I looked and saw a floating wineskin adrift in the current of a sleepy river that emptied here into the sea; I saw an enormous monster with the body of a hairless pig, boiled or singed by fire; the monster moaned and stained the limpid waters with red; it was fat and dark and had two teats upon its breast; it was bleeding, carried toward the sea by the slow current. When I saw it, I tried desperately to grab hold of the floating shells around me; I said to myself, this is God-the-Terrible; I said, I'm looking at the very Devil, and I think I fainted from terror.

Perhaps I slipped from swoon to sleep. When I came to myself I seemed to be reclining. My head rested on the sandy beach, my body was caressed by warm waves. I managed to struggle to my feet, blinded still by fear and the acceptance of death. I looked toward the sea; the wineskin monster was drifting toward the horizon, inanimate and bleeding. I stepped onto the beach and was bathed in light. It was as beautiful as the sunset: a light slanting horizontally across the beach it bathed in a glossy grayish luster. I told myself that was the light we had in life called pearly.

I stopped looking at the light and turned to see what things it revealed. Sire: that beach of the Beyond, the beach I stood upon for the first time, was the most beautiful shore in the world; the beach in a dream, for if death were the most beautiful and desired and now the most complete of dreams, this would be the coast of the Paradise that God reserves for the blessed. A white beach of brilliant sand and thick black forests: I recognized the tree of the desert, the sighing palm. And the clearest of skies, cloudless, pure burning light born of itself, with no winged messengers to interrupt its gaze.

My damp footsteps sank into the sands of Eden. I breathed new odors, like nothing ever smelled before, sweet and juicy and heavy. I thought of the promises of the gods, but here were realities. The immense rolling white perfumed and shining beach of Paradise was a vast sandy treasure chest spilling over with a wealth of precious pearls. As far as my newly recovered and astonished sight could see, large nacreous shells and

beautiful pearls covered the expanse of this providential beach. Pearls black as jet, tawny pearls, pearls yellow and scintillating as gold, thick and clustered, bluish pearls, quicksilver pearls, pearls verging upon green, some with diluted tones of paleness, others glowing in incendiary shades, pearls from all the mollusks, margarites, and minute baroques. The refracted light of all the mirrors of the world mixed with the white brilliance of the sands could not match the coruscating splendor of this pearly beach where death had thrown me. I buried my feet in the fabulous riches accumulated here, then quickly squatted to plunge my arms to the elbows in the treasure of this happy shore.

I bathed in pearls, Sire, precious pearls, pearls of all sizes, paragon pearls, graduated pearls, seed pearls; I swam among pearls, and I hungered and thirsted to eat and drink pearls, bushels of pearls, Sire, some the size of a large chestnut, hull and all, and round as all perfection, of a clear and glowing color worthy of the crown of the most powerful monarch, and smaller but no less shimmering baroque seed pearls worthy of being strung in the most divine necklace, then to preserve their pulsating life upon the palpitating breasts of a Queen.

The sea had sewn this beach in pearls, and the sea continued to strew its pearly shells upon the shore where they awaited the dew as one awaits the bridegroom, for they are conceived of the dew and impregnated by the dew, and if the dew is pure the pearls are white, and if the dew is murky, they are dark and shadowy: pearls, daughters of the sea and sky. I had emerged from their cradle and now walked among their coffers, Sire, and I asked myself heatedly whether I was seeing and touching these marvels with the senses I had lost, or through the perceptions of death, and whether when I was resuscitated I would lose them on the spot and see only sands and gull droppings where now I saw great treasures. I raised a large pearl to my mouth; I bit it, almost breaking my teeth. It was very real. Or was it real only in this land of death and dream? It didn't matter: I told myself that whether this were the prize or the price of death, I happily accepted—reward or final end.

I picked up pearls by the fistfuls and only then did I experience the sadness of death and lament the absence of life. I moaned. The only person who would profit from these riches was one who could remember nothing, either of this life or of his death. I longed to be a living man again, Sire, a man of passions and ambitions, of pride and jealousy, for here was the wherewithal to exact the most passionate revenge against the enemies who had harmed us in life, or to confer the greatest favors upon the coldest and most inaccessible of women—or the warmest and most approachable. Neither the fortress of

the warrior, nor the palace of the King, nor the portals of the Church, nor the honor of a Lady, I told myself at that moment, could possibly resist the seduction of the man who owned such opulence.

With outstretched arms, fists filled, I offered the pearls to the land of death. My shining gaze was returned by the veiled and inhospitable stares of the true masters of this beach. Only then did I see them, for their enormous carapaces blended with the color of the jungle behind them. I saw gigantic sea turtles, scattered along the verge where the sand ended and the jungle thicket began. And those sad veiled eyes reminded me of my old friend Pedro, and as I remembered him, I felt that the pearls in my hands grew soft and faded and finally died.

"Old man," I murmured, "I was the first to set foot on the new world, as you wished it."

And I threw the pearls back to the pearls. The sea turtles looked at me with suspicious torpor. And at that instant I would have exchanged all the treasures of the beach for the old man's life.

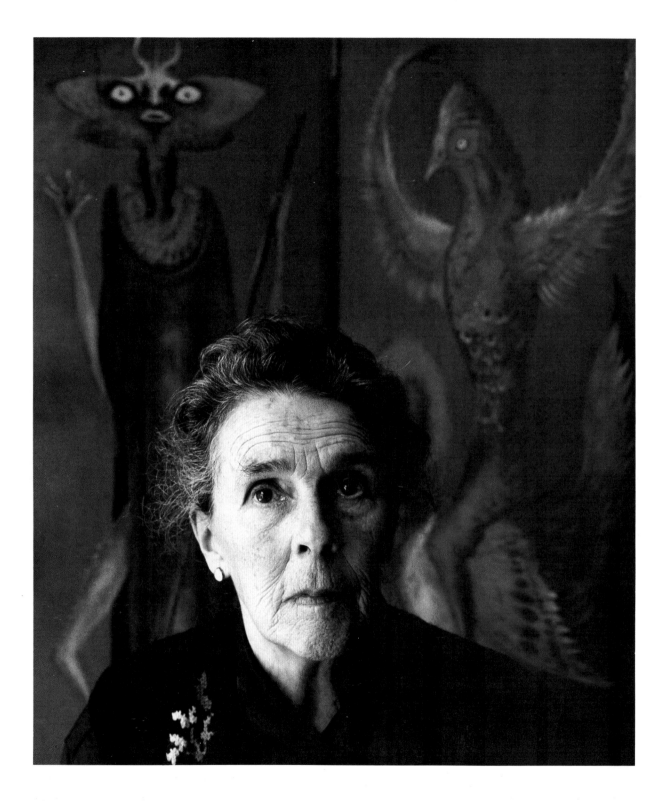

2. Leonora Carrington

LEONORA CARRINGTON

Clayton Green, Lancashire, England · 1917

White girl dappled mare

the stags and the ferns in the wood.

Tuft of black hair caught on a thorn

Those lines from Leonora Carrington's "The Happy Corpse Story"[1] recall one of her best-known paintings, a self-portrait dating from 1938. A fair young woman with a flowing head of black hair sits on a velvet princess chair in an otherwise empty room. She is wearing stark white riding jodhpurs, and her face displays a dazed expression that might be read as fear, shock, or the suspended consciousness of the dream state. Behind her floats a large, pale rocking horse that is echoed in the figure of a twin horse, mythic but real, seen through a draped window in the far wall, suggesting a stage. The rocking horse has no tail; the tail of the horse seen racing through idyllic woods is full and arched. The girl's right hand is extended slightly in the direction of an approaching hyena; the animal is memorable for its knowing, clear blue eyes and three lactating breasts.

This painting portrays both physical and spiritual selves. The viewer compares this vision with an earlier image, a photograph of Leonora taken on the day of her presentation at court. She is standing with a second woman, who looks much older. Their bodies are slightly turned toward one another, but both women gaze toward a spot somewhere to the left of the camera. Their trains are swirled to form a circle before their feet. Leonora holds an open fan before her, at waist level. She is the perfect subject for a pre-Raphaelite painting. Her face, beautiful, composed, expressionless—regal, or icy—is the face in the self-portrait. The hair especially, here so beautifully dressed and controlled, contrasts with the freedom of the hair in the self-portrait.

No one who has written about Leonora Carrington has failed to note the drama of a life that reads like a play script, a drama graphically illustrated in the contrast between the two representations of the same handsome woman. The salient facts of her biography have been enumerated many times but bear one further repetition. Leonora Carrington was born into a proper British family. Her father was a well-to-do industrialist (a 1948 feature in *Time* magazine called him a "British millionaire," and in a personal memoir Leonora herself referred to the "Carrington millions"). Her mother was of Irish heritage, and it is

easy to attribute much of Leonora's visionary world to the fey tendencies of the Celts. She received her early education from private tutors and in her teens attended schools in Italy and France. She wanted to study art, but her parents objected to her Bohemian ambition. She persisted, however, and it was while studying in London that she met Max Ernst and with him moved to Paris. Those were the years of the photograph and the painting. The Carrington-Ernst relationship led to dramatic consequences when Ernst was arrested at the outbreak of World War II, leaving Leonora alone. Eventually, she was granted permission to leave wartime France and fled to Spain, where she suffered a nervous breakdown that one feminist critic has categorized as an "artistic break*through*." In Spain, she married a French diplomat, Renato Leduc, whom she had met through Pablo Picasso; they subsequently made their way to New York and, in 1942, to Mexico. When the marriage with Leduc was dissolved, Leonora married a second time; her second husband was a photographer named Chiqui Weisz, and with him she had two sons.

Carrington's associations with Ernst, then Leduc, immersed her in the world of European surrealism. It is impossible to know how her work would have developed without those friendships, but there seems little question that she would have arrived at her style quite independently of any personal influences. The eerily mythic quality of her work merely intensified during her long years in Mexico. Recently, she has lived briefly in New York, then in Chicago, where one of her sons resides. Now she is back in Mexico looking "for a place to lay my old bones." For Leonora, Mexico is "a *wonderful* place, but a place that comes at you in a kind of *strong* way." Her finely modulated speech is voiced in a distinctive rhythm that emphatically underlines key words. "It has a lot of what they call here *duende.* How does one translate *duende?*" Enchantment, perhaps? "Yes, Enchant-

ment. To me, Mexico is a place that has never been *dis*enchanted, and that for me is what I *adore* about it."

As for laying her "old bones," it is possible to imagine Carrington in physical repose—she jests that she spends three-quarters of her time reading detective fiction. "It is the *great*est form of relaxation, although I *never* know who the murderer is." She finds it enjoyable, however, precisely because during the reading, "my subterranean mind works so *beautifully.*" And "subterranean mind" beautifully describes the creative intelligence that informs her fiction and her painting. That mind, one is sure, is seldom at rest. It is not common for an artist to produce both literary and visual art; in fact, one talent often seems to exclude the other. A painter, for example, will often state that all he has to say he says on his canvas. Carrington has done both, consistently and successfully, and the corpus of her work reveals a strikingly unified vision.

"Mysterious and awesome qualities exude from her hallucinatory images, frequently taking on the rigid striving of Giacometti's fleshless forms, at other moments inflated with the grotesque grandeur and cruelty of an Ernst canvas."[2] That might have been written about one of her otherworldly paintings; it is, in fact, Bettina Knapp's comment on Carrington's writing. The Carrington vision is all-encompassing: narrative is visual, the visual, narrative. In both cases, communication is more perceptual and experiential than cerebral. The same figures fill page and canvas: horses, hyenas, eggs, birds, houses, caves, flowers, fish, demons, gnomes, ghosts, and grotesques, along with a flowing line that circles and spirals to suggest earthly and celestial forms. A circle surrounded by feathery spokes is but one specific symbol that translates between printed word and painted object. In *The Seventh Horse,* this representation recurs as wheel, spider, and star. In a painting, it may be a head of hair, a golden au-

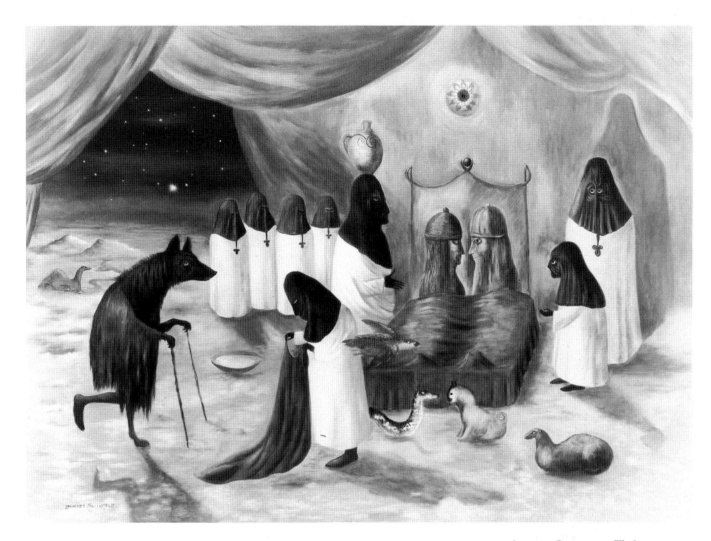

2a. Leonora Carrington, *The Lovers*, 1987, oil on canvas, 30 × 40 inches. Private collection. Photo: Brewster Gallery, New York.

reole containing a heart in an open breast, or a trio of dark suns surrounded by pale sunflowerlike fringe.

One of the stories in *The Seventh Horse* is "A Mexican Fairy Tale," which Carrington wrote in the seventies. It is a classic tale of quest, obstacles, death, and resurrection through love, an ageless fable made new in Leonora's inventive telling. One day while the hero, Juan, is tending his pigs, he hears somebody crying. His search for the voice, which is like "an iguana caught inside [his stomach]" leads him to a confrontation with the villainous Don Pedro, father of María, and meetings with a beautiful green, blue, and rusty bird that turns into a rainbow; a cactus named Piu;

Mole, with his starred snout ("I am blind, but I can lead you through the labyrinth"); and armies of red ants, each of whom "wore a bracelet of green jade on each of her slim legs." His journey ends with a marvelous feast. After eating so much his stomach "looked like a swollen melon," Juan himself is chopped into little pieces by Mole, who then "stuck [Juan's] head on the thorn of a maguey and dived into the hard ground as if it were water."

The second part of the fairy tale focuses on María, who in fleeing from the wrath of Don Pedro encounters a small hairless dog whom she recognizes as an ally. ("She thought: This dog is an ancient.") She comes upon Juan's head and weeps a tear hard as a stone, which she places in Juan's mouth. He speaks, asking her to sew him together again. With needle and sinews from the maguey cactus, María stitches Juan's body together—except for the heart, which is stolen by a Black Vulture. Juan and María know that if they are to find his heart, they must feed themselves to the earth. So the two descend into the underworld as Juan cries,

"Oh my poor lost heart, oh my stolen heart."

His wailing ran ahead of them and disappeared. It was a message. After a while a great roar came rumbling back. They stood together, shaking. A flight of stairs with narrow slippery steps led downwards. Below they could see the Red Jaguar that lives under the pyramids. The Big Cat was frightful to behold, but there was no return. They descended the stairs trembling. The Jaguar smelled of rage. He had eaten many hearts, but this was long ago and now he wanted blood.

As they got closer, the Jaguar sharpened his claws on the rock, ready to devour the meat of two tender children.

María felt so sad to die so far under the earth. She wept one more tear, which fell into Juan's open hand. It was hard and sharp. He threw it straight at the eye of the beast and it bounced off. The Jaguar was made of stone.

They walked straight up and touched it, stroking the hard red body and obsidian eyes. They laughed and sat on its back; the stone Jaguar never moved. They played until a voice called: "María. Juan. Juan. Mari."

A flight of hummingbirds passed, rushing towards the voice.

"The Ancestor is calling us," said María, listening. "We must go back to Her."

They crawled under the belly of the stone Jaguar. Mole was standing there, tall and black, holding a silver sword in one of his big hands. In the other hand he held a rope. He bound the two children tightly together and pulled them into the presence of the Great Bird. Bird, Snake, Goddess, there She sat, all the colours of the rainbow and full of little windows with faces looking out singing the sounds of everything alive and dead, all this like a swarming of bees, a million movements in one still body.

María and Juan stared at each other till Mole cut the rope that bound them together. They lay on the floor looking up at the Evening Star, shining through a shaft in the roof.

Mole was piling branches of scented wood on a brazier. When this was ready, the Bird Snake Mother shot a tongue of fire out of her mouth and the wood burst into flame. "María," called a million voices, "jump into the fire and take Juan by the hand, he must

burn with you so you both shall be one whole person. This is love."

They jumped into the fire and ascended on smoke through the shaft in the roof to join the Evening Star. Juan-Mari, they were one whole being. They will return again to Earth, one Being called Quetzalcoatl.

Juan-Mari keep returning, so this story has no end.[3]

Gunther Gerzsó was for a while a member of the group of surrealists whose core included Carrington, Leduc, her close friend Remedios Varos, and Varos's husband, Benjamin Peret. Gerzsó has reported that as Carrington became more fascinated with painters like Bosch and Brueghel, she became "more interested in the technical aspects of painting. The fact that mixing egg tempera seemed to mimic culinary procedure further enhanced its use in her eyes."[4] This exaltation of kitchen tasks recalls the similar attitude of an artist removed from Leonora Carrington by three centuries but consonant with her courageous and insistent quest for knowledge, the seventeenth-century Mexican nun Sor Juana Inés de la Cruz. Sor Juana's account of how her mind was constantly trained on finding meaning in ordinary objects is contained in her "Response to Sor Filotea," a document written in defense of her right to teach and write and study.

And what shall I tell you, Lady, of the natural secrets I have discovered while cooking? I see that an egg holds together and fries in butter or in oil, but, on the contrary, in syrup shrivels into shreds. . . . Observe that the yoke and the white of one egg are so dissimilar that each with sugar produces a result not obtainable with both together. . . . As women, lady, what wisdom may be ours if not the philosophies of the kitchen? Lupercio Leonardo spoke well when he said: "how well one may philosophize when preparing dinner."[5]

Like Sor Juana, Leonora has channeled her struggle for individual freedom within the boundaries of a traditionally female sensibility; each was able to glimpse the larger ramifications in an ordinary household activity. Rather than appropriate habitually masculine characteristics, Carrington's expression has been based on the concept that magic and alchemy are but a higher form of cooking, and creativity is merely an extension of gestation and birth. The house-womb is a constant metaphor in her work, and her blood, to quote from her memoir, is transmuted into "comprehensive energy . . . and also a wine which was drunk by the moon and the sun"—Woman as the universal creative force.

That memoir, En bas, is a striking document, the account of Carrington's experiences in a sanitorium in Spain. En bas is an exorcism and, at the same time, a lucid and rational examination of an irrational time. Her loss of mental equilibrium was precipitated by her separation from Ernst, but the roots went much deeper; they were buried in her resistance to the "hostility of Conformism" and in her refusal to tolerate any longer "the formulas of old, limited Reason." Both Sor Juana and Carrington were humbled and silenced by traumatic events in their lives. Sor Juana never emerged from her silence. Leonora, in contrast, like the butterfly from the chrysalis, emerged from the agonies she recounts in En bas to people her books and paintings with the rich fantasies of myth and dream. Once we have read her books or viewed her paintings, we can never forget that unseen world that hovers over all our shoulders.

3. Emilio Carballido

EMILIO CARBALLIDO

Córdoba, Veracruz · 1925

Cat: If there's one good thing about the sea, it's that it smells of fish. But the waves get you wet, and they don't understand what it's all about. The beach is not a very discreet place, and the sand can be really un-comfortable. But the moonlight feels warm along my backbone! And the air . . . There's something on the air. It's how light would smell, if you could smell it. PUSSY CATS! Pussy cats twinkling in the night sky: stars, planets, a whole Milky Way of pussy cats purring more sweetly than the waves and the wind, singing in a voice more beautiful than that of the planets. Sparks from their silky coats glitter like fireflies. Their blue and yellow and green eyes ignite fires that inflame my blood, the fires of Venus, and the Moon. Pussy cats. Pussy cats *every*where. I follow them on my velvety pads and corner them; I sing them unforgettable serenades; I weave in and out among them, and toy with their unbearably elegant tails; I tear out clumps of their hair with my claws, and rake them as I make love to them, and they rip my ears and skin, because that's how love is. But the beach is not a discreet place: waves break over you and soak you, and they just don't know how things are. Alleys are better. The moon shines brighter there; it's more intimate. It imbues garbage with mysteries, it offers advice, and electrifies you. Miaaaouuu. Miaaaouuu. (*Scratches the sand, urinates*) Although sometimes, sand is good for... (*Scratches, tamps down the sand*) It's hygenic. But when it comes to true poetry... it's pussycats, shadows in the moonlight, alleys, madness... MIAAAOUUU. MIAAAOUUUUU! (*Exits, bounding and turning cartwheels.*)[1]

That brief monologue by Mexico's premier playwright is an unusual moment in his theater. Although it is difficult to think of Carballido without thinking of cats—he is known to scratch at doors, rather than knock, and he signs each letter with a cat of his current mood hanging from, or curled inside, or illustrating his signature—they have until recently been inexplicably absent from his fifty plays, four novellas, and many short stories. In the last year, he has written a brief story for children entitled "Mil y uno gatos" ("A Thousand and One Cats") and this cameo performance for a cat who appears in his experimental play *El Mar y sus misterios* ("The Sea and Its Mysteries"), in which waves, gulls, sailors, lovers, and boulders play equally important roles.

Even for a writer as inventive as Carballido, a play that casts the sea as its protagonist is a bold innovation. It was received enthusiastically at its premiere in Cádiz, Spain (with waves chanting "Splash, splash, more and more splashes," and rocks echoing "Buruuummm, baruuuummm, super-splash!). It is successful because it reflects Carballido's gift for combining humor and poetry, a hallmark of his major works.

Emilio Carballido was born in Veracruz but moved with his mother to Mexico City when he was one. At the age of fourteen, he lived for a year with his father back in Córdoba, "in a big house with a patio and trees and a goat." He traveled that year with his father, who was a train conductor, making his first trips to the jungle and the sea. He has been on the move ever since. Traveling is nearly an addiction, and it is fortunate that he is constantly in demand for workshops, lectures, juries, and play rehearsals in foreign countries. Say "travel," and the cat-with-suitcases is on the road.

By one of those magically Mexican coincidences, Carballido and Vicente Leñero, unarguably Mexico's two leading dramatists, live across the street from one another in the San Pedro de los Pinos section of Mexico City. Leñero, Car-

ballido complains, can see Carballido's study window from a terrace and thus know when he is working, while Leñero's study light is not visible to Carballido. Certainly, one cannot see beyond the wall of Leñero's home from Carballido's front door. Inside Carballido's house, the numerous small rooms of the first and second floors are lined with paintings and graphics, primarily by Mexican artists, although an occasional Japanese and French artist is noticeable. Nephews, students, and friends come and go constantly, and order has given way to a barely controlled chaos. Guests usually end up in the third-floor studio, which Carballido added after buying the house. A tightly spiraled staircase opens onto a large, well-lit, loftlike room. Large plants divide the work space from a small kitchen and bath. A walkway through the plants leads to a tiny terrace with a view of rooftops (a gathering place, of course, for neighborhood cats) and the cupolas of a neighborhood church. The small, almost miniature, purple Underwood given to him by his father when he was sixteen sits on a cluttered desk positioned before the window facing Leñero's terrace across the street. A grouping of sofas and window seats surrounds a corner chimney, superfluous now in the warm March sun. Four startlingly blue eyes peer from the center of what appears to be a buff-colored two-headed creature that lazily unfolds to become two Siamese cats; they greet the lord of this domain, and the male, Tigre, exits quickly through the low door to the terrace, while the female remains to monitor the photo session.

Early in his career, Carballido discovered the combination of realism and fantasy, humor and poetry, that makes his voice unique. It is impossible to describe the combination; it must be experienced to be appreciated, although a few moments in his presence communicates the same combination. His works include extravaganzas that demand "a cast of thousands," but re-

cently preference and the economics of staging plays have motivated more two-character plays. Among those that have been widely produced, including runs on both coasts of the United States, are *Orinoco!* and *Rosa de dos aromas* (*A Rose by Any Other Names*). *Orinoco!* is a humorous *Outward Bound*. *Rose*—Carballido feels that plays with "rose" in the title always bring him luck— dramatizes two women's liberating escape from a bigamous husband. All four women in these plays are among the most fully achieved of Carballido's female characters, and Carballido is not surpassed by any Latin American author in his sympathetic comprehension of the female psyche.

With his close friend Marta Palau, Carballido shares a straightforward belief in everyday magic—not what the average Anglo-Saxon thinks of when he hears that word but belief in forces that affect the direction of our lives. *Brujas* ("medicine women" might be the closest translation) still play a role in their culture; they read tea leaves, hands, the I Ching, sticks, or offer spiritual cleansings in hot mineral spas. When asked (during the most recent of our conversations, which have spanned twenty-five years) why visual artists so frequently enunciate the word "magic," while writers almost never do, his reply is brief and simple: "Because we don't have to. It's in everything we do." Magical realism to Carballido is not a term that is limited to art; it defines one's life. On another level, this magic is poetry, a pantheism that permeates much of Carballido's writing. One such moment is found in *El sol* ("The Sun"), a rites-of-passage novella about a young boy's first love.

He lay watching the rhythm of the pines, and within this rhythm, the rhythm of the needles and the total harmony of the two rhythms and he understood the sun on the rim of the hills and he saw the relations between the rhythm of the slowly sinking incandescent disk and that of the pines and the branches and the needles of the pines. And he understood the movement of the ragged clouds and he understood the rhythm of the ragged clouds and their relationship to the rhythm of the pines, of every pine needle, and he understood what he was doing with his hands and he had never seen the stars shining so brightly, sparkling with those circles and halos and the hair and little vibrating threads intertwined among the trees, like the sound waves from antennae, like an immense silk cloth ripping or swishing or rippling, although the sound wasn't the sound of silk but of vibrating sheets of glass or tiny golden bells or musical saws or instruments very distant all of it as if it came from the moon in mid-heavens while the same reddish disk filled with mysterious symbols was hiding behind the hills trailing wispy clouds in its nebulous halos and stars melting together in the sky and music and the cocks crowing in the village and the awareness that time was beginning to flow.[2]

Most notable of all Carballido's characteristics is his ability to draw pleasure from every happening. Whether toasting the performance of one of his plays in Paris, the Mecca of Latin American artists, or triumphantly, proud as a peacock, parading the publication of a new book, Carballido celebrates life, sweeping up all those around him, as in the dance that closes *I, Too, Speak of the Rose*.

tail

Maximino: And now everyone . . .
Tona: . . . hand in hand . . .
Polo: . . . will hear . . .
Tona: . . . the abiding beat . . .
Maximino: . . . of the mystery . . .
Medium: . . . of our own hearts . . .
 (*The dance, the chain, continues. The light has been progressively intensifying, to the rhythm of heartbeats, until it reaches maximum intensity.*)

CURTAIN[3]

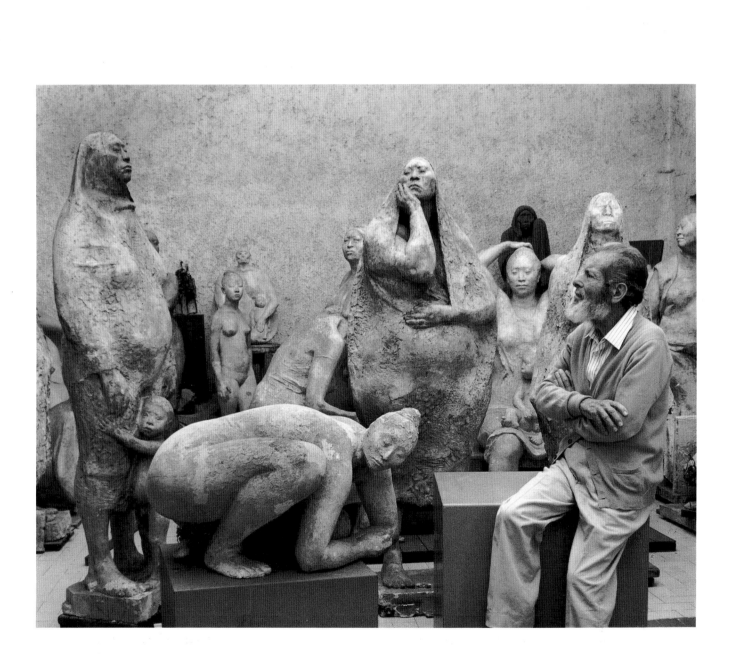

4. Francisco Zúñiga

FRANCISCO ZUNIGA

San José, Costa Rica · 1912

"Many people come here and ask, Why do you do so many women? Why do you do all those Indian women?" Those were Zúñiga's farewell words on our first visit. To ask that question is not to understand Zúñiga's preoccupation with form and volume, nor to appreciate the infinite potential of clay, wood, stone, and bronze. Zúñiga found his personal mode of expression in the sixties, after twenty years of creating monumental public sculptures, and in the same way that Emily Dickinson created a memorable body of poetry while working within a single, individualistic form, Zúñiga will leave a timeless signature in his sculptures and drawings of the eternal female earth force personified in Indian women.

What words best describe these female forms radiating such power and endurance? Are they not massive? Imposing? Stolid? Stately? Sensual? Statuesque? Monumental? Metaphors for the creative and regenerative forces of nature? Earth mothers? Eternal female? These magnificent women—in Zúñiga's drawings as well as his sculptures—stand squarely, monolithically, before the viewer's eye; they squat in the age-old crouch women have assumed in their labors, in caring for their children, in giving birth; they stride forward, arms swinging at their sides,

iguanas on their heads, to market; they sit, one arm loosely encircling a boulder-sized knee; they lean forward, hands clasped at the ankles, chin touching knee, one smooth flow of voluminous flesh; they wait, wrapped in rebozos that cannot cloak the adamant assertion of their flesh, with only the dignified masks of their faces uncovered; they recline, burdens temporarily eased, in a classic study of weight and volume; they cradle their children, protective arms enveloping a child nearly absorbed into maternal flesh.

These many women—occasionally there is a man, a boy, but rarely—evolved with a certain precision. In every case, Zúñiga approached his work as a problem in sculptural form. He recounts the progression of his sculptures, his expressive hands molding shapes in the air as he speaks.

"I wanted sculpture to be sculpture for itself alone. I was formed in a time when sculpture tended to be functional. It was for architecture, for adorning walls. I worked twenty years for the government, making monumental sculptures you can see all about the city. Then one day I asked myself, isn't sculpture valuable in itself? Is it not autonomous? Why must it be bound to a space? So, I thought, I am going to make a woman. Verti-

29

cal. Standing alone. The problem of verticality is not an easy one. You see standing figures everywhere, doing this, or this, dancing, but not just standing. So I began making a standing woman. Then I made two. Or three. I made a group, standing—just standing—because my sculpture is very severe. Look around. You see them standing. Or sitting. And then I made some walking. Now the problem was to make them slow. These standing women, I made them move, and walk. Some going here, some there, as they do in the markets, the native markets. A woman, carrying her things. Just go to Oaxaca and you will see a marvel of movement. Juchitán. Oaxaca. Mérida. Yucatán. That is my inspiration. I have never wanted to create sculpture that is merely intellectual."

Sitting in the large reception room of Zúñiga's home cum studio, office, and sculpture garden, surrounded by the sensuality of polished, pocked, burnished, and crosshatched surfaces, one never doubts for a moment that Zúñiga has succeeded in surpassing, while still retaining, intellectuality. He has recently returned from the United States, where he underwent major surgery. He has suffered the anathema of the artist: his eyesight is impaired, one eye still covered by white gauze; he must await complete healing before he returns for reconstructive surgery. "It's terrible in the darkness, no?" Zúñiga comments as we walk from the reception room to the sculpture garden and the studio where his plaster casts are housed. He is led by his older son, Ariel. Zúñiga loves the sun on his skin. He recognizes his location by Ariel's identification of the sculptures we pass. Zúñiga is a handsome man. His features reflect a Spanish heritage; he more closely resembles his father, he has said, than his beautiful mestizo mother. Though at this moment Zúñiga is deprived of sight, he sees in his inner world. He has been playing, he says, with clay, fascinated by the interior spaces of sculpture, working pieces from the inside out, renewing his tactile sense of the materials of his art. He enjoys answering questions. His thoughtful, coherently organized responses betray his years as a professor at the Mexico City Escuela de Pintura y Escultura. He recalls the titles and dates of publication of theoretical works that influenced him as a young artist. He lists great sculptors who have through the ages changed the course of the art. He traces (the graceful hands still constantly shaping and molding) his vision of the origins of sculpture itself.

"In my view, sculpture has always portrayed. From its beginnings, the chain has been a scratch deep in a cave, then a scratch on a stone. Later the stone was shaped and rounded; then with lines it became a fetish; then it took the form of a deer, or a horse. Or a Venus, a geometrical Venus with a nearly ovoid form. Then sculpture became three-dimensional. It escaped from the wall and the stone and became whole. As Boccioni once said, a bottle is a sculpture. He made a fountain from a bottle. Anything that has three dimensions is a sculpture. Like an egg, as Brancusi said. But Brancusi created an ovoid form that is not an egg. It is a new world."

The difference between the egg and Brancusi's interpretation of the ovoid form speaks directly to the essence of Zúñiga's art. "Zúñiga," biographer Sheldon Reich has written, "sees himself as a lone realist in a sea of abstraction." There can be little argument that Zúñiga is a figurative artist. There are sculptures—*Victoria* and *Shepherd Boy* spring immediately to mind—that are as true to life as sculptures by Renoir and Degas. The drawings—studies for sculptures and exquisitely detailed renderings from life—are classic in anatomical and sociological accuracy. Even the freest sculptures, among them the direct carvings of the sixties, depict the human form. The nature of Zúñiga's realism, however, deserves closer examination. In the majority of his works, his subjects are larger than life, not necessarily in the realm of

4a. Bronze sculptures in Zúñiga's garden. *Yalateca*, 1975 (foreground); *Juchiteca*, 1973.

physical measure but in concept. Though they are an absolute communication of reality, they are different from reality. The pelvic spread is too great, the head too small, the legs too massive to be those of a real woman. Zúñiga has referred to Brancusi's interpretations of nature's essential ovoid form, the egg. He is pleased by the men-

tion, in connection with his work, of a different philosophy of reality, Alejo Carpentier's *lo real maravilloso*, the marvelously real. In the explication of his thesis, Carpentier uses a phrase that seems singularly applicable to Zúñiga's creation: "an amplification of the scale and categories of reality perceived with particular intensity."

Zúñiga elaborates on that vital difference between reality and amplified reality. "Form is what matters. Despite the fact that I am a figurative artist, I continue to believe that form is the resolution of an interpretation of reality. Form is always an abstraction. People believe when they see a figurative sculpture that it is transferred literally from real life. No. The artist always has a vision of reality, and he transforms it to his own wishes. In my own case, I give primary importance to volume, to three-dimensional, volumetrical form. It must have weight. It must have density. It must have the weight of the very material that is being worked: the stone, or the wood. In direct carving, you simplify, you are forced to abstraction, because the material resists you, it has its own qualities. But then you learn casting, to broaden the range of techniques—because you want to do more than mere carpentry or, what do you call it, artisanry. You want to communicate something. And that communication is not something easily expressed. It is a kind of, let's say, transposition of reality—the kind of thing that Carpentier and other authors achieved in their writing. I feel that my work is like an apparent return to the past. I do not return to the past; I reclaim a new vision of that past in the great tradition, above all, the great pre-Hispanic tradition."

Zúñiga's love of Latin American history goes back a long way. Among the paintings and drawings in a large room off the reception *sala* is a bright, easily recognizable likeness of the great Latin American patriot Simón Bolívar. It was painted when Zúñiga was eight years old. Venezuela, the birthplace of the Gran Libertador,

recognized both men when it published this early Zúñiga as a postage stamp. Zúñiga believes that an artist's roots are irrevocably sunk in his culture. For him, Picasso is a Spanish artist, Gaudier-Breska French, and Moore, despite, ironically, strong pre-Columbian influences, ineffably English. (Zúñiga and Moore, incidentally, share the honor of being the only two living sculptors ever given a solo exhibition in L'Orangerie in Paris.) It can scarcely be a surprise that Zúñiga feels so strongly that his debts are hemispheric.

"My point of departure is not the Greeks, but pre-Hispanic art. I am not original in this. Diego [Rivera] did it. Picasso did it. [When I came here from Costa Rica] I saw these women in the street everywhere, selling vegetables and flowers, and they were sitting there like the sculptures I had seen in museums, like goddesses of the earth and the corn—some sitting like this, on their knees, others in the way we describe as 'a la mexicana.' Imagine my amazement! I had drawn sketches of small pre-Hispanic stone sculptures I had seen, and now I was seeing those sculptures sitting there alive, selling their fruit—the same women, the same dense weight, the same faces. They even looked like the sculptures—physically. Not just racial traits, but actual portraits. I knew pre-Hispanic sculpture very well by then. And I could see that despite the vigor of execution, despite a kind of stylization, each head was different. Each woman had a life of her own. And there they were. I was seeing living sculpture." Zúñiga laughs with delight at the memory of this epiphany. "And my work is based on that transposition. That is my most important motif, that transposition I make from the real, in a very ancient way. I base my work in the origins of sculpture."

The three last pieces Zúñiga worked before his illness left him in temporary darkness are sitting behind him: three relatively small marbles of kneeling and sitting women, black, magnetic, mystical. Ariel, before our first meeting with his

father, said something that relates to Zúñiga's placing the foundation for his work in the "origins of sculpture." "What's important in Zúñiga's work," Ariel told us, "is something that has not been seen, something about the nature of sculpture." A return visit, a second opportunity to speak with this sensitive artist, another walk through his "village" of nearly living sculptures, underscores the compelling force of his interpretation of nature's volumes, the mystery evoked by touching the origins of sculpture.

As we leave, we apologize for staying too long, for stealing energy and time from a precious store. "Oh, no," Zúñiga protests. "I'm glad you came. You bring me a little life." He's wrong. It is the other way around.

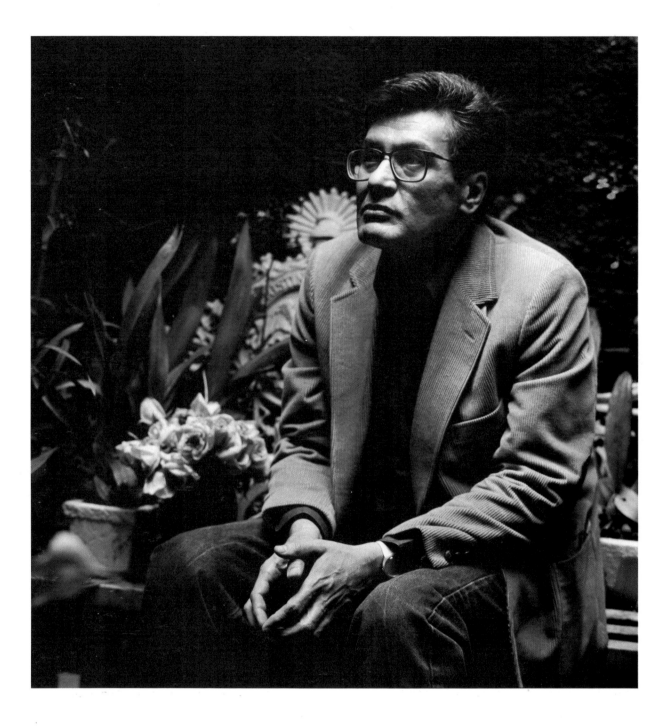

5. José Emilio Pacheco

JOSE EMILIO PACHECO

Mexico City, D.F. · 1939

"We promised you, José Emilio, that we would not insist on an interview as such. We will honor that promise, but perhaps we could just sit here and chat while we're setting up for the photograph?" The reasons for Pacheco's reluctance to be interviewed are not clear to the would-be interviewer. He is intelligent, he is articulate, and he is unquestionably one of the most important writers of contemporary Mexican literature. His resistance to the idea of discussing himself and his work is a phobia of long standing, however, one he articulated in 1982 in a poem published in *Trabajos del mar* ("Labors of the Sea") and titled "Una defensa del anonimato" ("In Defense of Anonymity"), written "to avoid being interviewed."

How shall I explain to you that I have never
granted an interview,
that my ambition is to be read, not "famous,"
 that it is the text that matters, not its author,
that I am leery of the literary circus.

. .

 To begin this non-response, I shall tell you
I have nothing to add to what is in my poems,
nor interest in commenting on them; I am not
concerned with (should I have one) "my place in history"
 (sooner or later, each of our ships goes down).
I write, no more, no less. I write. I offer half the poem.
 Poetry is more than black signs on a white page.
What I call poetry is the site of that encounter
 with another person's life. The reader, man or woman,
will make, or not make, the poem I have merely sketched.

.

 A strange world, ours; every day
there is more and more interest in poets,
 and less and less in poetry.
The poet is no longer the voice of his tribe,
 the one who speaks for those who do not speak.
He has become just another entertainer:
 his sprees, his fornications, his clinical history,
his affiliations or quarrels with the other clowns in the circus,
 the trapeze artist, or elephant trainer,
have assured a wide audience
 of people who no longer need to read poems.

35

.

I keep thinking

that poetry is something different:

 a form of love that exists only in silence,

a secret pact between two people,

 almost always two strangers.

.

In fact, the poems you have read belong to you:

 To you, their author, who invent them as you read.

In "Defense," Pacheco speaks of his persona as a poet (although denying that "Defense" is a poem: "These lines occur to me. They are not a poem. / They do not aspire to the privilege of poetry"). He is also a novelist, and critic and essayist, and editor and educator (he spends each fall semester at the University of Maryland). Like many of his fellow Mexicans, Pacheco is not limited to one form, although most of his critics and readers would probably classify him first of all as a poet. Pondering a question about his own sense of priorities, Pacheco responds with another kind of nonresponse.

Questioner Those who have followed your work are always impressed that you do so many things— the novel, editing, journalism, poetry. If you had to go to the grave with but a single reputation, which would it be?

J.E.P. (after a long silence) To tell you the truth, I haven't the least idea.

Q. As a poet, do you think?

J.E.P. To me, that's a very strange question; that's very difficult. It isn't like it is in the States. In Mexico, it's like being different writers. Some people have read your poems, and others have read your stories. Not very many (*his voice trails off*).

Q. But do you yourself feel you are more a poet, or more a novelist than a short-story writer, say?

J.E.P. No. For me, it's all the same way of writing.

Q. But it's not the same form.

J.E.P. No, it's not the same form. But when an idea comes to me, it comes with its form.

Q. It comes complete?

J.E.P. Yes. That's how the process works with me. Yes.

Perhaps, in a way, it is all "the same way of writing." Pacheco's celebrated novel *Morirás lejos* (*You Will Die in a Distant Land*) has many qualities attributed to poetry, the elliptical, hermetic style and experimental form typical of the Latin American "new novel." The same themes of cyclical time, despair, and a disintegrating world thread through all Pacheco's writings. *You Will Die* is based on the periodic purges Jews have suffered since Roman times. Historical events, often lent fictional authenticity by footnotes, are intercut with a present in which the identity of two puzzling characters must be established with the reader's complicity—much as the "author" who reads the poems must "invent them" as he reads. Some of Pacheco's work, a minimal amount in comparison with the magnitude of his productivity, has been published in English. Elizabeth Umlas's brilliant translation of *You Will Die* won the 1989 Letras de Oro prize for translation. Thomas Hoeksema's translations of selected poems from five published volumes carry the title of a major collection, *Signals from the Flames;* Edward Dorn and Gordon Brotherston have translated the poems of Pacheco's early *Tree Between Two Walls;* and Alistair Reid, a well-known poet and writer for the *New Yorker,* has provided readers with the fine translations of *Don't Ask Me How the Time Goes By.* Yet Pacheco has not received the English-language recognition he deserves. In the decade of the eighties alone, Pacheco published seven children's books, several scholarly and critical works, a collection of short stories, a book of his translations (which he calls, after Jorge Luis Borges, "approximations"), and six collections of poetry.

If it is true that he has "nothing to add to what is in [his] poems," it is there that we should look for this man who would like to avoid being interviewed: in the anguish of *Miro la tierra* ("I Look upon the Earth"), the long cry of pain occasioned by the tragedy of the Mexico City earthquake of 1985; in his translations and imitations of classic Greek and biblical writers; in the "midnight of mid-century" in *Tree Between Two Walls*; in the "death smell" of the woods, the "mud- and poison-stained waters" of *Irás y no volverás* ("You Will Go, Never to Return"); in the "unceasing screams" of *Fin de siglo* ("End of Century"); in the scores of poems in which this writer whose "ambition is to be read, not 'famous,' " has "written" himself. It is difficult to know where to begin, but if one had free rein in translating anything at all from the pages of this prolific writer, it would be a strong temptation to create a Pacheco bestiary. Animals frequently serve as alter egos, as metaphors, as personae through which the poet expresses his doubts, his insecurities, his nihilism. The poems may be as succinct as maxims, like this brief piece, "El espejo de los enigmas: Monos" ("Mirror of Enigmas: Monkeys"), that illustrates a recurring uneasiness about man's identity and his "superiority" to the beast:

When the monkey locks you in his gaze
one shudders to think that we may be but
the mirror of his derision,
we, his buffoons.

Or, this bow to Baudelaire's sense of the interrelatedness of all being, "Correspondencias en Stanley Park" ("Correspondences in Stanley Park"):

The swan's reflection on the pond
 assumes
that the true swan
 is its reflection.

Almost always, Pacheco appropriates the cruelty of the animal's world, the ominous threat that lurks just outside the door or in the evening dusk, to echo and accentuate our own, as in "Los pájaros" ("The Birds").

My earliest childhood memory of Veracruz
is that heavy groundswell:
black birds that seemed to carry night on their wings.
"They're called *pichos*," someone told me.
They must have been starlings or grackles, or of that feather.
The name, though, doesn't matter.
 What I remember
is their dark garrulousness, their fear,
the mysterious randomness of the way in which the birds,
like giant worms or locusts, obscured the trees.
They fell like meteorites from cornices and electric wires,
an unarmed throng attempting, vainly,
 to stem the tide of catastrophe.
The twilight, suffocated, faded and died,
ashes of a lifeless fire
 high in the branches.
The sky itself was a black bird that spread its wings
as unexpected silence settled in the air.
We checked into
 the hotel after a long journey.
My grandfather
 bought the Mexico City newspaper.
He read me the news of that bomb,
of that place with the strange, faraway name,
of that death that descended like the night and the birds,
of those living bodies
 snuffed out in the flames.

Pacheco's way of couching difficult philosophical questions in terms of man's relationship with animals, or animal's to animal, is merely a way of

emphasizing his belief that we are, as he writes in a poem entitled "Nupcias" ("Nuptials"), "obedient ants," "shoals of fish" with the hook sunk in our mouths. In another childhood memory, "Cerdo ante Dios" ("Hog Facing Its God"), Pacheco again levels the distinctions between man and beast.

I am seven. On the farm, I watch

through a window as a man crosses himself

then proceeds to slaughter a hog.

I do not want to watch the spectacle.

Almost human are the

premonitory cries.

(Nearly human, zoologists tell us,

are the feelings of the intelligent hog,

more, even, than dog or horse.)

God's creatures, my grandmother calls them.

Brother hog, St. Francis would have said.

Now but butchered flesh and dripping blood.

And I am a child but I ask myself:

Did God create hogs for us to eat?

Whom does He answer, the prayer of the hog

or the man who crossed himself and then killed the hog?

If God exists, why must this hog suffer?

The flesh bubbles in the oil.

Soon, I will be stuffing myself like a hog.

But I shall not cross myself at table.

In his poems, Pacheco often appears to be a man drowning in a sea of doubt and hopelessness ("sooner or later, each of our ships goes down"). Yet he continues to write, clinging to the fragile lifeline of words. Set against the nihilism of Pacheco's poems, everyday questions seem banal (perhaps the root of his aversion to interviews?). In the light of day, however, amid the evidence of man's eternal compulsion to tell a story, to set

ideas and emotions to paper, writing seems a normal topic.

Q. And what are you working on now?

J.E.P. I've just delivered a book of stories, a compilation of all the stories I've written. . . . No, No, not the published ones, that's another book—the ones that have been published in magazines but not collected. It's about a hundred and eighty pages; some very short stories, and then some that are very long, twenty pages.

Q. And then what will you be doing?

J.E.P. I'll show you something I have: four hundred pages of a novel. I've been working for years on this novel. The terrible thing is that when you're twenty you say, "When I'm fifty I'm going to know how to write." But that's not the case at all.

Q. And is it finished, or do you need to write more?

J.E.P. No, I have to cut. And then there are these things that happen to writers. I have to find a name for a character. He had a perfect name: Noriega. He *was* Noriega. But he can't be Noriega now.

Soon Pacheco will be publishing the still untitled novel, and another book will join the thousands in his home. One becomes inured to the presence of books in the homes of Mexican intellectuals. In Pacheco's home, however, books are *the* presence. His small *sala* is overflowing with volumes of English-language short stories, the largest collection, he believes, in Mexico. (And with flowers. Were there a competition for Queen of Flowers, Pacheco's wife, Cristina, would undoubtedly win.) His study, the stairs, all the rooms of the house are lined with books. Straight ahead as one enters the house is a dark room stacked to the ceiling with books. In this room, hundreds of volumes create labyrinthine passageways that lead to the perfect spot for reading: a small green velvet loveseat positioned beneath a window looking onto the patio where scores of Cristina's orchids cling to brilliant blue

walls. The golden light filtering through the window and falling on the loveseat and comfortable pillows would have been irresistible to Vermeer. There we might read the final poem of this brief encounter with the poet who "has nothing to add" to what is found in his poems, these lines "in imitation of Vladimir Holan," "La verdad del Infierno" ("The Truth of Hell"):

The poet forgives nothing,
not even death.
Yet, notwithstanding his miserable self,
some few signs survive,
in a certain ways famous,
in them, this is sure, remains
not perfection, which would be paradise,
but truth,
though that truth be hell.

6. Germán Venegas

GERMAN VENEGAS

La Magdalena Tlatlauquitepec, Puebla · 1959

Germán Venegas lives in the hills above Xochimilco in the village of San Andrés Aguayacán, far enough from Xochimilco that he felt it would be easier to meet at the main gate of the seventeenth-century church of San Bernardino de Cera in Xochimilco. The Xochimilcas are believed to have been the first of the Nahuatl tribes to leave their mythic Aztec homeland and migrate southward to the central Valley of Mexico. These peoples developed an agricultural system based on *chinampas*, or floating gardens: islands of plants anchored along the canals of Tenochtitlán. As the valley was drained, the islands became permanent; for years, Xochimilco was a vestige of life from the past and a popular tourist attraction crowded with flower-covered gondolas, taco and souvenir sellers, and throngs of Mexican families on Sunday outings.

We arrive on a Monday. Just as well, as the canals have drifted into disrepair. Xochimilco is a bustling small city. Thousands of men pass before the gate of San Bernardino de Cera. We watch eagerly for one of them to slow, but none stops before the party of gringos stationed before the gates. Venegas does not have a phone, but he does have an address. So we search for the highway south and soon are ascending the winding road toward San Andrés Aguayacán. The road is dotted with small communities, countable by the ubiquitous small plaza and church. There is evidence that this area is attracting wealthy Mexico City residents who have now overrun Cuernavaca in their desire to escape the smog and noise of the largest city in the world. Half-built mansions rise jaggedly from behind unfinished, seemingly endless, walls. Water is scarce in this area. Even preparing mortar for kilometers of territorial lines denotes the affluence of this advancing tide of urban refugees. Venegas's town, high above Xochimilco, has an entirely different flavor. Far from the rawness of construction, San Andrés de Aguayacán seems to have been carefully cut out of a picture book of the past. The street on which he lives is actually a cobbled road. Shaggy-barked trees, uniformly painted white to the height of six feet, meet to form a leafy canopy above pedestrians and automobiles, casting shifting shadows on the high walls that line the road. We might see this scene in Sicily, in Sienna, in Seville. San Andrés is the quintessential nineteenth-century village, a fragment out of time. The peal of the bell behind Venegas's metal gate shocks us back to the twentieth century, to the purpose of this pilgrimage. A voice calls out,

"Quién va?" (Who's there?), and with the announcement of our names the gate opens on a stricken face.

"Se me olvidó" (I forgot). Germán Venegas is of medium height. His face is round, with the slightly Oriental features that have given rise to legends of Chinese princesses who millennia ago drifted to the Pacific shores of Mexico. Venegas's black, pony-tailed hair is covered by a knitted cap. Wood chips cling to the wool, to his eyebrows, and to his long mustache. With apologies we are invited into a grassy courtyard. A fragrant bed of brightly colored flowers borders the path to the house. A large, masterfully carved rocking horse stands in the patio; a figurehead that Pablo Neruda would have coveted for his collection juts from the side of the house. The cool living room is dominated by an enormous, wall-sized, black and white Venegas tapestry. Venegas prepares coffee, served in individually crafted mugs, apologizes again, and we all relax and begin to chat. Signs of the artist are everywhere; we want to see more. Venegas leads us to a closet in his bedroom where we see the promise of an elaborately carved headboard ("I'm making this for my wife, but I got sidetracked"). From the depths of the closet Venegas pulls a two-foot-high stack of large drawings, at least three by five feet, and begins turning through them. Some are black and white sketches: charcoal nudes, torsos, arms, heads and shoulders, all obviously studies in motion. "I don't always have a model," he explains. "I don't have as much opportunity as I would like to work from life." When there is color, it is dark, very dark—primarily midnight blues, wines, dark grays.

Questioner *(enunciating the obvious)* They're very dark, dark in both senses.

G.V. I was in a dark period when I was doing them.

Q. Does that mean that these are something you've worked through?

G.V. Yes. (*He smiles.*) Some of these were dreams—things that are behind me.

These dark sketches and washes are closely related in tone to the paintings in a 1988 Venegas show held in a Mexico City gallery: landscapes with blasted trees, monstrous scorpions and mutant apes emerging from the annihilation of war or volcano, faces distorted by voiceless, Munch-like screams. Seeing only these nightmarish canvases, one would carry away a distorted vision of the whole of Venegas's work. There is a more colorful, less Stygian side to the Venegas canon, a world of festivals, masks, Holy Week, prostitutes, skulls—all the myths and realities of Mexico, past and present. It would be an error, however, to see these canvases bursting with color as celebratory; Venegas is too ironic, too caustic, too incisive to slide into frivolity and self-indulgence. But he can be playful and humorous as he records and observes.

"When," Venegas was once asked in an interview, "you paint a man in a *charro* sombrero standing in the middle of a bullfight urinating, and the man's limbs are bottles from which steady streams of alcohol are pouring, what are you saying?"

"I'm having fun."

"But, are you *poking* fun."

"Well, of course, but without being mean about it."

There is no meanness in the self-portrait in his richly lit workshop across the patio. The pensive young man in this portrait is indifferent to the nude behind his back, to which Venegas points and shrugs. "Pornography," he laughs—divorced from meanness, as is his *Paraíso perdido* ("Paradise Lost"), a large oil in blues, purples, and reds. A flatly drawn saint holding the stylized model of a medieval town fills the upper two thirds of the canvas. He stands, floats, poses, in unsaintly angularity, knees bent, feet splayed, one arm uplifted in bony blessing. His right foot rests on a

skull graced with a rather jovial, or perhaps fool-ish, grin; his left foot barely grazes the black, loathsome coil of a creature part whale, Loch Ness monster, scorpion, wolf. Before and beneath him are two archetypal figures: a prizefighter and a prostitute. The boxer is blue, bright blue; he stands in a crouch, gloves cocked in readiness to engage the viewer. The nude prostitute's back is turned, but she, too, engages the viewer with an over-the-shoulder gaze. Her legs gleam in black silk stockings; her bare buttocks glow fleshily. Irreverence? Irony, certainly. It is the icons not present in the canvas that complete it. Venegas knows well, as does his Mexican viewer, that the boxer has a medallion of the Virgin of Guadalupe pinned inside his black trunks, or glued to the visor or dashboard of his car—should he be fortu-nate enough to have a car. The prostitute will have a shrine to the Virgin in her room and a bloody crucifix over her bed. In addition, Ven-egas is not an untutored naïf. His courses at La Esmeralda—few Mexican artists have not passed through La Esmeralda—exposed him to all the traditions of western art. His *Paraíso perdido*, using the images of Mexico's popular culture, is a take on the traditions of past centuries: the placement of holy figures in the superior section of the canvas, with mere mortals—often the artist's pa-tron or the individual who commissioned the painting—occupying the lower segment. Venegas does not represent himself bodily, but a second black serpent-monster, the lowest creature in the painting, breathes out the letters "G. Venegas" in black on a white breath or tongue.

Setting aside iconography, what is striking in *Paraíso perdido* is a technique typical of Venegas, the addition to canvas of three-dimensional mate-rials, often wood but also papier-mâché and ob-jects from the popular culture. Here the village, the face of the saint, and the full figures of the boxer and the prostitute are carved, polished, and painted wood. In a different series from the early eighties, Venegas produced flat scenes with mo-tifs reminiscent of retablos (traditional altarpieces or scenes from the lives of saints) enhanced by metallic-toned, roughly textured papier-mâché figures that seem to have been pressed onto the canvas and scribed with a stylus. In a compara-tively brief time, the decade of the eighties, Vene-gas evolved through three modes of expression, each with an entirely different visual impact: Francis Bacon nightmare, three-dimensional scenes influenced by the retablo, and brilliant canvases with carnival colors and lacquered wood elements. Still a fourth mode, also three-dimensional, may be his most powerful and ar-resting: canvases in which a sculptured wood form is a dynamic element evolving from, not an appended highlight of, the painting.

One need only step into Venegas's workshop to see the vitality of his carving. The scent of wood fills the air. A nearly complete saint-and-donkey stands on a large wooden work block. In a small adjoining room, two brightly painted Judas masks like those worn on the Saturday before Easter hang high on the wall.

Q. Are these yours, Germán?

G.V. No, they were done by my father.

Q. Your father? He was a carver? You learned from him?

G.V. No. Actually, I've been teaching him, and one of my brothers. Many days, we are all working here. They are doing something else today. And my wife is off at a painting class. Do you mind if I work while we talk? I have a deadline.

Q. Of course not. We'd like that. This is a com-missioned piece, then?

G.V. In a way. Wood is very difficult to find—pieces this size, anyway. I saw this piece, well, the fallen tree, one day outside a village not far from here. So, I made a deal. I got the wood, and I make the saint for them in payment.

Q. That sounds like a good arrangement. He's very beautiful. Will you use color, or leave the carving natural?

G.V. I would leave it natural, but they have asked for color.

Q. Germán, do you paint here in this studio, as well as carve?

G.V. I want to be able someday just to paint. I'm trying to arrange things so I can do that. But right now I have orders for the carvings.

One hopes that the carving will not disappear from Venegas's work. Back in the Polanco district of Mexico City, in a show of the Centro Cultural's recent acquisitions, are two pieces by Venegas, large paintings in which carved torsos of natural wood burst from the earth tones of the canvas as if responding to the moment of Creation, to Michelangelo's hand of God imbuing His nascent creatures with the breath of life. Venegas has said that his use of reliefs evolves from the wooden masks and carvings he sees in markets and fairs and that drawing on those traditions is a way of keeping them alive. Guillermo Samperio, currently the director of the literature program of the Instituto de Bellas Artes and a frequent commentator on contemporary art, describes Venegas's style as

> a burlesque of reality, a disregard of the subtleties of misfortune and concordance with popular excess. . . . Venegas observes life from a booth at the fair, or through a slit in the circus tent; his people, objects, landscapes, symbols, and animals dance in space, fuse, float, intermingle, interweave, sweat, make love, torture, laugh, kill, as if, as they are deprived of human values and dignity, they had lost a sense of ethics. [His paintings are] a stage set, mimicry, comedy, in which a pulque glass is important, a devil, a clown's nose, a scrap-iron toy, a papier-mâché skull, a bathing beauty, the lion of Xochimilco. . . . In some moment of quiet contemplation, we discover that

the argument of the painting is *real.* The sly peephole has facilitated this idea, but also has helped us understand that the paintings have watched us observing them through the Cyclops eye. . . . Germán Venegas paints the face of the urban and village barrio. He allows himself the ironic, playful turn that even when it sinks to the lowest depths shines with insistent light.[1]

The light in Venegas's studio is soft but refulgent, blessing equally the saint and the "pornographic" nude.

Elena Poniatowska

ELENA PONIATOWSKA

Paris, France · 1933

"I write to belong."

Elena Poniatowska's life, the immediate history of her family, reads as if it were the script for a dramatic novel or a film. In the swings that often occur from generation to generation, we might speculate that the fictional quality of Poniatowska's reality caused her to gravitate toward her style of writing: writing based on fact, everyday but often uncommon real events and real people. Poniatowska refers to her trademark manner of narrating as "testimonial literature"; it is a mode reminiscent of the New Journalism of Norman Mailer, Truman Capote, and Tom Wolfe, although it developed quite independent of and before that North American literature. For fifteen years, newspaper journalism was Poniatowska's major expression (she has more than once asserted that she was assigned interviews because it was a task not sufficiently important for male reporters). Journalism was a perfect training ground, in addition to a passion in itself. "You get hooked. There's an old saying, 'When that viper bites, administer last rites.' It fills your head. Some internal convulsion makes you sweat ink." One brilliantly edited and written book of reportage, *La noche de Tlatelolco* (*Massacre in Mexico*), is in its forty-ninth printing. One absorbing testimonial novel, *Hasta no verte Jesus mío* (*Till We Meet Again*) has reached twenty-nine editions.

Poniatowska says that she never made a conscious decision to pursue a newspaper career. "I never decided to be a journalist. I thought I could be a journalist, but then, I could have played piano, guitar, or sung." She likes to quote an incident from the life of a woman she greatly admires, Leonora Carrington, the British painter and writer who came to Mexico in the forties and stayed to become an institution in the arts of Mexico. "Someone once asked Leonora why she had decided to live in Mexico. For a moment, she didn't answer. Then she opened her eyes very wide and said, 'I don't think I've ever made a decision in my life.' That's how it was with me. Things have simply happened to me.

"I write to belong. My family on the side of my mother and grandmother and great-grandmother were always on trains. They lost their hacienda during the Revolution and lived in Biarritz, then in Paris, and finally in England in a home called Fairlight—Fairlight, not Wuthering Heights, which I would have preferred. They traveled from Karlsbad to Lausanne, from Marienbad to Vichy, to take the waters. They got off at a station, stayed a week, and got back on the train.

7. Elena Poniatowska

They would watch the switchman growing small in the distance, his lantern a blinking firefly. Everyone called Mamy-Grand, who was widowed while still young, the Madonna of the Sleeping Cars for all the trains, the many, many trains she had taken. She was always in black, her throat very white, her décolletage lighting the ebony of her mourning veils and crèpes de chine. Elena Yturbe de Amor's traveling companions were three be-ribboned, be-hatted, be-linened, be-petticoated little girls whose small faces were swallowed up in a bubbling froth of embroidery: Biche, Lydia, and Paula, my mother; behind them in these photos, their nanny, also stiff with starch and tight curls. Mamy-Grand carried her samovar with her (because my great-grandmother Elena Idaroff was Russian), as well as her own silk sheets to put on the hotel beds. It isn't that we were Gypsies, although there is a little of that in our blood. Even today Biche wears ropes and ropes of pearls that bump against her still-flat stomach, and her chains clack like train wheels on railroad tracks."

Elena's father was French. Her great-great-great-grandfather was Stanislaus Augustus Poniatowski, the last king of Poland before the partitioning of Poland. From that time on, the Poniatowski family have been French. Joseph Poniatowski was a Maréchal de France during the time of Napoleon; Michel Poniatowski was Valéry Giscard d'Estaing's minister of the interior. Elena's Mexican mother—Paula Amor, the daughter of the Madonna of the Sleeping Cars—was living in France, and it was there that she and Elena's father fell in love. During World War II, her father, because of his American mother, was a liaison officer for the French and American armies. Her mother drove an ambulance. Before coming to Mexico in 1942, Elena studied in France. In Mexico, she not only learned to speak Spanish from the maids in her household but she also listened to them in the kitchen and followed

them about their daily lives; she "intuited Mexico" through them. That is one reason, she says, she felt such empathy for Jesusa Palancares, of *Hasta no verte*: they spoke the same language. To this day, Elena claims that Castilian Spanish, or literary Spanish, is not a language natural to her. As a teenager she attended Eden Hall, a convent school in Philadelphia, which helped form the reservoir of experiences that she drew from to create her first published book, *Lilus Kikus*, the story of a young girl who, according to the late Juan Rulfo, "sat in the spiral staircase of her imagination" to impose order upon a confusing world.

Elena Poniatowska is a small woman, blonde, quick to smile and laugh, warm, and friendly. She shares with the other women of her family, she says, a "peculiarity": a tendency to be "absent," to be elsewhere in her mind, a condition that some might call abstraction. Others might consider it intensity, purpose. Elena is engrossed in a nearly completed novel during the times we meet in 1989 and 1990: at her home in Coyoacán, during a downpour, one of the rain god Tlaloc's daily summer drenchings; in the heat of San Antonio, at a program on women writers; in the unbelievably noisy lobby bar of the elegant Hotel Nikko in Mexico City. She is fighting deadlines and obligations, her mind always on the completion of her novel. A thousand pages of interviews led to her project, which began as a commission for a film script on Tina Modotti, an Italian woman who accompanied Edward Weston to Mexico and acted as his nude model. Dissatisfied with her knowledge about Modotti, Poniatowska began to interview people who had known her. After collecting so much information and having abandoned the film project, she decided that she should turn her information into a novel, a novel based on the most accurate facts available, a roman à clef about now-legendary days in Mexico.

Diego Rivera, the tacit villain of an earlier Poniatowska novel about a woman he lived with in

Paris, appears here with his wife Lupe, an exuberant, extroverted woman who tended to dominate any gathering. Rivera customarily appeared carrying his fruit-diet dinner tied in a red kerchief and boasting, "I have the purest intestines in the world." Weston, who himself had once been a vegetarian and agreed with Diego that Mexico was a paradise for vegetarians, was fascinated with Rivera, as Poniatowska describes in *Tinísima* ("Fabulous Tina").

Weston could not take his eyes off the enormous figure of Diego Rivera. The pistol riding over his belly contrasted with the amiable, even sweet, smile. That affable smile was a permanent feature of his fleshy face. He was explaining to one of the lady guests, "They call me the Lenin of Mexico. All Mexican artists are communists, at least, those of us who are good. We're not your coffee house politicos, we're dead serious"; his small, sensitive hands constantly massaged the butt of his pistol. Weston called Chandler, who was clinging to Elisa like a limpet. "Take a good look at that man. He's a genius. Look at his hands, they're the hands of an artist, and look at that forehead: a wide brow is always the sign of intelligence. Look, his hair has receded and left a bald area half the size of his head—an enormous dome, Son. Look hard; that's the brow of a thinker." Diego was monopolizing the conversation. When he did pause, he listened to each person among his audience, bestowing on each the same placid smile, his tiny hands folded over his belly until his contagious laughter sent shock waves through his folds of flesh, and the pistol, which had worked its way to his side, seemed less gigantic. What a laugh Diego had! Chandler could not keep from staring: at the awesome girth, at the all-mighty pistol. "Do you think he uses it to protect his paintings?" he asked his father. . . .

Weston lived in revelation, that given him by Tina, and that of the country she was inviting him to share. "I love it here; I feel I'm one of the people," she would say; she blended in with frightening ease. He had never seen her so exuberant, so feverish. She attracted people like a magnet. When there was a knock at the door, it was for her. Everyone who knew she was back in Mexico wanted to see her and renew their friendship. De la Peña showed up one Sunday afternoon; he had bought one of Weston's photographs in the Bellas Artes. Apparently, the negatives of Tina had been a profitable investment; the purchasers all fell in love with the model. If they didn't find her at home, they kept coming back.

They were often awakened at daybreak by the blast of gunpowder; the first time it happened, they ran to the balcony, alarmed. Weston put his arms around Tina. "Could it be the beginning of a new Revolution?" All the color had drained from Weston's face. By now, though, they were used to the fireworks, but once Weston had said to Elisa, "We heard a lot of firecrackers this morning," and the girl had replied, indifferently, "Yes,

there was a lot of shooting in Tacubaya." "That's Mexico for you," De la Peña had laughed, boastfully. "The hare pops out of the hole you least expect." When Weston had asked nervously whether in fact there would be another Revolution, Roubisek, the owner of the Aztec Land Gallery, had replied: "Not one. Forty."

In 1988 Poniatowska published *Nada, nadie: Las voces del temblor* ("Nothing, No One: Voices from the Quake"), a book similar in format to *Massacre. Nada, nadie* is also testimonial literature, using the personal witness of hundreds of survivors of the 1985 earthquake that devastated a large part of central Mexico City. The book recounts man's infamy (ignored building codes, bureaucratic snarls in rescue and resettling efforts) and man's grandeur (the ground swell of love and bravery that arose in response to the cataclysm). These two enduring records of apocalyptic events in Mexico's history, *Massacre* and *Nada, nadie,* along with two collections of her newspaper columns (*Palabras cruzadas* ["Crossword"] and *Fuerte es el silencio* ["Powerful Is the Silence"]), *Domingo 7* ("Sunday the Seventh," a book of interviews with presidential candidates), and *Ay, vida, no me mereces* ("Oh, Life, You Don't Deserve Me," a collection of literary essays) constitute the corpus of Poniatowska's nonfiction.

Poniatowska's fictional works center around memorable, strong female protagonists—as in *Lilus Kikus,* illustrated in its fourth edition by Leonora Carrington, and *Tinísima*—a silent but positive indication of her inherent feminism. In 1979 she published *Gaby Brimmer,* the chronicle of a remarkable woman who overcame the obstacle of cerebral palsy to complete school and become a writer and the mother of an adopted child. Poniatowska's most traditional novel, in the sense of being elaborated as fiction rather than novelized fact, is *Querido Diego, te abraza Quiela* (*Dear Diego, Love, Quiela*). The novel developed from a letter Diego Rivera wrote to his mistress Angelina Beloff, the mother of his only son. Rivera lived with Angelina ten years in Paris, yet, as Poniatowska indignantly observes, "He did not even recognize her thirteen years later when he saw her in Mexico." To that one authentic letter, Poniatowska added a series of fictional letters that form a moving story of betrayed love. She has also written *La Flor de Lis* ("Fleur de Lis"), a novel, and a collection of short stories, *De noche vienes* ("You Come by Night"), all of which have been individually translated into English and published in literary magazines and anthologies.

Elena Poniatowska has a unique voice and a strongly individual style. If we are to believe this accomplished woman, whose nose crinkles so charmingly when she laughs, things "simply happened" to her. One must protest, instead, that she has been more active than passive in creating her success. Or maybe, like Lilus Kikus, she followed the signs.

The nuns told her the story from the Bible about the God's servant Uzzah and the ark skillful carpenters constructed for God from cedar wood sheathed in gold. The ark was transported from Gibeah to Jerusalem by oxcart; at a moment when the cart was shaken, Uzzah put forth his hand to the ark. God smote him, and he fell dead, because he had touched the house of the Lord God. "And David was displeased that Jehovah had made a breach upon Uzzah, and he was afraid of the Lord that day."

Through that account, Lilus understood that to belong to God, you had to give yourself completely. You had to know Him and fear Him. And believe in His signs. In this life, that is more important than anything. To believe in signs, as Lilus believed from that day on.[1]

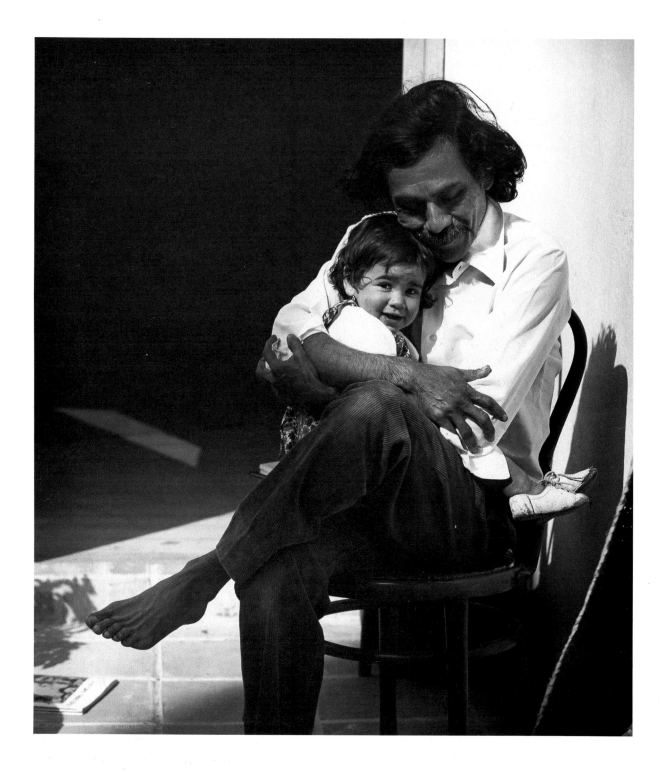

8. Francisco Toledo with daughter, Sara.

FRANCISCO TOLEDO

Minatitlán, Oaxaca · 1940

When one considers the range and level of Francisco Toledo's talents, one often thinks of Picasso. Like Picasso, Toledo paints in many media and, in addition, creates ceramics, tapestries, graphics, frescoes, and sculpture. Like Picasso, too, Toledo is incredibly prolific. There is the same pulsing energy, the same urgency to create, that characterized Picasso's career. Toledo's heritage, like that of another superb Mexican artist, Rufino Tamayo, is Zapotec Indian. That mythic past can be seen in Toledo's production. He has been called a magic realist, a monstrous realist, a fantastic realist. Toledo is anything but a naïf, however. He has studied and worked in Paris and has donated a sophisticated art collection to the people of the state of Oaxaca. Critics claim to see the influence of Klee in his work. In truth, however, confronted with this unique and immediately recognizable body of work, it is difficult to see anything other than Toledo.

Toledo's art is uncompromisingly erotic, exuberant, and vital. It is rich with figures from nature: scorpions, grasshoppers, coyotes, rabbits, crocodiles, frogs, iguanas, birds, and fish—frequently indistinguishable from phalluses. Humans, usually women, also appear, and both beasts and humans engage in assorted couplings and transmogrifications. Few colors are ignored in Toledo's palette, but earth tones predominate: ochers, browns, maroons, greens. In part his work must be considered autobiographical. Some early paintings, for example, reveal a fascination with shoes. Toledo's grandfather was a cobbler, and the western shoe, so different from the traditional Indian sandal, seized the young Toledo's fancy, becoming a kind of fetish. At the same time, his work is undoubtedly mythic, welling from immortal tribal tales and legends and enriched by indigenous symbols and forms. Subjects, forms, objects, are often built of layered fragments, like scales or dried leaves; canvases are filled with repeated images, colonies of small creatures, in concentric, swirling compositions that create a world of fable: pranks, rituals, obsessions, and birth and death cycles.

The myth of the artist, the legend of the man, precedes Toledo. "He has no house." "He never travels with a suitcase, only a key to where he's staying." "He has no studio; he works wherever he is." "No one sees him." As with every myth, there is a kernel of truth from which the tale grows. One may see him—if one has the fortune

to find him in Mexico, and if one is introduced by his good friend and gallery representative Alejandra Yturbe. He does have a house. It is bare and uncluttered, although Toledo and his young daughter, Sara, and Sara's Danish mother, Ana Ekatherina, are just moving in. In a subsequent visit, the stark white walls are beginning to fill with the artist's works, but plainness is still the ruling principle. Whether Toledo travels with a suitcase is not resolved, but the question of studios is settled: his ceramics studio is in Cuernavaca; he produces engravings in Mexico City and in Paris. Perhaps he does paint wherever he is, but one of those places clearly will be the large, clean room in this house, where tables and shelves show signs of developing into a well-arranged workroom.

There is no tape of any conversation. The sight of the recorder threatens adamant silence. The offending recorder is quickly tucked away, but the prevalence of the Toledo myth, nonetheless, is explored. No house? No studio? No belongings? Toledo finds the immediate absurdity genuinely amusing. His face lights up; he smiles and shrugs. "But I'm just normal." Toledo is slow to speak, but his gestures are eloquent. He shrugs a lot, in self-deprecation, looking away and lowering his eyes. He hugs his body continually, as if he were cold. He is, in fact, painfully shy. He is a restless creature, shifting from foot to foot, his bare feet finer than the powerful hands. He is willing to cooperate but seems bemused, puzzled that anyone should be interested in him or his surroundings. To satisfy this strange curiosity, however, he leads the way through the bare rooms. The effect is one of Shaker simplicity transferred to a Mexican ambience. One bedroom contains a large brass bed covered by an Indian blanket, one caned chair with a broken-out seat, a large *arcón* on legs, and two shirts hanging on a nail in the wall. The part of the legend having

to do with worldly possessions seems to be grounded in fact.

Every room of this house-in-process-of-being-restored is lined with large shelves stacked with rectangular bundles neatly wrapped in brown paper. One room at the back of the house is used for nothing but storage of these intriguing bundles. A variety of possible contents comes to mind, but the answer is surprisingly uncomplicated. The bundles contain books, books published by Ediciones Toledo. It is then that Toledo begins to talk. We have established a key to conversation; he has no reluctance to talk about any subject other than himself, as long as he is not inhibited by the knowledge that he is on record. His publications include poetry, children's stories, and photography. The major focus of Ediciones Toledo, however, is regional: books on Oaxacan and Zapotec culture, facsimile editions of early newspapers and magazines, and family histories. One of the most impressive books is a facsimile edition of the finest Zapotec-Spanish dictionary, originally published in 1587. The publishing house, Toledo explains, is primarily a family operation (Toledo has six brothers and sisters). Asked whether after centuries of oppression and oblivion, there is a growing sense of Zapotec pride, of rescuing and consolidating a cultural heritage, Toledo again seems bemused. No, there is no question of pride. It is just that he has his home and his family and, well, that is just the way it is.

Little Sara follows Toledo everywhere, sitting on his lap or sucking on a tube of Colgate toothpaste. "It cools her gums." When he spreads some books on the floor to sign them, Sara wants to draw on them. The almost certain parallel prompts the question of whether Toledo had been the same. "I don't know," he says, illustrating his innocence with a typical shrug. "My family has never said when I started drawing." In this case, nevertheless, it is tempting to believe the

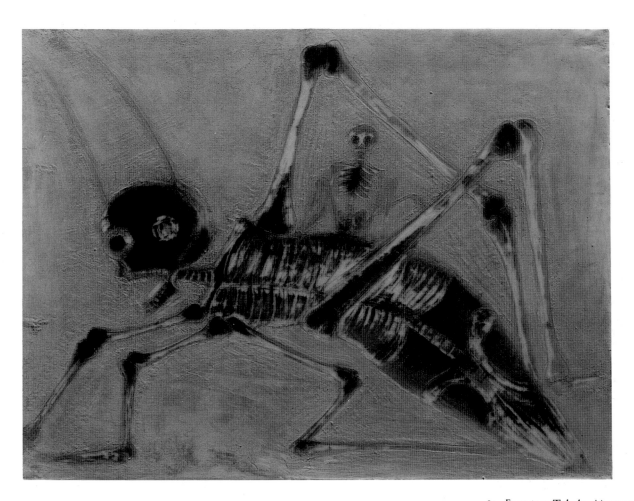

8a. Francisco Toledo, *Muerte y grillo*,
1990, wax relief, 60 × 80 centimeters.
Courtesy of Galería Juan Martín,
Mexico City.

published stories of how Toledo used to draw on
the walls of his grandmother's house—because
when attention is diverted from him, Toledo will
turn to draw on the brown paper covering a new
window in a bedroom door, or on a torn piece of
cardboard lying in an open doorway. For him,
drawing must be as natural as breathing. And
again, the resemblance to Picasso is conspicuous.

One of the pieces of art in Toledo's spartan
home is a photograph by Graciela Iturbide. Her
stunning collection *Juchitán de las mujeres* ("Juchitán,
Town of Women") was published by Ediciones
Toledo. This photograph portrays a white-haired
woman and an adolescent girl, each holding a fer-

tility fetish, a stylized hand with fingers out-stretched like rays of the sun in a child's drawing. Suddenly, there is Toledo's presence, one of his self-portraits comes to mind, a fiendish self-representation with whirling cobwebs for eyes and penislike projections growing from the top of the head. Is it possible that the projections in the self-portrait echo the visual pattern of the fetishes prominent in Juchitán culture? "Maybe; could be," is the honest answer. Now two people shrug, and chorus the Mexican cliché, "Quién sabe?"

Verónica Volkow, the young poet whose poems have been published by Ediciones Toledo, has studied Toledo's art in detail. For a brochure announcing the publication by Era of a collection of Toledo's paintings and ceramics, Volkow wrote a general commentary on Toledo's work and a description of the artist at work that captures dramatically the dynamic energy of the creative process.

Toledo's subjects surge from the raw material, from clay, plaster, paper, wax, metal. Anything, it appears, can become a raw material, the place where the subject appears. Subjects also emerge from one another. A deer from a lion, an iguana from a woman, a cricket from the mouth of a toad. A chain joins all beings in the meshing gears of their devourings, their copulations, their mirrors, their metamorphoses. They incorporate one another. The entire universe seems to be joined unto itself, emerging from and terminating in a circle that may begin from any mouth, any sex, any eye, any orifice, any touching. Figures surge from the page and also are devoured by the page, as if the page were a great maw or a white vagina.

Here is a labyrinth of fragments. Perhaps all fragmentations lead to the labyrinth. A figure in space, having the volume of relief but lacking the figuration of distance, is partitioned from the background. The outline of a rabbit is stitched together; it seems to be sewn of the background. Bodies, in their turn, break up; they are formed of scales, assembled. The torsos of pugilists are divided into segments like the land parcels in *Land Titles of Juchitán*. The drawing is the first division of land. It is the original, the essential, raw material to be divided; the divisions are its creations, its children. Every part is indivisible from the whole; it acquires the animism of autonomy: a foot may become an animal; a toad, a hand. All, finally, may also become raw material; anything may emerge from another being.

The Toledo background does not represent space, it simply envelops the figure. Space is the support, the pedestal, of the figure. The figure is not separate from the background, it surges from the background. All space, ultimately, is enclosed in a network of lines. If there is space in the background, it is that of the interstice, not the open sky. As in a strange play of inversions, external space suddenly is devoured by the figure, converted into internal space: a wildcat encloses space, encircles it, as if encircling a void; through that void races a rabbit. What is by nature external can be involuted, turned into a fold. The labyrinth has no exit; the outside is only one more fold, one more skin, of a limitless series.

In the fresco, light becomes a raw material, covering or being covered. Light surges from within things, from their center, like a fountain. In an almost mystical inversion of the world, it is no longer light that beams down, that falls upon things, but is converted into light that rises, gushes upward. In the fresco, as in the watercolor, light is taken away from the image, primordial light, engendering light, just as stone is taken from the sculpture. In a contradictory game between *via de pongere y via de levare*, paint is imposed to hide light. . . .

With an aerosol can, Toledo sprays blue onto the fresco, then splatters orange with his hand; he spreads the colors with a spatula, then with a stylus he traces a web of figures. He follows the groove with a brush (tracing not from a figure but from a web of figures), then smoothes everything again. He brushes segments of the fresco, bringing out a thicker grain on the prepared surface. He flicks a bottle containing brown paint, lets the paint trickle down, begins a different web of drawings with the stylus, rasps downward with the spatula, softening the texture. He scrapes certain areas, proceeds to a different web of forms, follows that labyrinth with a blue brush, scrubs vigorously between the lines to bring up a square of white from what has been color. With a fork, he draws a web of concentric semicircles, combs that with a grooved brush, adds green-brown impasto, completely covering parts of the fresco. He scrapes over it, uncovering the underlayer, adds two faces, covers them again, draws two crabs, works the impasto with his fingertips, and sprinkles red and blue powder on the figures.

At some point, the process ends, although it could continue. With Toledo, the act of painting turns into a ritual of unending creation and destruction: he paints and removes paint, draws and buries the drawings; he works on successive palimpsests; to erase is to reveal the color that has been devoured. Untiringly he pulls out his magic figures, as a magician pulls objects from a hat, a sleeve, a foot—from anywhere. His work is the creation and reproduction of infinity.[1]

Manic energy. True enthusiam—if one returns to the roots of that word: possession by a god, supernatural inspiration, artistic frenzy. As Toledo accompanies us to his front gate, he stops, as if transfixed. He points to a succulent in a large pot, a flat, thick-petaled flower the color of ripe olives, its leaves arranged in concentric rosettes. "Isn't that beautiful." His words are a statement, not a question. Although Toledo must pass that pot every time he goes to the door, it is as if he were seeing it for the first time.

9. Verónica Volkow

VERONICA VOLKOW

Mexico City, D.F. · 1955

In Mexico lines of communication among artists of different genres are more open than is the case in the United States, where the line of the poet, say, and the line of the sculptor follow trajectories that seldom intersect. A classic example of the relationships that form across artistic lines in Mexico is the triangular ("Not a French triangle!") friendship among the poet Verónica Volkow, the photographer Graciela Iturbide, and the artist Francisco Toledo. The professional interactions among these three create a small art universe in itself: Toledo has published Iturbide's photographs and Volkow's poems. Volkow writes text for Iturbide's photographs. Toledo illustrates Volkow's poems. Volkow dedicates a collection of her poems to Iturbide.

Questioner How did all this come about, your collaboration with Toledo and Graciela?

V.V. Toledo just called me and said he wanted to do a book with me, so—The book came out in two editions; one was a *de lujo* edition with Toledo's engravings. It was all so surprising and unexpected. I don't know, really, how it happened. But Toledo is always surprising.

Q. And Graciela? How did you meet her?

V.V. Well, we met at her house. I was with a friend, and this friend wanted to visit her. So, I liked her photographs very much, and we started talking, and—I don't know—things just worked out.

Three books published by Ediciones Toledo were the result: Iturbide's *Sueños de papel* ("Paper Dreams") and Volkow's *El inicio* ("Incipience") and *Los caminos* ("Highways"). There are personal as well as professional signs of the friendship: a Toledo pot sits on a low coffee table in the living room of Volkow's apartment in Coyoacán, and half a dozen of his vibrant graphics enliven the walls. On a high, narrow chest stands a painted figure of a blue-robed woman wearing a tiny pearl necklace. "She's my Virgin," Volkow says. "Any special Virgin?" "No. Actually, she belongs to Graciela, but I take care of her." Might she be the princess of the labyrinth?

HER STORY OF THE LABYRINTH

Only the ear of the labyrinth

heard the princess scream,

heard her scream, and registered the footsteps

of her repeated image in the passageways.

Yes, the princess screamed

and her scream echoed over and over again through

the endless branching corridors.

The princess had nothing at all to do

 or almost nothing

except perhaps retrace with every day the labyrinth,

those identical passages like mirrors of passages,

those paths tangled

into a knot of paths.

Where to go?

Where to find the secret door behind the mirror?

Where, in the light of day, with one step,

find access to another space, a real and different place?

Yes, surely the labyrinth has an eye,

but how to know whether it gazes outward

or stares only inward upon itself?

And perhaps the princess is but an image

of a former princess in the gaze of the eye. How to know?

In any case, the princess

does not feel real,

and every morning obsessively

she traces the outline of her face.

Meanwhile, the hand of the labyrinth

silently weaves her footsteps,

and invisibly unravels her life.[1]

Volkow is best known as a poet, but she also has a reputation as a critic and essayist. Among her nonfiction works are *Diario de Sudáfrica* ("South African Diary"), prologues and texts for numerous art books, texts for a dozen exhibition catalogs, and essays for *¡Siempre!* (such as her three pieces on the Marquis de Sade's *Justine*, corporeality in the work of the Japanese director Mishima, and, to close the circle, like a snake biting its own tale, Mishima's version of the *Marquis de*

Sade). Geometric patterns seem to spring up irrepressibly in Volkow's life and work; we see them in the intersecting maze of the labyrinths that crisscross the pages of her poems, in the triangle of creative energies flowing from and to Iturbide and Toledo, in the circle of repetitive cycling of time and the recurring mirror-eye imagery of her poetry. The word "eye" itself, in Spanish, suggests the circle: "*ojo*," round eyes joined by the curve of a nose, the stroke of a pen or brush? "God is an eye," Volkow writes in "*Angeles románicos*" ("Roman Angels"). And the mirror-eye that gazes, and returns the gaze of eternity, appears in her critical writing, as it does also in poem VIII of *El inicio*.

Our bodies bound like mirrors

bound like mirrors by desire

my eyes lost

in the well of your eyes

your eyes suspended

 in my eyes

 toward the infinite

series of similitudes

road to smaller, like worlds

 perspective

on all that recurs eternal . . .[2]

Verónica Volkow is a small woman; her long brown hair is a dramatic frame for the regular, modeled features, the high cheekbones, that reflect her Slavic ancestry ("My mother was Spanish, and my father was Russian"). She completed a master's degree at Columbia University in New York and has been a resident poet in the celebrated writers' program at the University of Iowa. Whether in Spanish or English, she speaks rapidly, in spurts of sentences. She pauses thoughtfully following questions, revealing a cer-

tain caution in responding to anything in the area of her personal life. As she speaks, she rolls, quite vigorously, a long strand of pearls between her palms, as if shaping rolls of clay to prepare a coil pot. Her intensity is similarly evident in the order of her apartment—the careful arrangement of coral branches, small, dark terra-cotta pre-Columbian heads, and Toledo *boîte* on her coffee table—and in the compressed energy of her poetry and prose.

Q. Did you begin with poetry?

V.V. That was the first genre I worked in. And then I started on essays. It took me a long time to develop a style in the essay, and now I work with that a lot—the essay, and also the chronicle. It's as if I always need a reference to reality. I can't construct something beginning just from a fiction. Even if I write narrative, it always starts with a fact.

Q. Elena Poniatowska does that, too.

V.V. Yes. Maybe that's something very characteristic of feminine literature.

Q. I'm interested to hear that, because women have always been accused of being intuitive rather than objective, isn't that true?

V.V. Yes, but intuition is always linked to reality.

Q. And not magic, then?

V.V. Magic is also linked with reality.

Q. Marta Palau works directly out of magic. And Leonora Carrington. And Angela Gurría believes absolutely in *duende.* In the case of writers, however, most seem more grounded in traditional reality. You sound more like a painter.

V.V. (smiles broadly) Maybe that's because I always work with painters. I'm always working with painting.

Like many of Mexico's most successful women artists, Verónica Volkow comes from a family that is comparatively new to Mexico. Is it coincidence that Margo Glantz, Elena Poniatowska, Angeles Mastretta, and Verónica Volkow all are

LANDSCAPE FROM AN AUTOMOBILE

Blue is the color of distance

the color in which mountains disappear

sinking into the sky

it is the color of pools approaching

the unfathomable depths of the remote

amid sharply drawn grasses and stones

swallows wings that open

and close like fists

one instant photographed by the water

shadow again as they race across the earth

afar off

men outline the fields

with strips of trees

furrows of earth

and trace the symmetry of their designs

on woodland ragged as rocks.[3]

first- or second-generation Mexicans? Does that infusion of new blood from the Old World instill a need or an ability or even independence that women from more traditional Mexican families may not have achieved?

V.V. Well, I don't know. Graciela Iturbide, for instance, comes from a very old, very notable Mexican family.

Q. Agreed. This observation can't be proposed as a formula for success. But Margo told me that she writes to reintegrate an inherent fragmentation; she feels that all her writing is an exercise of reintegration, that it has to do with not feeling entirely a part of her surroundings.

V.V. Perhaps my need to write does have some relation with my country. In my case, it's a need to find my roots, to find a foundation, since that's not a given—because I come from an interrupted history, because there's a hiatus in the history of

my family. Yes, writing for me is to construct my own origins.

"Laberinto" ("Labyrinth"), with its allusions to the Spanish Civil War, may be a poem written to fill in the "interrupted history" of the maternal side of her heritage.

LABYRINTH

no one ever reaches the end

or his flowering

the poets died young in the avenues

spared the anguish of aging

it was like a city of fossilized streets

in which the face of the impetuous rose was not revealed

nor wound opened to permit the idea of possibility

it was like an impregnable labyrinth

of streets lost in themselves

endlessly identical and impenetrable

streets that ended at the same door

and the same sidewalk

in perpetuum.[4]

On the side of her Russian father, Volkow made a voyage to bridge a hiatus.

V.V. I traveled to the Soviet Union, and I want to write about it. These are the notebooks I take when I travel (*pointing to the handsomely bound books spread on the crocheted lace tablecloth*). I've come back to them because I want to write about that trip.

Q. Are you fluent in Russian?

V.V. No, I don't speak a word of Russian. I went as a tourist.

Q. Did you meet any of your family?

V.V. I met some cousins. My family home is not there anymore.

Q. When you work, do you work around a theme? That is, will you do a collection of poems on a theme? You told me that your first book consists of erotic poems and your second of mystic poems. Or do your collections take shape after the fact?

V.V. Sometimes I work with projects. But also, at a given moment, your life changes and certain dimensions become more important than others. So in a way, yes. But sometimes I try to go in one direction, and poems come from another, unexpectedly. I write, I sometimes think, for spiritual survival.

ENIGMA

Enigma perforates our bodies

a surface opens

that once was closed

the stone's

stone dream

and we are blinded by the splendor

of an unexpected existence.[5]

TEODORO GONZALEZ DE LEON

Mexico City, D.F. · 1926

There are many ways of thinking. González de León
thinks principally in terms of forms, volumes, and
rhythms.

<div align="right">OCTAVIO PAZ</div>

The Colegio de México is a research university for postdoctoral study. Its faculty is composed of Mexico's intellectual elite. Although the Colegio is not a perfect analogue to the French Académie, entrance into this exclusive assembly is tantamount to membership in a similar inner circle. It is the tradition that upon initiation, the new member presents a major paper. González de León's lecture on the occasion of his admittance in late 1989 was "Architecture and the City." His respondent was Octavio Paz. Both presentations were published in January 1990 in *Vuelta*, a monthly journal of which Paz is president and director.

González de León's lecture is structured on three basic topics: the city as an entity, aspects of a specific city (Mexico City), and problems of cities and potential solutions for metropolitan issues. For his first topic, he expounds his views on the origins and development of the city.

Cities are the result of chance, design, time, and memory. That is, they are built by people, regulated by government, modified by time, and preserved by memory. Good cities result from an equilibrium among these four factors; in such cities, order of design favors liberty, and the urban memory of its inhabitants acts to correct and, should that correction occur, profit from the effects of time.

González de León describes conditions that determine the ideal city and argues how an imbalance among the four factors results in urban deterioration.

Second, González de León examines three ideal periods in the life of Mexico's capital city.

In the history of Mexico City there have been three moments when collective actions have created a diversified, yet unified, architecture. The first occurred in the early sixteenth century, when the city was an island that was partly natural and partly connected through that inspired invention, the *chinampa*, or floating garden. . . . The second moment dates from the end of the eighteenth and beginnings of the nineteenth centuries, when the development of the city achieved true unity and a unique style. Urban

61

10. Teodoro González de León

order was articulated through a variety of plazas that dictated the hierarchy of block, neighborhood, and city. By that time, however, the relationship with the ecology of the valley had already been severed. . . . There is, finally, a third moment of urban integration which comprises the thirty years between 1925 and 1955. By then the city was a very important center with a certain complexity in services and industry, but its structure was still very evident. . . . The air was clear, and visibility often reached 100 to 150 kilometers.

This was the Mexico City the late Alfonso Reyes referred to as *la región más transparente,* "the land where the air is clear," a phrase Carlos Fuentes used as a title for one of his early novels.

As the third theme of his address, González de León points out specific ills that plague Mexico City—past failures and potential solutions.

Experts promise a chaotic scenario for the future of the metropolitan area: problems of transportation, a shortage of services, and pollution that will render the city unlivable. Fortunately, man has almost failed in forecasting the future. I am heartened, on the one hand, by how this enormous city functions, how its inhabitants react in the face of problems and catastrophes. On the other hand, I do not forget that demographic growth will continue.

While his views are not totally apocalyptic, González de León's warning is chilling.

In the twenty-first century, the largest cities will be in developing countries; it is calculated that by 2025 there will be nineteen metropolitan areas containing between fifteen and thirty million inhabitants, of which seventeen will be in the Third World. Only one will exceed thirty million: Mexico City.

When we visit González de León in his starkly elegant home in the Hippódromo-Condesa section of Mexico City, those terrifying statistics seem, temporarily, far away. His home, a restoration of an Art Deco residence of the twenties, is obviously the house of an architect with classical inclinations. (To quote Paz once again, "The farthest thing from González de León is the baroque.") Cool, bare white walls emphasize line, plane, and space. One large arched window in the *sala* frames a tranquil view of a blue pool edged by blue-green papyrus plants rising serenely against a severe white wall. Concrete spans strategically placed across the patio block out the presence of surrounding city buildings while structuring a succession of segments of blue sky. Marvelous Mexican light creates chiaroscuro drama in every room and floods the long second-floor studio where González de León paints. For like his mentor, Le Corbusier, and like Léger, another Frenchman whose art resonates with his, González de León is an architect-painter. In addition to the evident mind-set of "forms, volumes, and rhythms" to which Paz referred, the paintings in this studio also reveal a theatrical flair that is at first view surprising in this disciplined artist. Objects are not confined to a single dimension but jut boldly from the canvas surface. Cloth that has taken on the stolidity of concrete hangs in dramatic swags from one corner of a canvas or is applied in folds in sensual contrast to geometric shapes that suggest architectural instruments or materials. On second thought, a sense of drama is not at all out of place in the work of a man who designs enormous complexes in a land where monumentality is a tradition.

A second day, in his nearby office, González de León discusses a portfolio of his most significant creations, many of which evolved in collaboration with his longtime colleague Abraham

10a. Teodoro González de León and Abraham Zabludovsky, architects, El Colegio de México. Photo: Julius Shulman.

Zabludovsky: apartment complexes; impeccably calibrated private residences; the Mexican Embassy in Brasília; office highrises; banks; a park and zoo in Villahermosa, in the state of Tabasco; the service and tourist areas at the pre-Columbian ruins of Chichén-Itzá, on the Yucatán peninsula; libraries; Supreme Court buildings; the Tamayo Museum in Chapultepec Park; the Colegio de México itself.

Every nation has cultural idiosyncrasies and topographical and climatological specifics that determine to a large degree how its edifices are constructed. Anthropologists and social scientists, and certainly architects, are aware of how greatly such cultural factors contribute to a national identity. One such example in contemporary Mexican life is the integration of open areas, usually interior, into Mexican constructions. The pyramids of Mexico, those symbols of the indigenous past, are almost uniformly solid structures. Space, therefore, to pre-Columbian civilizations was a concept deriving from the placement of large masses within a carefully controlled landscape. It is, as a result, one of those interesting cultural peculiarities that the indigenous peoples of Mexico were accustomed to open-air, not enclosed, ritual areas. The convents and churches built by the Spanish in the New World were subsequently adapted to accommodate vast numbers of individuals in outdoor spaces. In remarks he contributed to his entry in *Contemporary Architects,*[1] González de León comments on specifically Mexican constants in his work, one of which is the patio, a form of interior open space he inherited from both Mediterranean and indigenous traditions. (It should be noted that the patio is an even more perfect adaptation for Mexico than for her ancestral Spain, since in Mexico all four sides of a building receive direct sunlight.) To González de León, the patio "is not a void to be contemplated . . . but a central space in which people circulate." It is the organizing force for routing movement, the "most significant element in the whole construction: an area of encounter, exchange, and coexistence." We may also deduce that in González de León's spatial vision the patio is to the edifice as the street is to the city. "The metro," he said at his inauguration to the Colegio, "if expanded, will in the long run make our city more 'walkable,' and this is the only true way to understand and enjoy it." Only by walking through the heart of a man-built construction, whether building or city, may one truly experience it.

González de León has devoted serious thought to the philosophy and theory of architecture. At the same time, he has a straightforward approach to its practice.

Questioner Is it possible to establish a comparison between the way an aspiring architect learns by working with you and the way Indians learned from the Spanish colonial artists who trained them in European styles?

T.G.L. Yes. Architecture is a craft. I worked with Le Corbusier, in France. Two years. Architecture is a craft you learn in the same way crafts were learned in the old days, passed from maestro to student—seeing how he works, being beside him, in his silences, his boredom, his doubts. That is how it is learned—not in school.

Q. By doing.

T.G.L. One feigns in school. It's a pretense, eh? In school, the professor acquires a vocabulary different from the one he uses on a work site. Architecture is a system of trial and error, a constant battle between aesthetic and purpose, an attempt to arrange a marriage between form and function. The architect resolves problems, but he also has the mission of making forms, of leaving significant forms.

That mission is González de León's life work. His art is enduring. It is solution and invention. And it is a highly visible definition of *mexicanidad,* "what is Mexican."

T.G.L. As an artist, one cannot have a conscious preoccupation with *lo mexicano.* I believe that if it flows from the subconscious, if it is subtle and not programmed, it comes out well. I believe, too, that artists must be open to the world and let *lo mexicano* well from within, from the Mexican spirit. And that's when Mexican is good—as Octavio says, when it rises from the subsoil.

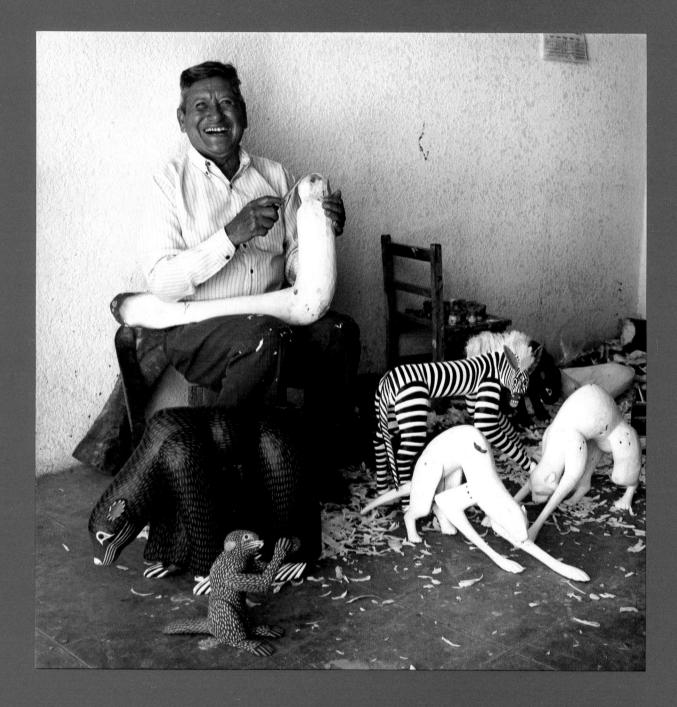

11. Manuel Jiménez Ramírez

MANUEL JIMENEZ RAMIREZ

Arrazola, Oaxaca · 1920

The state of Oaxaca is a crafts lover's paradise: weaving, pottery, wood carving, tinwork, paper flowers, jewelry, baskets. Art is innate among the Zapotec and Mixtec peoples who inhabit the Valley of Oaxaca. Two men of this heritage, Francisco Toledo and Rufino Tamayo, while never abandoning their roots, have become artists of international renown. In the world of crafts, too, local artisans have established international reputations. One of them is a master woodcarver, Manuel Jiménez Ramírez; he is known primarily for his astounding animal carvings, although he is also the creator of many religious and festival figures. Jiménez lives and works in the village of Arrazola, Xoxocatlán, reached by skirting the majestic ruins of Monte Albán, a city the Zapotec Indians had established as a sacred center by 200 B.C. and which by 1400 had become a sacred necropolis. Jiménez lives in a modern house equipped with all the visible signs of Western industrial society's success, the rewards of his artistry. His workshop is considerably more spartan, closer to his shepherd-boy origins, with a feeling of single-minded purpose: wood carving.

Don Manuel meets us at the door of his garagelike workshop. The floor is local tile; a few pieces of wood have been tossed haphazardly into one corner; wood shavings mark the ceremonial center, washing like foam around two small, almost child-sized chairs. A third, doll-sized chair holds an assortment of small glass paint jars. Jiménez is a jovial, friendly man who looks much younger than his seventy years. He obviously thrives on his work and often during the course of our conversation bursts into hearty laughter. He is experienced in being interviewed but seemingly has not tired of telling his story to the curious who come to admire his art and ask him the inevitable questions. He takes the initiative by asking, "Do you want me to tell you how I began? Or what would you like to know?" We are happy to follow his lead. He offers some preliminary technical information: the pieces are carved while the wood is green; once complete, they are left several days in the sun to cure; all the pieces are subjected to a gasoline bath to rid the wood of insect infestation; the carvings are painted after assiduous sandpapering.

Once those general details are communicated, chairs are brought for us to sit down. "Sentaditas," says Don Manuel, "y empezamos a picar." It is difficult to express briefly what those few words

convey. Mexican Spanish is characterized by the use of the diminutive "ita" or "ito," endings that soften a word and make it affectionate and intimate. In effect, the simple "sentaditas" says, "Won't you nice ladies take a seat and be comfortable." "And then," Jiménez adds, "we will get to our whittling" ("empezamos a picar"). It is not easy to discern whether arranging this tableau of the artisan at work is a conscious bit of theater for foreign guests or whether Jiménez is merely utilizing his time, making the best of periodic interruptions. In either case, the performance is riveting, the audience duly appreciative, for Jiménez is not only a master carver but also a compelling storyteller. He recounts the story of his life with a charming naïveté that is balanced by a clear sense of self-worth. There is beauty in his telling, a biblical sonority in his phrasing. This is an oft-told tale, but as in the oral tradition of tribal lore, each telling is as fresh as the first. One question sets this ancient memory in motion.

Questioner How old were you when you began your carving?

M.J.R. I was about ten or twelve. *Mis padres,* my mother and father, had put me in charge of grazing all our neighbors' animals. I looked after the animals, and people paid me. They paid me one real a day, twelve centavos. Twelve centavos! There were goats and sheep and burros and bulls and horses. I looked after them all. So, that was how it was—I, spending my days tending the animals and earning twelve centavos a day. There by Monte Albán. A shepherd. A pastor. Yes, every day, sitting quietly and watching the animals, being sure they had pasture to graze on. Then one day, an idea came to me—here, in my head. Why don't I make animals? The thought just came, a gift that had fallen to me from God. And so I said, Why *don't* I make animals, the way they really are? It was just as if I had thought, Why don't I take a drink of water? There they were, and there was I,

watching after them and observing their movements, how they stood: some with their heads down, like this, eating, and others with their heads up, looking around. So I learned all the movements of the animals. That was how I learned to make my animals. First I made them of clay. I found clay in the streambeds, in the arroyos. I worked the clay with my hands (here Jiménez says *manitos*—the ending makes his hands something more than mere hands) and formed it into a ball. Then I began to make my first animal. My hands already knew everything they needed to know. And so I set the first one on the ground and began to make another. And that is how I began making animals—first in clay. But then after a while, another thought came to me, and I asked myself, Why don't I make some animals of wood? So you see, I did it all by myself. Solo, solo ("alone").

Q. Don Manuel, did you make masks when you began carving?

M.J.R. Yes, I made masks.

Q. How long did you do that?

M.J.R. Masks? Well, I made masks for a year or so. And I sold them in Oaxaca. Masks. But for me, masks became very—very *pobre,* unfulfilling, because I didn't sell that many. And then as soon as they saw mine, all the campesinos began making masks, too. So I stopped making masks and kept on making my animals. But my heart is heavy that in all the towns they are making animals now. They are copying my work. Yes, copying, copying. But, I have always been the maestro—because, for a long time now, I have been, well, it seems, famous in my country. And the president himself invited me to work in museums in the capital. I worked there three years, for people in the capital, making crèches, making nativity figures, making, all kinds of people, little old men, yes, all kinds—Filling many, many orders. After three years of working there, the president ar-

ranged for me an invitation to the United States. He recommended me, because I was intelligent, and for an intelligent man, an, let's say, artistic man—well, he recommended me to a museum in Los Angeles. I did a mountain of work there. Pieces they requested. I have friends in places like San Diego and San Francisco and Santa Monica and San Antonio. And people come here from New York and Japan and Canada. My work is known around the world. My pieces are even in Jerusalem.

At this point, Don Manuel turns to introduce his son Isaía, whom he has taught and who has been working alongside him. A second son, Angélico, is also involved in the family craft. Don Manuel explains that his sons don't carve animals. They confine themselves to "sirens, crèches, angels, Christ figures, all kinds of sculptures," a division of labor belied, at least superficially, by the pieces the men are working on as we talk. We ask about the wood Jiménez uses for his figures and learn that it is bought from a source in Mitla, a few miles away, information that is not surprising considering the arid terrain around Oaxaca. What is slightly surprising is that Jiménez prefers the wood of the chaparro tree, a scrub oak, over more substantial limbs of larger trees. This preference, considered more rationally, is all too logical. One glance at the pieces at the master carver's feet—arching backs, craned necks—and the advantages of the twisted, gnarled limbs of the chaparro are immediately apparent. Don Manuel improvises on pieces given him by nature; he does not carve from blocks of wood. He does use woods other than chaparro: cedar, and limbs from trees with expressive names such as *palo de águila* (eagle tree) and *palo de muerto* (dead man's tree).

M.J.R. *(referring to chaparro)* But this is the wood people like best. It can be sanded very smooth, very, very smooth. It's like skin—flesh. It's the flesh of the wood. When it's painted, it's like the animal's skin. See? Be careful! (Jiménez bursts into boisterous laughter as a tentative finger strokes the wood.) Careful, that's bare flesh. My animals are alive!

Q. How do you decide what each piece of wood will be?

M.J.R. The minute I see a piece of wood, I know. This one will be a *guajolote,* a turkey. That one will be an armadillo. You just look at the wood and you see right away what it will be. This one will be a turkey, because it's a short piece. And its tail will be sticking straight up, yes?

Jiménez finds this part of the conversation vastly amusing. How do you know what it will be! He is entertained by the need to elaborate on the obvious. He is having a marvelous time. To the question of how long he has worked in this particular place, he answers, "Thirty years." His son corrects him. "*Más.*" "Yes, more. Maybe forty years." In that same chair? Gales of laughter. Yes, the same chair. "This is the original chair." Don Manuel seems in danger of falling off that chair in the merriment of the moment. This mood is cut short, however, by a question from a member of our group who had not heard the early part of the conversation: "Did your father make animals?"

M.J.R. I told you that earlier! It was a gift from God. I learned from living animals. It was a gift that fell from heaven to awaken me. Awaken me, awaken my mind—because my mind was dark, closed. Many people never awaken. That is why I am the maestro, the maestro who learned without a maestro. I learned by myself, from God and myself. God was my maestro. He will always be my maestro. Only God knows how much longer I have to work with my wood.

12. Gunther Gerzsó

GUNTHER GERZSO

Mexico City, D.F. · 1915

Gunther Gerzsó has been called "the only great hard-line Mexican abstractionist." He did not begin as an abstractionist. He himself identifies three influences in his painting: Cubism, Surrealism, and pre-Columbian art, each of which may be perceived in varying degree, although often more implicitly than explicitly. Octavio Paz has posited that although Gerzsó abandoned surreal figuration early on in his career and turned inward toward a nonfigurative space, he continued to be influenced by what Paz calls the "inner model" of surrealist inspiration. It can also be argued that the flat, overlapping areas of Gerzsó's current painting are still laid out on a cubist grid. Perhaps the most cogent general statement on Gerzsó's art can be found in John Golding's foreword to the handsome volume *Gerzsó*, published in 1983.

It might be true to say that from the start Gerzsó's true quest was for a pictorial space which would acknowledge the demands of twentieth-century pictorial formalism with its insistence on flatness, on the integrity of the picture plane, but which would also evoke spatial sensations which could suggest or stand for both the hidden recesses of the human mind and the cavities and more secret places of the human body, both of which in turn find an analogue in his response to the cosmology of landscape.

At one point, at least, Gerzsó considered himself a realist. In 1966 he said, "I do not consider myself an abstract painter. I see my paintings as realistic, based on Mexican landscapes and pre-Hispanic cultures. Friends of mine who travel through Chiapas tell me what they see there is what I paint." Gerzsó's wife, Gene Cady Gerzsó, refers to his paintings as "metaphysical landscapes." In a recent conversation in his home, Gerzsó said, "Here and there, I consider myself a European academic painter." He adds that he does not know what his paintings mean. "I leave that to others to interpret." He dangles tantalizing references to two psychiatrists who are "writing about all this." But when pressed for details, he throws up his hands: "I really can't explain it." On occasion, however, he can explain a painting with great clarity, enough that one suspects he knows what his paintings mean to him.

We have been talking about finishing a painting. How does he know when he's through?

"Ahhh. When it sort of feels good. It's strictly intuition." And then he turns to an unfinished work.

"This one I think I started three years ago. Oh, no, it's longer than that. Anyway, it's when I went to San Antonio and had open-heart surgery in Houston. . . . Oh, yeah, I did. And before, in San Antonio, they put a thing up my vein to the heart. And this is— When I came back, I started this picture. And this is—yes, right, this is the line. And this is my rejection. See? This is me. And this very dark— This is like death coming. This, you don't want this. I'm going to call it Santo Noviembre. San Antonio, November."

It is easy to listen to Gerzsó. He is one of the best raconteurs on two continents. From a deep armchair in the tranquil *sala* of Gerzsó's Colonia Altavista home, stories flow in fluent, vaguely New York, English.

"Well, maybe this is going back too far, but I think this is where it all started, really. I was born here, but my mother sent me to Europe to my uncle, a brother of hers, who was an art dealer. So I was sent to Switzerland, to his estate there, and I was supposed to take over—to become an art dealer. He didn't have a shop, he had this enormous house. And every time a painting arrived, I would be called away. I was twelve, and I would be playing cowboys and Indians, or something. And he says, 'Well, young man. You are supposed to be my successor, so, now, who painted this picture? Come, now, what is it?' And I would say, Well, maybe it's Italian. 'What period?' And then I'd say, Well, maybe it's Tintoretto. And he'd say, 'No, no! Can't you see?' And this was how I was trained. And I had to go to the museums in Paris. Every day I had to go for an hour—just like religion, you know. And then I would have to make a report. And this is where I got the feeling that a painting is a surface. When we went to the Louvre, together, you know, he would always

look at paintings like this (Gerzsó indicates a nose almost touching the canvas). And I would be about six feet from it. And he would say, 'We know it's Venus and Adonis, by so and so. But you have to *learn*, because every painter has his handwriting. And some day you'll see a painting by somebody, and you will know. Your brains are like a battery, they must be charged.' And he was right, you know."

Had it not been for Hitler, Gerzsó might today be an art dealer in Paris. Instead, he returned to Mexico. By then, through one of his mother's friends, he had become interested in set design. In Mexico, he met a set designer from the Cleveland Playhouse who helped him find a job there. It was in Cleveland, while considering a move to New York, that he became serious about painting.

"One day the kid who cut the ham and cheese at the delicatessen said, 'You know, Gunther, you shouldn't be a set designer. You should be a painter.' He'd seen some—I'd started, on Sundays, to do watercolors. And I said, No, no no. What a life. Horrendous. But if it hadn't been for this grocery store—a ham sandwich! And a quart of milk and a cookie. That was in 1936."

Gerzsó returned to Mexico for a year but found that his own assessment of the life of an artist was proving all too true. He was packed, ready to return to Cleveland for gainful employment, when another pivotal event in his life occurred.

"This man knocked at my door and said, 'I'm a motion picture producer, and I would like you to design my next movie.' I said, Well, I'm very sorry. I don't know anything about movies. He says, 'You'll learn!' "

Gerzsó did learn, and for the next twenty years he worked with Mexican, French, and North American directors (in 1983 he was persuaded by a friend to work on one last film, *Under the Volcano*) and earned a reputation as an ultrarealist. He

12a. Gunther Gerzsó, *Morada antigua*,
1964, oil on canvas, $23^5/_8 \times 28^3/_4$
inches. Photograph courtesy of Mary-
Anne Martin/Fine Art, New York.
Photo: Sarah Wells.

would work in the mornings, and in the after-
noons, "I went and painted a picture. That had
nothing to do with what I was doing on the set."

Or did it? Perhaps the specific painting had
nothing to do with the specific film being pro-
duced. But the two worlds—Gerzsó's painting
and set design—are nonetheless bound together.
At first, the activities seem to function at opposite
poles. Theater and film are centered to a large
degree around people, yet the human figure, at
least figuratively speaking, is absent from

Gerzsó's work. Taken a step further, however, the focus on the space and drama of the theatrical set is extremely pertinent to Gerzsó's canvases. Gerzsó agrees. "Well, my paintings have a lot still of the theater in them, you know. And they still are, like, from sets." The comment is underscored by a small work removed from one of the many shallow sliding drawers in Gerzsó's studio. It greatly resembles the paintings that describe irregularly shaped planes, or overlapping geometric shapes, creating an illusion of varying depths. This object, however, is truly dimensional, not illusion. It is flat, covered with intricately cut and layered pieces of paper—something like the shapes in a pop-up book. Gerzsó runs a finger beneath several of the flaps and lifts them slightly, to demonstrate that they are not bound to the surface. The flat rectangle of this paper object conveys the sense of a stage set, but one that has collapsed inward upon itself to form a one-dimensional surface. It is in theater, too, that Gerzsó finds his link with the surrealists.

"You know, someone said that if Breton had seen more of my paintings, he would have invented a new branch of surrealism. And that's right—because I have nothing to do with them, even though I was influenced by them. The only one I have any connection with is Chirico. It's all this kind of theatrical business. You know, if you go to Venice, and you see the Tintorettos, all that is theater. And Picasso's *Guernica* is theater. But when I started to paint, I never in my life—or to this day—had read any explanation about the great surrealists. I just didn't. And when I met these people, Leonora (Carrington) and Remedios (Varos), I felt that I sort of belonged to them—their mentality and so forth. Of course, I cannot call myself really part of that group, because they are the Old Guard of Paris. And they were disciples of Mr. Breton, and Soupault, and all of them. We didn't know. As a matter of fact,

everyone was going crazy thinking what they were doing was terrible. Leonora would say, 'Uh, Gunther, I have to talk to you. You know that ground on the canvas? It didn't come out.' I mean, nobody analyzed what we were doing. It was all technical problems. And Leonora was into, you know, mysticism. Yes, and alchemy. And sometimes she would stand on the terrace in her house, and she would say, 'Yesterday, I saw a flaming—red—ball—going through the sky.' The last time we saw Leonora, we were remembering all those surrealist games we used to play. And she said, 'Gunther, please do the imitation of the lighthouse.' And I said, No, I'm too old."

There is a story, too, about how Gerzsó came to know the group he refers to as "the refugees."

"It was '42. I went to see this group; it was (Renato) Leduc and Leonora and Remedios Varos, and then there was the poet Benjamin Peret. And I had gone to see them because I was working for the British, where they had their office here during the war. And they said to me, 'Soooo, why don't you make some models to put in the show windows? Maybe DeGaulle reviewing the troops or whatever, or the bombing of Cologne.' And this friend of mine, Juan O'Gorman, uh, I said to him, You know anybody who could make models? And he said, 'Yes, there's a bunch of refugee surrealists who are living over there in a tenement.' And so I went. And it really was a tenement, what you call a *vecindad*. And there was Remedios living there, with Peret. And they had big holes in the floor. But on the walls, they had drawings by Picasso and Max Ernst and so forth. And I said to Remedios, Those are the best reproductions I've ever seen. But no, they were real. And this is how I met them, and it was like the sky opened up when I came in with some money. So they made DeGaulle reviewing the troops. The troops actually marched by. They did several things for the British office. And then Leonora

made a design for a living room. I wonder if she knows we still have the sofa?"

Another cupboard reveals a priceless Carrington, something we would today call soft sculpture: an overstuffed flowered sofa on which four figures are seated. Gene Gerzsó points to them, one by one: Peret, Remedios Varos, Leduc, and Leonora. Each is costumed in impeccable detail. The women's hair is real hair. And Gerzsó recalls that the Carrington drawing in the entry hall below is the design for the kitchen clock. There are other artifacts from that time, as well. One of them is a small wood sculpture. "I was with Leonora in her studio, and there was a piece left over. And I said to her, Can I use this piece? And then we went *hrmmm, hrmmm, hrmmm.* I was there about five hours, and this is what came out." Something that took more than five hours surfaces from another of the shallow sliding drawers, a painting of a train traveling through a green meadow. "Traveling" does not adequately convey its movement. Actually, it is merrily puffing along at quite some distance above the ground, as removed from trainly reliance on track as Magritte's locomotive erupting amid billowing smoke from a bare living-room fireplace. It is no surprise that when Breton met Gerzsó he bestowed the ultimate accolade: "I congratulate you. You are one of us."

And now Gerzsó is Gerzsó, no one else—a Mexican European Surrealist Realist Abstractionist. As he says, whatever.

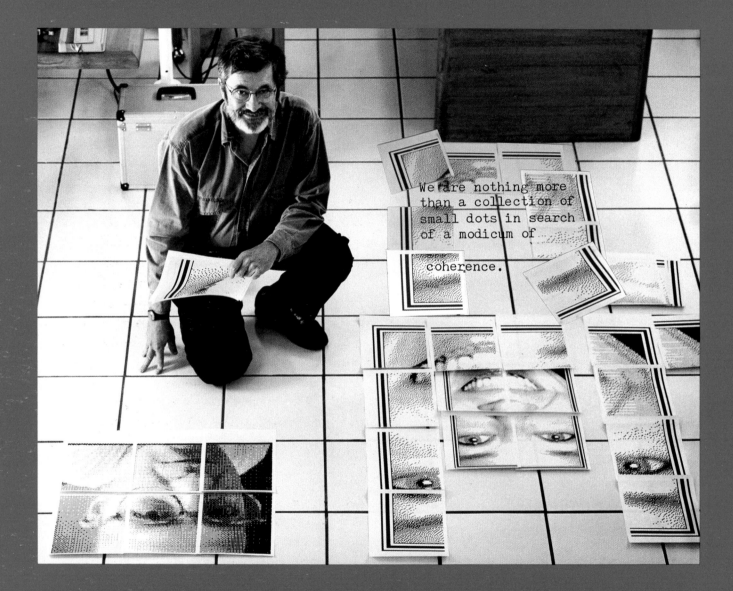

We are nothing more than a collection of small dots in search of a modicum of coherence.

13. Pedro Meyer

PEDRO MEYER

Madrid, Spain · 1935

Meyer does not mix exegesis with his images. He limits himself to presenting unique realities which others will specify or distort, as the case may be. I saw this in Mexico. I saw this in Nicaragua. Interpretations pass; the image remains.

Those thoughts appear in Carlos Monsiváis's introduction to *Espejo de Espinas* ("Mirror of Thorns"), a collection of Pedro Meyer's photographs from the eighties. The reliability of the photographic image, the truthfulness of the captured moment, and directness of communication are among the subjects that arise on first meeting at Meyer's sleek contemporary residence in the Coyoacán district of Mexico City. Meyer, a tall, bearded, dark-haired man as sleek as his high-tech home, is a naturalized Mexican of German parentage, and a true cosmopolite. His fluent and precise English was polished during study at North American universities. He has photographed in the streets of New York City, the deserts of Arizona, and the training camps of Sandinista armies in Nicaragua. Meyer suavely directs the conversation among the group assembled on his shaded patio: his houseguest, an editor-writer-

translator; a fellow photographer; a North American writer-editor-educator; and a translator-interviewer. The conversation strays from the philosophy of photography to the philosophy of translation. It seems he shares the thesis that the primary obstacle to translation is not language but culture. Translation, however, was not to be the subject of this meeting.

P.M. (laughs) I'm interviewing *you* now.

Questioner I was just realizing that. How you are manipulating our conversation! But you tell me how you translate culture.

P.M. Oh, I agree with you. I wouldn't phrase it any differently.

Q. But with your camera, you bypass the barrier of words, don't you?

P.M. No, you have exactly the same thing, only worse—worse because, you see, when we use a photograph, anybody, from any culture, will always read into the image whatever he feels is appropriate, starting from his own culture. And there is nothing to cause him to say, Well, I really don't understand this; what I'm reading is something completely different from the reality. So, very often, viewers in different contexts will have totally different perceptions of the same image:

the way the picture is interpreted, what's important, what's not important. The myth that photography is a universal language is—just that.

Q. Just that. That's fascinating. A translator looks for the photographer to have the easier task, since photographs are immediately perceivable. On the other hand, if in the corner of your photograph you have a Virgin of Guadalupe, and your viewer doesn't understand the resonances of the Guadalupe, then what you're saying is that he misses the text. Is that part of—

P.M. Well, not only that. The photography director of the San Francisco Museum of Modern Art was telling me one day that exhibitions of photography are the most visited of all the arts. And in spite of the number of people who visit photography exhibitions, and despite the fact that you have an exhibition of some great masters of photography, nothing stops someone from coming in and saying, Look, you see that elevator there? I used to have one exactly the same in the building where I lived. Or, I had a car like that, or whatever. So the fact that this great master of photography made a picture in which the object appeared, but had a different meaning, does not prevent someone from making that totally personal reference to the elevator that was in his building. And that doesn't happen in, let's say, painting. Although today, with computers, that whole story is going to change, because you can do a photograph of something without its ever having existed.

Meyer is certainly prepared for the computer revolution. Here is where cosmopolite blends with technician. Leaving the pleasant patio of his home, passing through a traditional *sala* filled with magnificent, fragrant bouquets, threading through a personal gymnasium worthy of Arnold Schwarzenegger to the enormous room where Meyer works and composes, is like taking a walk through time. The bells still echoing in the patio have resounded for centuries through the narrow streets of Coyoacán; inside awaits a futuristic world that would stir the envy of the most advanced electronics fanatic. Meyer's huge workroom is divided into various islands: a conversation grouping of black leather-and-chrome chairs around a chrome-and-glass table; long tables lined with photography books, magazines, photographic folios, and individual prints; one workspace devoted to writing, with a spacious desk, typewriter, assorted telephones, gadgets, work in progress; and then the heart of the complex, an assemblage of computers that resembles the Houston command center for the U.S. space program.

Q. When did you start working with computers?

P.M. When? About nine years ago—as soon as they started to come out. That one over there was my first computer, the first computer that came to Mexico. If you looked through the Apple files, you would find that invoice number one.

Q. A part of history! Would you tell me a little bit about what you're doing, how you are using computers?

P.M. Well, among other things computers can do is allow you to manipulate images. For example, let's say I take a picture of all three of you as I see you at this moment, but for some reason I find that what's in back of you clashes with the color of your sweater or something. I take it out. I eliminate it. But then I also think that maybe Trisha, who was on this side, would be much better over there, and I can take another picture of her, and position it differently, and create something that didn't exist at all.

Q. So in a way you're becoming a painter, moving farther from reality—always remembering "reality" is in quotes.

P.M. You see, people have always seen photography as a factual representation, which it never was. With computers today, it's becoming more and more evident that the picture can be manipulated, and thus the credibility for an image will

13a. Pedro Meyer, *José Guadalupe Posada Visiting Santa Monica USA*, 1988, silver print.

not rely anymore on the fact that it's an image, any more than you believe words because they're words. You believe words because of who wrote them. So if you believe in a text because of the author of that text, the same will be true of images. Today people believe in images for their own sake, whereas nobody believes a word because it's written. A word is believed, or not believed, depending on the context. And much the same will happen with images. So you will have images that can be utilized as a testimony of something that happened, because you know that I have credibility. It has always been thought that photography, because it was made by a machine, was strictly—

Q. A science?

P.M. Objective. Now, with the computer, art, the concept of photography, has opened up the awareness of the general public, has made people aware that something created with a tool has a value equivalent to something created by the hand. So, you can use a computer to manipulate, and you can use the computer to speed up the process of how you work in the darkroom. You see, for example, here, this is quite interesting. These are negatives I developed just last night. (*He places a negative in the machine.*) You can enhance it or use a big TV—which makes me able to choose [among negatives] immediately. From here, I put it into the computer and have a printout of the image, so I know how it looks.

The print can be enlarged, darkened, lightened, fragmented, and composed anew; any sec-

tion can be isolated, portions can be deleted, images added. To the uninitiated, the process resembles film editing, or computer graphic art—or black magic. It also recalls the graphics revolution of Andy Warhol: faces multiplied to form a kaleidoscope portrait, a single face magnified until the illusion of wholeness is exploded into pin points.

One of the forms Meyer has been producing is a combination of photo and text. He demonstrates a portrait that has been greatly enhanced and also refracted, a reality portioned into many individual parts and then reassembled before us. The portrait, now in many sections composed of patterns of black and white dots, is realigned against the black and white squares of the tiled floor. The enlarged text becomes visible in one small corner: "We do not, of course, see atoms with the naked eye, even though they are what form us and give us substance. We are nothing more than a collection of small dots in search of a modicum of coherence."

One must step back, literally and figuratively, from the pyrotechnics of electronics to remember that for equipment to function, it must be manipulated by a talent. Nothing comes out of a computer that is not fed in by a human intellect, and nothing appears in Meyer's photograph that is not chosen by a discerning eye and controlled by a creative imagination. It is, after all, human beings who are almost exclusively the subject of Meyer's camera, humanity revealed in epiphanic moments—war, worship, pain, sex, celebration, despair: A Pemex oilworker exalted by an infinity of cloud and sky, a bridal couple whose dubious future is implied in the groom's unreadable but clearly cold gaze into the camera lens, the Zúñiga earthiness of a monumental female bent over washing her hair. And there is also the heightened drama of juxtaposed images—Meyer has been eloquent on the subject of editing the photographic text. A hospitalized guerrilla whose legs have been amputated almost at the trunk, delicately thin, ethereally beautiful, lifts himself on one elbow, his maimed body nearly naked except for the cloth laid over his genitals and the riveting white bandages on the stumps of his legs. That aestheticization of human misery—to quote a concept of Meyer's art proposed by a perceptive critic—contrasts with and complements a photograph depicting a fallen icon: a toppled statue of Somoza, symbolically hollow, similarly legless but additionally headless, lying not in a hospital bed but in an abandoned field amid brick rubble. Dictator and guerrilla, oppressor and oppressed, two dissimilar men similarly felled by the obscenity of war.

Most recently, Meyer has been in the United States working on a project for which he received a Guggenheim fellowship. Large prints are stacked in an anteroom to his darkroom. He flips through them rapidly, at our request, a new assault of sensuality and brutality, faces and icons—the Statue of Liberty, a carnival huckster, a construction worker, the Last Supper displayed in a wax museum—effigy and reality. One image transports us to Santa Monica, USA, the living presence of José Guadalupe Posada, the Mexican engraver whose skulls and skeletons floated and clanked through turn-of-the-century newspapers and magazines. Monsiváis's precept, seconded in Meyer's analysis of the reading of the photographic text, is impeccable. The image remains, intractable. The viewer will see in its dramatic black and white the truths, and the lies, he seeks.

ABEL QUEZADA

Monterrey, Nuevo León · 1920*

In 1989, Gabriel García Márquez, who now maintains a residence in Mexico, wrote a magnificent García Marquesian description of Abel Quezada's painting.

> His is a personal and disquieting poetics which may be read either forward or backwards through the magic of *esdrújulas* [those *wonderful* words that are accented, as is their Spanish name, on the third-to-last syllable]: chimerical boxers, hydraulic soccer-stars, androgynous senators, lugubrious terpsichores, waterlogged compasses, caloric financiers, sorrowful carnivores, beneficent murderers, sadomasochist firemen, clinical corpses, somnambulist astronomers, identical prostitutes, inhospitable hospitals, cardiac weightlifters, abandoned dirigibles, mammiferous toreros, prostatic poolplayers, a heraldic Maximilian, a stupefied Juárez, and barbarous gringos.

Those frolicsome fragments appeared in García Márquez's introduction to a collection of Abel Quezada's paintings entitled *Cazador de musas* ("Hunter, or Captor, of Muses"). In the introduction García Márquez recounts the story of a painting—*La dama de la Coupole*, a solitary, black-haired, green-eyed woman holding a half-empty glass of red wine—that Quezada had promised him for thirty years and, finally, in 1986, lent him for a century minus one year, the missing year presumably introduced to shatter the mystic symmetry of *One Hundred Years of Solitude*.

Abel Quezada has not always been a painter. His first and signally successful career was that of cartoonist. He is, in fact, Mexico's premier cartoonist, the creator of figures as memorable as Kilroy and the Schmoo. Among his creations are Gastón Billetes, a name roughly equivalent to V.B. (for Very Big) Spender, a nattily dressed fellow with an enormous diamond nose-ring (not pierced in the Indian style but worn firmly encircling his prominent proboscis), and El Tapado, Quezada's characterization (character assassination?) of the PRI presidential candidate. (PRI is the party that has dominated Mexico's politics for most of this century, and every six years, in a secret-society anointment, it selects a new president of Mexico.) Quezada's characters are seen every day in the city streets and halls of government, taco vendors and policemen, powerful pol-

*Abel Quezada died of leukemia in early 1991.

14. Abel Quezada

iticians and hangers-on, debunked and demythologized by the satirical but always humane pen of Abel Quezada. Carlos Monsiváis has described Quezada's cartoon style as "a mixture, in equal measure, of the comics, the essay, the short-short story, the one-liner, the newspaper feature, and the caricature." Quezada is, however, modest about the narrative aspect of his cartoon art.

Questioner I am taken with the strong presence of the narrative line in your cartoons. If you were primarily an author, would you see yourself as a satirist, an essayist, or historian?

A.Q. Well, I'm not— I had to write, but I've never really been a writer. When I was a cartoonist, I was forced to write. I wrote a lot. Sometimes I wrote more than was called for and then cut it— and then illustrated it. I've never published stories. (Quezada has published at least one short story, but his disclaimer is essentially accurate.)

Monsiváis sagaciously points to the similarity of Quezada's cartoons to the comic strip. North American readers would find them much closer to the format of *Doonesbury* than to the single-panel cartoon common to the English-language editorial page or to the tradition of the *Saturday Evening Post* and the *New Yorker*—a magazine for which, incidentally, Quezada has· contributed twelve cover drawings.

But that was Quezada the cartoonist, a phase of his life that belongs to the past. "No, I don't draw cartoons now. I used to draw. Now I'm a painter. A naïf." It is true that Quezada is universally described as a naïf. The term is nonetheless misleading—unless, despite the oxymoron, one may be a sophisticated naïf. Quezada's oils, particularly the striking portraits, are much closer to Modigliani than to the Douanier, much more reminiscent of Matisse than of Grandma Moses. Perhaps Quezada is best described as a Mexican Postimpressionist with humor. His is, whatever its designation, a style that creates arresting canvases with an additional, comedic element in titles

and inscriptions that elicit delighted double and triple takes. Consider, for example, a Van Gogh blaze of sunflowers entitled *Casi-copia de García Guerrero* ("Near-Copy of García Guerrero"), whose legend reads, "This painting was intended to be a copy, but because García Guerrero paints things so difficult to copy, it is, instead, a 'near-copy.' "

At times Quezada's humor is direct and visually perceived, independent of its written subtitle or caption, as in *Bonito centro de mesa en una cena de sentados* ("Beautiful Centerpiece at a Sit-down Dinner"), which depicts the "good taste" of the "best Mexican society" in the persons of bejeweled and dinner-jacketed guests seated around an elegantly appointed table on which a gargantuan gold bar replaces the traditional floral centerpiece. At other times the humor is magnified by the artist's satiric gibes, an irrefutable remnant of cartooning days, as in *Retrato de un gran general* ("Portrait of a Great General"), which pokes verbal fun at its already burlesqued subject: "The Mexican Revolution produced so many Generals that had Mexico, at that time, waged war against the United States, it would have won by sheer majority of numbers. Later the Generals turned to fighting one another. Their numbers dwindled radically, and thus the United Sates was saved from a second defeat."

Many North Americans have enjoyed Quezada's covers for the *New Yorker* and his illustrations for *Time* magazine and the *New York Times Magazine*, for which, a number of years ago, he painted a cover featuring the flower of Latin American literature: Octavio Paz, Jorge Luis Borges, Mario Vargas Llosa, Gabriel García Márquez, Carlos Fuentes, and, seated at a small table slightly behind his illustrious fellows, the late Juan Rulfo, the revered author of the classic Mexican novel *Pedro Páramo*.

Q. I've always been enchanted by this cover and have carried it with me for years.

A.Q. Alan Riding has the original of this painting. It's in Paris.

Q. Poor Rulfo. So melancholy.

A.Q. I put him there because when someone is very different from everyone else, we say in Spanish, *"Come aparte,"* "He eats alone."

Q. I had always wondered about the reason for that. How sad he's gone. Speaking of covers, this cover you did for *Artes de México* is wonderful.

A.Q. These are Mexicans in London.

Q. Specific people?

A.Q. No, just types.

Q. But how do you know they're Mexicans?

A.Q. Don't you see the little mustaches? They're on the *Orient Express.* You see? *Voiture, wagon-lit.* And this *(he points to the numbers on the car)*—

Q. Do they mean something?

A.Q. (He laughs): That's my telephone number.

14a. Abel Quezada, *Stars of the Boom,* 1983, oil on canvas, 17 × 24 inches. On loan from the artist to Mr. and Mrs. Alan Riding. "Stars" are, left to right, Juan Rulfo, Mario Vargas Llosa, Octavio Paz, Gabriel García Márquez, Julio Cortázar, Carlos Fuentes, Jorge Luis Borges.

Quezada is an aficionado of trains (as he is of transport of all kinds, and of sports, two of his major subjects). In addition to the cover for *Artes de México*, he painted a superb train for *Proyecto por el mural "México saliendo de la crisis"* ("Project for the Mural Mexico Emerging from the Crisis"). The project was never completed, a note explains, because, "among other reasons, while in the planning stages, Mexico entered another crisis." This large oil, 160 meters by 360 meters, represents a golden Mexican countryside dotted with signs of gaiety and prosperity: haystacks from an abundant harvest, tractors, combines, trucks hauling poultry, a pueblo in miniature, with singing and dancing and a group of toreros being driven into town in an open touring car, escorted by cheering children and barking dogs and a horseman emptying his revolver into the air. Among naïfs, this would be Quezada's Mexican tribute to Grandma Moses. This bucolic resplendence is split horizontally by the length of the red and green train, each window of its passenger cars filled by the head and shoulders of a prominent Mexican. *"Los Divinos": el tren de mis amigos* ("the Train of My Friends"), a still more train-shaped canvas, 50 meters by 248 meters, painted two years earlier in 1986, represents an even more intimate passenger list. On this train, the large, shiny, modern Union Pacific engine is driven by A. Quezada. Quezada's wife, children, sons-in-law, and grandchildren occupy the first car, former presidents of Mexico the last. In between, each immortally honored by his name emblazoned beneath his window, ride the great writers, artists, and intellectuals of Latin America, primarily Mexican but with a sprinkling of foreigners whose lives are somehow bound to Mexico.

On the small canvas, Quezada is primarily a portraitist. His women subjects are graceful, languid, and sensual. While we are talking, for example, to illustrate a point, Quezada draws a fluid line on a huge sheet of white paper. An elegant woman appears. Matisse? "I was thinking of Matisse," Quezada agrees. The men he portrays tend to be men of action, military men or sportsmen or, occasionally, a metaphor for twentieth-century man's alienation such as a lone jogger in a Charles Addams–like Central Park, or *El filder del destino* ("Fielder of Destiny"), a small figure dwarfed by a blue-green sky toward which he gazes, eternally awaiting the high fly ball that never falls to him, so drained of expectation that his gloved hand hangs by his side.

In March 1990, Abel Quezada is painting a mural for Pemex, the government-owned oil monolith. This circumstance is probably not entirely fortuitous, since among his business enterprises are investments in an oil-well drilling firm. The mural will be installed, along with an already completed companion piece, in the office of the chairman of the board.

A.Q. (accompanying us the length of the wall displaying the nearly completed mural) This is an allegory of the oil industry in Mexico, from the beginnings.

Q. Yes, that's a fine dinosaur.

A.Q. You remember, those animals died and the oil was formed from the remains.

Q. Ah, and an Olmec head peering through the jungle.

A.Q. And here is the way they drill to get the oil from the subsoil. These are scientists and geologists *(he indicates figures standing around a comically simplified gauge divided into segments marked "None," "Some," and "Lots")*, and these are some of the pioneers of the industry.

Q. I was just going to ask, are these recognizable, that is, real people?

A.Q. These are *(he points to men in business suits and fedoras)*, and these are not. And here is a family that worked in the industry at its beginnings. And these are two men who are supposed to guard the environment: ecologists.

Q. What does *ducto* mean?

A.Q. *Ducto* is the pipeline.

The mural moves from prehistoric time with its dinosaurs and earliest civilizations to a futuristic city of the twenty-first century.

A.Q. This is the baseball field. When the Americans came here to explore for oil, they brought baseball to Mexico. And here are some of the present directors.

Q. And the town fire engine, and coffee groves. Oh, that's wonderful how it melds into the future. The plane is changing in midflight.

A.Q. Yes, no smog, almost no cars. The perfect city. The library, the Museum of Modern Art, agriculture—well, all the good things oil gives humanity.

When this large project is completed, Quezada will again be painting in the studio in his beautiful home in Cuernavaca. And he will be attending the opening of his one-man show in the Parisian Galerie de Nesle, and playing resident tourist in New York, where he went as a young man "in search of something better," the city where now he maintains a stylish apartment. Quezada is a man who seems genuinely content with his life: his family, his profession, his world. On his worktable in the cavernous studio in the Pemex complex, appropriately situated in the shadow of the Mexico City Torre de Petróleo, sits a small, translucent red Buddha.

Q. This is your Buddha?

A.Q. Yes, that little fellow is for good luck.

Q. Do you carry him everywhere?

A.Q. Um-humh. I found him in Macao.

Q. So he lives here now, and later he'll go back to your studio?

A.Q. Um-humh.

The rotund belly is not noticeably glossier than the other portions of this ruby-colored god, but it must have been rubbed more than once. If not he, some god has smiled on the brushes of Abel Quezada.

ANGELES MASTRETTA

Puebla, Puebla · 1949

One of the best available word portraits of Angeles Mastretta is one she herself wrote for the jacket of her runaway best-seller *Arráncame la vida (Mexican Bolero)*:

Angeles Mastretta was born in Puebla, Mexico, in October 1949. She studied journalism in the Political and Social Science Faculty of the Autonomous University of Mexico and did her doctorate in solidarity with lost causes. She is also a professional worrier.

For the past twelve years she has devoted herself to journalism and literature in the foolish belief that what happens in Mexico is her business. She is obsessed with her children, pines for her father, and now and again fights with her husband, although he is an admirable specimen of the genre.

She is indecisive, unpunctual and feels the cold. She sleeps badly and it shows. In the mornings she is absentminded, and in the afternoons she is prone to bouts of melancholy, which are cured by a siesta. She sometimes confuses hunger with existential anguish.

She is incapable of giving orders and saying no, but finds asking favors easy. She has several bosom friends, and her mother thinks she wastes too much time talking to them on the phone. Like all mothers, she is right, of course. But how else can you love your friends in Mexico City?

She is inquisitive and so talkative that when there is no one around to listen she tells stories, writes down her fantasies and memories, and invents characters that get under her skin and absorb other people on lazy afternoons.

This book wanted to be a political novel but it turned into a love story. The author says she will never be good at anything else.

The warmth and freshness and breezy humor displayed in those words are incarnated when one meets Angeles Mastretta in person. She is a whirlwind of charm. It is easy to picture this intelligent and attractive woman as the host of a television talk show or as a famous Italian screen star. There is much about her that still suggests her Italian heritage (her paternal grandfather arrived in Mexico in 1910): the cheekbones, the rich chestnut hair, the animated gestures, the husky, sensual voice. She is at the same time avowedly Mexican and has chosen specifically Mexican dishes for the lunch we enjoy along with her uninhibited answers to questions about her life and work. She speaks in a rush of expressive English marked by strong emphases and purely Mastretta inventions.

15. Angeles Mastretta

"I learn English with a family when I was sixteen. I live with them for three months. My family, we didn't have very much money—not enough, anyway. So they send us. Then they call us by the phone, and they stick with us awhile in English, and if we answer—more or less—they bring us back home." Mastretta's small audience is enthralled as the delicious lunch, and conversation, continue.

"And now, you see, we watch the movies. You can follow the subtitles—you get accustomed to both languages. But we don't have an opportunity to talk. So, many times I know the words but I never use them. I told you about how I learned. I just knew how to say, 'Oh, how wonderful.' 'Isn't that nice?' 'Are you sleepy, honey?' 'Go take a nap.' Those were the only words they taught me. I need more than that to carry on an intellectual conversation."

Mastretta's introduction to English came at about the same time she was writing a book of poetry called *La pájara pinta* ("Colorful Bird"), a title taken from a popular Mexican song. "Where did you find that book!" she protests. "I've had that book under lock and key all these years. I didn't even know the book was going to be published. I sent it off to a competition, and two years later I had the book in my hands. And no one ever said anything to me." It is true that the poems are the poems of a young girl—a talented young girl. "An *uninformed* girl," Mastretta emphasizes. Her novel is a different matter. It is informed writing. If one needs proof beyond the twenty editions in Mexico and its translation into nine languages, there is the seal of critical approval in the spate of articles scattered through academic journals. Numerous scholars have analyzed the narrative and textual strategies of this novel grounded in the provincial politics of the thirties and forties, in which *l'éducation sentimentale* of the narrator and protagonist Catalina is accompanied by her increasing awareness of the ploys of power. Mas-

tretta's third and current book will be in a third genre, the short story. Its origin is similar to that of Isabel Allende's *House of the Spirits*. Both grew from a need to communicate with a family member. Allende's book began as a letter she was writing to a grandfather from whom she had been parted by political exile. The letter turned into a novel. In the case of Mastretta, the separation was caused by illness, not politics, and the family member addressed was her infant daughter.

"This little girl"—Mastretta refers to the beautiful child who has come to the table to beg a sweet—"when she was three weeks old, was dying. And I was dying. I was almost crazy with worry and grief. She was in the hospital in intensive care. And so I could only see her once a day. All the mothers who were believers in God and the Holy Queen, and everything, would go into their child's room with all these things to hang up, and prayers. But I didn't have anything to say. I didn't have any hope to give her. I didn't have any hope for her, or for me. It was—so I just sat near her one day—once I could talk—and I said, Look, you can't die, because you have a long line of women behind you. We have all been working a long time for you to be you. So you can't do this to me, and to my aunts, and to my grandmother, and to everyone. You can't do this. You can't die. I can't have another little girl, so you must live! And so I began to tell her the story of her aunts. There were so many strong women in my family. I just started telling her that story—of her aunts. And when it was over, I thought to myself, I should write a book about them."

And now the collection is near completion.

"I don't know whether this book is going to be successful. You know, I think I know what's going to happen. It's a funny book. And it's a book that is always close to being melodrama. The challenge is to play with that up to the moment, to the second, that it begins to be funny, or like a TV sitcom, and then play it straight. And that is what

is very hard because these are short short stories, five to ten pages, some two. I love compressed, compact stories. I like the Russians, I like the big long books, but I would never be able to write one. You know why? Because I always want to know what's happening. Because when I read, I read very fast. I remember the first time I read *Anna Karenina*. I couldn't stand it. I had to skip to the end, because everyone knows that she kills herself. So when I started to read, I knew *what* was going to happen. I wanted to know *why* it happened. It was making me almost sick to have to wait. Remember, for example, there is this character, this man that has a farm, who's always going with the farmers, or watching the stars—for hours. I was wanting to know what was happening to that girl who was going to kill herself. I couldn't stand it, so I skipped a lot."

Did Angeles Mastretta always want to be a writer? Did she write as a child? "I liked composition in school, but I didn't know I was going to be a writer. It wasn't that when I was five years old the Holy Spirit came to me and told me, 'You're going to be a writer.' No. I wanted to be a mother." And she is. She is both mother and writer. "But if I didn't write, and things like that, I—You have to have a place to run. If you just live with the truth all the time, that can be terrible."

We would all linger longer at the table, but the light is changing, and we must think of photographs. Angeles Mastretta does not like to think about being photographed. Her grandmother told her that the camera steals your soul. So we ask her about her house, all white, with a sunken dining room and lots of gleaming silver. The U-shaped front of the house is enclosed in a glass gallery reminiscent of a nineteenth-century European spa.

"Yes," she replies, "we moved after my book came out. I decided to buy an old house and restore it—this house. I told myself, I'm going to restore it in three months. And it took two years

and a half, and more money than I like to think. It was terrible. I thought it was never going to end. I cried all the time. I was ready to sell it. I bought the house and I started, and then four or six months later I was ready to sell it. That was when I sold the book to England and to Germany, and they gave me money. And then I sold it to France and to Italy. And I put the money in the house. My husband, this splendid man I live with—I don't know how you say *bolsa*, 'stock market'?—you know how before it crashed it kept going up and up? Well, he said, "You are very impractical. Why are you spending all that money in a foolish house?' And I told him, I'm like Scarlett O'Hara. I need the land. I don't want a roof garden. *I need the land*. But I wasn't writing, because I was thinking of walls and floors. I felt terrible. I was sick all the time. I was dizzy. I had dozens of colds. My stomach was always upset. Terrible. I didn't even want to talk about it. But I have a doctor who is absolutely mad. And he told me, 'You're not writing. You must.' I said, Don't press me. I don't want you to tell me. I want to do it when I want to. Okay, okay. Don't kick me. I'll do it, I'll do it."

And now Mastretta is writing, every day. And the aunt stories are nearly finished.

"If I wrote only when I felt inspired, that would be never. So now that I have decided that I have to finish this book, I write from nine to two or three in the afternoon. After that, there's too much going on. If I can find half an hour, that's great. And if possible, I might find two hours. Sometimes I can write six hours a day. It depends. But the rule is, the morning is mine, because when the kids come back, they have a thousand things they want me to do."

The children *are* back, and they are growing bored with the gringo invasion. And the splendid husband is home, and the glamorous writer is turning back into the glamorous wife and mother. Later, looking back over a day of such high energy and warm generosity, we agree that every-

one does "have to have a place to run," even beau-
tiful, successful women. We are moved by the
prescience of the "uninformed" fifteen-year-old
who wrote this poem:

I write searching
for pleasure
and for the present
and for time for loving
for laughter
and for reason to be laughing

I write from the doubt
irrevocably pinned to my waist
from solitude
and companionship

I write to be alive.

Todos los días, en la mañana temprano, me miro al espejo y dibujo mi auto retrato.
José Luis Cuevas

16. José Luis Cuevas.

JOSE LUIS CUEVAS

Mexico City, D.F. · 1934

"José Luis Cuevas" is a name known not only because of the talent and achievement it represents but also because Cuevas has made a career of keeping himself in the public eye. Cuevas has been called the enfant terrible of the Mexican art world. He was, undeniably, a prodigy, and his precociousness accounted in part for his early fame. At the age of ten he was enrolled, albeit briefly, in La Esmeralda, Mexico's de rigueur school for painting and sculpture. By the time he was nineteen, he was exhibiting his work in one-man shows. In 1954 he had a show in the gallery of the Pan-American Union in Washington, D.C., and a year later, in the Edouard Loeb Gallery in Paris, where Picasso bought two of his works. L'enfant was brilliantly launched. Le terrible accompanied him like a malicious Siamese twin. The truth is that Cuevas has made a career of contentious exchanges. At a time when Mexicans held los tres grandes—Rivera, Siqueiros, and Orozco—to be roughly equivalent with the holy trinity, Cuevas attacked them vigorously for their "mindless nationalism." He scorned the Mexican maxim "Como México no hay dos" ("No country can match Mexico"). Individually, although he respected Orozco, he accused Rivera and Siqueiros of "lacking substance." Rivera "had little to say

about painting." Siqueiros was "out of date." Cuevas was slightly more ambivalent about the increasingly monumental figure of Rufino Tamayo; he praised his work, classifying *The Sleeping Musicians* (1950), now in the Museum of Modern Art, as the best easel painting to have come out of Mexico, but he vilified Tamayo and his wife, Olga, personally. In "Story of an Enmity," Cuevas recounts his meeting with Tamayo, who was painting a mural—an enormous magenta watermelon—for the branch of Sanborn's on Lafragua and Reforma. When Cuevas presented a letter of introduction, he writes, "Tamayo did not even look at me. When we left, he did not respond to my timid words of farewell. I left the café boiling with rage and pain."[1] The feud that developed from that meeting, exacerbated by Cuevas's determined will for retaliation, continued over the years, interrupted by brief periods of "playing at friendship," a pattern for relationships formed with a multitude of important figures around the world.

His affinity for public rancor has earned Cuevas the predictable notoriety and dedicated detractors. Only a great talent saves him from being reduced to the status of a personality. There is no finer Mexican draftsman than Cuevas. His

93

brutal figurative world has been compared to that of Grosz, Bosch, and the Goya of *The Caprichos* and *The Disasters of War,* and his satire to the violent humor of Hogarth and Daumier. Prostitutes, drug addicts, and asylum patients are recurring subjects. His illustrations for *The World of Kafka,* his lithographs entitled *Crime by Cuevas,* and the *Cuevas-Charenton* series all display his affinity for the grotesque and the freakish. Carlos Fuentes, who has written extensively on Cuevas, sums up the Cuevas world as

> figures shamed (redeemed) by (born of) (condemned, promised to) their obesity, their anal nakedness, their funambulist's vulnerability, their fetal retreat, their filed teeth, their tangled onomatopoeia, their glandular gaze, their humpbacked long-suffering, their digital incompleteness, their porcine snuffling, and their exitless solitude.[2]

Cuevas expressed his own philosophy in the second issue of *Nueva Presencia,* a manifesto against the Realist school: "Man, as the most important artistic theme, must be penetrated, vivisectioned, his entrails exposed to the world to show the agony and the despair of existence today."

In one of his most compelling formats, Cuevas groups together a series of human representations, inevitably grotesques, within an implicit frame. The effect is that of a pre-Columbian codex, in which small figures march across a space unified by their interrelated actions and a time excised from chronology to encapsulate their myth-reality. *Historia de un crimen* ("Story of a Crime") is but one example of this form, a collection of human monsters stamped on the page like evil cameos. Decapitated heads appear in several aspects: one held by the forelock, one with a clutch of devil's tails implanted in the bridge of his nose and rising above the crown of his head. A man weeps a tear that seems to have drained his

eye from its socket; his head rests directly on small feet. A second man rises from the crown of that head; only misshapen hands betray *his* abnormality. A carnival-masked head is topped with a reptilian skull. A bizarre monstrosity composed of an unspeakable combination of body parts is centrally displayed on an upside-down poster. Smiling, grimacing, scowling, mocking faces; a plump odalisque; an effete angel; the neutral visage of José Luis Cuevas himself. There is no eye contact among these fragmented creatures, no touching other than the overlapping of spatial planes, yet these victim-monstrosities are irrevocably linked in the story of the crime. It is not difficult to deduce Cuevas's world vision.

Nor is it unusual to find Cuevas in the center of his abnormal universe, for Cuevas, like his predecessor Frida Kahlo and the younger Nahum Zenil, is an obsessive self-portraitist. In a video that accompanied a recent exhibit in the Santa Ana, California, Modern Museum of Art, Cuevas stated, "I greet each day with a self-portrait." These portraits may well derive from his dreams. "I dream almost every night," he writes in *Historias para una exposición* ("Tales for an Exhibition"). "I do not always remember what, but I awaken with the uneasiness dreams can cause. When I can remember, I write the dream in a notebook I keep in a desk drawer close to my drawing table. I refer to it from time to time in search of themes for my paintings." One dream he recounts illustrates perfectly the El Bosco world that peoples his canvases.

> I awakened in the early morning from a disturbing dream, feeling very distraught. I did not dare get out of bed, but lay there a half hour with my eyes wide open. I was afraid to go upstairs to my studio and discover that what I had dreamt had become reality. It was there, where I work, that the dream had taken place. Everything was very neat, but something was happening on my draw-

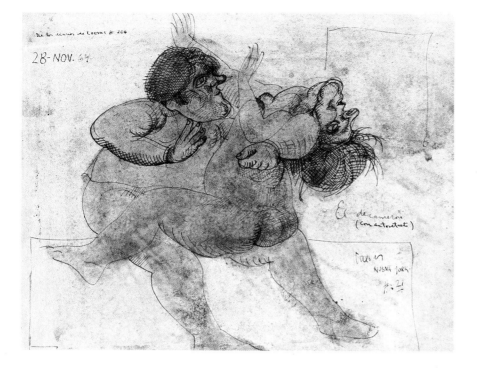

16a. José Luis Cuevas, *The Decameron*, 1964, pen and ink on paper, 8 × 10 inches. Photograph courtesy of Mary-Anne Martin/Fine Art, New York. Photo: Sarah Wells.

ing table. An infinity of figures were lying there, moving in slow motion and from time to time making sounds. Someone above me commanded me to draw, granting me no respite. There was no way I could avoid the sentence. Bound to the task, I drew everything taking place on my table. My models were many and diverse; there were prostitutes carrying slabs of meat on their shoulders, accosted by hungry children grabbing for the prize. Suddenly a person would surge forth whom I had known in my childhood. A girl, for example, who had died from rabies when she was six. She was my age and lived in the house next door. In the dream I recaptured the terrible image I had forgotten: the dying girl gasping for breath amid horrible moans. Froth bubbling from her lips. Drawing her in my dream saved her. The paper on which I had made the sketch turned into a bird that soared off to heaven. The same happened to a crippled workman who had suffered an accident in the factory I had lived above

as a child, and to the criminals with Italian surnames who had been allowed to escape and then been shot down before the window of my house in the alley called El Triunfo.

One Sunday afternoon in August, we sit in Cuevas's spacious studio on the second floor of his beautiful San Angel home, designed by the renowned architect Teodoro González de León (and completed during an intense public feud). The neatness alluded to in his dream is not an invention. Everything is in its place, in a studied order. Photos and paintings, many of the young Cuevas, fill the walls. Books and prints are scattered on long tables. A large brass bed covered with ruby spread and draperies dominates the room. Pencils, etching tools, pens, brushes, bristle from an assortment of tins and pots, but there is little evidence of work in progress. This orderly clutter is very different from the cool white space

of the living area downstairs, the *sala* dominated by the huge canvas of *The Marquis de Sade as a Child*, the squared stones of the patio surrounded by bamboo and greenery. Cuevas first sits and then stretches out, á la Récamier, on a long saffron-colored sofa. It is clear he is proud of his writing, as well as his painting.

Cuevas's personal essays—ranging from scabrous attacks on éminences grises, through salacious accounts of seductions, to entertaining meditations on international celebrities—reveal both a draftsman's eye for sketching a true portrait and a gossip columnist's tongue for eliciting avid interest. These pieces have been collected in, among other works, *Cuevas por Cuevas* ("Cuevas on Cuevas") and *Cuevario* (a play on *bestiario*, "bestiary," with echoes from the "caves" of his name), scrupulously precise titles for this consummately self-conscious individual. And now he is completing another autobiographical book, *Cuevas antes de Cuevas* ("Cuevas Before Cuevas"), based in large part on the columns he writes every Sunday for the newspaper *Excelsior*. "The fact is," he reports gleefully, "that my writings are longer than [Fuentes's] *Terra Nostra*. The first part is ready for publication; it covers my life from my childhood to the time I leave to mount exhibitions abroad." Previously published fragments of his life have been placed in chronological order, interwoven, and augmented. Asked whether his life might not be filmed some day, he agrees that his life would make a good movie, "because I put in a lot of the erotic." "It used to be," he continues ruefully, "that the erotic parts came from my diaries, but now they make up my memoirs. That's the difference." From a man who has consistently fictionalized his existence, the insinuation is that this is yet another tale by Cuevas.

No one would deny that José Luis Cuevas is a controversial artist. His fractious behavior has earned him the ultimate condemnation from some critics: that he is without talent, or that he has consumed his talent in Daliesque cavortings and tantrums. Others are more benign, believing that whatever his personal behavior—and one must never forget that Cuevas himself created his persona—an enduring talent triumphs over the pettiness. Cuevas has recently achieved one of the hallmarks of lasting fame, the opening in the historic center of Mexico City of a museum bearing his name. With the José Luis Cuevas Museum, formerly the Convent of Santa Inés at number 13 Academia, Cuevas joins the limited number of Mexican artists for whom museums have been named, including Diego Rivera, Frida Kahlo, and, among contemporaries, only Rufino Tamayo. The museum, like the baroque mirror in his study that reflects his youthful portrait through infinite time, will serve as a gallery of views reflecting the many facets of this intriguing artist, helping this and future generations to identify the true, not the fictionalized, essence of José Luis Cuevas.

CARLOS MONSIVAIS

Mexico City, D.F. · 1938

For a man who has written so much and influenced so much public opinion, Carlos Monsiváis is a man of few words. He tends to respond to questions in monosyllables, managing to inject "yes" and "no" with a multitude of shadings from "absolutely, couldn't agree more," to "highly dubious" to "what a strange question." North Americans might think of this amiable man (who denies that he is called "the guru of Mexican intellectuals") as a rumpled Tom Wolfe, a man who airs opinions, forms reputations, and—especially in the case of Monsiváis—champions popular art. No one in Mexico knows more about what is going on: what's cool, what's hot, who's in, who's not. He opens an interesting-looking envelope that has just arrived in the mail: an invitation to a cocktail party for Abel Quezada's new book (Monsiváis dedicated a chapter of his landmark *Días de guardar* ["Days to Hold Holy"] to Quezada). Angeles Mastretta? "You must see her. I think she's the most successful novelist now in Mexico." Enrique Diemeke? "He's in the States right now." Nahum Zenil? "He's extraordinary." A vast network of information flows in and out of Monsiváis's studiously cluttered study. What is in his typewriter at this minute? An article on the Bo-

lero Festival being held in the Alameda park, which he will fax to Spain tonight. And what is the next priority among the mounds of books and papers and correspondence on his desk? A manuscript "on Mexico" in preparation for Verso, the English publishing house. "On Mexico today?" "No. A survey."

Monsiváis's anthologies of Mexican literature have shaped the taste of students of several nations. Now we want to learn something of the tastes of the man behind the mountains of newspaper columns and magazine articles and introductions to books of all genres. He is gracious in sharing his interests with this invasion from the North. It is clear he has already welcomed an invasion of a different breed of animal. As with Emilio Carballido, from the first visit it is difficult ever again to think of Monsiváis without an accompanying recollection of cats. A staggering kitten emerges from a pillowy nest as we enter the traditionally book-lined rooms that serve as Monsiváis's library and study. "They know in the neighborhood that I will take them in." Nina Ricci, a young tabby with white feet and paws, hogs the camera while photographs are being taken. "Nina, you are showing off too much." An

17. Carlos Monsiváis

elderly stateswoman, Rosa Luxemburg, and a demanding Siamese skid and slide over the desk to perch on the lap and shoulders of their felidaephile master. A large black male who "hangs around outdoors—I call him Chocorol; he's a Narco"—slips in to check the never-empty feeding station. It is difficult to keep count. Later comes the fond, already presumed admission: "They are my masters."

There are collections other than cats. Monsiváis does display signs of being a compulsive collector. "I have to confess, I like my environment." There are bone carvings by a Oaxacan artist, miniatures that would please an Oriental potentate; a roomful of black and white caricatures, many hung, many stacked along the four walls waiting to be displayed; oils and drawings by Mexico's finest artists, many dedicated specifically to Monsiváis, such as the Carrington and three "Monsiváis by Cuevas" line drawings; striking oils by turn-of-the-century painters; several Tamayos—"I'm happy with the Tamayo drawing, he gave it to me last year"; and also several Toledos, including a wonderful bronze and a unique Toledo cat graphic encircled by the letters of Monsiváis's name. A small storage room is filled with video cassettes for the bar-sized television screen in the upstairs *sala*. A totally self-contained world—no wonder Monsiváis expresses pleasure with it. But there is more: a museum of miniature rooms, shops, homes, an entire convent–"The convent is my madness"—all recreated in exquisite detail, small Mexican worlds illustrating infinite Mexican patience, unequaled Mexican craftsmanship. The walls of the sombrero *tienda* are covered with diminutive straw hats of incredible variety; the *olla* market stall features lilliputian clay pots and jugs and platters; a shop for more expensive cookware gleams with minuscule copper pans and glazed earthenware.

It is not a great leap from those stereotypes of Mexican daily life in the barrio and pueblo to the world of real people, the world about which Monsiváis has written so much. Politics, pop, literature, art, kitsch, music—little escapes his compassionate but never sentimental eye. His *Días de guardar*, like Octavio Paz's *Labyrinth of Solitude*, is a book that reveals the Mexican soul. It is so Mexican, so filled with tribal references, so linguistically specific, so permeated with symbolic names and places, that probably only another Mexican can truly comprehend it. Yet the reader who does understand even a part will greatly enhance his understanding of Mexico. At the same time that *Días de guardar* is a portrait of a culture it is also, like Elena Poniatowska's *Massacre in Mexico*, an account of the events that led to, accompanied, and followed the tragedy of the student protest of 1968, all the upheaval and bloodshed and struggle of that year that has become a part of Mexican mythology. *Días de guardar* is interlaced with aphorisms, *albures* ("inspired insults"), games, lists, photographs, reportage, slogans, and eloquent depictions of customs and beliefs. One of the most brilliant of the latter is a chapter describing the celebration of the day of the Virgin of Guadalupe, the dark-skinned Madonna whom Mexicans worship as their own, a symbol of nationalism, an icon of true religious fervor, a personal savior. Monsiváis presents the fiesta through scores of scenes, snapshots that together form an animated twenty-four-hour documentary on every aspect of this holy feast day. A few selected paragraphs communicate vital moments in the progress of this outpouring of communal emotion: gathering together, the climb to the sanctuary, the mood of the celebration. To experience the phenomenon of pulsing, coalesced devotion displayed at the shrine is to touch the very heart of Mexico.

December 12—The Virgin of Guadalupe

From the provinces, from every neighborhood, from every public and secret corner of the capital, people break away from their normal activities and join in the march. Supplied for the weather: woolen ponchos, blankets, knitted caps, hats of questionable felt, thick sweaters, shawls, thin or ineffectual overcoats. They walk without haste, conversing; bottles pass from hand to hand; there is laughter but also a mood of reverence. All carefully planned: they will go together; together they will leave the neighborhood or block or apartment, right after dinner. Raúl will bring his guitar. Juanito will bring his guitar. Víctor will bring his guitar. The Lady deserves their all. She is their patron saint; they, Her devoted. Hurry, now; come along; don't be lazy; you can do without your car for once; the walk will do you good; a little sacrifice will be repaid; it will be duly noted.

There are no streets: the D.F., the Federal District, lowers its mask, its pretense of being a city. There is only The Way, the ascent of Mount Carmel, that begins in the town of Tlalpan, the Vía Dolorosa that originates in Azcapotzalco, the Road of Perfection that starts from the Calzada de la Viga, the contempt for bodily suffering that is born on the outskirts of the Colonia Sifón, the spiritual absorption that materializes in the atrium of the Iglesia de Romita. There are no streets: there is only a route of penitence that is being collectively formed and dismantled. La Avenida de los Insurgentes and the Calzada de Tlalpan and the Avenida Melchor Ocampo and the Ribera de San Cosme are routes of temptation now disregarded, dusty roads trodden by the feet of pilgrims yearning for beatitude. It is the night of December 11, the Eve of the Festival of the Virgin of Guadalupe. . . .

The vow, the promise, the offering of mutilated flesh. On their knees, they make their way toward the Sanctuary, bleeding, fainting, mortified in flesh, afflicted in spirit, oblivious to the blanket the wife, the husband, keeps arranging to ease the suffering, galvanized by gratitude. *Most Holy Virgin, we give thanks to Thee.* Favor is being transformed into pain. And the bleeding flesh, the open wound, the stabbing, palpitating, agonizing sensation of being vanquished by the rebellion of the flesh, the inability of the flesh to resist the assault of Temptation, is the price of, the complement to, gratitude. The wound is a relic, an offering, a redemption. There is one man—a liberal, a leftist, a non-Catholic—who sees nothing in the vow but an odyssey of futile self-punishment. There they are, doing harm to themselves, mortifying their flesh, humbled in the endeavor of acceding to the Virgin through their pain. Does the soul tremble? Is there spirituality in this suffering? Who knows? Why not, instead, insist on the liberal, leftist, non-Catholic

affirmation that condemns fanaticism in the name of reason? How, in Mexico, may the advantages of reason (plan) over fanaticism (communication) be demonstrated? The vow has been made because of an accident from which the victim has emerged unscathed, or because of a paralyzed son asleep now, deep in his frightening dream. Gratitude for the blessing received, for the blessing still to come, gives definition to the notion of sin. Sin is having been born; sin is still to be living; impotence is sin and patience is sin; sin is having raised your hand against your mother, and sin is having brought these unfortunate children into the world. The people are amending the words of Saint Paul: the wages of sin is not death, it is gratitude. If we give thanks to the Virgin for our pain, She will absolve us of the sin of being alive. . . .

In the atrium of the Basilica, mariachi groups and performers are singing *Las Mañanitas*—Happy Birthday—to the Virgin. The holy sanctuary is the joyful site of celebration on this blessed day. Her birthday. Her fiesta. Lines of pilgrims, naves overflowing with faithful, groups of Indian dancers, bouquets of flowers, bands of musicians, the *voladores*, the Indians of Papantla who ceremonially swoop through the air suspended from tall poles, are all part of the communal demonstration. What is there that is *not* at this holiest of Mexican shrines? Because it is the Virgin's day, the celebrants are united by a single will: to enjoy themselves, to be happy in order to gratify Her. A night of fellowship, of absence of any walls between Her and Her faithful, between worshiper and neighbor. *Devotion:* balloons, feather headdresses, conch shell trumpets, eagle warriors with mandolins. *Diversification:* television cameras, clogs, pre-Cortesian musical instruments, people fainting and masquerading.

In the environs of the Basilica, people are quarreling, killing each other, raping, getting drunk. The splendor of the fiesta is tediously twofold: reverence and profanation. A line of policemen inspect those ascending Tepeyac hill [to the original sanctuary]; weapons are seized in order to purify the sacrilege. Police guard the faithful from violence in transgression. Friends make confessions; *compañeros* have an all-out good time, the family is united in diversion and contrition. The night of all Mexicans is in full swing.

Attractions fill the open spaces around the Basilica: puppet shows, the snake lady, the bearded woman, the house of mirrors, food and refreshment stands, religious pictures and scapulars for sale, the insignia of various religious fraternities. Bells, tall lighted candles, the crush of crowds, mass. Let no one reduce this declaration to tears or reproach: in Mexico, mysticism, before it can exist, requires the blessing of numbers. In what order of gregariousness do we move? From nation to clique, from society to gang. To recapitulate sometimes is to interpret. And enumeration is interpretation when appearances are all we have left of this cliché, this commonplace, we call reality.[1]

18. Amalia Hernández

AMALIA HERNANDEZ

Mexico City, D.F. · ca. 1920

The house lights dim. Stage lights up. Curtain. A pyramid is outlined against the horizon. A chorus of men robed like figures on a Maya frieze begin the stylized movements of the *Concheros* ballet. The dancers, called concheros, are named after the guitars made from the shell of the armadillo, some of which are encrusted with seashells and considered true works of art. The most eye-catching aspect of their dress is a plumed head-dress: a flat, ornamented shield curves in a U around forehead and cheeks and rises in a triangle or rectangle to a height of six to eight inches; dozens of long, spotted feathers (Aztec royalty would have worn the feathers of the quetzal, but these look like those of a regal pheasant) sprout from the headdress, like streamers trailing from an exploding skyrocket. Ceremonial shin plates sheathe the dancers' legs. A band of geometrically patterned cloth swathes their hips; a tubular roll of cloth folds over at the waist and continues as an elongated loin cloth. Ankle rattles, pebble-filled gourds, and an assortment of percussions sound in a steady crescendo. The harsh rhythm of the *tzlcahuaztli* is added, a wooden rasp scratched with the rim of a conch shell. The concheros are danc-ing their way to the festival of their pre-Hispanic and Catholic gods.

The audience is struck simultaneously by sound, movement, and color. After the first mo-ments of spectacle, the eye begins to focus on the individual dancers. They are young and uni-formly handsome. They tend (in the North American frame of things) to be small, fine-boned, medium- to dark-skinned, and, without exception, black-haired. Their individual fea-tures range from the distinctive Maya profile to the strong but different aquiline profile of the peninsular Spanish. An interesting resonance with Egyptian motifs is noticeable in the back-drop and the costumes: the treatment of the loincloth, the headdress, the semicircular pec-toral, the capes that fall straight from the shoul-ders, the pyramid itself. Was the costume de-signer perhaps taking a bit of license for dramatic effect? That question motivates a stroll the next day through the National Museum of Anthropol-ogy. There, in ocher, black, ivory, and tan murals, are the prototypes for the Egyptian look-alikes. An anthropologist would obviously find dis-parities. The average observer sees only the over-all similarities. And there is more in these murals: monster masks, Indonesian in tone; men wearing trousers that could have outfitted the king of Siam; a handheld staff topped by a fish one might

see on an ancient Chinese ceramic. We recognize from the ballet *Los Mayas* the men whose arms end in gigantic lobster claws. A seated man with an alligator head might have been painted by Francisco Toledo. There is more than enough here to inspire the wildest flight of a costumer's fancy. Standing before the centuries-old murals, one can in one's imagination connect pre-Columbian civilizations with those of Pacific island cultures, the peoples of the Nile valley, even Von Donegan's visitors from outer space—an amazing diversity and exoticism verifying that Mexico enjoys the world's richest variety in national dress. Even today, more than fifty different Indian peoples survive, each with their distinctive regional costume. Add to pre-Columbian images the rich traditions of Spanish folklore, and one begins to capture the color and exoticism of the Ballet Folklórico.

Amalia Hernández is the founder, choreographer, director, and enduring guiding spirit of the ballet. Doña Amalia herself is not robed in an indigenous costume at our meeting, but her bearing and presence betray her life in the theater, as well as the fact that she was first a dancer, and then an impresario. She conceived, gave birth to, and continues to nurture the several companies of the ballet and even today travels for brief periods with different groups of her touring companies. This evening she has returned from a tour of several Mexican states; her company is performing—to a large and enthusiastic audience—in a theater in the working-class neighborhood of Tlatelolco, some distance from the Palacio de Bellas Artes, where the resident company regularly performs. Tours of the United States, Latin America, and Europe are routinely triumphant. The Ballet Folklórico is, among other things, one of the most successful tourist attractions ever achieved. To North Americans, it is arguably the most visible, and pleasantly absorbed, representation of Mexican culture and art. The major states of its devel-

opment, from beginnings to triumph, took place within the decade of the fifties.

The authentic history of the Ballet Folklórico and biography of its creator may remain unwritten, but it is more than legend that in 1952 Doña Amalia created her own dance company, after having left a job as teacher and choreographer at the Bellas Artes Institute. The following year, her small group won a television contest for best national ballet. A commercial sponsor brought the troupe to television, and during that phase Hernández created a ballet a week for sixty-seven weeks. The next rung of the ladder was sponsorship by the Department of Tourism, which was followed by successes outside Mexico. Hernández is quick to attribute the beginnings of true success to President Adolfo López Mateos, who in 1959 mandated government funding and backing for the troupe. In 1961 the ballet, invited to dance in Paris, won first prize in dance at the Théâtre des Nations Festival. It is no accident that the glow from this luminous spectacle has not diminished for three decades. Doña Amalia has added safeguards to maintain the smooth functioning and high quality of the ballet. The School of Ballet Folklórico was opened in 1968. The school also sponsors a project to film folk dances in situ, striving to save rapidly disappearing traditions of dance. Costumes, sets, and props are rigorously maintained, and the backstage visitor, often disillusioned by close views of the creatures who from a distance seem so sparkling, is impressed by the cleanliness and attention to detail of the costumes of this troupe.

Doña Amalia has created a small dynasty in the Ballet Folklórico. Her daughter, Norma López Hernández, is director of the ballet's resident company, and another daughter, Viviana Besante, is a principal dancer in the evening's performance. Doña Amalia is slightly weary from the tour through the provinces but commanding in a purple wool cape, her white hair combed se-

verely back from her handsome face. She is laughing and joking with her old friend, our theater companion, Emilio Carballido. Watching them together recalls Carballido's stories of decades of travels with Hernández on behalf of the arts. Their most recent shared adventure was a red-carpet visit to Russia, flown in Aeroflot transports, an adventure eased with an endless supply of champagne and caviar. Doña Amalia responds to questions cordially but briefly.

Questioner Your performances are always filled. Looking around tonight, I wonder how many people may see the Ballet Folklórico in a year's time

A.H. (laughing) I don't think we Mexicans ever count.

Carballido How many *would* see the ballet in one year?

A.H. Well, there are many national tours. What exactly are we looking for?

Carballido Say, a year's attendance.

A.H. A year's attendance—I'd have to ask you.

Carballido I haven't a clue.

A.H. How many weeks in a year?

Q. Fifty-two.

A.H. Well, based on maybe three hundred performances a year, and an audience of fifteen hundred per performance, that would be somewhere around fifty thousand.

Carballido Fifty thousand! That's wild.

Q. Doña Amalia, how much of what we see in a performance belongs to a world that has totally disappeared, and how much still exists?

A.H. Ballets are reconstructed from pre-Hispanic legend, and from the hieroglyphs and codices, and other sources. And then, folklore is alive in Mexico.

Q. Do you still recruit dancers from the provinces?

A.H. Many come from our own schools, but we still find some in provincial ballet schools.

Q. Your ballets are so well known that I imagine audiences do not want any changes in the program. Does the program evolve over time? Can an exceptional dancer inspire an adaptation or new presentation?

A.H. Well, a creative artist might suggest a theme, and we would develop a ballet from that. (*She turns to Carballido and laughs.*) Like you.

Q. Over a long career, you must remember moments of great triumph. Is there some special incident that stands out in your memory?

A.H. (without skipping a beat) Oh, yes. It was last week. Our plane seemed not to be able to gain altitude, and I was sure we were never going to clear the mountains as we took off. (*Everyone laughs.*)

Carballido I'm going to ask you my own question. You started your company in the fifties. Didn't you dance in a ballet set to music by Chavez?

A.H. Yes. I danced in the time of the Roc.

Carballido Well, I won't ask you any more questions. Except, wasn't it López Mateos who first backed the ballet?

A.H. Yes. He was the one who invited me.

We have come full circle to the stories of the beginnings of the Ballet Folklórico. Legends about Doña Amalia precede the founding of the Ballet, however. It is told that when as a girl she wanted to study ballet, her wealthy, powerful, and extremely conservative father built a dance studio for her at their home so she could study privately, because young ladies did not expose their legs; that once when she secretly won an extra's role in a movie being filmed in Mexico City, shooting was interrupted to allow the passing of the police escort of the governor of the Federal District—Amalia's father—but the escort did not proceed until the father was accompanied by his protesting daughter; and that when she decided to start her own dance company, she pawned her father's Cadillac to obtain funds for her project. Doña Amalia was, and still is, no ordinary woman. Hers is a life waiting to be converted into a novel or film, or perhaps a new folkloric ballet: the Ballad of Amalia Hernández.

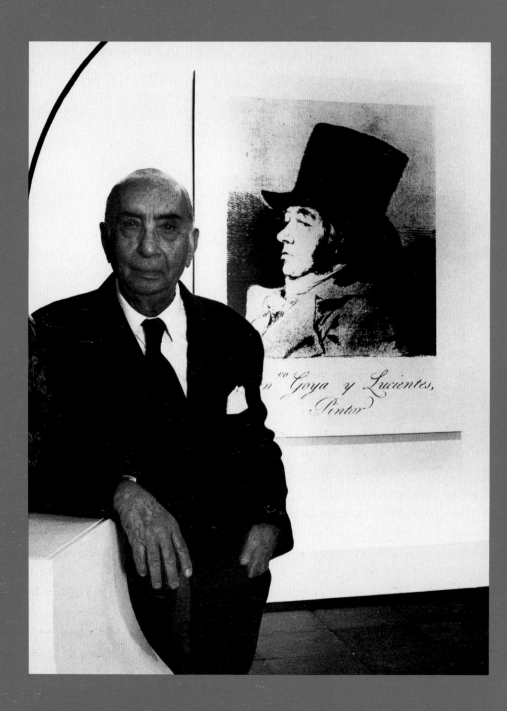

19. Fernando Gamboa

FERNANDO GAMBOA

Mexico City, D.F. · 1909*

We are welcomed at the door of a second-floor office in the Palacio Iturbide, now the administrative offices of the Bank of Mexico (Banamex), by a slim man in tweeds. The straight back, the slight forward inclination of the torso, the general bearing is reminiscent of José Ferrer. It is not Ferrer, of course, but Fernando Gamboa, who since 1983 has been the director of the cultural arm of Banamex. The position has no analogue in the United States, but it might be compared to a nationwide curator of art serving within the home offices of City Bank. Since assuming these responsibilities, Gamboa has sponsored various cultural activities and publications and has organized more than two hundred exhibitions throughout the Republic of Mexico. He has, in fact, spent a lifetime facilitating exhibition of the arts. Octavio Paz has called him the *fundador,* the founder of the extensive system of Mexican museums. Gamboa has made artworks available to multitudes of viewers. In Mexico, he has mounted a thousand exhibitions of national and foreign artists. He has, in addition, sent one hundred and forty shows of

Mexican art to major cities on five continents, including, in the United States, New York, Chicago, Philadelphia, and Dallas. If a nation is to enjoy its artistic patrimony, public space is required for its viewing, and by planning and installing six Mexican museums, Gamboa has enriched the cultural life of his country. In 1944, under his direction, the Museo Nacional de Historia was incorporated into Maximilian and Carlota's beautiful palace on a high promontory in Mexico City's Chapultepec Park. In 1948, the initiation of the Museo Nacional de Artes Plásticas accompanied the reorganization of the Instituto Nacional de Bellas Artes, which plays a role in the Mexican art world similar to that of the Smithsonian Institution in the United States. At that time, referring to changes of attitude following the democratic revolution of 1910–1920, Gamboa spoke of the importance of government curatorial and educational activities in the arts and of the need to value Mexico's own contributions to the world of art:

> For the first time in our history as a free nation, we highlighted the grandeur of our pre-Columbian cultures, which until then had been only partially evaluated. For the first time, too,

*1909–1990. Fernando Gamboa was killed in an automobile accident during the preparation of this book.

19a. *Calaveras* (skulls). This example
and those on pages 109 and 110 are by
José Guadalupe Posada from *México en el
arte* (October 4, 1948).

we turned our eyes toward the art produced by
our peoples. Before the Revolution, our society
was inclined to model its tastes on foreign
models. The ideal was imitation of all that was
European. The fact that our country has one of
the great traditions in art had been totally ig-
nored. . . . Little by little, our art assumed
greater significance, as a tangible reality by
which to measure the expression of the soul of
the people and as a vehicle of cultural advance-
ment for those same peoples.[1]

In 1950, Gamboa oversaw the establishment of
the Museo-Taller José Clemente Orozco in Gua-
dalajara, founded in the memory of one of *los tres
grandes*, the triumvirate of muralists who were the
first Mexican visual artists to achieve interna-
tional renown. And in 1971, he opened the Museo
de Arte Prehispánico Rufino Tamayo in Oaxaca,
which houses the fine pre-Columbian collection
Tamayo donated to the people of his native state.
The Tamayo museum is located in a beautiful old
building in which handsomely displayed pieces
are placed against brilliantly colored cases and
walls—violets, salmons, blues—following Ta-
mayo's own color coordination. Though the col-
lection is comparatively small, its quality is
unrivaled.

In 1975 and 1981 Gamboa installed his final
two museums, the Museo de Arte Carrillo Gil and
the Museo de Arte Contemporáneo Rufino
Tamayo, designed by Teodoro González de
León, one of several museums in an impressive
cluster of museums in Chapultepec Park.

The Palacio Iturbide is itself a work of art, an
exquisitely restored colonial residence built in
1780 by Francisco Guerrero y Torres and now
one of the landmarks of the historical center of
Mexico City. The light, open interior patio of the
Palacio serves as gallery space for public exhibi-
tions. This day there is a Goya exhibition featur-
ing engravings from the fourth edition of *The Ca-
prichos*, which were given to Mexico by the
Pittsburgh author and designer Edgar Kaufman in
gratitude for Mexico's kindness to American sol-
diers during the Second World War. The huge
mirrors and gilded tables that are a permanent
part of the exhibition space stand in singular con-
trast to scathing social satire of the life-size black
and white blowups of the engravings.

In an essay in *México en el Arte*, Gamboa once
traced the tradition of the *calavera*, the skull, in
Mexican art and life. The Goya engravings so
memorably displayed in this beautiful patio re-
mind us that the much-discussed theme of death
in Mexican culture is a heritage from both Spain
and pre-Columbian societies, a point tellingly un-
derscored by Gamboa. He highlights in the essay
the peculiarly Mexican fusion of humor and death
as evidenced in the savage political cartoons of
the master Mexican lithographer and engraver

José Guadalupe Posada—a not-too-distant cousin to the Goya of the engravings displayed in the stately calm of the Palacio Iturbide. Gamboa wrote his comments in 1948. Nothing has changed. Death continues to permeate the art and literature of Mexico. Carlos Fuentes, Germán Venegas, Guillermina Bravo, José Luis Cuevas, and Manuel Alvarez Bravo are but a few of the artists whose works are filled with figures of death in its many guises: coffins and cemeteries, the candy skulls sold on All Saints' Day, the bleeding wounds of Christ, the hollowed-out belly of Chac Mool awaiting still-palpitating hearts, and, of course, *calaveras*.

Calaveras

November 2, the day dedicated to the dead, is in Mexico an event filled with curious customs, among which is one prominent in the behavior of those who, immune to any sense of tragedy, festively declare that they "cry their heart out" while leaving no plate set before them untouched, nor any cup half-empty.

In general terms, the Mexican is born endowed with a sense of humor accompanied by a kind of insouciance in the face of death. To this point, it has been said that the Mexican owes his indifference to a special idiosyncrasy, to an atavistic heritage from pre-Hispanic cultures, to his long and fervent practice of Catholicism, which has accustomed him to the idea of death, or, as some Mexican sociologists indicate, to the inertia occasioned by the absence of personal security that for centuries has hovered like a cloud over our national life. However that may be, November 2 is a day that serves as an excuse for bantering with death, for confronting death with profound familiarity. Neither does the Mexican leave his sarcasm behind on that day, applied both to himself and his fellows. . . .

This humor flourishes with unwonted vigor when aimed at a political target; the clearest evidence of this fact lies in the proliferation of satirical publications in our recent past.

As an artistic representation, death was in pre-Hispanic times magnificently integrated into religious manifestations. During the Colonial epoch these expressions were replaced by pathetic representations of Christ's agony, as well as by the countless skulls that played an essential role in Catholic liturgy.

"Skulls"—the representations of living creatures, things, even abstract ideas in the form of skulls and skeletons—were created in Mexico by the lithographer Santiago Hernández. The first of them appeared in 1872, bearing overtly political interpretations. These skulls, which evoked specific political figures, were passionately executed, as if

their creator wished in creating them to anticipate the death of the person alluded to. . . .

Before José Guadalupe Posada arrived in Mexico City, another engraver, Manuel Manilla, was also known for his skulls. But it was Posada who, surpassing all other artists, cemented the tradition. In this specialty, he was guided by the same incentive that inspired all his work: expressing the sentiments of the people.

He was a faithful interpreter of popular expression, and his skulls passed from hand to hand, receiving the general approbation of the Mexican people. Posada had the ability to convert anyone into one of his famous skulls—a general or a president, a scholar or a bullfighter, an ant or ear of corn, a thief or a dandy. One of his last works, the "Huerta skull" (the devastating caricature of a cruel and corrupt president, Victoriano Huerta), achieved sensational popularity throughout the nation. Posada poured into that composition all a free man's loathing for a tyrant, whom he portrayed as a repugnant, scorpion-tailed tarantula in the act of greedily devouring other skulls.

This tradition, now so deeply rooted that it forms a part of the Mexican being, has been augmented and even glorified in contemporary art.[2]

GUILLERMO SAMPERIO

Mexico City, D.F. · 1948

"The situation of literature in Mexico has changed in degree of both quantity and quality. We must give our attention to all writers, as well as to an ever-increasing number of readers. Narrators and short-story writers have proliferated; there is a very active movement in children's literature, and the number of young essayists has also multiplied."

Guillermo Samperio is discussing his responsibilities as director of the literature program of the National Institute of Fine Arts (INBA). INBA itself is probably most closely related in scope and function to the complex of the Smithsonian Institution in Washington, D.C., although INBA combines museum functions with an advocacy role for contemporary artists. INBA is the official government center for all the arts in Mexico: it publishes journals; hangs shows; awards prizes; presents operas, ballets, symphonies, and plays; holds conferences; and distributes information. In short, it serves as an enormously powerful and visible center for arts activities in Mexico. The offices of INBA are spread around the central area of the city, in the Latin American Tower, the National Museum of Art, the Palacio de Minería (Palace of Mining), a number of churches, theaters, and historic buildings, and in the symbolic edifice of the Palacio de Bellas Artes itself.

Focusing on the specifically literary activities of INBA, Samperio continues: "In addition, journalism is beginning to assume a stronger presence in literature. I'm referring to criticism and reportage, and when we add to that all the traditional and emerging hybrid genres, you will see that we have an enormous flow of information to organize and process. The mere mass of material creates a series of problems in communication. We cannot continue to channel publicity directly to the public. If we are not to fall behind, we must utilize the resources of technology, use massive print and electronic media, to absorb more efficiently our daily artistic production. If it is to be of value, the Division of Literature must keep up to date."

Samperio's office, on the third floor of the Latin American Tower, the tallest building in Mexico City and long a landmark in the heart of the old city, reflects the energy necessary for the difficult task of monitoring all literary activity and transforming that information into publicity, conferences, magazines, prizes, tours, and other endeavors beneficial to writers and to writing.

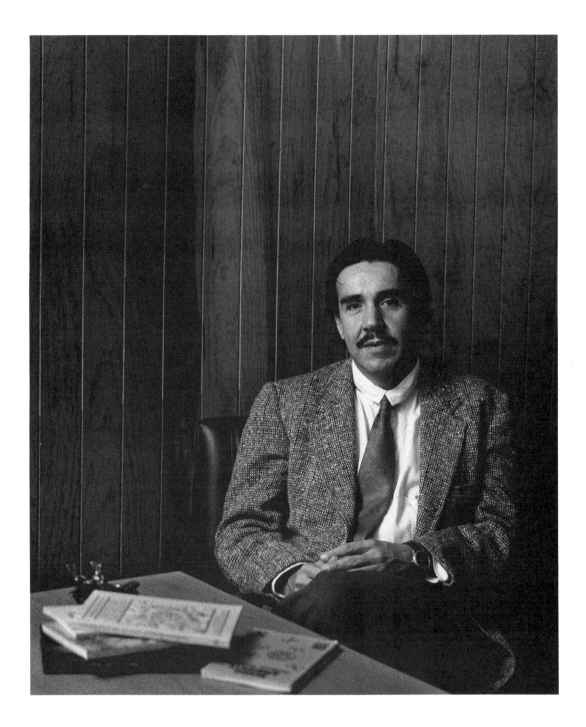

20. Guillermo Samperio

When we emerge from the elevator, the frenetic activity in the large open office area resembles a Hollywood set of a great newspaper city room: people hurrying in every direction, typewriters clacking, sheaves of papers tottering on cluttered desktops. The illusion is almost immediately shattered, however. There are no crusty old editors here, no tired and aging beat reporters. In this noisy, bustling room, every visible person is young; all the women would be playing the ingenue, all the men the cub reporter. After we step into the director's small office, a haven of relative quiet, Samperio offers the explanation that would have been unnecessary after a moment's thought. All these young people are aspiring writers, and working in the literary division of INBA provides invaluable experience and practical training and contacts.

It is Samperio's challenge to direct the energies of this corps of talented young people, many of whom are already published writers, and to coordinate the many functions and responsibilities of his office. In his own writing, Samperio's specialty is short fiction. He has published a dozen collections of stories, fiction, and tales, along with other books he defines as *relatos* (accounts) or *prosas breves* (brief narratives). Samperio attributes his style to two female progenitors, his mother and his paternal grandmother. He owes, he believes, his use of language to his mother, Rosa Gómez, "widow of Samperio," who was born in the Distrito Federal (D.F.) of the twenties. "Despite the implacable correctness of the style that dominates literary writing," Samperio says in one of his prologues, "I have conserved and protected my *defeño* [D.F.] language." The grandmother, a native of Veracruz, influenced Samperio less in style than in an attitude toward life. He describes Doña Clarita as a devilish, gossipy woman who loved jokes and who was given to exaggerated and risqué language. "Who could ever have imagined," Samperio questions, "that at the heart of my scrib-

blings I would find the speech and the roguishness of two women providing the intersection between language and structure that informs all my writing." That writing tends toward the surreal and the metaphorical, the phantasmal and the mysterious, as seen in a typical fiction, "El hombre de negro" ("The Man in Black").

> "A man wrapped up to his nose in a black cape, with an emotion buried deep in his chest like a stake, surreptitiously violates the wall of time in which he existed and the concrete wall of an office building. Dramatically, mysteriously, he ascends the service stairs. If he hears a sound, he stops, places his right hand on the hilt of his sword, and waits for the danger to pass. He continues upward, while in his head echoes a silvery song—"You, Only You"—whispered by crepuscular voices. He reaches a peculiar floor; he knows which direction he must take. He penetrates the farthest room, where a woman's scent is so strong he recognizes it the moment he steps inside. He breathes deeply, to bring to his memory the presence that is at that moment but silence and shadow, enduring but transfigured time.
>
> The Man in Black places his hand beneath the long cape, rummages about in his chest as if uprooting a torment, and pulls out a luminously yellow flower he has snipped from time, a flower perhaps grown in a garden north of San Marino. He places the flower in a terra-cotta vase, and leaves.[1]

At the same time that Samperio delights in the conceit—perhaps a few lines dedicated to the fiery wedding of two *cerillos* (matchbox matches) or the tale of a young girl who "began one day to be green, and then was green both inside and outside"—he is also the astute portraitist of the city of his birth. In his youth, Samperio experienced difficulty in accepting his origins as he described in the introduction to *Gente de la ciudad:*

I hated the D.F., the way people spoke. I could scarcely face the fact that I was a *chilango* [slang for a native of Mexico City], and until I was thirty or so, I found it difficult even to admit I had been born there. . . . Deep inside, I felt I must be some kind of extraterrestrial. And though I did not consider myself a Federal Districter [*distrito-federalense*]—even the words sounded horrible— neither could I recognize myself as a Mexican, even less a Latin American, and certainly not European, despite my great-grandfather from Santander, Spain. Finally, though, I came to feel that the Capital truly was my home. I became fond of my concrete, if not my soil. My apathy became interest and my objections, concerns.

That interest and concern have taken concrete form in one of Samperio's most recent publications, *Gente de la ciudad* ("People of the City"). In this collection of impressionistic portraits and landscapes accompanied by his own drawings, Samperio focuses on shopkeepers, barbers, taxi drivers, the homeless, servants, seductive women, drunks—examples of the inexhaustible potential of twenty million real and fictional stories. In a triptych, *"Sueños del temblor"* ("Earthquake Dreams"), Samperio delves into his own consciousness to paint the hovering fear that haunts every citizen of this ancient city that has survived centuries of glory and adversity.

The walls were bulging outward, windows shattering: the monstrous convulsion of death. It could have been the house on Astrónomos, especially because of all the glass. The explosion of wall and windows happened without warning, just as I was walking past them. I saw everything through a haze. I could not comprehend the source of the explosion: perhaps deep in my subconscious I supposed it was a bomb. Suddenly there was a woman beside me, probably Blanca—she is the most likely, if not the most appropriate. Just at the moment I protected her with my body, I knew that the pieces of the house flying toward us were one of the faces of the earthquake.

I am the survivor of a major earthquake. I wanted to go outside, but a precipice yawns right before the open door, crisscrossed by a multitude of pipes, cables, and steel reinforcing rods. Groups of men were working at different levels of the gaping hole, like trapeze artists or speleologists. People—perhaps beside themselves—were blaming the disaster on construction workers. A sense of foreboding, of the stirring of repressive forces, hung in the air. I may have been living in a house in the Colonia Roma. I had to get out of there, go somewhere safe. Hugging the walls of houses, edging along the precipice, I reached the street corner. There I climbed down, clinging to the twisted metal, until I reached a dangling rope. I grabbed it and swung to the opposite wall. I struggled back up to the street through a tangle of metal and steel rods. I walked several blocks through the nearly total devastation of my city. Clusters of people were engaged in animated conversation, surrendered to a kind of resigned fatalism. Suddenly I found

myself in the midst of a street party, talking with several friends. We were drinking and listening to a portable radio when soldiers arrived and told us it was forbidden to drink alcoholic beverages in a public place. Someone stepped away from the group and spoke out:

"Don't you realize what is happening? At least you ought to allow people to get drunk. Or would you rather we were all dead?"

This must have happened in a public parking garage, or a tall government building. I was with a large number of people who had gathered on the flat roof, waiting to be rescued. The floor of the roof was too unstable to walk on; any movement could have been fatal. We had already seen several people fall through. Finally someone discovered a way to climb down to the street. We all line up at the edge of the roof. Just as I am about to climb over the edge, I see my daughter in the middle of the flat roof; my mother is walking toward her. I feel a paralyzing apprehension; a number of the survivors look from woman to girl, girl to woman. Now, with absolute panic, I realize that my mother, once she has picked up my daughter, is *trying* to fall through, stamping hard on different sections of the roof. I think she must be mad, and wants to die. Without really thinking, but moving with caution, I rush toward them. I strike my mother with my fist and, before she drops, take her in my arms and start back toward the ledge of the roof. To my surprise, as I support them, the floor of the roof supports me. We rejoin those preparing to climb down to the street.

21. Four pots by Dolores Porras

LUIS GARCIA BLANCO

MARIA ROJAS DE GARCIA

IRMA GARCIA BLANCO

DOLORES PORRAS

ADELINA MALDONADO*

Santa María Atzompa, Oaxaca

Few peoples have utilized clay with such variety and beauty as the Indians native to Mexico. Most observers are properly appreciative of the pre-Columbian treasures that enrich museums around the world, the everyday vessels and ceremonial figures and utensils that take our breath as we stroll past artfully lighted museum cases. We are less cognizant, however, of treasures being crafted today by descendants of those anonymous artisans. In Mexico, in 1992, five hundred years after the Old World was first exposed to the timeless craft of pre-Columbian potters, contemporary masters are molding, shaping, painting, and ornamenting works that will be the museum pieces of future generations.

Mexican pottery can be classified by village—Miriam Harvey identifies eighty-six discrete groups of potters—in the same way that an individual's home territory can be recognized by the shape of a man's straw hat or by the embroidery or weaving on a woman's blouse. Among the most famous types of Mexican pottery are the Talavera ware of Puebla, typically tiles and tableware revealing Spanish-Moorish influence; the intricate

cross-hatching and painstakingly repeated motifs of Tonalá; the dark green pineapple ornamental constructions of Michoacán; the Guerrero flora and fauna decoration now familiar on amate bark paintings; and the two best-known types of Oaxaca pottery, the green-glaze pieces of Santa María Atzompa and the black pottery for which Rosa Real de Nieto, simply known as Doña Rosa, was so justly renowned. After Doña Rosa's death, Teodora Blanco Núñez emerged as Oaxaca's premier potter; she developed a style of ornamenting unglazed pottery alternately called *pastillaje* or *bordado* ("embroidery"). When Doña Teodora died, two of her children, Luis García Blanco and Irma García Blanco, continued, with individual variations, the tradition of their mother's whimsical and captivating creations. Two other women of the village of Santa María Atzompa have also earned reputations as master artisans: Dolores Porras, who is known for her glazed polychrome ware, and Adelina Maldonado, who creates stunning terra-cotta pieces decorated with applied motifs. A strange note: none of these contemporary artisans has chosen to work in the Doña Rosa black pottery tradition.

The Blancos are totally dedicated to potting:

*Adelina Maldonado died an untimely death in the last weeks of 1990.

117

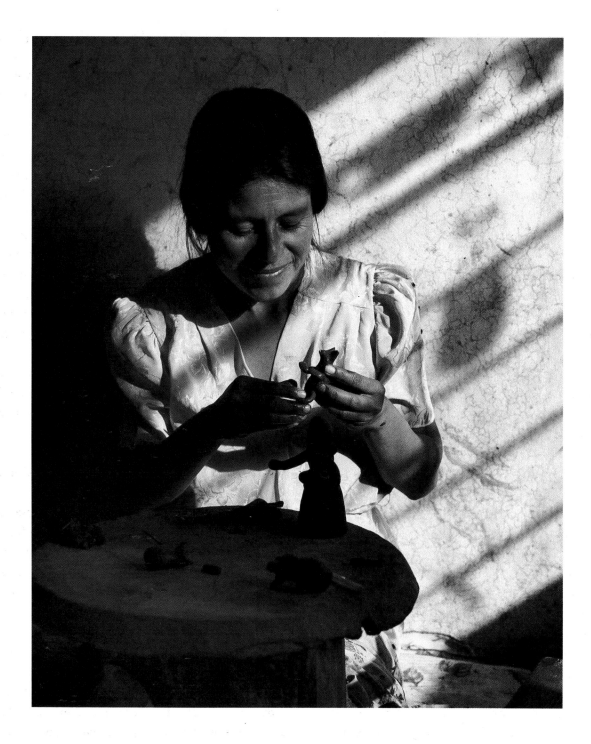

21a. Irma García Blanco

Luis, Irma, Luis's wife, a brother-in-law, their apprenticing children; only Irma's husband, who works in Mexico City, is excepted. A small industry has sprung up from the signature "monas" and other figures born of Doña Teodora's inventive mind. When we visit the two Blanco households, everyone mentions the last piece Doña Teodora worked on before her death on December 23, 1980, the day of a major Oaxaca festival, the Day of the Radishes, the day when radishes of all sizes and shapes are used to construct an astounding variety of fanciful forms. The pottery piece to which we are finally led is itself the epitome of fancy. It is an extremely large mona, the female figure with a bell-shaped skirt that was raised to an art form by Doña Teodora. It stands in one of the concrete-floored open areas in which the Blancos work, an icon in a barren sanctum. This mona is typical of Doña Teodora's style, yet subtly different. The "embroidery" for which she was known—the applied flowers, leaves, grapes, and garlands—has been flattened and affixed in such a consistent pattern that the body of the mona seems to be covered with lace. The mona, typically, holds a small animal in each arm: here, two sheep, perhaps the lambs of God. The figure's hands, however, are not typical; these fingers are individually shaped rather than scribed by scratches of a thorn on a closed fan-shaped hand. This mona has the characteristic, slightly slanted, Doña Teodora eyes and the eyelashes made with the thorn scribe. The familiar *arracadas*, pendant earrings, have taken on a life of their own: along with a cascade of flowers, they fill the unusually long space between ear and shoulder with spills of intricate texture. The face of this mona is surprisingly fine-featured, and strangely contained—like a nun in her wimple—within an open, toothed bird beak. The figure carries an unadorned *apaxtle*, or small earthen vessel, on her head. Doña Teodora died without completing this masterwork.

Irma García Blanco, Doña Teodora's daughter, has continued and enlarged upon her mother's style. Like her brother, she makes clay nativity pieces—manger scenes and the three kings—in the tradition of the large-nosed, blank-faced wood carvings found in the markets. Two recent significant pieces, variations on the mona theme, are distinctively Irma's. One is a male figure with beard and heavy eyebrows; in the place of Doña Teodora's flowers and fruit, it sprouts small individual figures, many of which resonate richly with pre-Columbian sculpture. This creation is crowned with an exuberant headdress of gods and animals. A slightly smaller piece slips toward the macabre. The masculine face has been transmuted into a skull; the tiny figures that cover the body are skeleton musicians. The piece is obviously inspired by the Day of the Dead. Irma García Blanco's work incorporates her mother's teaching but, at the same time, has "advanced" farther into the past than that of her mother.

More faithful to his mother's style, Luis García Blanco and his wife, María Rojas de García, have also developed a specialty: figures for specific holidays and series of miniatures from the Mexican tradition of fantasy bands (animals or skeleton figures playing a variety of musical instruments). The fame of the Blanco family is firmly established. Luis and María work largely on commission.

Questioner Are these large pieces for special clients?

L.G.B. Yes. A person comes from a *tienda*, a store, and selects what he wants. I sell to many different persons from many different countries. My mother was very famous, and many people come here to buy pieces. Now we are making the big sets for next Christmas.

Q. These, then, are for Christmas—the three kings.

L.G.B. And I make many pieces for the Day of the Dead, many different conceptions. I make a lot of

119

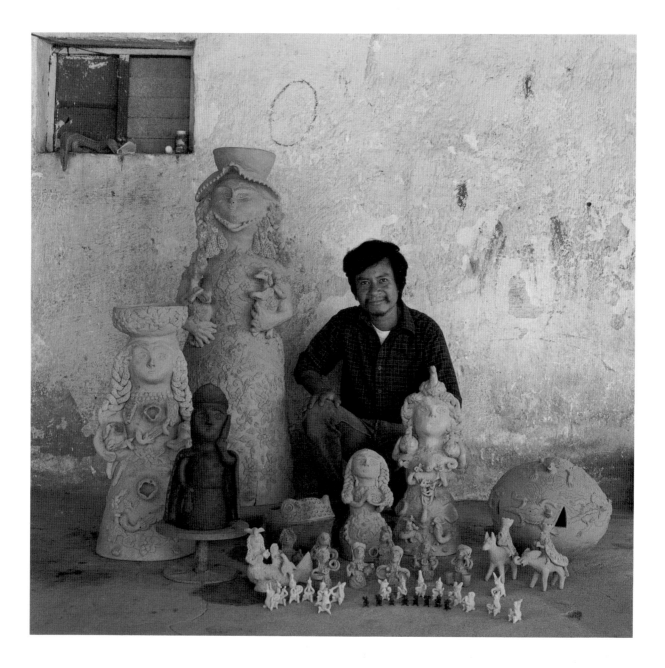

21b. Luis García Blanco

these. One man from Chicago, who works for a museum, bought eleven of these sets. This is a baby, this is a priest with a book, and this is a demon.

Q. But the demon is smiling, and he's larger than the priest.

L.G.B. Yes, exactly.

Q. When do you paint your work? There's a piece in the other room that's painted, but none of these.

L.G.B. When I have orders, I paint them. Otherwise, I use only natural colors.

Q. This round piece with the frogs—are the holes for a specific purpose?

L.G.B. No. We get different ideas. One person used it for a lamp. I've also been decorating platters for making tortillas, with flowers. A lot of tourists come to Oaxaca just to see the potters. When my mother began working with all these figures, she was not sure why she began to make her monas. But the Chalalac Sor told her, "I need some monas." My mother thought and thought, and said, "How can I make monas?" because no one here was doing that. But she started, and before long American tourists were coming here with their cameras. And after a while she decided no cameras, but she kept making her monas.

Q. And now you continue that, you and children. That's many generations, isn't it?

L.G.B. Yes, many generations.

Dolores Porras's mother was also a potter. She was not famous, however, like Doña Teodora; she made pieces referred to as corriente: everyday articles for eating and cooking, for *mole* and *chocolate* and *café*. Dolores herself began working in clay when she was about thirteen (she is now fifty-three). Like many of the artisans of these regions—a good example being the master carver Manuel Jiménez Ramírez—she takes pride in being self-taught. Porras exhibits a slight suspicion when we arrive at her brightly colored home,

gleaming like a large turquoise set in the ocher dust of Oaxaca and surrounded by a mosaic of tumbled pots of every description. Her reluctance seems not so much directed to the outsiders who will spread her fame as to the distraction from her work. While the camera is being set up, Doña Dolores carries on a lively conversation with the local potter and teacher who is accompanying us, asking about the señoritas who have come to talk with her and photograph her; justifiably, she complains about the man who had appeared the year before and taken many photographs (and time) and then left, never to be heard from again. When she is satisfied that ours is a legitimate undertaking that will result in concrete evidence of the worth of her craft, she is friendly and cooperative. She is happy to discuss questions of technique and clays and slips with her local colleague and with the North American potter who is acting as photography assistant on this trip to Oaxaca. As she warms to the discussion, she often giggles, and her eyes twinkle. She is proud of having been invited to work in a museum in Santa Fe, where her husband built a kiln for her and she worked in a combined demonstration and exhibition. In contrast to the members of the Blanco family and Adelina Maldonado, Porras has made her reputation with the green-glaze pieces for which Santa María Atzompa is known throughout Mexico and, especially, her polychrome ware.

Adelina Maldonado was not at home when we arrived. An assistant helpfully filled in, following from the beginnings the process of elaboration of one of her huge pots. We were shown the two clays with which she works, *primero* and *segundo*. Clay is brought to her workshop by truck and burro from San Lorenzo Cacaotepec, after which it must be worked by hands and feet to refine and purify it. "If a tiny stone remains," our tutor explains, "the piece will shatter when it is fired." In

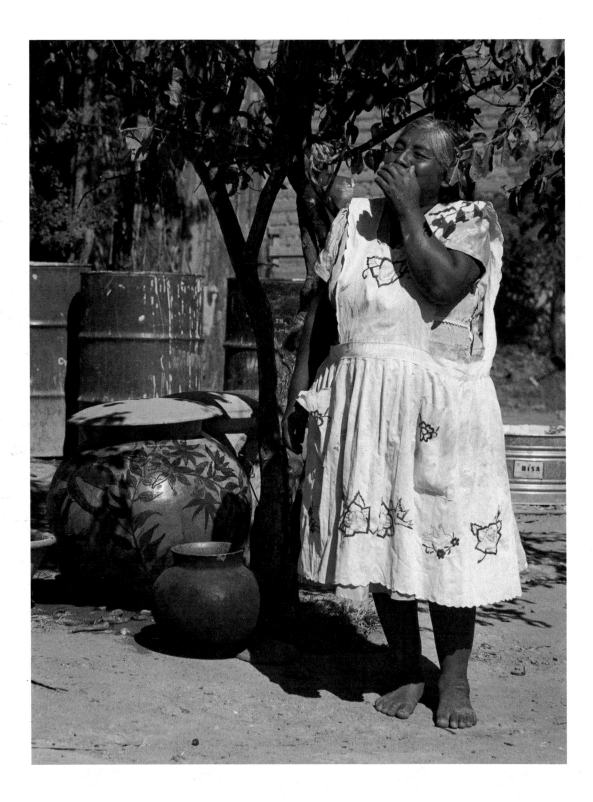

21c. Dolores Porras

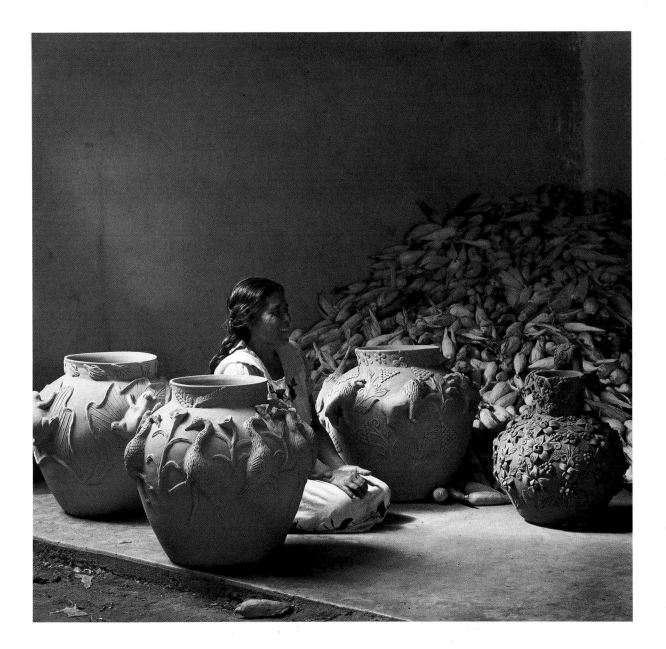

21d. Adelina Maldonado

this household, contrary to procedures in, say, the state of Guerrero, it is the man who prepares the clay and the woman who executes the designs. "And with time," our helpful guide Domingo adds, "they teach their arts to their children." The pots usually are formed in molds, not thrown or constructed by other methods. It is in the ornamentation of the pots that Doña Adelina expresses her creativity.

In one of the courtyards we see baskets of small finished pieces: candelabra and ash trays in the green glaze we also saw in the workshop of Dolores Porras. A discussion follows among the potters on the painting and firing processes required to produce that distinctive glaze. As soon as Doña Adelina arrives, however, we are led directly to her own masterpieces, which depend on sculptured and inscribed ornamentation.

Q. How long does it take to decorate one of these pots?

A.M. Sometimes I do one in a day.

Q. A day!

A.M. Yes, from three in the morning to nine at night.

Q. That's quite a day. Is this clay (referring to the cameolike shield affixed to a huge terra-cotta tub) different from the clay of the vessel?

A.M. No, it's the same.

Q. And is the head modeled on—

A.M. It is my daughter.

The family resemblance is clear. Doña Adelina has a gift for realism in addition to the flair for fantasy revealed on pots in an adjacent area of the courtyard, displayed before an enormous mound of ears of corn. One pot is encrusted with the *bordado* that Doña Teodora made famous: five-petaled flowers, tendrils, and grapelike clusters. Maldonado's individual gifts, however, are most evident on pots of less ornate concept but equally stunning effect: repeated frogs on lily pads; dancing cranes bracketing single calla lilies; majestically marching lions, teeth bared in roaring encounter; and nesting turtledoves perched on stylized grapevines and attending to three chicks with mouths agape.

Simplicity, artistry, enchantment. We thank this artist in a flower-embroidered apron and return to our hotel. Doña Adelina's smile reflects her joy in her work, a joy that endures in the art of her inspired creations.

OCTAVIO PAZ

Mexico City, D.F. · 1914

Octavio Paz is certainly the greatest living poet of the Spanish language. The corpus of Paz's poetic creation has grown simultaneously in several directions. First, as an inner renewal of the Spanish language, then as an outward connection of our renewed language with that of the world.

CARLOS FUENTES

Few critics would dispute Carlos Fuentes's assessment of Paz. Latin America's most recent and Mexico's first Nobel laureate in literature, Octavio Paz has a fame in Mexico and Latin America that a North American can appreciate only by equating it to the celebrity we accord entertainers, politicians, and sports heroes. That a literary figure can enjoy such prominence, such universal recognition, demands of a North American a learning process in cultural attitudes. Poetry, literature in general, is deeply embedded in Latin American culture. It is not strange or esoteric to be a poet. Latins agree that poets have things to tell us (though as Latins have no exclusive claim to beatitude, they do not always listen). Poets are often Latin America's radicals. When Pablo Neruda returned to Chile after years of exile, eighty thousand fans filled the Santiago soccer stadium to hear him read from his poems. The political euphoria that flowed from the early years of the Cuban revolution are inextricably bound to the phenomenon of the Boom, that explosion of Latin American literature that made Latin American names recognizable even to North American readers: Jorge Luis Borges, Gabriel García Márquez, Mario Vargas Llosa (who in 1990 was a candidate for the presidency of Peru), Pablo Neruda, Carlos Fuentes, and others. Latin American nations traditionally reward their writers with diplomatic posts. Carlos Fuentes and Octavio Paz both were ambassadors (in Paris and New Delhi, respectively), until Paz resigned to protest the events of the 1968 student uprisings in Mexico, and ten years later Fuentes resigned over the ambassadorial appointment of a particularly disliked former president of Mexico. The acts and words and convictions of poets do have import in a Latin American society. Paz's increasingly conservative posture has in recent years earned him enmity from the more leftist segments of the Mexican political spectrum. Whatever one's reaction to that, the point here is that the Mexican people care about a poet's beliefs.

People think of Paz as a poet. It must be noted that he is also an essayist and critic. His writing in

125

22. Octavio Paz with Aztec sunstone.

Photo of Paz: Jorge Claro Léon.

Collage and sunstone photo: Carole

Patterson.

those areas is so important that he would be considered a major Mexican author had he never written a line of poetry. The combination of his accomplishments is formidable. In 1987, New Directions published *The Collected Poems of Octavio Paz, 1957–1987*, a remarkable undertaking and an honor still not granted such poets as Mallarmé, Apollinaire, Rilke, García Lorca, or Montale. Most of the translations of those poems, from the mature period of Paz's writing, are the work of Eliot Weinberger, who in recent years has been the principal translator of Paz's poetry. Paz had published poetry for twenty-six years before the appearance of *Piedra de sol* (*Sunstone*) in 1957. It was this poem, however, along with the collection of essays entitled *El labyrinto de la soledad* (*The Labyrinth of Solitude*), that established Paz as a major international literary figure, and it is *Sunstone* that opens that monumental presentation of Paz's poems in English translation.

Can one approach *The Collected Poems* without expressing awe?* Awe before the spectrum of tenderness and rage, quest and questioning, hope and hopelessness, vision and despair, that flow from the pen of Octavio Paz? Awe before the dedication and sensibility of Eliot Weinberger and other translators who prodigiously recreate this poetry in English? Awe in the presence of the richness and abundance of the poems produced during the three decades represented in this collection? We must not forget that during this period Paz also published twenty-five works of prose. Some are slender (but always dense), like the provocative comment on translation *Traducción: literatura y literalidad* ("Translation: The Literary and the Literal," 1971) and the empathetic studies of Marcel Duchamp and the Mexican Xavier Villaurrutia. Many, however, are major, and lengthy, critical

* This discussion has appeared in similar form in *Sagetrieb* 7, 2(Fall 1988): 145–153.

statements, among them a significant treatise on the philosophy of poetry, *Las peras del olmo*("Pears from the Elm Tree," 1957); commentaries on literary figures and movements, such as *Los hijos del lima: del romanticismo a la vanguardia* ("Children of the Mire: Poetry from Romanticism to the Avant-garde); and his most recent prose work, the monumental study of the time, life, and work of a seventeenth-century Mexican nun, *Sor Juana Inés de la Cruz o Las trampas de la fe* (*Sor Juana Inés de la Cruz; or, The Traps of Faith*). We state our bedazzlement at the outset, to exorcise it, to clear our eyes for an unprejudiced look at thirty years of the poetry of—there is no other way to say it, prejudiced or not—Latin America's greatest living poet.

Reading the masses of criticism written on Paz's work, we wonder whether anything can have been left unsaid. Intelligently, thoughtfully, sensitively, critics have examined Paz's increasing reliance on paradox, the steadily disappearing punctuation, the experimentation with placement of words on the page (the former contributing to ambiguity while, paradoxically, the latter drives the reading of the poem, reducing ambiguity). His poetry has been described as "reality in flux," as a "palimpsest of time and space," and as the effort to bridge the gap between the ancient "rupture of world and word." Essayists have pointed out Paz's fascination with Eastern thought, his Hegelian fusion of thesis and antithesis into synthesis, his consuming sense of the indigenous past in his own and his nation's present.

The universalism of Paz's interests, the reach of his mind, is apparent in the names that appear in *Collected Poems*. Poems explore the visual world of such artists as Joan Miró, Robert Rauschenberg, Joseph Cornell, Roberto Matta, and Manuel Alvarez Bravo; pay tribute to writers from the Spanish tradition—both contemporary and historical —Quevedo and Cervantes, García Lorca, Carlos Fuentes and José Emilio Pacheco; and reveal his

relationship to other artists both closer and far-ther away: Basho, Mallarmé, John Cage. . . .

Collected Poems begins with *Sunstone,* in a new translation by Weinberger. The poem consists of 584 lines, recreating the 584 days of the Aztec calendar; it begins and ends with the same six lines, wheeling eternally through time and space like the large hieroglyphic-carved, circular stone that is its structural metaphor:

> a crystal willow, a poplar of water
>
> a tall fountain the wind arches over,
>
> a tree deep-rooted yet dancing still,
>
> a course of a river that turns, moves on,
>
> doubles back, and comes full circle,
>
> forever arriving.

This "song of never-ending beginning" leads to *Days and Occasions,* then, to use Paz's own words, to the "transfiguration and disfiguration" of the formal poetry of *Homage and Desecration* based on a Quevedo sonnet, through the transitional poetry of *Salamander* and the brief *Solo for Two Voices* to *East Slope,* a major collection resulting from Paz's love affair with the East. This poetry inspired by Paz's travels continues through *Toward the Beginning,* through the mandala-poem *Blanco* and the con-crete *Topoems* (poems that form a visual as well as semantic impression), and reaches a natural and inevitable culmination in *Return,* arguably the most bitter of Paz's books, in which even expres-sion is ossified, nature is obscene, and human be-ings are mutilated.

Obsession and rage yield to confession and in-trospection in the autobiographical *A Draft of Shadows,* a long poem in quest of self-identity. With the exception of the brief collaborative *Air-born,* written with Charles Tomlinson, there is a hiatus of thirteen years between that long, very personal poem and Paz's most recent book of po-etry, *A Tree Within* (1987). That time span is re-flected in the variety of forms and themes of the poems, translations of Indian and Oriental poets, the prose poems of "Scenic Views," homages, epi-taphs and mortuary diptychs, landscapes—real and surreal—and love poems. In spite of thematic and formal disparity, the collection is unified by an underlying current of love, not merely Paz's eternal "grounding" in the female, but explicit tribute to his wife, Marie José. This obeisance can be traced from the brief title poem—"A tree grew inside my head / Your glance sets it on fire"—to the coda of the concluding "Letter of Testimony."

Paz is not alone, of course, in writing from the "tree" that grows inside his head. We live in an age of self-centeredness and self-examination. Our lit-erary modes are characterized by tricks and truths of self-referentiality—stories about story-telling, novels about novelizing. If this self-consciousness can be seen as the mark of our cen-tury, Paz will certainly be one of the supreme representations of the age, for never has a poet been more conscious of his being-in-writing. Through the ages, poets have written to extol beauty, to express emotion, to explore thought, to experience experience. Paz's poems are all these things, and more. But principally, obsessively, Paz writes to insure and assure his being; he writes to avoid the void. Words are "sign seeds"; each letter "is a germ." A seed "explodes in the air with a burst of syllables."

Blanco, Paz's second major long poem, was pub-lished in 1967. It is the sister peak to *Sunstone,* rising above the snowcapped sierra of Paz's sixty years of writing poetry. Paz himself describes *Blanco* (which, among several translations, can mean "white," "blank," and "target") as a mandala. The central poem is interrupted and surrounded by the four movements of poems on love and sensation, which are interjected on every fourth leaf of the text (the original publication unfolds in one long accordion-pleated strip of paper; the last

leaf can be joined to the first to create, as in *Sunstone*, a circular poem). A poem about the *logos*, the word, occupies the center of the mandala, and the four elements of water, fire, earth, and air act as a unifying force; four colors (yellow, red, green, and blue) represent different stages of the word. And, finally, the typeface and graphics lead the reader back to the beginning of the poem. Woman is as central to *Blanco* as the word; perhaps the best reading of the poem is to consider it a diagram of the triad woman-word-world. Woman is the cleft in which the seed of the word is deposited and takes root. Being is word, and woman is the vehicle for that being.

It would be a grave disservice to Paz, and to Mexican literature, to leave the impression that Paz's poetry totally overshadows his prose. Paz's *Peras del olmo* and *The Bow and the Lyre* are brilliant musings on the poetic process. In his study on Sor Juana Inés de la Cruz, he accomplishes three principal goals: a reconsideration and revision of the history of Nueva España, that is, colonial Mexico; his reading of the biography of Sor Juana (a "reading," because factual information is extremely limited); and a penetrating analysis of Sor Juana's writings. At the time of the publication of the English version in 1988, John Kenneth Galbraith wrote, "No one uses language, and here history, so to enrich knowledge and enlarge imagination as does Octavio Paz. The proof is in this wonderfully compelling book."

The Labyrinth of Solitude, published in 1950, remains the single most informative, most insightful, most beautifully written book on *mexicanidad*—what it is to be Mexican. The last chapter, "The Dialectic of Solitude," goes beyond the specifically Mexican condition to set forth Paz's views on the reasons for contemporary man's sense of isolation and his hopes that man will be allowed to return to dream and myth.

The feeling of solitude, which is a nostalgic longing for the body from which we were cast out, is a longing for a place. According to an ancient belief, held by virtually all peoples, that place is the center of the world, the navel of the universe. Sometimes it is identified with paradise, and both of these with the group's real or mythical place of origin. Among the Aztecs, the dead returned to Mictlán, a place situated in the north, from which they had emigrated. Almost all the rites connected with the founding of cities or houses allude to a search for that holy center from which we were driven out. The great sanctuaries—Rome, Jerusalem, Mecca—are at the center of the world, or symbolize and prefigure it. Pilgrimages to these sanctuaries are ritual repetitions of what each group did in the mythical past before establishing itself in the promised land. The custom of circling a house or city before entering it has the same origin.

The myth of the labyrinth pertains to this set of beliefs. Several related ideas make the labyrinth one of the most fertile and meaningful mythical symbols: the talisman or other object, capable of restoring health or freedom to the people, at the center of a sacred area; the hero or saint who, after doing penance and performing the rites of expiation, enters the labyrinth or enchanted palace; and the hero's return either to save or redeem his city or to found a new one. In the Perseus myth the mystical elements are

almost invisible, but in that of the Holy Grail asceticism and mysticism are closely related: sin, which causes sterility in the lands and subjects of the Fisher King; purification rites; spiritual combat; and, finally, grace—that is, communion.

We have been expelled from the center of the world and are condemned to search for it through jungles and deserts or in the underground mazes of the labyrinth. Also, there was a time when time was not succession and transition, but rather the perpetual source of a fixed present in which all times, past and future, were contained. When man was exiled from that eternity in which all times were one, he entered chronometric time and became a prisoner of the clock and the calendar. As soon as time was divided up into yesterday, today and tomorrow, into hours, minutes and seconds, man ceased to be one with time, ceased to coincide with the flow of reality. When one says, "at this moment," the moment has already passed. These spatial measurements of time separate man from reality—which is a continuous present—and turn all the presences in which reality manifests itself, as Bergson said, into phantasms.

If we consider the nature of these two opposing ideas, it becomes clear that chronometric time is a homogeneous succession lacking all particularity. It is always the same, always indifferent to pleasure or pain. Mythological time, on the other hand, is impregnated with all the particulars of our lives: it is as long as eternity or as short as a breath, ominous or propitious, fecund or sterile. This idea allows for the existence of a number of varying times. Life and time coalesce to form a single whole, an indivisible unity. To the Aztecs, time was associated with space, and each day with one of the cardinal points. The same can be said of any religious calendar. A fiesta is more than a date or anniversary. It does not celebrate an event: it *reproduces* it. Chronometric time is destroyed and the eternal present—for a brief but immeasurable period—is reinstated. The fiesta becomes the creator of time; repetition becomes conception. The golden age returns. Whenever the priest officiates in the Mystery of the Holy Mass, Christ descends to the here and now, giving himself to man and saving the world. The true believers, as Kierkegaard wished, are "contemporaries of Jesus." And myths and religious fiestas are not the only ways in which the present can interrupt succession. Love and poetry also offer us a brief revelation of this original time. Juan Ramón Jiménez wrote: "More time is not more eternity," referring to the eternity of the poetic instant. Unquestionably the conception of time as a fixed present and as pure actuality is more ancient than that of chronometric time, which is not an immediate apprehension of the flow of reality but is instead a rationalization of its passing.

This dichotomy is expressed in the opposition between history and myth or be-

tween history and poetry. In myth—as in religious fiestas or children's stories—time has no dates: "Once upon a time. . . " "In the days when animals could talk. . . " "In the beginning. . . " And that beginning, which is not such-and-such a year or day, contains all beginnings and ushers us into living time where everything truly begins every instant. Through ritual, which realizes and reproduces a mythical account, and also through poetry and fairy tales, man gains access to a world in which opposites are reconciled and united. As Van der Leeuw said, "all rituals have the property of taking place in the now, at this very instant." Every poem we read is a re-creation, that is a ceremonial ritual, a fiesta.

The theater and the epic are also fiestas. In theatrical performances and in the reciting of poetry, ordinary time ceases to operate and is replaced by original time. Thanks to participation, this mythical time—father of all the times that mask reality—coincides with our inner, subjective time. Man, the prisoner of succession, breaks out of his invisible jail and enters living time: his subjective life becomes identical with exterior time, because this has ceased to be a spatial measurement and has changed into a source, a spring, in the absolute present, endlessly re-creating itself. Myths and fiestas, whether secular or religious, permit man to emerge from his solitude and become one with creation. Therefore myth—disguised, obscure, hidden—reappears in almost all our acts and intervenes decisively in our history: it opens the doors of communion.

Contemporary man has rationalized the myths, but he has not been able to destroy them. Many of our scientific truths, like the majority of our moral, political and philosophical conceptions, are only new ways of expressing tendencies that were embodied earlier in mythical forms. The rational language of our day can barely hide the ancient myths behind it. Utopias—especially modern political utopias (despite their rationalistic disguises)—are violently concentrated expressions of the tendency that causes every society to imagine a golden age from which the social group was exiled and to which man will return on the Day of Days. Modern fiestas—political meetings, parades, demonstrations and other ritual acts—prefigure the advent of that day of redemption. Everyone hopes society will return to its original freedom, and man to his primitive purity. Then time will cease to torment us with doubts, with the necessity of choosing between good and evil, the just and the unjust, the real and the imaginary. The kingdom of the fixed present, of perpetual communion, will be re-established. Reality will tear off its masks, and at last we will be able to know both it and our fellow men.

Every moribund or sterile society attempts to save itself by creating a redemption myth which is also a fertility myth, a creation myth. Solitude and sin are resolved in

communion and fertility. The society we live in today has also created its myth. The sterility of the bourgeois world will end in suicide or a new form of creative participation. This is the "theme of our times," in Ortega y Gasset's phrase; it is the substance of our dreams and the meaning of our acts.

Modern man likes to pretend that his thinking is wide-awake. But this wide-awake thinking has led us into the mazes of a nightmare in which the torture chambers are endlessly repeated in the mirrors of reason. When we emerge, perhaps we will realize that we have been dreaming with our eyes open, and that the dreams of reason are intolerable. And then, perhaps, we will begin to dream once more with our eyes closed.

Paz has been the director of two literary journals in Mexico, *Plural*, in the seventies, and now *Vuelta*. Their pages have been the forum for literary polemics and political debates. Paz sees the two as inextricable. In June 1990, Paz was in Madrid for a series of lectures that he chose to focus on the politics of his country and of the world. "A great reform of the intellectual class, through self-appraisal, is imperative," Paz said. "The political thinker should reread the classics. Politicians should discover how useful it is to read poetry; they should recapture with their reading the truth of human passions."

"The present void is extremely dark" were Paz's words in summation, "but literature can alleviate the darkness."

LUIS ARTURO RAMOS

Minatitlán, Veracruz · 1947

> Este era un gato
> con los pies de trapo
> y los ojos al revés.
> ¿Quieres que te lo cuente otra vez?
>
> •
>
> There once was a cat
> whose green eyes turned back
> and rag toes turned in.
> Do you want me to tell it over again?

The murderer always returns to the scene of the crime, and to prove it, here am I, seventeen months after the death of Mr. Copeland, looking through the same window he used for his surveillance. Perhaps I am too young (although I've been told often enough I look like an old man) to understand the reason for his long vigils before the window, but I do know that when he looked out he recognized all the plazas and statues, the twisting, turning alleys, even the doves that so consumed his attention. It is impossible to know exactly what another person may have seen during his vigil. It would mean standing in the exact spot, looking from the identical height. Many times I watched him place his hands on the ledge of the recessed window and lean out in order to encompass a broader view. I saw him, sunk in his armchair, follow the day from one side of the window to the other, as if it were a small round object he could roll between his fingertips. Windows are closely related to memory, and I am sure that is what he was using them for. I cannot imagine any other reason. The panorama of rooftops and television antennas, the

23. Luis Arturo Ramos

wedges of green forced between the buildings by the trees, the blinding light off the sea, penetrate the windows of this hotel room to encapsulate the certainty that it was memory, and what memory clarified, that held Mr. Copeland in room 509 for the nearly three months he lived in the port at the time of his second disembarkation.

From here I can see the ocean. The curve that tenses and then slowly relaxes. And farther out, to the right, the deserted—or swarming, according to the hour or the temperature—seawall. . . Now it is I who wait, and while I am waiting I reconstruct the story, seventeen months after the murder, sixty-one years after his first disembarkation.[1]

Este era un gato ("There Once Was a Cat"), from which that scene is taken, won the 1988 Narrativa Colima prize for the best novel of the year. The broad acclaim the book received in Mexico was seconded in the 1989 Yearbook of the *Encyclopedia Britannica*: "The major novel of the year in Mexico was Luis Arturo Ramos's sixth book, *Este era un gato*, a subtle but accessible story set in Veracruz where a U.S. Marine returns years after having participated in the invasion of the city in 1914"—an invasion motivated by the arrest of American sailors in Tampico (and one Ramos saw continued in Nicaragua in the eighties). In that incursion, individual U.S. sharpshooters were assigned to clean out pockets of resistance in the city. In Ramos's novel, one of them, Roger Copeland, shot the brother of a young prostitute with whom he had fallen in love, "a woman with one smoky eye"; this woman, in turn, felt forced to avenge her brother's death by shooting Copeland. He survived and, sixty years later, returned to Veracruz to recover at least the sense, if not the subject, of his lost love. Around that character and those motifs (particularly, a world seen through a window, through a rifle sight, through a godlike eye) Ramos weaves and unweaves the stories of two young men of Veracruz, Bolaño and Miguel Angel, who through numerous retellings of events seek less to untangle the mysteries surrounding Copeland than to impose coherence

upon their own existence—and perhaps concoct the perfect narrative. The double meaning of the Spanish title cannot be transferred whole to English. To a Mexican reader, it is the familiar first line of a children's song that has no ending. At the same time, it is a story being reconstructed by the narrator Bolaño for the benefit of *este gato*, a cat-become-a-tiger, his friend Miguel Angel.

Luis Arturo Ramos is an intellectual, more than intuitive, writer. Not only does he approach his writing methodically—careful plot outline, clear sense of development, scrupulous rewriting—but he is also able, after the fact, to analyze his work with rare clarity. As we talk in March 1990, he reaffirms concepts previously stated in interviews at the time of the publication of his novel and reveals new insights into his general literary philosophy, as well as specific thoughts on this novel.
Questioner *Este era un gato* has a unique atmosphere. You can feel the humidity in the air, hear the sounds of the port.
L.A.R. I'm delighted to hear that.
Q. It also, for me, has the flavor, the tension, the tropical atmosphere, of a spy film of the thirties or forties.
L.A.R. It is a novel with three readings. One is the detective story, the suspense you refer to. The second has to do with a cosmic order; it's really a religious novel, too. And the third is political, outlining the apprenticeship of a young fascist.

This novel is essentially visual, seen from the perspective of a sharpshooter.

Q. Who waits and watches from his window.

L.A.R. And through his telescopic sight. That's like the view of the camera, right? I've just seen *Sex, Lies, and Videotape,* in which the camera is a character. In *Este era un gato* he's looking—the window is a lens. Everything is seen as if by a photographer or a film director. In fact, the window is to some degree the eye of God. I've always been fascinated by the Masonic symbol, the triangle containing the eye of God.

Q. Oh, the symbol on the U.S. dollar bill.

L.A.R. Masons see God as a great architect. The world is constructed as if it were the work of an architect, in mathematical and geometric terms. That's how I want my novels to work. The image of the eye in the triangle is like that of the telescopic sight—the all-seeing eye—that kills or lets live, because God kills.

Q. The novel, Luis Arturo, is so clearly a film.

L.A.R. Exactly. That's the idea. Everything I write is visual and cinematographic. But then I belong to an eminently visual generation, right? Our whole world is visual. I approach, I narrate, reality almost from the point of view of a camera—that external reality, long shots, close-ups—and this causes the syntax of my novel to be visual and cinematographic. But I also use the possibilities of literature: introspection and inner emotions.

Luis Arturo Ramos is a Veracruzano, a native of the state of Veracruz and a present resident of the city of Veracruz. He is editor-in-chief of the University of Veracruz Press, director of cultural activities for the university, and editor-in-chief of one of Mexico's finest literary journals, *La Palabra y el Hombre* ("Word and Man"). He published two novels before *Gato: Violeta-Perú,* a novel that takes place on the city bus traveling the route designated by its title, and *Intramuros* ("Within the Walls"), a story based on the wave of refugees that came to Mexico following the Spanish Civil War.

It is significant that both *Gato* and *Intramuros* are set in Veracruz, significant because novels about the provinces outside Mexico City tend to be about rural, not urban, subjects.

Q. I keep in mind, Luis Arturo, that the settings of your novels and short stories—three collections, isn't it?—are almost exclusively Veracruz—both the city and Minatitlán, the town where you were born. When we speak of Mexican literature, should we also speak of the Veracruzana literature (the way we think, for example, of Southern writing in the U.S.)? How do you think of yourself as a writer? As a Veracruzano? A Latin American? Mexican? All the above?

L.A.R. I think of literature as a set of Chinese boxes: a small box that is Veracruz, then a larger box that is Mexico, which fits inside Latin America, which in turn fits inside the world. The novel is, inescapably, a metaphor. So although I set my works in the port of Veracruz, they necessarily refer to Mexico and Latin America. Veracruz is, historically and symbolically, of great significance in the life of my country, of all Latin America. Veracruz was the first Spanish city. For almost five hundred years, Veracruz was the first impression new arrivals from Europe received of Mexico. For me, it may be even richer in history and symbolism than Mexico City. Also, Veracruz and Campeche were the only walled cities in a country that has a remarkably long coastline. The people of my country are generally inlanders, no? People of the mountains. Everything is concentrated in the center of the country.

Q. In this sense, I've always thought—especially in the arts—that Mexico is far more like France than it is the United States. Mexico City is like Paris. Everything is controlled from one city. That happens to a degree in New York, but not to this extent.

L.A.R. Yes, everything is concentrated here, at the farthest possible distance from the coast. And as a result the literary map of this country is still to be

drawn. When you speak of the city or of the urban novel, you think of novels set in Mexico City. And Veracruz and Guadalajara and Monterrey and Puebla and all the other cities are overlooked. We have to begin to write the story of this nation's geography.

Q. Another question, Luis Arturo, that inevitably arises in a discussion of Mexican and Latin American literature is that of magical realism. You know the story, of course, that García Márquez has said he could not find the voice of *One Hundred Years of Solitude* until he began writing it here in Mexico. One may have one's own ideas, but it is much more important to learn how Mexicans feel about this question. Once and for all, is it valid to apply the term "magical" to Mexican reality?

L.A.R. Mexican and Latin American reality is extremely complex; it is a reality that has synthesized time and space. At this moment, for example, sitting here in the Hotel Nikko, we could be in any hotel anywhere in the first world. The people you see are very sophisticated, very well educated; compare that to others of our peoples who live in an age of prehistory. Right now, at the close of the twentieth century, there are people in my country who still do not speak Spanish, who have no concept of nation, no concept either of nationality or Mexicanity. Anyone with a certain intelligence will realize that this means time and space have been erased. We are living one hundred years of the century—all the years of this century. I am not, I cannot be, living 1990; I am living 1890–1990. For me, that isn't magic. That's just reality.

Q. In so many ways, your past continues to be your present.

L.A.R. Contrasts are less marked in the United States.

Q. We have so little past by comparison. And we have suppressed the magic.

L.A.R. I don't know. I think your reality is very magic, very fantastic. Once I was riding from Kansas City to St. Louis on a Greyhound bus— now there is one of the last fantastic realities in the U.S., the Greyhound bus stations. It's a five-hour trip, and we were driving along and suddenly I saw a house coming down the highway—a *house*. And then later I saw a boat, a boat right in the middle of the meadows of the Midwest. I see a boat sailing down the highway. Now that can be very amazing.

Q. *(laughing)* I'd never thought of it; it's a familiar sight to me.

L.A.R. I think we all have a kind of blind eye for our own magic.

Q. Or make of it what we will.

And this is what we expect of the artists among us: to turn a seeing eye upon reality, to create, in fact, a new reality that would not exist were it not for their manner of seeing, a process Luis Arturo Ramos's narrator Bolaños describes in this paragraph from *Este era un gato*.

Although some believe that we have no right to disturb so much as a dewdrop, I knot the threads only to unravel them later. Serene, wrapped in the confidence of my responsibilities, I apply myself to the reconstruction of events with the assurance of a detective who facilitates the crime in order to congratulate himself later on the mathematical precision of his solution. With the threads I weave a design rich with meaning; later, with the same composure, I remove the warp. One by one I arrange the threads before me and take note of the unstable texture that creates a longing for the firmness that gave them life and direction. Memory dignifies, but when it evokes regret it is self-corrupting. The design grows dark, and muddy; it infects and contaminates everything it touches. That is what happened with Mr. Copeland, and that is exactly what I am going to explain to Miguel Angel when I see him walk through that door.

"Do you want me to tell it over again?"

24. Pedro Ramírez Vázquez

PEDRO RAMIREZ VAZQUEZ

Mexico City, D.F. · 1919

In the late sixties, travelers often carried tucked in a pocket Arthur Frommer's *Dollar-Wise Guide to Mexico* (in those long-gone days a double room at Mexico's premier hotel, El Presidente, ranged from $17.60 to $21.60, and an "expensive" entrée was $3.20). Thousands of tourists depended on Frommer to guide them to the best sights and entertainment. His comment on the then-new Museo Nacional de Antropología e Historia was significant: "By general consent, the world's finest museum is Mexico's new National Museum of Anthropology, which was built by the architect Pedro Ramírez Vázquez and a team of worthy helpers in 1964. If Sr. Ramírez never did another thing, he'd still deserve the fame of centuries." Sr. Ramírez has, it is scarcely necessary to comment, done other things, continuing to design major buildings in Mexico and around the world, but Frommer's contention remains essentially correct: to design a peerless building visited by millions is equivalent to creating one of the great epic poems or great symphonies that have lighted their creators' names through the centuries.

The National Museum of Anthropology is characterized by the handsome materials and the sense of great space that are the direct heritage of pre-Hispanic cultures. It is basically a large, two-story rectangle built around a 600-foot interior patio and situated on an eleven-acre site in Chapultepec Park. Ramírez Vázquez's design was based on the comfort and convenience of the museumgoer, as well as optimum display conditions for the museum's treasures. Unlike the more traditional chain of rooms found in most large museums, in the National Museum of Anthropology it is not possible to view more than two exhibition halls without returning to the long central patio. This arrangement allows the visitor to rest, or consult the guidebook, or select the exhibits that most interest him. The dominant interior architectural feature is a giant, aluminum umbrella overhang that covers half the space of the patio; the umbrella rests on a carved bronze shaft that is bathed in a continuous flow of water cascading onto black cantera paving and offering a cool retreat from the sun of the open patio. That uncovered space contains a large pool recalling the lacustrine origins of the peoples of the central Valley of Mexico; rectangles of papyruslike chinamitas create patterns of feathery green against the large paving stones of various tones of gray. The walls of the individual halls are principally glass, offering unobstructed views of the centuries-old ahuehuete trees of the surrounding

Chapultepec Park, and eight of the twelve archeological halls provide access to open-air displays of architectural features, such as a Maya temple, or of created habitats. After enjoying the beautifully displayed pre-Columbian pieces in the downstairs halls, it is easy to overlook the magnificent dioramas on the second floor of the museum, with their exact reproductions of the dwellings, implements, and clothing of a broad range of indigenous communities. These recreations of figures occupied in their daily chores are an unforgettable lesson in a way of life that has not suffered radical changes for hundreds of years. Outside the museum stands a massive, carved stone god that has become the popular symbol of the museum, Tlaloc, the rain god. Tlaloc was discovered in a cave near the ancient city of Teotihuacán. He was transported with all due ceremony from his cave, strapped recumbent atop truckbeds dwarfed by his massive weight, to his position on the grounds of the museum overlooking the constant stream of traffic that flows day and night along the Paseo de la Reforma. Tlaloc was moved during the winter dry season. To mark the occasion, he reasserted his antediluvian prerogatives by providing the city with an appropriate diluvial drenching.

In constructing this monument to Mexico's Indian heritage, Ramírez Vázquez called on the major artists of Mexico. Rufino Tamayo, for example, painted the large mural in the main vestibule; it depicts the struggle between good and evil as represented by Quetzalcoatl, the plumed serpent, the good god, and the evil god Tezcatlipoca, seen here as a red, black-spotted jaguar. The two creatures carry out their eternal struggle before a brilliant half-red, half-blue background representing the temporary victory each gains in the eternal cycle of day and night. Leonora Carrington also contributed a mural. Hers is an implicit reiteration, in her typically surreal vision, of that same cycle: forces rise from the depths of a dark underworld through the diaphanous haze of creation to the rosy red skies that are, in turn, threatened by the first wisps of apocalyptic clouds that will begin the whole cycle anew. Carrington's fantasy figures swim, flow, fly, through the golden mists of the central section of the canvas. Other murals distributed throughout the museum represent the birth of the corn god, a Rousseau-like pre-*Homo sapiens* jungle, and market and ceremonial scenes. Each of the halls is dazzling. The Mexica hall is considered to be the most important. It is there the visitor may see the Aztec calendar stone, or Sunstone, one of Mexico's most familiar symbols. With great skill and sensitivity, Ramírez Vázquez has quoted characteristics of pre-Columbian civilizations throughout the construction: the sweeping sense of ceremonial space evident in ruins from Teotihuacán to Monte Albán, the perforated wall that affords visual and physical continuity between interior and exterior spaces, the richly ornamented surface contrasted with the severe expanse of intricately fitted stone blocks, motifs such as latticed walls and iconographic details, and, everywhere, the warmth of handworked materials, a tradition of Mexican architecture from its beginnings and one made possible today only by Mexico's enormous available force of skilled craftsmen.

It is a long distance in scale from the proportions of the National Museum of Anthropology to the panorama of Mexican architecture that is taking shape in the gardens of Ramírez Vázquez's office and home in fashionable Pedregal de San Angel. There Mexican skill and artisanry are again called on, this time to create a collection of miniatures of the architectural jewels of Mexico's history that will be installed in a park in Tijuana, Mexico: the Cathedral of Tepoztlán, the famed marble Palacio de Bellas Artes, the observatory at Chichén-Itzá, the church of Santa Prisca in Taxco; and Tajín, the Temple of the Niches, in Veracruz. These exquisitely detailed miniatures

24a. Pedro Ramírez Vázquez, architect, the Umbrella (inner courtyard space) at the Museo de Antropología, Mexico City. Photo: Armando Salas Portugal.

of architectural masterpieces are complete down to tiny stained-glass windows and mosaic domes. In the course of an informative monologue on the techniques of crafting these marvels of miniaturization, Ramírez Vázquez pauses before the reproduction of the complex of Uxmal to point out a fascinating anomaly. "Here you can see a very important feature of pre-Hispanic architecture. It seems difficult to believe, but these decorative elements are prefabricated. Each unit is a facing independent of the stone of the building. This means that there had to be a preconceived design, a mass production of these components, and a methodical application. At the same time, in this piece, which is a mask, the upper part and the interior of the eye is one stone, the eye itself is

another, the nose yet another; yet if this piece falls, everything collapses. It is like a keystone. . . . Yes, they used mortar, but this construction tells us that the builders were able to estimate the weight of the upper portion to be borne by the section below. This was truly an architecture of prefabrication."

For fifteen years, Ramírez Vázquez taught classes in urban architecture, and he has been honored with the Jean Tschumi prize of the International Union of Architects "in acknowl-

141

edgment of a lifetime devoted to the formation of young architects." Related to his dedication to education, and among his most rewarding accomplishments, is the design of a prototypical rural school used throughout the Republic of Mexico, twenty Latin American nations, the Philippine Islands, Indonesia, India, and Yugoslavia. The prefabricated sections of this simple and efficient building are designed so that they can be transported to remote regions by donkey, even by canoe. The building can be assembled with ordinary tools and is intended to be finished in materials native to the site. To date, more than 200,000 of these schools have been constructed in Mexico. For the design, Ramírez Vázquez was awarded the Grand Prize of Honor at the Twelfth Triennial of Milan.

Some of Ramírez Vázquez's most interesting ideas are found in his investigation and analysis of the history of the urban settlement. His books are a storehouse of synthesized information; the ingenious use of color coding and graphs allows the reader to grasp at a glance the intricate permutations of the inception, development, and decay of urban centers around the world. To the ethnocentric North American of European ancestry, it is always a shock to be reminded of the age and the size of hemispheric cultures before the arrival in the New World of European explorers and settlers. Ramírez Vázquez, who is fond of diverting and instructive bits of information, recounts an interesting correlation his research has revealed: "The curve of the increase in world population, throughout the history of mankind, almost identically parallels the rising curve in the speed of transportation." If space travel becomes a commonplace, we agree, humans will need other planets to colonize.

Ramírez Vázquez counts among his major installations abroad the Museum of African Art in Dakar, Senegal; the Nubia Museum in Aswân, Egypt; the architectural design of the new capital of Tanzania; and the Mexican pavilions at three world's fairs—Seattle, Brussels, and New York. In Mexico, particularly Mexico City, his architectural legacy continues to grow. Among the projects in the city that he himself considers most enduring are the Museum of Modern Art in Chapultepec Park, the Aztec Soccer Stadium, the Japanese Embassy, the New Basilica of the Virgin of Guadalupe, and, the most recent major museum in this city of museums, the on-site exhibition space of the Templo Mayor, beside the Mexico City cathedral. The Templo Mayor of Tenochtitlán was the umbilical center of the Aztec universe. Its eventual discovery could have been predicted; it is common knowledge that the Spanish constructed their cathedrals and churches on or near the ruins of demolished indigenous temples. What was not known was the extent or the exact dimensions of this pre-Columbian ceremonial center, only that layers of ancient civilizations lay beneath the vast zócalo on which the Metropolitan Cathedral stands. The temple was in fact discovered by accident in 1978 when workmen digging trenches for electric cable unearthed the first artifact, a large round stone (less symmetrical than the Sunstone, found nearby in 1790), on which is carved the dismembered body of Coyolxauhqui, the sister of the Aztec god of war. The thousands of artifacts, more than seven thousand of which are dramatically displayed in the museum, are of unparalleled beauty and inestimable artistic and historic value; they include a mesmerizing wall of skulls and perfectly preserved statues of eagle warriors that rival the great stone warriors of China.

Arthur Frommer was correct: Ramírez Vázquez's reputation was eternally established with his design for the National Museum of Anthropology. In the intervening years even more of the face of Mexico City has come to bear the imprint of the architectural designs of Pedro Ramírez Vázquez. The architect is one of our civilization's

most anonymous artists. Of the hundreds of thousands of visitors who have enjoyed the grace and splendor of Mexico's National Museum of Anthropology, or worshiped in the Basilica of the Guadalupe, or roared approval in the enormity of the Aztec Stadium, most probably are unaware of the identity of the man who created that space for their education, worship, or sport. If the gods allow, these monuments will stand through the ages, and though few things are eternal, it is surely immortality enough to know that in future centuries these edifices, like the Templo Mayor itself, may be the subject of archeological study.

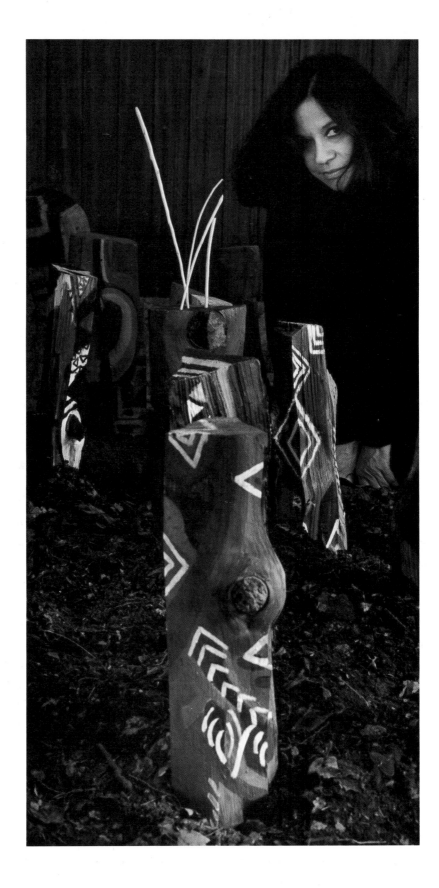

25. Marta Palau

MARTA PALAU

Abesa, Lérida, Spain · 1934

"I saw with clarity that all roads in my art lead toward ritual." Marta Palau wrote those words for a 1990 exhibition in the gallery of the Organization of American States in Washington, D.C. The road of her life began in Spain. She was brought to Mexico at the age of six by her parents: "My father believed in the Republican cause and had to leave Spain. I'm Catalan by origin, but really, I'm Mexican, because this is where I grew up." Palau may be a Spanish Mexican, as she refers to herself, but her artistic and cultural roots go back even farther, to a time before national divisions, a time of origins. This small, animated woman with dark eyes and coal-black hair has a Jungian sense of collective memory, from which she draws ideas and inspiration. In a modern world, Palau is most moved by primitive cultures and in her art employs the timeless forms and symbols of indigenous peoples everywhere. Her preferred materials are natural: fibers, corn husks, cotton and woolen fibers, sticks and twigs, the paper and bark of the amate tree, hemp—all the variety of nature's textures—and, in her most recent installation, earth itself, along with a ring of coarse salt.

Palau established her reputation as a tapestry artist. Her interests are much broader, however, than weavings, and her brief comments for the program of the OAS show (printed on the following page) demonstrate that even unbeknownst to her, her many paths in art—painting, sculpture, "ambiential" constructions, and weavings—were converging into a single path that would encompass many forms: ritual art.

In a return visit with Palau, following her most recent invitation to Cuba to exhibit her *Heráldica de naualli,* she speaks of the crystallization of the magical tendencies of her work.

M.P. My work has been undergoing a change, no? There is a tendency in Mexico to pigeonhole artists. I have been classified primarily as working with textiles. I'm tired of that format. Actually, for three or four years now, I haven't been working just with textiles but with fibers of all kinds. I certainly don't have any objection to working with textiles, but I'm not happy that I've been pigeonholed this way.

Questioner It *is* incredible. I know, for example, that you paint a great deal but are seldom thought of as a painter.

M.P. I think it is very clear and very fundamental now where I'm going—a question you had asked me—and that is in the direction of everything connected with rite. Not magic as such, not witchcraft, but with a feeling of creating a setting.

145

Naualli—Circle of Salt

Art leads me by the hand down unexpected paths. Perhaps they are already there, waiting, and emerge at the precise moment I need them. My interest in natural fibers led me to the traditions of the people and, almost simultaneously, to my need to know their myths and rituals.

In 1987 I traveled to Brazil and had the opportunity to see examples of the art of the Amazon Indians. That encounter was fundamental. Its impact was reaffirmed when I learned that these peoples use languages very like ours, languages with the same charge of magic. In 1985 I produced my first ritual installation, *Los bastones de mando* ["Staffs of Authority"] in an exhibition in Mexico City I entitled *Mis caminos son terrestres* ["My Roads Are Earthly"], although I was not then aware that it was a ritual installation. Then in the Nineteenth Biennial in São Paulo, in 1987, I presented an installation I called *Recinto de chamanes* ["Enclosure of Shamans"], and once again did not allude to it as ritual art. It was only when I began to work with these Nauallis, with the installation *Heráldica de naualli* ["Naualli Heraldry"; in Nahuatl, *naualli* means male and female witch, magician, sorcerer, necromancer] exhibited in 1989 in the Third Biennial in Havana, that I saw with clarity that all the roads in my art lead toward ritual.

Palau credits her trips to Cuba for much of her recent inspiration. It was there that she decided she would construct an installation of ritualistic and fetishistic staffs, because she had been receiving many "signs about staffs." As in Mexico, in Cuba the presence of indigenous gods is strong. Palau relates an experience with a *santero*, a Yoruba witch doctor. "They throw these special shells. They look something like these. Not these, but a special kind they search for. They cut off the back so you can see inside. Then they, well, roll them in their hands and throw them on the ground. That's after they say a kind of prayer in Yoruba. They throw the shells, and with each toss they count the shells that land right side up. They put the number on a slate. If seven land up, they write seven. They throw them four times, so there are four numbers. And every number is a letter. It's,

like, a kind of science, no? And then they say, such and such a saint, maybe Changó, was doing such and such a thing, and what that means, and then they begin to tell you things. And the friend I went with was told she needed a cleansing. I went with her to act as interpreter. It was wonderful. The whole spell was a very magical thing. I was thrilled to be seeing it."

Looking around the personal and individualistic *sala* of Marta Palau's apartment in the Colonia Polanco, one sees further signs of her fascination with the magical. There are beautiful pieces of aboriginal and indigenous art; the wall above the fireplace, for example, is covered with black African masks and fetishes. Palau has her own household gods. Shelves on either side of the fireplace hold a minigallery of silver-framed snapshots of family and friends. Bookcases are heavy with art

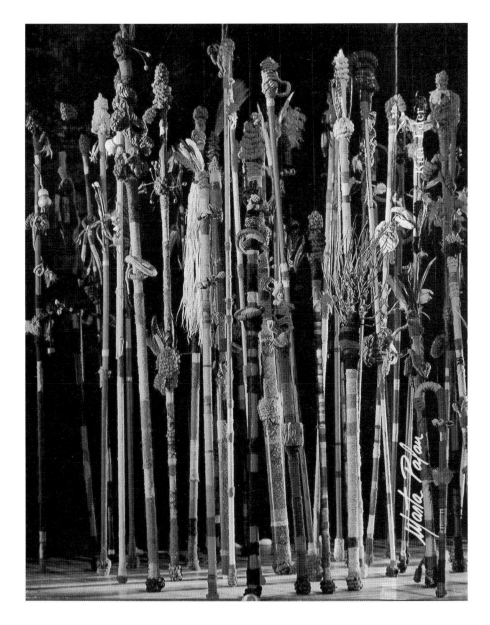

25a. Marta Palau, *Mis caminos son terrestres XI*, 1985, installation, Palacio de Bellas Artes, Mexico City. Photo: Enrique Bostelman.

books, and plants are everywhere. One wall is dominated by a striking Palau painting in dark red-oranges, golds, and black, very Oriental in tone. The painting, which was exhibited in 1969, is a strong reminder that even at the height of her creativity in weavings and tapestry, Palau was indeed working in other media.

Among numerous fascinating *objets* in this beautiful room, a few eye-catching rag dolls are an

unlikely link with her fellow artist Francisco Toledo. "Oh, I did these for the *costureras*, the seamstresses, you know, in the earthquake. They were caught in a building, and they were, they were trapped. And most of them were killed. So anyway, they formed a *sindicato*, a union [to assist in their own recovery]. And every year artists make designs for them—for dolls. And this is one of my designs, and this one, too. First the *costureras*

had to teach us how to make them. This doll's name is "Lucha." *Lucha* means "fight" or "struggle," but it's also a name. Like your name can be "Luz," but they call you Lucha. So every year now they have this exhibition of works of different artists. And now it has become so important that they are putting the show several places." In Toledo's nearly bare studio, too, we saw a doll design in the making. Toledo's doll was not stitched but constructed of wood and the small terrapin shells that appear everywhere in his painting and ceramics.

Marta Palau's first tapestries were woven hangings. Later, her work began to move from the wall toward constructions and ambiental pieces, huge sculptures of coarse wool that flow from rods suspended high in trees or fall from amid tall white columns placed in a natural landscape or hang suspended from a ceiling, Niagara Falls cascades of long, clotted spumes of white. Palau's *Autoretrato* ("Self-portrait") is an example of both her creative imagination and her elfin sense of humor. A curtain of coarse, off-white wool recalls the backdrop of a small stage. Invisibly suspended before it and covering half its area is a gray woven face with wide white smiling lips, the pointed Palau chin, and wide-set, eyelash-fringed, dark eyes, one of which is lowered in a complicitous wink. Standing forward and slightly to each side of this staged portrait are two large Plexiglas hands. Gray cords stretch slackly from the tips of the upright fingers and thumbs to the bottom of the face weaving. The symbol perceived is head-to-hands, mind-to-creation. The visual effect is that of a stylized cat's cradle, the string games of varying complexity played by children of all cultures. For Palau, the creative urge is universal; we recognize it especially in children of nature, that is, persons who still live close to the earth.

Among the standard media Palau has worked in are monumental sculpture, serigraphs, collages, and acrylics. She executed, for example, a series of painted compositions she calls *Poesía ausente*

("Poetry of Absence"), inspired by a friendly rivalry with Emilio Carballido. On a joint visit to New York Palau was chagrined by Carballido's ability to awake each morning with a new enchanting story from his dreams. She was envious of the richness of Carballido's dream life until one morning she awakened with her own dream, which centered on clothing—specifically, the medical whites worn by her daughter, who is a doctor. Upon her return to Mexico, Palau created a series based on that dream, using various articles of clothing arranged on canvas and then painted over as part of a nearly sculptural composition.

There is, apparently, no limit to Palau's fertile imagination. The work of the last five years taps directly into the bottomless well of shared human memory. During that time, she was moving from wool and cotton to coarser, woodier fibers such as hemp and corn husks. Tapestries of dyed husks form large columns and posts and bales and combine with threaded fibers, bamboo, and jute fringe in hangings that might have graced a shaman's wickiup. Bamboo tepees appear, enclosing a central, shaft-encircled core of feathery fibers. All the latter constructions were exhibited in her show entitled *Mis caminos son terrestres*, which included *Bastones de mando*, the ambiental construction she now recognizes as her first ritual installation, and the winner, in 1986, of the Second Biennial in Havana. *Bastones* consists of a forest of tall rods wound in stripes of bright yarns—pink, red, fuchsia, violet, turquoise, lapis, yellow—and imbued with magical powers by the addition of a multitude of feathers, twigs, nuts, and beads, and looped, puffed, braided, twisted, and coiled yarn ornaments. Each of the individual staffs is intriguing in itself. The whole is magic, a visual feast that speaks directly to the viewer's senses, bypassing language to connect directly with the Jungian collective unconscious that somehow recognizes these brilliant objects, reacts to them, without the ability or the need to

verbalize that recognition. Palau believes that even civilized, that is, urbanized peoples carry the memory of magic "in their genes."

Q. There is something in the air of Mexico. Is it something beyond the mere presence of the past?

M.P. I think it exists in all cultures. You have it, for instance, in the art of your American Indians.

Q. We had it, yes, but we suppressed it.

M.P. You suppressed it, but you could not extinguish it. It exists. When you look at what they did, it's totally magic, isn't it? Art begins as ritual magic—for the purpose of capturing a spirit, let's say. Like the cave drawings in Europe. To capture the spirit of the bison they were going to hunt the next day—they drew the picture the day before they were going out to hunt so they would be successful in the chase. That was already a magical thought.

Q. But you still have that, what shall we call it, presence here.

M.P. Yes, we've never lost it. We have this city, which is like the center of ritual magic.

Q. Yes, I know. That's why, against all logic, people continue to flock here, to Mexico City, to the site of the gods.

M.P. When the Spaniards arrived in Mexico, Mexico City was already the largest city in the world. It had, at that moment, the highest population of any city in the world.

Q. And now it does again.

M.P. Yes, it's come around again. So you have to ask yourself why there has always been an enormous city in this valley, even during the time of the Aztecs. There were one hundred thousand people here then, and the largest cities in Europe had only sixty thousand or seventy thousand.

Once while being driven between St. Louis and Columbia, Missouri, in the days when he still would not travel by airplane, Carlos Fuentes elaborated on the same point. There are solutions to the overcrowding and poverty rampant in Mexico City, he said, but they will never be effected.

If families, entire communities, were relocated along the thousands of miles of Mexico's shoreline, they would be able to subsist on the land and on fish from the sea. That solution, however, is unworkable, he lamented, because no one wants to leave the land of his gods, the central valley of Mexico. Marta Palau lives in that city and, in the midst of twenty million human beings, evokes nature, weaving a magic that stretches from the indigenous peoples of Brazil, Cuba, and North America to the cave painters of Europe to the *naualli* of Mexico—ritual and art that are perhaps inseparable.

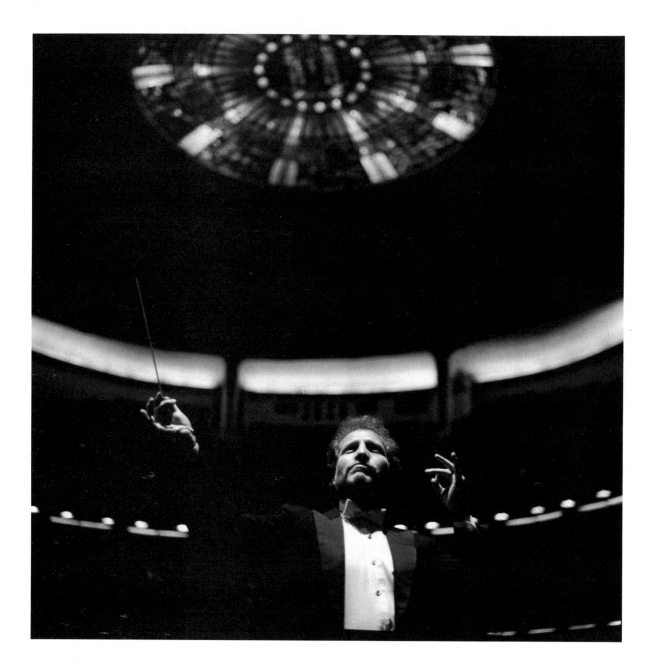

26. Enrique Diemeke

ENRIQUE DIEMEKE

Mexico City, D.F. · 1953

Mexico is blessed with a music-loving public, a group of fine young conductors, and some superb concert halls. Those three elements have come together, as they often do, in March 1990, resulting in a memorable performance of the opera *Salomé*. Enrique Diemeke, the opera's director, is one of the finest of Mexico's young musical elite, having earned a place in the coveted Exxon–Arts Endowment Conductors Program, in which he spent two years with the Rochester Philharmonic Orchestra. Now he is in the second year of a three-year appointment as musical director and conductor of the Flint, Michigan, Symphony Orchestra; also among his credits are appointments as the artistic and musical director of the National Opera of Mexico and musical director of the Mexico City Bellas Artes Theater Orchestra. Diemeke is typical of the distinctly international cast of classical musicians around the globe. A novelist or artist might, if he chose, live and work in the country of his birth. That is a luxury—or limitation, depending on one's point of view—a young conductor may not consider. Within the last year, at the invitation of the Chinese government, Diemeke has spent five weeks in the People's Republic of China, where he led the Shanghai Symphony Orchestra and the Central

Orchestra of Beijing in a series of concerts and where he was also the first conducter to perform a symphonic work by a Mexican composer. In May, Diemeke conducted the Chamber Orchestra of Moscow, the State Orchestra of the USSR, and the Tashkent Philharmonic Orchestra. In September, he performed in Milan and Como, Italy, and in October, he conducted in Poland and in Hungary.

Questioner You have been traveling and working in China, in Russia, in Poland, and in Italy. As a matter of curiosity, at what point do you feel you become a citizen of the world, and not Mexican? You will, for example, be living in Flint for the symphony season.

E.D. Yes, traveling back and forth.

Q. So when does an artist who works so much outside his country lose a sense of his roots?

E.D. Well, you know, I'm discovering that answer little by little. You find that music is really very international. When you communicate with musicians who are Chinese, for example, who don't speak English, you will usually have one person who translates, to help you describe what you want to do, and you use English or maybe French for that; but the language of music is very international. You say *presto,* and everybody knows

151

you're talking about fast; *allegro*, everybody's going to be happy; *piano, forte, crescendo, diminuendo, sotto voce*, all this terminology in Italian is understood; everybody gets the idea. And then you feel that you are at home, and you need only a few monosyllabic words to say what you want. Of course, when you go out on the street and do things tourists do, you find out it's different. But really, all of it is very rewarding, to be able to work *and* to act like a tourist.

Q. In your China experience, to pursue that for a moment, you say that when you say *presto* everyone knows what it means. But is there still not a gradation of language? The Chinese come from a very different musical tradition. Do you not find the orchestra in Beijing very different, say, from one in Italy?

E.D. In a way, fortunately, they are all different, because there is a personality of each group, and it really presents a challenge. And they give their part and you contribute yours, and this combination makes something special. And that beauty cannot be well, first of all, described in words, and second of all, it cannot be repeated. So someone like me, a person who is a little sensitive and moved by things, these experiences give me a special moment. And so that motivation gives you this special thing that you always want to keep, and it doesn't become a boring routine you're used to. You are looking forward, you come to the experience for the first time—and maybe for the last time.

Q. I know that you directed the first work by a Mexican symphony composer ever performed in China. How was it received by the orchestra, and by the public and the critics?

E.D. We were performing a Latin American suite, and it was really special, because I could see the faces of the musicians discovering something new, you know? I think that unlike many other places, I felt that in China and the Soviet Union, even in Poland, when I offered this Mexican pro-

gram, they found it very refreshing—because they always play the same repertoire: Brahms, Beethoven, Tchaikovsky, and Mozart, and probably their own contemporary composers. And when I did this program they said, "Oh, it's very refreshing. It's something we don't do every day."

Q. I'm sure the public was very enthusiastic.

E.D. Yes, they were very enthusiastic. In China, they express themselves very differently. They talk, and they move around to show their appreciation. And if they're very quiet and don't move, that means they don't like it. It's not like Japan, where it's the other way around. If they don't talk, if they don't move, that means it was wonderful. And that's why I love all these audiences; they all respond in different ways. Mexicans are very responsive, and they want more, more, more. The Americans and the British, they applaud three times, and that means it was very good. And if they applaud more, that means they are milking the applause.

Q. One question more, if you don't mind. I must ask about your phenomenal memory. You conduct three hundred and fifty orchestral and operatic works without a score. That's not something one can learn to do. I assume you were born with that talent?

E.D. It's a musical memory.

Q. I know, but it's still phenomenal. You do usually conduct without a score?

E.D. Usually. Other musicians have it. It won't work for everything. I think it runs in the family.

Enrique Diemeke's mother, father, and brother are all professional musicians, reinforcing his sense that music and musical memory run in the blood. The houselights dim in the luxurious hall of Mexico City's Palacio de Bellas Artes, with its scintillating Tiffany glass curtain and Art Nouveau glass ceiling. The conductor lifts his baton—not consulting a score—and an eager audience settles into an international evening with Richard Strauss's *Salomé*.

Music, with the connotations the word bears in twentieth-century Western civilizations, probably began in Latin America with the arrival of the Spanish. Alejo Carpentier, the renowned Cuban novelist and a fine amateur archaeologist and musicologist, argues that like much of the development in other areas, the history of music in Latin America was erratic. "The musical history of Europe," Carpentier writes, "the process of its development, was continuous and logical, attuned to its own fundamental laws, occurring as a series of techniques, of tendencies, of schools, . . . until through successive stages it reached the avant-garde experiments of the present time." The case of Latin America, he continues, was different. "It did not develop under the laws of the same values and events, but responded to a variety of imports, transplants, grafts, psychic impulses, and cultural factors that makes an analytical approach impossible: a constant tension between the native and the foreign, the indigenous and the imported."[1] In his exploration of Latin American music, Carpentier makes an interesting distinction between the folkloric and the ethnographic—which is, in fact, the music of pre-Columbian civilizations.

"When music is revealed to us in its 'pure state,' that is, as primitive ritual function, it cannot be considered music since the signifier responds to notions of the signified now lost to us. This can be illustrated by what happened once when Malraux was viewing a piece of sculpture from ancient times. He said that before being a 'statue' (that is, a work of art), that statue had been *something else*: an intelligible personification of the Divinity, a cult object, the materialization of a difficult concept, a manner of attaining the Transcendental. That is how music was before it was *music*."[2]

Carpentier's words pertain directly to pre-Hispanic music. That music was ceremonial accompaniment. The Spanish chroniclers recorded descriptions of Indian religious and civil ceremonies, noting, however, that to them the music seemed slow and repetitious. Since the time of the Conquest, a few authors have attempted to recreate, imitate, or revive the old forms. The seventeenth-century poet Sor Juana Inés de la Cruz, for example, wrote a number of tocotines, an Indian-style dance song, and Blas Galindo, to cite one example in the twentieth century, composed a piece scored exclusively for indigenous instruments. In Mexico, those instruments tended to be of six principal types: flutes (including ocarinas, and panpipes), the marine snail shell, the vertical drum, the horizontal drum, calabash rasps (human bone rasps are also known),

and pebble-filled gourds.[3] Many of those prototypical instruments are played today and are found in Mexican markets as tourist souvenirs. The influence of pre-Columbian music, nonetheless, compared with the major impact of indigenous cultures in the fields of art and architecture, seems to have been minimal, and when popular music groups refer to themselves as an *orquesta típica*—or mariachis—no primitive instruments, as known before the arrival of the Spaniards, are used. The typical popular ensemble today is composed of violins, guitars, and harp and may also include flutes, clarinets, and trumpets. North American music lovers will recognize the typical mariachi rhythms—should they not be directly familiar with them—in Aaron Copland's *Salón Mexico*.

ENRIQUE BARRIOS

Mexico City, D.F. · 1955

In a different Mexico City hall the Philharmonic Orchestra of the National Autonomous University of Mexico is rehearsing. It is directed by Enrique Barrios, who has just returned from several months in England where he was resident conductor for the Covent Garden and London Philharmonic orchestras. The Sala Netzahualcoyotl is located on the university grounds in the southern part of Mexico City. It is an impressive auditorium. The stage is low and enclosed on three sides by public seating; behind the stage, seats for a large chorus close the fourth side of the performance area. The acoustics in the Sala Netzahualcoyotl are among the best in the world. This hall named after an Aztec poet seems an appropriate place to ask Barrios about Mexico and the musical world.

Q. *Mexicanidad* is a topic that often arises in discussions of literature and the visual arts. I am aware that, just as in art and literature, a nationalistic period can be identified in the history of Mexican music and that some contemporary composers have made concerted efforts to incorporate pre-Columbian themes into their works. But speaking in general terms, what is *mexicanidad* in music? Have you found there is such a thing as a musical Mexican accent?

E.B. In composition, one cannot help but feel Mexican roots, they are so strong and so ancient. In playing music of international composers, the style must be that of the composer. We can't go around Mexicanizing everything we play. That would be like putting chili sauce on pancakes. I find that I am happy, though, to be back in Mexico, back to my roots—although I learned really interesting things in London. They do things very differently in the ways they rehearse, and their directors have left archives for studying certain works. I found it to be a very rewarding experience.

Q. I know it is different for musicians, but there are visual or literary artists who may not be well known outside Mexico because they make no effort to promote themselves. With reputations, its difficult sometimes to know what is art and what is publicity.

E.B. Oh, I think that is very clear today. It's like Coca-Cola. I am not convinced that Coke is the world's greatest beverage, but it is certainly the best-known. And publicity has had everything to do with that. At the same time, I am convinced that no truly talented artist will remain undiscovered in today's world. In music, anyway, there are not that many. It's interesting. In London I saw

155

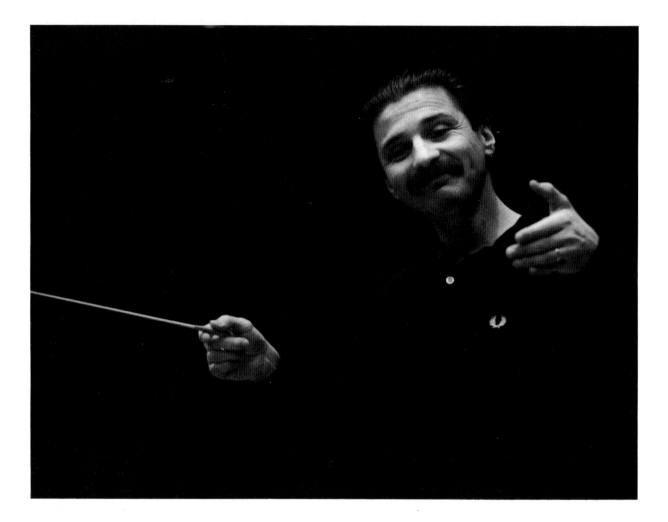

27. Enrique Barrios

millions of directors but very few who are outstanding. Some, in fact, are very bad. There is an actual shortage of artists. Take tenors—you can count the great tenors of the world on the fingers of one hand. From there you drop to the fourthrate. There are no second- or third-class tenors.

Q. Is that simply fate, the *forza del destino*?

E.B. It's also because the first-class singers get all the work, and then the others have no place to sing, and so they are stalled at an inferior level.

Q. It has always interested me why certain countries produce great musicians and others don't. The question is why—and let's set Mexico aside for the moment—why Spain, for example, has not produced great composers.

E.B. Well, there was Falla, and Albéniz.

Q. And Villa-Lobos in Brazil and Chavez and Revueltas in Mexico—we assume exceptions. But there is no great tradition of composers in Spain, as there is in Italy, for example.

E.B. Yes, especially when you think that Spain, like Italy, is a Latin country. And its popular music is so beautiful. Just as beautiful, really more beautiful, than that of Italy. A similar thought occurred to me in London. In that city they can name the finest orchestras in the world, great orchestras, but they really don't have a school of composers—or directors. Ninety percent of their directors are foreigners. And neither do they have soloists, while France has excellent soloists but no composers or orchestras.

Q. It may be a question of schooling, but I doubt it. It must somehow be related to a national essence.

The question of national, indeed, hemispheric essence is one that fascinated Alejo Carpentier. He is credited with introducing the term "magical realism" into general usage—although, in fact, his term, *lo real maravilloso*, was subtly different. Carpentier writes:

> The blood of one or other country of our continent runs through seemingly "cosmopolitan" scores. Here, it is a manner of using the percussions; there, a rhythmic impulse; still again, a hint of a scale, a characteristic cadence, a particular sonority; that is, a revealing "collage," a musical line, the humor of an expression, the melancholy of a clime. Or, more overtly, the content of an imprecatory, vengeful text sung forcefully by a singer or choir . . . It is not "national" or "nationalist" to quote a folkloric theme. A melody a famous Argentine musicologist identifies in his book as the theme of a colonial candomblé [dance of black South Americans] is sung in Mexico, at a slower tempo, as a sentimental ballad. A well-known Colombian romance passed for a long time as Cuban—after being re-edited, with slightly rhythmic modifications in the accompaniment, in Havana . . . When Debussy and Ravel wrote habaneras; they continued to be as French as the American "savages" were French that Rameau had dance in his *Indis galantes*. The Dies Irae of the Gregorian chant becomes a magnificent Argentine tango when played on the bandonion [large concertina] with a Rio Plate rhythm. . . . If the habit does not make the monk, the *theme*, in music, is not sufficient to validate a passport.[1]

Carpentier believed that regardless of theme, ultimately some national characteristic revealed one's essence. "Chassez le naturel," he writes, and "il revient au galop. One's sensibility, the specific sensibility of one who is born a Latin American . . . will always be manifest."

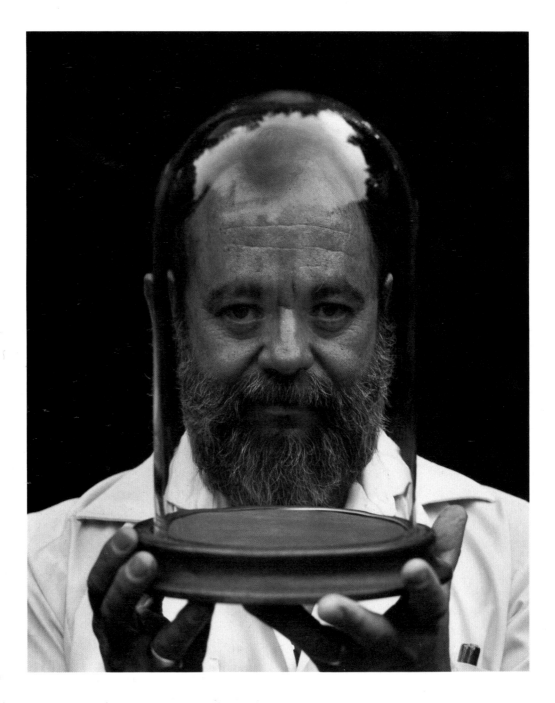

28. Alfredo Castañeda

ALFREDO CASTANEDA

Mexico City, D.F. · 1938

"It could be a personal, internal archetype. I don't know. It could be many things. It could be my guardian angel. Or maybe it is I, myself, coming to know myself little by little."

Alfredo Castañeda answers the question that obsesses the viewer of his haunting canvases. Who is, what is, the persona that appears again and again in his paintings? The doppelgänger of Carlos Fuentes? The "other" of Octavio Paz? Castañeda's alter ego? His spiritual twin? With few exceptions, Castañeda paints human figures. These subjects appear in multiple representations or with multiple parts; one figure is split to form two partial bodies; identical faces rise from a single shapeless body; a bearded male head emerges from between the legs of a squatting bearded man wearing an identical expression of frozen terror; body parts, arms, eyes especially, are doubled, tripled, quadrupled. Even when one, subjects are not whole. Something is forever escaping normal reality. A shoulder disintegrates into small fragments, as if attracted toward the similarly crumbling mosaic of a facade on the near horizon. Behind an empty, caned chair, a head floats on the insubstantial surface of a heavily textured wall. A blind face is intersected by the curve of an obliterating round ornamental plaque. Tiny flowers on a man's shirt drift upward against a dark background, floating like snowflakes or stars in a night sky. A bearded male face is attached to the body of a young girl in a pink dress; the rough outline of a torn oval traced on the canvas beside him–her suggests an even more dizzying disjunction, absence. No one is allowed the luxury of wholeness.

We fear this void, this instability. We want to read these staring, expressionless faces, reintegrate these dissolving bodies, stabilize this shifting, centerless world.

Questioner We were talking on the way here, commenting on how the eyes in your paintings have changed. At first, they were as if—
A.C. Blind.

Q. Yes, blind. And now, one face has two or three pairs of eyes. That obviously says something.
A.C. Yes, it does. I don't know. Maybe a kind of inner change. I don't know. Maybe, somehow, I'm showing myself something.

Q. In a kind of psychoanalysis?
A.C. Yes.

Q. Look at this painting. There are so many eyes, they're dizzying.
A.C. Yes.

Q. *(Referring to the black jacket and white collar):* Is he a Puritan?

159

A.C. Well, I don't know. He might be from the time of Rembrandt—a seaman from that period. He is someone I have painted more than once. [The eyes] are to a degree a symbol of something I may want to reach. I don't know. I don't know.

Q. The eyes must cause even you a little dizziness.

A.C. A little dizziness, yes, and a little—pleasure.

Alfredo Castañeda is a quiet man, serious but affable, dignified yet unafraid to direct his peculiar irony toward himself. In his starched whites he looks a little like an officer on a luxury cruise ship. He works and lives in Cuernavaca, in an attractive but not ostentatious home with a small pool and pleasant gardens. After the eerie reality of his painting, one is struck by the normality of his surroundings, an impression not lost on Castañeda's intelligent and hospitable wife, Hortensia. "People come here and say, 'You seem to live a very average life. Where are the holes in the wall?'" Her mention of holes refers to Castañeda's penchant for pocking his canvases with trompe l'oeil bullet holes. The device is seen at its most realistic in a painting like *Péguenme tres balazos en la frente* ("Shoot Me Three Times in the Forehead"). Here a lovable, shaggy black and white dog with intensely human eyes is staring directly and dolefully into the viewer's own. He stands with his forefeet on a large red ball. The ball, his hind feet, and his face are centers of three identical targets formed by three concentric circles that impose an implied triangle upon the arched space of the painted canvas. The right and left targets are punctured by poorly aimed shots, some of which are entirely wide of the mark. The third point of the triangle is pierced by three perfectly aligned shots placed in a horizontal line just above the dog's (the being's?) eyes. Castañeda recounts a "perfectly normal" source of inspiration for this effect. "There was a period in Germany when they used important paintings for target practice. I read that in a magazine, and I was very impressed

that they left holes in their paintings. So I began to put holes in my paintings after they were painted." What Castañeda does not say, but surely realizes, is that he has always been leaving holes in his paintings—whether in the void of the blind eyes of his early portraits or in a detail like the broochlike aperture in the chest of *Mateo*, through which one views the sailing ship of this bearded captain in the seventeenth-century black cloak, white collar, and plumed hat. "For where your treasure is, there will your heart be also." (*Matthew* 6:21.)

The question is perennially asked of creators: Whence this imagination? Whence this vision of a centrifugal world in which everything is in danger of being spun from its center? North American art critic Edward J. Sullivan has astutely signaled that connection:

> As a Mexican artist, Castañeda is by no means alone in his use of disjunctive space and time. I find this aspect of his art more linked to Mexican literary than pictorial traditions. In many modern and contemporary novels by some of the country's most renowned writers we are presented with an analogous rapid switching of realities within a single "scene." We might think, for example, of Carlos Fuentes, who is particularly adept at this technique and uses it to great advantage in books like *La muerte de Artemio Cruz* or *Terra Nostra*. Given Castañeda's propensity for literary creation, this is not surprising.

Resemblances to Fuentes in theme and manipulation of time, in an overall world vision, are especially strong. And once more, the question is posed. Are there not strong resonances between Castañeda's work and that of many contemporary Mexican novelists and poets? Castañeda systematically rejects any conscious linkage. He consistently identifies sources in times other than the immediate present.

A.C. I like very much the traditional literature of all religions. I like poetry very much, religious poetry. My reading is closely related to what I paint.

Q. Saint John of the Cross is obvious.

A.C. Or Blake, or Eliot, or Pound. And the Spanish. Yes, Saint John, Saint Teresa, a little.

Q. Do you consider yourself a religious man?

A.C. Yes.

Q. In the vein of orthodox Catholicism, or something more personal?

A.C. In my case, I am a practicing Catholic. But I am also a student and admirer of the Tao. I like those teachings very much, very much. And I understand many things about Christianity much better when I read the Tao, or read about Buddhism, or other religions.

Q. A kind of panreligion?

A.C. No, not fusion. Simply understanding one's own religion better in the light of others.

Q. Everything in your work leads to that same point, to knowing oneself and one's world better.

A.C. Yes, I am very interested in an art that can communicate self-knowledge. When they see what I paint, I want people to be moved by the desire to travel within themselves, to discover themselves, to feel what I am trying to say. I don't know whether that can be called psychological painting, or traditional painting, because what I am proposing is all the traditions of all countries. When people read a traditional book from any culture whatever, inevitably they are going to know themselves better. That is really what I want to paint, that quest for self-discovery. I don't know what to call it; that is rather difficult. I have often asked myself what my style is, what school I might— I believe that I have a relation with surrealism, but I am not a surrealist. That I have a relation with symbolism, but I am not a symbolist. That I have very important ties with the art of New Spain, with the early colonial period, the retable, the gaze of the subjects.

Q. Which you see in the *santos*, no?

A.C. Yes, yes, yes. And that moment of contact between the two great cultures here in Mexico— like a clash, a tremendous spark—I feel that with me when I look at things outside myself.

Q. It's always present?

A.C. Yes, that amazing encounter is always present.

Earlier in the afternoon, by the pool, we had discussed normal and practical matters: the household filled with his children and visiting nieces and nephews, the cat named Cat, the early influence of two uncles who were painters, satisfactory management of his career by galleries in Mexico City and New York, the trajectory of his painting as recorded in the photographs contained in two large scrapbooks. Even this practical conversation, however, is shot with the glowing mystical thread that stitches together the fabric of Castañeda's reality.

A.C. This painting, for example, has a lot to do with the tradition of the alchemists. See? "Drink, but be not converted to three." He's a mystic, maybe twelfth- or thirteenth-century Spanish. He could also be the Magician of the tarot cards— here [in the grass growing from a tall top hat]. And this one in Phoenix, this prisoner.

Q. It's like a play of mirrors.

A.C. Of times. Of unifying times, time past with— You know something very interesting? Vegetal life unifies the mineral, and animals unify space— what is sowed here is carried there, bees transport pollen, and so on. Man unifies time; he unifies the times of all times, through ideas.

Q. Which is history.

A.C. History, exactly. And love unifies spirits. I believe that the goal for everything we do is to unify, unify, unify. This is a present given me by a poet, José Emilio Pacheco. And this painting was a premonition. I painted this face [with a hole in the forehead], and a friend of mine bought it and told me, "I bought it because it looks very much like

my brother, who just shot himself." He was my first client, that friend.

Q. Then dreams are very important in your work.

A.C. But I didn't dream it! I felt it as a necessity.

Q. You use that word "necessity" very often.

A.C. Yes, "necessity." I have to do it.

As he has the necessity to know himself, as he has to offer his viewer an inner journey into his own psyche. Castañeda entitled one of his several shows in a New York gallery "If Only We Knew, You and I." And he enlarged upon this theme in the following poem, which was included in a small portfolio of postcard reproductions of four of the paintings in the exhibition.

28a. Alfredo Castañeda, *When the Mirror Dreams Another Image*, 1988, oil on canvas, 11 ³/₈ × 15 inches. Photograph courtesy of Mary-Anne Martin/Fine Art, New York.

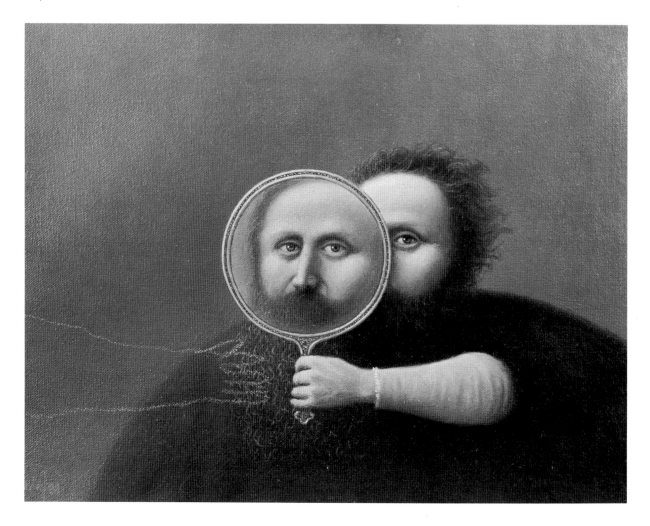

Wing hidden among forgetfulness and pious lies.
Where to place you? Scrap of lace. Spattering of the
Most High in this collapsed center.

And this knapsack?
And this money?
And the flowers and the song?

Rise to your feet, my friend! Observe the curving line
that seems to disappear among the folds of your
mountains. Follow it! It is the line between death and
your death. Walk that line and live forever!

And this house?
And these my brothers?
And honor and country?

After walking so long toward the West, what have I
known of things? What have I known of myself? Eat
of this which is enriched with vitamins, proteins, and
minerals! And what have I known of the Self of
myself?

And this sadness?
And this yearning?
And this space nearly glimpsed?

A gaze risen from among all gazes. Why do you tell
me this? "YOU MUST BE BORN FROM ON HIGH!" Voice
hidden in the center of the mirror, Must I stand on
my head?

get ready ... set... hop right in!

You have no voice, you are fire now

Everything melts

you are swelling with energy

sit down at your typewriter give it life inflame it

 at last you have finished

 writing the book.

29. José Agustín

José Agustín (signature)

JOSE AGUSTIN

Huautla, Oaxaca · 1944

Watching José Agustín in action is a little like watching a brush fire. He burns with intense energy. He moves and talks rapidly, his expressive hands never still. On a late-night Mexico City television talk show—interviewed, not interviewer, as he was for five years on his own show, _Letras vivas_ ("Living Literature")—he sears the air with words, responding to brief questions with ten-minute, racing monologues. Agustín is not a reluctant conversationalist.

Today, by his own definition a dedicated family man, Agustín has mellowed substantially from the irreverent cult figure of the sixties, the man who rejected his family name, retaining only his given names in order not to be confused with a well-known uncle. That Agustín was the young rebel who spearheaded the movement known as La Onda, the literary phenomenon that galvanized a generation of Mexico's youth avid to embrace the counterculture of "What's Cool." "Brash" was a word often applied to the young Agustín. "Barbarians" was a milder description of the onderos, the school of writers who espoused the tenets of La Onda. Their literature and their behavior were based on rebellion: their writing featured an idiom almost incomprehensible to the uninitiated, their music was high-volume rock and roll, their

attitudes blared scorn for bourgeois society and revulsion for parental values. Agustín, called the enfant terrible of the literary world, in many ways played a role similar to that of José Luis Cuevas in the world of art. Like Cuevas, Agustín stirred controversy, attacking the most highly regarded figures in his field. "The great majority of Mexican writers are on the wrong track," he proclaimed. "It's obvious that they're old, physically and literarily."

Like Cuevas, too, Agustín was precocious. By the age of twenty-two, he had been twice married and had published two novels and his autobiography. An account of his first thirty years reads a bit like a soap opera: his first marriage at the age of sixteen (after bribing the judge of a provincial town) and his subsequent flight to participate in the Cuban literacy campaign; his well publicized dalliance with the famous actress Angélica María; his association with Mexican and foreign media and music personalities; his later marriage, divorce, and remarriage (by the Church in Mexico and by the state in Denver) to Margarita Bermúdez; and, finally, his seven-month imprisonment in Lecumberri on suspicion of trafficking in narcotics.[1]

Agustín's literary iconoclasm is obvious in both

form and language. His twenty books comprise a consistent attack on traditional narrative, less overt in later works but nonetheless sustained. The language of his early writing was so impenetrable that it motivated the publication of a glossary of Agustinian slang. That secret language was in considerable degree responsible for the instant response to his early books by the young. His experimentation with form is equally unconventional. Agustín describes one work rather conservatively as a "novelized drama." Another inventively employs the cinematic techniques of zooming in and out, panning, and, as popularized in *Tom Jones,* freezing the shot to address his audience. Agustín's novels are in fact loosely structured narratives formed by a series of short stories. And throughout his texts flow the torrents of words: obscenities, puns, neologisms, phonetically spelled foreign adoptions, phonemic distortions, phrases from songs, and a stretching and bending of normal syntax and grammar that may on the surface seem irreverence but on closer observation can be seen as an obsessive concern for exploring the limitless possibilities of language.

Agustín lives with his wife, Margarita, and their three children in Cuautla, a residential development outside Mexico City, not far from Cuernavaca. His lawn is emerald green; his studio faces a swimming pool whose cool waters are very blue. Visiting professorships in the United States have probably had less to do with this traditionally suburban way of life than the air, which is stimulating and crystal clear, as the air of Mexico City once was. We are happy to sit on the veranda in the late afternoon, drinking coffee Agustín has prepared himself and discussing his most recently published novel and two works in progress, one a historical chronicle of Mexico covering the forty years between 1948 and 1988—a disciplined kind of writing, he says, he has never attempted before—and the other a play that has given him "freedom" and a "magical contentment."

J.A. It's a really strange story, about a couple that receives a chain letter containing a box of nail clippings. The letter asks you to cut your fingernails and toenails, put them with the others, empty them into your tub, and then bathe in the solution. It's called *Baña de uñas* ("Bath in Nail Clippings").

Q. Does it end, or go on forever, like a chain letter?

J.A. Oh, the chain goes on. The work ends.

José Agustín likes to laugh. His speech is punctuated with laughter, and his humor spills over into his writing—another feature that entrances youthful readers. While we are talking, a dog wanders in through the front gate. "Oh, that's Archi." "Archie?" "We call him Archi because until very recently he was the archenemy (*archienemigo*) of this dog of ours." Archi could be the dog he had in mind when he wrote:

here we have the wife

 who owned the garden of the wind

and here is the dog

 who urinated on the garden of the wind

 of the wife

here we have the golden road

 to boundless devotion

 followed by the frightened dog

 who urinated on the garden of the wind

 of the wife[2]

Agustín's most recent novel, *Cerca del fuego* ("Near the Fire"), like many earlier works, is based on a series of related though autonomous fragments. It tells the story of Lucio, a writer, who cannot remember the last six years of his life. The novel is an account of his struggle to recapture his memories and , in the process, to purify himself by fire. The cover, a painting by Agustín's brother Augusto Ramírez, depicts a man on fire plummeting from the skies before the Mexican presidential

palace, which is flying an American flag and is also ablaze, an apt metaphor for the violence, misery, and hopelessness of Agustín's vision of contemporary Mexico City. The novel ends with a fragment entitled "Instructions for walking into fire, and what to do once there."

There are several techniques; here I will explain the so-called "quickie." First of all, you must remove your clothing; it won't do for them to be burned with you, even though the undershirt was Donovan's favorite; then you stand before the oven door, which is taller than you; open it quickly, and—this is important—without thinking about it, stand in the opening; the mere heat from the flames rising higher than your head will burn you, like fire leaping through exploding fields of corn.

Now that your skin and your hair have burned, and the odor is unbearable, get ready . . . set . . . hop right in! Everything melts, you realize that in a fraction of a second your blood has boiled, evaporated, your body has suddenly ceased to be, you have no eyes, and what you see is the fire consuming you, the flames you have become. You have no voice, you are fire now, and you are not burning, you are swelling with energy, you are an infinitely minute igneous spore; you are simultaneously contracting and expanding, you have before you celestial spheres, the throat of midnight, all landscapes, all times, you see the man who writes books, that is your stopping place.

Now, leave the oven, run, streaming a shower of flames, to the baths. Take a cold shower. Comb your hair, slap on lotion, and get dressed. Now you sit down at the typewriter, pound the keys, they respond, as always, you have to finish, to pull out what had been taking shape without your noticing, you have made possible the incisive reality that as it crystallizes seems so familiar, here it is, before you, neat in the precise formation of the words that compose and animate it, that give it life, inflame it, make it blaze enduringly, that print it on this page and make you see that, oh, yes, at last you have finished writing the book.

Selected entries from a glossary of Agustín slang (the words in brackets are the literal definition): *

acordeón [accordion]: cheat sheet

almejas, ponerse [clams, to become]: to get smart; to be on the lookout

azul [blue]: cop

billetero, dejar para [billfold, to leave like]: to beat to a pulp

canoa, hacerle agua la [canoe, to spring a leak in]: to be a homosexual

*Compiled by Stella Clark, in *José Agustín: Onda and Beyond,* edited by June Carter and Donald L. Schmidt (Columbia: University of Missouri Press, 1986).

¡clarines! [clarinets (punning with *claro*, sure)]: of course

chicle atómico [atomic chewing gum]: bubble gum

chueco [bowlegged]: crummy (*¡Qué chueco!: What a bummer*)

chupar [suck]: to booze it up

desmelenarse [lose one's *melena*, mane]: to go wild

doctorademelón [melon doctor (female)]: a "shrink"

epatar [borrowing from French, *épater*]: to shock

existencialoco [existential nut]: a "flake"

flamenco [Spanish dance]: "high" (on alcohol)

ganado [herd]: girls

grillos [crickets]: students involved in politics

iguanas ranas [iguanas frogs]: the same to you

loca, ser [crazy, to be]: to have "round heels"

lucha, hacerla [battle, to do]: "to come on to"; to "score"

¡mangos!: No way!

miau [meow]: maid (maids are also called *gatas*, cats)

moler [to grind]: to "bug"

paquete, aguantar la [package, to put up with]: to put up with a lot of crap

pintear [to drizzle]: to play hooky

plantar [to plant]: to stand up

polaca [tunic]: politics

politeco [polytech]: cop

potable [potable, drinkable]: good looking; "foxy"

puestísimo [very set]: ready to go; "hot to trot"

quemada [a burn]: great embarrassment; "put-down"

ranchero [person from the country]: shy; awkward

refriteador [person who refries something]: imitator; impersonator

servilleta, su [napkin, your (pun on *su servidor*)]: yours truly

tango: fuss; "scene"

tijeras, llevar las [scissors, to carry]: to tell someone "to cut it out."

transar [to compromise]: to keep illegally

vaciado [cast, in sculpture]: super; great

violín, hacer el [violin, to do a]: to make an obscene gesture

GRACIELA ITURBIDE

Mexico City, D.F. · 1942

Photography was not Graciela Iturbide's first career choice. Even as a girl, she had a camera and enjoyed snapping landscapes—"anything different"—but without any premonition that photography was to be her life. "I wanted to be a writer. I studied the liberal arts, but—well, I married when I was very young, and had my children." Those children are now young men, and Iturbide's domesticity has evolved into a peripatetic and conscientious investigation of the indigenous cultures of her land. At the moment, she has no permanent address. She sometimes lives among the Indian women she has photographed so beautifully and truthfully. She is a native of this city, however, and is obviously at home sipping her coffee beneath the umbrella-shaded table in a restaurant garden separated by much more than miles from the dusty village streets she has so sensitively and graphically recorded.

"I have always been very interested in the culture of my country," she says. "Always. So I have always tried to work outside the city. It has been a way that I, that I could know our culture, learn more, be closer to the people I so greatly admire. That was how I began my work—with native peoples. When it comes to the indigenous world, you have to remember that they are very much out-side the mainstream. There is, of course, that magical part, [Carpentier's] wondrous reality, that goes along with the exclusion, the exploitation. They've lived quite removed from civilization, because of lack of highways, and other reasons. There are the two things: the magical part, the fiestas, the rites—which fortunately still exist—along with the exploitation, which has been severe. I am interested in both. There is still a very strong culture and, currently, a sense that it must be rescued, an awareness in Mexico of what Mexican culture truly is."

After abandoning her first dreams of being a writer, Iturbide studied cinematography. Again her program was interrupted. After completing three years of a five-year degree, she met Manuel Alvarez Bravo. For a year and a half, in the early seventies, she served an apprenticeship with the master Mexican photographer, abandoning film to devote herself to photography. Although she decided not to pursue a career in directing or writing, it can be argued that her photography profits from cinematic and literary instincts. Iturbide believes that a photograph is a self-portrait, an expression of the photographer's individual dreams and sentiments. She accurately perceives the subjective aspect in the apparently objective

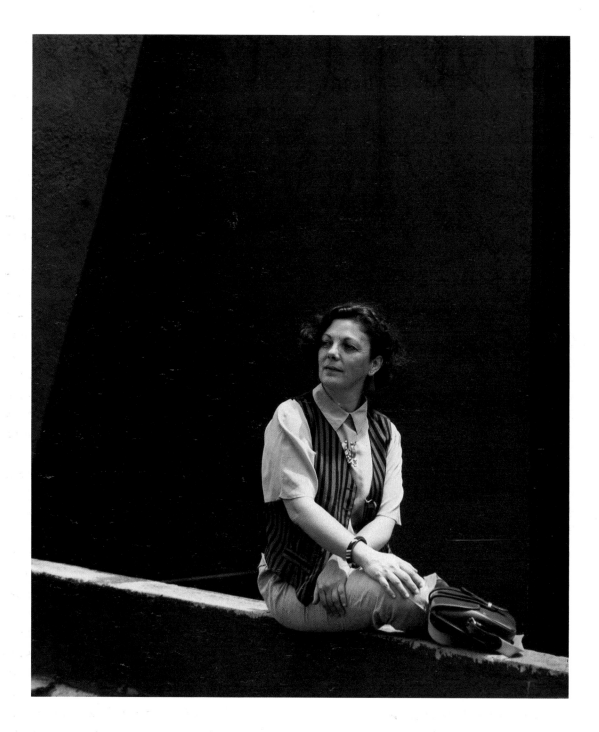

30. Graciela Iturbide

photographic image—some inner reason for the artist's choosing one representation of reality over another.

The young Mexican poet Verónica Volkow explored the interior world of Iturbide's image in her introduction to *Sueños de papel* ("Paper Dreams"). Dream, precisely, is the figure she believes best expresses the Iturbide image.

> The dream is ever present in the work of Graciela Iturbide, the dream as deviation or as will, almost always as necessity, the necessity to be other. More than observe, Graciela's camera seems to dream. . . . It is not strange, therefore, that the portrait is dominant in her work. Her portraits are not of the social being, however, but of man captured in his solitude. Creatures who stand before themselves, perhaps dreaming.

Dream and solitude. And the ultimate dream and solitude: death.

G.I. I'm working now on a project about the fiesta and death in Mexico: everything connected with how the Mexican plays and, in some way, what happens with death in Mexico.

Questioner I seem to hear an inescapable resonance with Octavio Paz's *Labyrinth of Solitude.*

G.I. Yes, I think death is an obsession we have, and that those of us who have a creative talent must understand what death means among our people. There are many fiestas, and many very peculiar manifestations, very special. Well, what I'm doing is, I'm traveling through small villages to see what can be said in photographs.

And Iturbide's photographs speak eloquently. Some photographs speak the language of an indigenous culture. A barely adolescent girl lies on a white-sheeted bed, surrounded by the red blossoms that symbolize her deflowering. *La señora de las iguanas,* probably the most widely reproduced of Iturbide's portraits, wears a bizarre crown of lizards above an impassive face. A white haired woman and a prepubescent girl hold aloft the styl-

ized five-fingered hand representing fertility; the fetish obliterates the face of the girl. And a woman in a flowering white skirt escapes across a craggy terrain toward a barren landscape. Arms outspread to maintain her footing suggest a cross. She is looking toward the ground; her bent head, her dark jacket, and hip-length black hair combine to trace a deathlike figure fleeing from (toward?) a rendezvous. But this woman-death is anchored to life by the weight of the stereo she carries in her right hand—death with a boom box. How different our cultures are.

And yet, even amid cultural specificity, Iturbide's women project universality. Two women, spraddled legs covered by voluminous petticoats, sit in a sparsely furnished room, chairs angled toward one another. The richness of skirts and shawls, the profusion of lace and ribbons and embroidery, attest to their standing in a specific community. But the earnestness of their gestures, the intensity of the dialogue that erases the presence of the camera, transcends ethnicity. These are two women engaged in female exchange. Substitute adornment, slightly modify the profiles, and these matriarchal figures can be inserted into any culture.

Graciela Iturbide delves deeply into the Mexican consciousness—especially the female consciousness. She is not only Mexico's finest woman photographer. She is Mexico's finest photographer of women. To achieve the rapport exhibited in her portfolio of indigenous women, she has had to call on not only her inherent artistry but her impressive patience and sensitivity as well. She has established bonds with these women, won their trust and friendship. The results are photographs that document an often hallucinatory world of death and misery, a magical grotesquerie that is the medieval *danse macabre* and the provincial dance of squalor. There are, in counterpoint, photographs of proud and free women, principally in the work on the women of Juchitán, in the

state of Oaxaca. Iturbide's collection documenting this matriarchal culture, *Juchitán de las mujeres* ("Juchitán, Town of Women"), was commissioned by Francisco Toledo and published by his Ediciones Toledo. The introduction by Elena Poniatowska rounds out a collaboration among three of Mexico's finest artists. In her playful and poetic commentary, Poniatowska describes the relationship that allowed Iturbide to capture such moving photographs.

Tiny, fragile, she stands beside the mountainous mass of lymph, water, and fat of the Juchitán women, who put their arms around her and lead her by the hand to the river to wash clothes and bathe. With them, she eats iguana stew and whips the chocolate and swigs beer beneath the noonday sun. They swing her in the hammock, taking care not to lose her, and at dusk they ask her to go with them to the cemetery or to stay with them as they braid their hair with bright ribbons, layer their petticoats and sashes, deck themselves with necklaces. Graciela, little anise seed, is part of all their rites, sesame seed in their *moles*, teardrop in all their weeping, crock for all their stews, sheet for all their beds, flea in all their pallets, froth on all their foaming beverages.

Graciela Iturbide, imager of the spirit.

30a. Graciela Iturbide, *Mujer Angel*, 1979, silver print.

Volkow on the Photograph*

A photograph has a strange association with reality; it is, and is not, reality. Reality has ceased to be reality; it has begun to exist in a different form while at the same time remaining profoundly faithful to itself. This process, which has always been the natural function of the imagination, has suddenly become the property of an *object*. Reality transformed, by an apparatus, to an image. The photograph surprises us by reproducing—more, perhaps, than his external reality—man's internal life.

Our first impression from a photograph is that it is a continuation of memory. Looking at a photograph is like remembering something we have known, or something witnessed by others. The photograph is a primary form of a strange common and collective memory, the deliverance of an ancient intimacy. The internal has become external; a photograph is the mysterious Sea of Solaris.

But the photograph has an immediacy that memory does not possess. Memory flees from us; the photograph seems to be approaching. Memory is evanescent, as if constituted of mist; the photograph, in contrast, suffers intense scrutiny. A memory can never be sufficiently substantial to bear examination.

Perhaps a photograph is more like our dreams. Like dreams, photographs appear; other, floating worlds appear. The dream is more immediacy than reality, and the photograph is more real than immediate, but both, upon further consideration, are linked by an extraordinary and unique truth: more than objects, more than phenomena, they are distinct dimensions of reality. Both are different, alternative immediacies counterposed to reality. They are not real, they are something else. Their very ontology is different.

Perhaps only the mirror is as mysterious. It thrusts us within ourselves. It transports us, beyond the here, to a parallel but other world, into a strange corridor of simulacra. An infinite, silent chess game. The photograph, also silently, leads us inside it, but its inner space is elsewhere: there is no here or now; it is another place beyond real space. The hole in reality, the photograph could be the first time machine.

Aside from reiteration, there is nothing truly strange in the mirror. Its world is *other*, but it is like our own. In our voyage into the photograph, on the other hand, there is always something that startles us. Something that makes us uneasy. It is alien to us; yes, despite its similarities, it is alien. The photograph has a different life, a life that is not ours

*From Verónica Volkow's introduction to *Sueños de Papel*. Colección Río de Luz. Mexico City: Fondo de Cultura Económica México, 1985.

but its own, only its own. Seeing it, we are envious, stupefied. It comes out of our existence, but it exists outside of time. We are left breathless; it has removed time from those rooms, from those landscapes. Here is another world with faces, animals, roads, realities, fictions, but one devoid of becoming, a mute world untouched by events. The essence of the photograph is an unimaginable fixity, a miraculous permanency. The photograph, above all, is a phenomenon of time.

A photograph, mysteriously, is never a self-contained object. As Roland Barthes has pointed out, it flows outward; it perforates its own skin. Like Klein's enigmatic bottle, the photograph's content overflows the space that contains it; its surface cannot be apprehended. It originates in itself. Its inwardness is also outwardness. It is the sign of one side and the reality of another. It is word and it is thing. In some way, the photograph is the most perfect of epistemological objects; no idea, no concept, no theory, no image fabricated by man contains this potentiality—to be both direct imprint and image, to be both interiority and exteriority, to be and not be reality. The photograph is the dream dreamed by intelligence. It requires no verification; it disdains the blind premises and the a priori suppositions of meticulous methodologies. It mocks, in its instant, man's zealous labors in pursuit of his thorough but indecisive quest for exactitude. Effortlessly, the photograph has been infused with reality. It is, quite simply, a new organ of the senses, something akin to a different eye inside the eye.

It is as if we could travel many roads without altering our destiny; as we follow Oedipus, the photograph permits us to stay in place. It is, in the last word, like walking into a dream that is not a dream. And in its invitation to reality, as much as in its equivocal denouement, the photograph forces us to retrace philosophy's centuries-old journey in the impossible search for the space of the reality that lies behind ideas and senses. The photograph is an inward journey and an impossible movement outward, by means of paper and image, through and against interiority. We are like Orpheus pursuing Eurydice into the depths of Hades. The photograph has become a new theater of ontology. It literally re-presents reality in the timeless interplay of fictions.

PABLO ORTIZ MONASTERIO

Mexico City, D.F. · 1952

I have a strong impression that black and white photography better suits our reality, which is painful and dramatic. Somehow, black and white is a more symbolic language than color.

For me, the book is clearly the publication in which photography works best.

Those two statements from a 1987 interview in *Aperture* articulate the ars poetica of Pablo Ortiz Monasterio, representing his philosophy as an artist and as an editor and publisher. As an editor, Ortiz Monasterio helped initiate the ground-breaking Río de Luz series of high-quality photography books intended to reach a large audience. The handsomely produced and edited volumes exhibit the work of an individual artist or bring together a thematic collection. The results are truly exceptional. In his own work, Ortiz Monasterio's search for his subject matter has taken him great distances, both temporally and geographically. He shaped one series of photography around the life of a sixteenth-century Italian surgeon, Gaspar Talliacotti. He created one experimental narrative focused on the inhabitants of a Greek village and another photographic account of Portuguese subjects. Following the Latin American intellectual's traditional pattern of jour-

neying abroad to gain new perspective on his native land, Ortiz Monasterio returned home to record various planes of the many-faceted Mexican reality. One project has been to preserve for posterity cultures that are in danger of disappearing, specifically, the worlds of the Huave and Tarahumara Indians. He has collaborated with Graciela Iturbide on a project called Los Vecinos (Neighbors), a documentary study of intercultural relations on the Mexico–United States border. The venture involved photographers from both nations and focused on the border towns of San Diego and Tijuana.

"I want to go back and work with one particular fellow," Ortiz Monasterio says, "one connected with the *maquiladora* industries [assembly plants on the Mexican side of the border]. He's wealthy and lives in La Jolla. I want to photograph how rich Mexicans live, some of whom live in the States.

"Tijuana is growing a lot. There are lots of jobs; it's very active, very dynamic. It's filled with contrasts. It's a very Mexican city. American tourists don't really see Tijuana. They go to one street, to shop and go to bars and pick up girls. The young kids show up on Friday and Saturday afternoons and get drunk. It's good business, but there's a lot of resentment. You know, it's interesting. We here

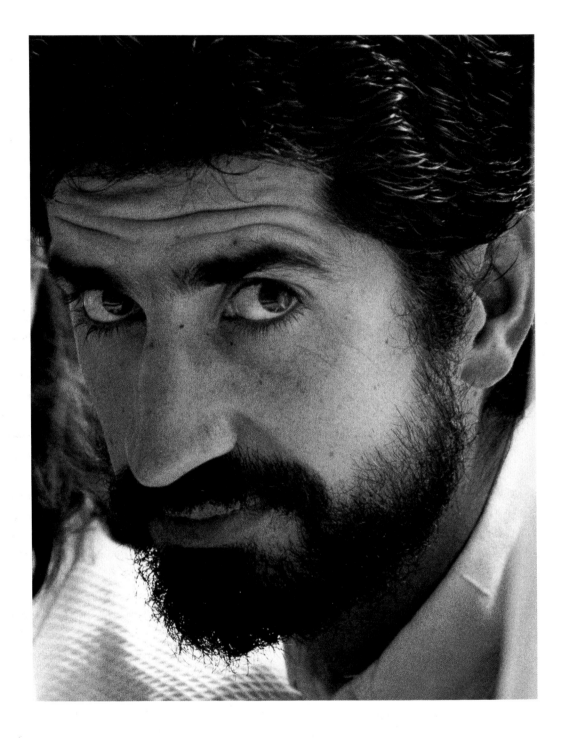

31. Pablo Ortiz Monasterio

in the center of the country thought these people on the border were losing their identity. No way. They are much clearer about it than we are. They have to fight this thing—nationality, whatever it is—every day.

"The Mexicans in Tijuana are selling North Americans the Mexico of the fifties—the serapes, the whole bit. You can still get a quickie divorce. It's the Mexico Hollywood created, the one American people expect to find. The Mexicans say, 'You want the fifties, we'll give it to you.' I saw a photographer with a donkey and an old-fashioned camera. You don't find that anywhere else in Mexico, but people want 'the real thing.' It really is like going to the movies. It's not Mexico, it's the Land of Cheap Dreams."

Ortiz Monasterio is a great admirer of Graciela Iturbide. He edited her *Juchitán de las mujeres.* He worked with her on the San Diego–Tijuana project. In fact, there had been a possibility that she would join us, that these two united by common photographic interests would be joined now on the other side of the lens—subjects, not the discerning eye. But Iturbide is leaving for San Francisco; today she will not step through the looking-glass lens. In her absence, Ortiz Monasterio asks to be photographed with his twin baby girls, Julia and Leonor. He clearly shares the photographer's nearly universal aversion to becoming created object rather than creator.

Ortiz Monasterio's best-known work is a collection entitled *Los pueblos del viento* ("People of the Wind"). This chronicle of the Huave, one of the few Indian tribes whose livelihood is centered around fishing, documents the surreal world of a people trapped between historical and contemporary times. The Huave exist both in their ancestral world—they tell that long ago they sailed from Peru up the coast of South America to settle along the Oaxaca coast—and in the electronic age, and they subsist in an area of inland saltwater

lakes and land that more closely resembles a moonscape than a portion of this earth, a land of constant winds, where the fronds of the palm trees "are always combed toward the south." The primary impression from the photographs is one of wrenching penury. A young female teacher perches on a battered table in a schoolroom furnished with one blackboard, a catch-all cabinet, a bucket, a broom, the table, and two unmatched chairs. A seemingly mesmerized mother, accompanied by an older woman, holds a young infant. She is sitting on a bed covered by woven palm matting; a few rags and scraps of clothing complete the furnishings of the palm-leaf hut. There are signs, however, of the industrialized world and of sporadic affluence. A guitar-playing youth sits in a hammock strung in a dirt-floored, thatch-walled room featuring a large electric range (with an oven that appears to be used as storage) and a television ensconced like a chalice on a goblet-stem base. And the camera still captures instants of beauty. A young boy in the middle distance of a vast landscape walks toward the camera. He appears to be skiing across gentle, snow-covered hills. It is only on closer inspection, when one notes the bare chest of the boy and recognizes that the pale light originates from the sun, that the snow turns to white sand. In another moment of breathtaking magic, a spotlighted night fisherman stands knee-deep in water that blends imperceptibly into an inky sky. The staff in his hand lifts a fine net from the milky water of the illuminated foreground: the papery translucent wing of a monstrous insect, the gossamer dorsal fin of a giant fish, the radiant tail of a miniature comet spraying threads of tiny stars across the black sky.

"The camera doesn't lie," Ortiz Monasterio answers in response to a question about prints of his current work that seem to portray an impossible reality. "It doesn't have to be blurry; it can be sharp. This is photography. Full-frame, thirty-five

31a. Pablo Ortiz Monasterio, *Pescador Huave,* 1980, silver print.

millimeter, straight photography. Everything is real—even the things we dream." And now he is applying that real magic to a documentary on Mexico City. "It will show how it feels to live in a city like this—the violence of the city, the catastrophe. Not only things like floods or earthquakes but the everyday reality."

PATRICIA QUINTANA

Mexico City, D.F. · 1946

An army travels on its stomach. The way to a man's heart is through his stomach. From individual to institution, no man or woman is exempt from the need for food and, once need has been satisfied, for the pleasure provided by good food. When we are away from home, among the things we miss most are familiar dishes. What we know of a people often is what we know about its cuisine. We North Americans have appropriated the culinary essences of many cultures, claiming them as our own. A cuisine we think we know, but one we have badly misperceived, is that of Mexico. Patricia Quintana is eminently qualified to dispel that misconception, a culinary expert who lectures, writes, and teaches that tacos and burritos do not express the range of Mexican foods and who demonstrates that the riches of the Mexican table deserve to be ranked with those of France, Italy, and China.

Patricia Quintana is the author of two cookbooks, *El sabor de México* (The Taste of Mexico, 1986) and *Fiestas de la vida* (Mexico's Feasts of Life, 1989). These books offer more than an array of delicious national dishes; Quintana presents descriptions of Mexican culture, traditions, and festivals along with the rich diversity of its fare. She demonstrates how specific dishes are related to marriage feasts, market days, religious celebrations, and national holidays. Quintana studied in Paris with the renowned chefs Michel Guerard and Gaston Lenôtre. Her own cooking is a sophisticated and subtle blend of European and native styles. She is concerned, however, that traditional Mexican dishes are in danger of dying out, so she and other Mexican experts founded the Círculo Mexicano de Arte Culinario (Mexican Circle of Culinary Art) to document and preserve classic Mexican cooking. Quintana has served as chef for the Ministry of Tourism; she writes columns for the Mexican edition of *Vogue* and for a major Mexico City newspaper, *Novedades;* she has run her own cooking school in Mexico City since 1980; and she leads culinary tours in which participants visit a variety of restaurants and markets, prepare native dishes, and absorb the culture and customs of Mexican life.

Patricia Quintana is concerned with the total ambience of gastronomy. When she presents one of her dishes—as she did at our request among pottery and textiles from the state of Michoacán, which gives the handsome shop in the Polanco area of Mexico City its name—she creates a microcosm of a place and an event, in this case, a christening brunch. To provide the flavor of the

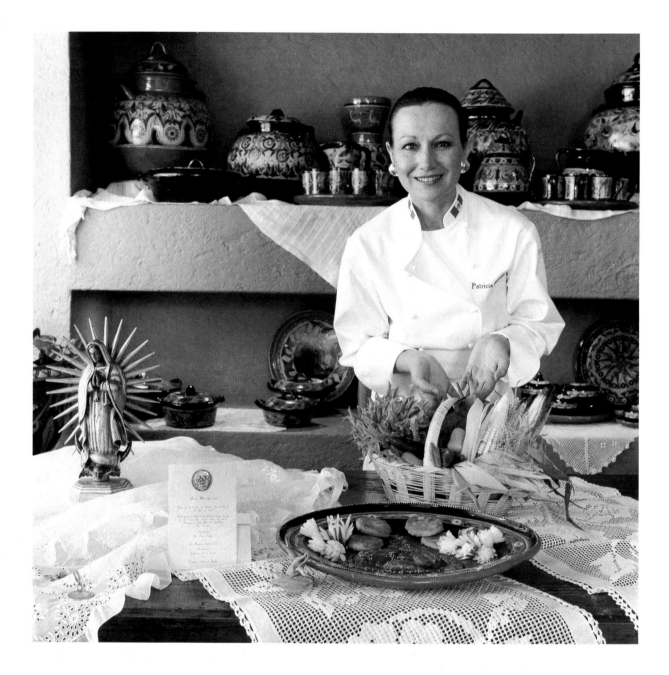

32. Patricia Quintana

occasion, she adds to the table a christening gown, gifts, a small gold locket, a prayer book— all the familiar objects that create the atmosphere of that special moment in Mexican family life. The *mole* she has prepared is arranged on the plate with great artistry. The yellow squash blossoms that are a staple in Mexican cuisine are, in their basket container, more a bouquet than an ingredient. Photographs and words can partially convey the artful presentation of food. Only by tasting the dish, however, savoring the aromas and experiencing the pleasure food brings to the palate, may one truly appreciate the art of a great chef.

A mole [pronounced *mo*-lay] may vary from region to region; basically, mole is a spicy sauce served with turkey and created from a variety of ground ingredients that may include chilies, chocolate, cinnamon, nuts, pumpkin seeds, sesame seeds, prunes, plantains, and charred tortillas. Quintana writes that

> the moles of Puebla, for example, are sweeter and milder because of the influence of the Spanish nuns. The moles from Santa Ana Chautempan in Tlaxcala are hotter, slightly thinner, and smoother than elsewhere. When the great Aztec ruler Moctezuma was at war with the people of Tlaxcala, he punished them by withholding their ration of salt. Perhaps it was then that they began to use honey, fruit and hot chilies in their moles. Oaxacan moles are best known. Among them, black mole is probably the most famous.

To the average North American, mole sounds like an exotic dish. During the centuries following the encounter between the Old and the New Worlds, however, we have lost sight of the exoticism of foods we now take for granted, foods unknown to the remainder of the world before the arrival of the Europeans. It is difficult to imagine what meals would have been without such staples. The tomato, for example, was domesticated in Mexico and taken to Europe following the Conquest where for two hundred years the Italians were the only Europeans to eat it. Corn is native to this hemisphere, as are potatoes, sweet potatoes, pumpkins, squash, and kidney and black beans. The turkey, called *guajolote* in Mexico and *pavo* in Spain but misnamed in English in a confusion with its cousin the guinea fowl, is native to Mexico. And legend has it that in a similar misidentification Christopher Columbus mistook the chili for the Asian peppercorn, hence the misnomer "chili pepper." Spices like allspice and vanilla are native to the Americas, along with the avocado, the pineapple, and an endless variety of fruits, many of which only now are becoming known in North American produce departments. And finally, we owe a national passion, chocolate, to the pre-Hispanic cultures of our hemisphere. The Maya first carried cocoa beans to Mexico. Moctezuma served golden goblets of a honey-sweetened beverage called chocolatl to Cortés. Cortés carried the beans to Europe, where they were acclaimed by Spanish aristocracy and their cultivation monopolized for nearly a century. The Spanish princess Marie-Thérèse presented cocoa beans to Louis XIV as an engagement gift. Thomas Jefferson praised "the superiority of chocolate, both for health and nourishment." Baker (1765), Nestlé (1875), Lindt (1879), and Hershey (1893) added their refinements to the bean. Today the per capita consumption of chocolate in North America averages eleven pounds per year, a long way from a frothy Aztec brew served by royalty as a sign of hospitality.[1]

Few people are better informed on the history of Mexican dishes than Patricia Quintana. In gathering information for her books, she traveled through every region of Mexico. In a novel in progress, she describes, with the appreciation of an art historian, her encounters in search of the riches of a limitless cuisine.

I delved ever deeper into information about pre-Hispanic cuisine, and into histories left by the scribes of the priests, from [Bernardino de] Sahagún to Bartolomé [de las Casas], who made notes, and occasionally drawings, of everything they saw. I studied the Codices, the significance of the maize-made-god, and of cocoa, the elixir of the deities, made fragrant with *ixtlixochitl* and *xanath*, the legends and stories and presences of which our peoples have left records in their crafts and their gastronomy. I learned the diversity of dishes of the magical lands of Oaxaca, their chilies, their seven moles, their herbs, their cool fruit drinks, their mouth-watering cheeses. I tasted stews in San Cristóbal de las Casas, and the round cheese of Ocotzingo; admired the beautiful woolen skirts and colorful blouses of women who, with their young children, the woven baskets on their backs braced with leather head straps, carry carrots and kindling twenty or thirty kilometers to market day; watched the parade of Indian art on water jugs borne on the shoulders of women making their way among the stalls; wondered at the enormous vegetables, larger than any I have ever seen, grown by Indians on the changing climatic zones of the mountain slopes; noted the red beans, black beans, chilies of many varieties: subtle aromas blending with the savor of roast pork and smoke from clay vessels filled with maize. I traveled to Veracruz with its many cuisines flavored by the European influences of Italians, French, and Germans. I experienced the meeting between savory Totonac and Huastec dishes: *Zacahuil, bocoles,* enchiladas, *guajes, pico de pájaro* chilies and heart of palm, squash tamales with dried shrimp, all the riches of the open-air markets of Santa María, Chicontepec, Huejutla, Tamiahua, with its freshwater fish from the lakes and the Pantepec River washing the shores of Alamo and Chapapote. And to the south, Yucatán, the spell of its smiling women in their beautiful huipiles, displaying mameyes, *chayas,* and special blends of spices, bathed in the tang of an endless variety of broths and stewpots, young pig and chicken in spiced marinades, venison roasted in an underground oven, the white masa for the pozole sold in great round balls kneaded and shaped by the dark hands of Indian women. Time stops, as it does in the ruins of Uxmal, where in the Patio of the Nuns the prayers of mysterious spirits rise upward along with flocks of fluttering birds and the mysticism of the Maya is joined with essential human magic, the rite of Quetzalcoatl and the Jaguar Warriors of Chichén-Itzá, the enchantment of the cenotes with their legends of young girls sacrificed to the gods. Tulum, blown by ocean breezes, mirroring memories of the era of Chichén, when every spring the serpent descends [the stone steps symbolizing] its voyage from heaven to earth and becomes one with the eagle and the serpent, with the myth of Monte Albán and the legacy of the Olmecs, with the astronomy of the Maya people, their rationality, their knowledge of

the concept of the zero, and of the infinity of the soul and the cosmos. History paints the legendary gastronomy of these peoples who domesticated plants in the Valley of Mexico. At the hour of the Conquest our culture was subjected to the designs of new thinking in religion and gastronomy; colonial customs, the fusion between clay and copper cooking pots signifies a cuisine growing richer and more baroque through time, through the union of two cultures. As cultures blended, united in the mysticism of their encounter, pagan festivities joined with Christian ritual. Ingredients were enhanced with the addition of milk, almonds, olive oil, olives, wheat, and with the confections of the gentle hands of the nuns: *mamones, pepitotias, capirotadas, dulces de leche* with walnuts and almonds. To mark our independence the famous *chiles en nogada* were created, the white sauce and green chilies, piñon nuts and pomegranate seeds, repeating the red, green, and white of the Mexican flag. Over wood fires, cooking and cuisine were created by women who rose at 4:00 in the morning to begin laying out their ingredients, to start the morning boiled coffee and breakfast bread. What variety of customs: the symphony of singing pots bubbling in old haciendas of Hidalgo, when the ritual pulque and honey brought strength to the hearts and heart to serenades, where amid carriages and silver-bedecked charros weddings were celebrated with great outdoor pit barbecues; the pulque bread of Tlaxcala and mole of Santa Ana Chautempan; all the subtleties born of woman's imagination, the witchcraft of the fire under the clay cooking pot, the indigenous metate, the comal and the art of the tortilla, the masa made from the maize, holy grain mediating between heaven and earth, indigenous salsas and aromas of cilantro and the green tomatillo, the savor of fresh cheese with the bite of *pápalo*, weekly open air markets, cavernous enclosed markets, fiestas—all the vigor of the blessings we take from the earth.

GLOSSARY

bocoles corn tortillas cooked with black beans, cilantro, cracklings, or cheese

capirotada dish consisting of meat, corn, cheese, and spices

cenote deep natural wells into which offerings were often thrown

charros expert horsemen

chaya plant with smooth, dentate leaves eaten as a vegetable

cilantro coriander

comal large, flat, clay dish on which tortillas are cooked

dulce de leche milk custard

guaje gourd formed of two nearly round spheres connected by a short neck

huipil rectangular weaving with a slit for the head, worn as a blouse

mamey fuzzy brown fruit with coral-colored flesh and shiny black pit

mamón cake with egg and cornstarch

masa basic dough for tortillas

metate stone with concave upper surface, used for grinding and pulping

pápalo leaf or fruit of the *Bauhinia* genus of plants, often called "cow foot" or "goat foot" because of resemblance to cloven hoof

pepitotia sweet paste made of squash seed and molasses or unrefined sugar

pico de pájaro long, thin chili

pozole masa formed into a ball in preparing a beverage

tomatillo resembles a small green tomato; actually a type of ground cherry, with lemony flavor

zacahuil small pig in a crust of masa dough and red chili, wrapped in banana leaves and cooked in its own juices

ISAAC VASQUEZ GARCIA
HERLINDA AND FELIPE GUTIERREZ

Teotitlán del Valle, Oaxaca

Colors are an integral part of human culture, and they have been the subject of philosophical enquiry from the time of Aristotle. The use of pigments, chiefly red and blue, is known from the late Paleolithic in the Old World, and there is no ethnographic record of a people without a sense of color. Powers of [color] discrimination appear to correspond with cultural level generally. Colors . . . are often associated with particular moral or spiritual qualities, with objects of religious veneration, and with rank and position or caste. In many parts of the world, colors are or have been used to represent the four traditional elements and the four cardinal points. Among the ancient Mexicans, red stood for east (or west), white for west (or east), blue for south, and black for north; four kinds of rain, controlled by the god Tlaloc, were also given color emblems. The contemporary Maya identify the cardinal points with different combinations of black, white, yellow, and red. Almost everywhere, red as the color of fire, the sun, and blood (and thereby life itself) has unusual significance, symbolizing magnanimity and fortitude, majesty and power, both temporal and supernatural. In Nahuatl, *tlapalli* denoted "color" in general and "red" in particular (similarly, in Spanish, *color* and *colorado*). The hieroglyph for the village of Tlalpan (eastern Guerrero) was "a circle with the interior painted red . . . and containing the mark of a human footprint." Thus to give colors phonetic value was very unusual, if not confined to Mexico.[1]

185

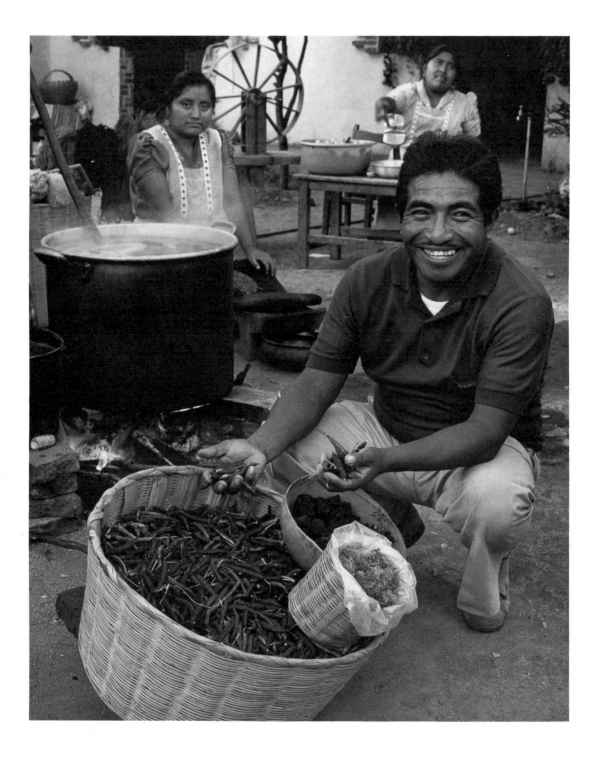

33. Isaac Vásquez García

That excerpt from an ethnogeographical study of cochineal illuminates man's eternal fascination with color and the concomitant use of color for enlivening our daily lives. Nature has provided the gamut of the color spectrum, and indigenous peoples have always learned to coax marvelous dyes from sources as varied as flower stamens and seashells. With the advent of chemical dyes, Mexican weavers, artisans of all kinds, found an easier way to color their crafts. But some purists—we may well think of them as pure artists—have abandoned the harsher, flashier colors obtained from artificial agents and returned to the natural dyes of their ancestors. Among them are a few weavers from the village of Teotitlán, in the Valley of Oaxaca. One of these weavers, Isaac Vásquez García, has made a concerted effort to research centuries-old coloring techniques. He is a walking textbook on the subject and eager to share his information. The story of the cochineal, the insect from which a brilliant and durable red dye is extracted, is among the most fascinating examples of man's artistic ingenuity. The cultivation of the cochineal, or *cochinilla,* was a major industry in colonial Mexico, and early illustrated documents identify the insect's natural enemies and depict how the insect was harvested from its host, the nopal cactus. The practice is dying out now, however, and weavers are having to go farther and farther afield to obtain the quantities they need. When we visit Don Isaac in his well-organized home and workshop, he shepherds us through the engrossing process of extracting the prized red from the innocuous-looking cochinilla insect.

Questioner Do you cultivate any cochinilla yourself, or do you have to buy it all?

I.V.G. We don't have many nopales, and they yield only a few cochinillas, not nearly enough for our work. Since we use red in almost all our weaving and cannot produce enough to meet our needs, we buy most of what we use in Peru. It's the best; the climate is very favorable there. You used to be able to buy cochinilla in a museum [shop] in Mexico City, but lately we haven't been able to get it there. The cultivation of cochinilla is being lost everywhere.

Q. We would love to see how the cochinilla is produced, especially since the process is in danger of disappearing.

I.V.G. Well, you see here we're using *hoja de tejute* as a fixative for the dye. This is the old way. We tried using chemicals instead of the tejute leaf or limón, but the color doesn't come out right. It's much better with tejute or limón. We've experimented with many combinations. I began weaving when I was twelve, and I was fifteen when I began my research on natural and chemical dyes—making comparisons. And it was clear to me that the best results come from nature, like the cochinilla. So we stopped using chemicals. And I set out to learn what makes the very best colors, because every herb, every plant, dyes—they all give color. But they don't all look good or last. I researched all the pre-Hispanic codices. I learned that the Zapotecs and Mixtecs used four basic colors. That's all—four. They used cochinilla for red, indigo for blue, huisache for black, and rock moss for brown and yellow. With these four colors, they achieved more than forty tones.

Q. What is a huisache?

I.V.G. It's a thorny plant [an acacia tree] that grows wild around here. It gives a fruit, a pod, that contains the beans from which we get our blacks and browns. This is huisache. And here are some cochinilla.

Q. Oh, they're dried. Are they dried in the sun after they're harvested from the nopal?

I.V.G. No. First you kill the insect in hot water. You put them in a cotton sack and dip them in boiling water, or in steam. They die in the steam.

Q. And then they're dried?

I.V.G. And ground to a powder. I have a tub here ready to show you. I'm going to put the cochinilla

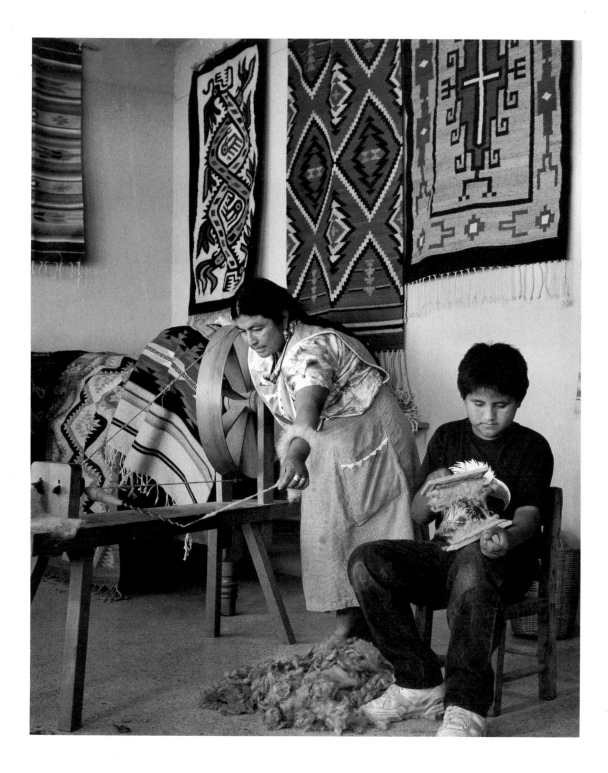

33a. Herlinda Gutiérrez Sosa and son, Felipe

in the water where the rest of the ingredients are boiling—the juice of the limón and a handful of tejute leaves, to set the color. You see that it's dark now, almost purple, but with the limón it will change color. This has been simmering for half an hour.

Q. How often do you do this process?

I.V.G. We do it every month. We are doing this little bit today to show you how it's done. Now we are ready to add the wool.

Q. Do you put it in all at once?

I.V.G. Yes, everything at once. It goes very fast. The wool will get darker and redder in a minute. Now this pot has the huisache. We want the wool with the cochinilla to boil for an hour more, for a deep, deep red. And the black will get blacker. Boiling and stirring, this is the process.

This abbreviated demonstration, the boiling and stirring and talking, has taken several hours. It is not difficult to understand why most weavers substitute easily acquired chemical dyes for the laborious process of which we have witnessed only the culmination. Vásquez shows us various containers of the indigo and moss used for the blue and yellow families of colors. We know that orange peel will provide a different yellow, and oak bark, rose or pink. We have also read that aged human urine, combined with the cochinilla, results in delicate tones of lavender. There seems to be no end to man's ingenuity.

We are curious about whether the dyes have other uses. Are any of them used as herbal remedies or medicines? "No, only to dye." The Japanese, though, use cochineal for cosmetics. In answer to another question, Vásquez laughs. "No. Even though it makes such a pretty color, it doesn't taste very good." After his instructive briefing, we appreciate all the more the magnificent rugs and tapestries in the showrooms where the Vásquez weavings are displayed, in a building across the courtyard from the weaving rooms.

Q. I am sure you have been teaching your children, Don Isaac.

I.V.G. Yes. I have eight, three boys and five girls. I have taught them as my father taught me. The tradition has been handed down from generation to generation.

Q. About how many generations of weavers have there been in your family?

I.V.G. Oooooh, many. Many. Many years of weavers.

Q. Hundreds?

I.V.G. More—maybe a thousand. From the beginnings of our village.

That village, of course, is Teotitlán del Valle, which has been a town of weavers for as far back as communal memory reaches, one of the hundreds of Mexican villages in which the craft of the parent is handed down "from generation to generation." Those are the same words we hear from Felipe Gutiérrez, who with his children and wife, Herlinda Gutiérrez Sosa, also produces magnificant weavings. We arrive, unannounced, just at the beginning of a five-day celebration for the wedding of the oldest Gutiérrez daughter. We are welcomed with warm hospitality, absorbed into the festivities, and seated at one of many tables to participate in the wedding feast—the best mole we have ever eaten and excellent Mexican beer— an unexpected, and unforgettable, demonstration of Mexican courtesy. As we leave, we make an appointment to return three days later, when we again see and hear evidence of the proverbial Mexican family traditions.

Q. We assume, Don Felipe, that you were taught by your parents?

F.G. Yes. I learned from my mother and father, and they learned from their mothers and fathers, and their grandmothers and grandfathers.

Q. Many generations.

F.G. Oh, as long as the pueblo has been here. Generation after generation, working with wool.

Gutiérrez is teaching his son, also a Felipe, who sits beside his mother carding wool. A continuous, rasping sound fills the workroom with a rhythmic *rac, rac, rac.* The Gutiérrez family, like the Vásquez Garcías, relies on natural colorings to dye wool. And from them we learn the arduous steps of preparing the wool for the bath of dye. Except for purchasing the wool, which is done by the male members of the family, there is no division of labor by gender. Everyone knows how to do everything, from preparing the wool through the weaving. The children work when they are not in school, and Don Felipe tells us that he began working when he was seven, although eight or ten is the average. The dyeing is left to adults and older children, because of the danger of scalding a young child. The weaving, Gutiérrez says, may be the easiest part of the whole process—"Not that anything is easy." Carding and spinning, forming the skeins, dyeing, washing the finished weaving to set the threads even more tightly, all are difficult and time consuming.

Q. So, after you buy the wool, what do you do first?

F.G. We carry the wool to the river (there is no reliable water source close at hand) and wash it. We put it in baskets and wash it in the river.

Q. With any agent? Soap?

F.G. No, nothing. Just water. Then after the wool is dry it is carded. And after drying and carding, we make the large balls of yarn, then skeins, so the wool doesn't get tangled. Here, I'll show you one. We make the skeins according to each project, the amount we need for the work we have in mind. These are different tones of red that we have dyed with cochinilla. Or if the design calls for blue, we use indigo. Here's some of the blue. Always in these big skeins to keep it from snarling.

Herlinda Gutiérrez is at work at a large loom that she operates with foot pedals, placing the weft threads by hand and combing them down compactly. Before the arrival of the Spanish, Indian weavers worked on backstrap looms, which are still used by some weavers. Most of the walls of the Gutiérrez workrooms are covered with magnificent examples of their artistry. Many of the geometric designs are centuries old, the diamonds and triangles and rectangles that appear in crafts throughout the world. Nature motifs are also prevalent: birds, jaguars, butterflies, flowers. Some tapestries incorporate figures from pre-Columbian codices. The weavers of Teotitlán have also included in their repertoire patterns from other indigenous cultures, principally Navajo, which they have learned from books. A simple rug may be completed in a relatively short time, perhaps four weeks. A large or complex weaving may take over a year.

"Most of our work is our own combination of Zapotec and Navajo designs," says Don Felipe. "This one is an original Zapotec design. When we make a new design, we put it on paper [like a template]. After two or three times, it is perfectly engraved in our minds. Once begun, though, we have to follow the design. Certain rules must be followed. For example, if you begin with the *grecas* ["Greek key"] taken from the stone facades at Mitla, you can't change to different grecas. That rule does not apply to a free pattern—a landscape or original weaving. There you can do anything that's in your imagination. But the geometrical motifs cannot be changed."

We do not know how long the weavers of Teotitlán, the children and grandchildren of the Gutiérrez and Vásquez families, will continue the craft of their ancestors. For the present, at least, some few artisans are consciously conserving the practices that were begun long before the historic Encounter between two worlds.

RUBEN BONIFAZ NUNO

Córdoba, Veracruz · 1923

Rubén Bonifaz Nuño is a study in contradictions: a scholar whose rational and edifying studies are counterposed by poetry that is often impenetrably hermetic; a poet whose muse may be "more delicate than the small flowers with which I sometimes adorn you" or, alternately, "coiled with taut power, beautiful, with scales like feathers . . . cold rattles resounding, three-pronged tongue vibrating"; a man whose dark pin-stripe exterior masks a fierce pride in Mexico's indigenous past. Bonifaz Nuño is the author of more than forty books, an educator, poet, anthropologist, translator, editor, and administrator. It is highly appropriate that his center of operations is his office in the fabled main library building of the National Autonomous University of Mexico. The colorful mosaics covering the four sides of this ten-story building, rising like an enormous, intricate cloisonné matchbox in the center of the grounds of the Ciudad Universitaria, are familiar to anyone who has ever received a postcard from Mexico City. The north and south faces of the library depict, respectively, Anáhuac culture (Mexico before the arrival of Cortés) and colonization by the Spaniards. The symbolism of that cultural dichotomy, of the two worlds that shaped contemporary Mexico, is applicable to this poet-scholar whose work is filled both with echoes from the European heritage of his beloved Latin authors and with allusions to the symbols and figures of pre-Hispanic peoples.

The University of Mexico is a story in itself. A student who enters with a good secondary-school record may follow a full schedule of classes at a tuition of less than five dollars. University education is, in theory and in practice, free. Mexicans have not been slow to seize the opportunity.

Questioner It is very beautiful here. You see a lot of students but, surprisingly, not the hordes we expected to find.

R.B.N. Yes. We have 350,000 students enrolled; here in the University Center, 125,000. With professors, the total numbers are 400,000.

Q. We were discussing on the way here that the hundreds of thousands of students currently in the educational system will surely bring about change.

R.B.N. Education is the single, the only answer to our problems. Things must change.

Q. Are there not terrible problems in preparing enough teachers?

R.B.N. My God, yes. When I entered the university—although I'm aware that that was some time ago—we were 20,000. That included everyone,

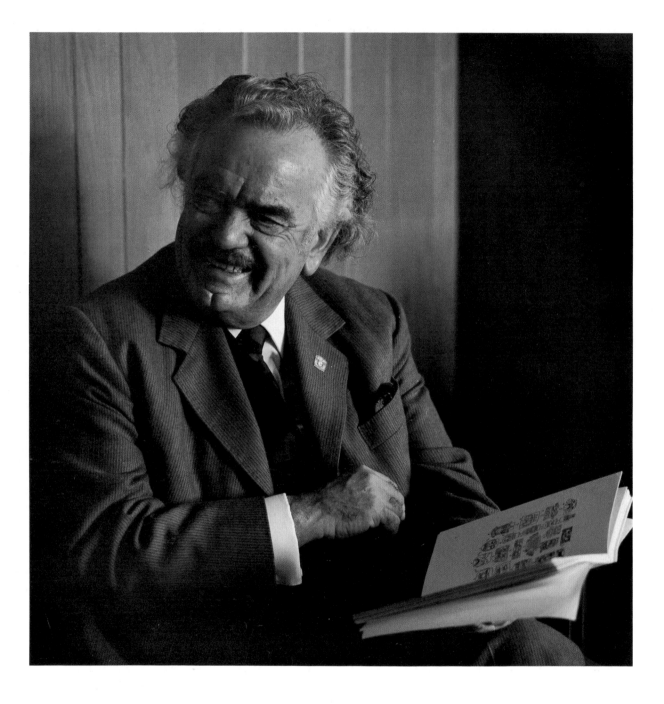

34. Rubén Bonifaz Nuño

undergraduates, everyone. The finest intellectuals in Mexico were fighting to teach a class. I had the best minds in Mexico for my teachers—and that was in preparatory school, not the university. I owe my entire academic formation to the two years in those classes. And now, we are losing a generation of students. If you could only see the textbooks being used to teach children in the primary schools. In a social science text, for example, you will find absolutely shameful concepts. Children are taught that the superiority of one man over another is based on race, that a white man is superior to one of color.

Bonifaz Nuño is obviously obsessed by problems of social injustice, without ceasing to be the person he is, a sophisticated intellectual. His scholarship is impeccable; his poetry is characterized by a precision that approaches the elegance of a mathematical theorem. For decades he has studied, taught, and translated Latin, the ancestral tongue of Spanish. But underlying the European base of his professional life run deep currents of true passion, a burning nationalism based on restoring the stature of the pre-Hispanic past and, with that restitution, reaffirming the dignity of each and every Mexican. "Look, we Mexicans, and I'm speaking of eighty million people, have for centuries been defined officially as mestizos [persons of mixed racial heritage]. That is how we are referred to as a people. Can you imagine? To define a man on the basis of his race? And, after defining him on that basis, categorizing him as a member of a race that is inferior? That is what happens here in Mexico—to everyone. So, the only thing we have that is uniquely our own is our indigenous, pre-Hispanic past. Everything else was brought here from another hemisphere. It was imposed on us. And how shall we defend ourselves? By turning to our pre-Hispanic origins. Not by a return to the past. Rather, I seek the grandeur of that past to lend dignity to our lives today."

Bonifaz Nuño's near-hostility toward Spanish-European influences in Mexico would, if carried to its logical conclusion, be a denial of his own professional and personal heritage. The urgency of this duality is borne out in many ways in Bonifaz Nuño's poetry. On the one hand, there are the meticulous translations from the classics and the poems that derive from traditional Western and Christian influences such as Shakespeare, Catullus, and the Spanish Renaissance poets Fray Luis de León and Garcilaso de la Vega; on the other, lines that might have been written by the Aztec poet Netzahualcóyotl. A recognition of the centuries-old conflict between the cultures of the Old and New Worlds may explain what critic Frank Dauster has called "irreconcilable forces and an inner duality" in his work.

Bonifaz Nuño is one of the most highly regarded of Mexico's poets. It is surprising, then, that in our conversation he so cavalierly disavows his dozens of books of poetry and poetry translations to state that in his opinion "the only important thing" he has done in his life consists of the anthropological studies in which he attempts to rectify established error and ignorance about pre-Columbian cultures. He repeats his dismay at the manner in which Mexico and Mexicans have been defined and given identity. Although he speaks with great courtesy, even friendliness, Bonifaz Nuño does not hesitate to express the old resentments Mexicans feel toward North American and European intervention in Mexican affairs.

Q. How might past wrongs be rectified?

R.B.N. It is not an easy question, because what is ours, our past, had been studied and assessed and defined by foreigners. It is your countrymen, you see, who have been telling us who we are. Just pick up any book on the subject of pre-Hispanic cultures, and if you are curious enough to consult the bibliography you will find that the essays are not written by us. We Mexicans, because we are thought of as mestizos, are left to imitate and fol-

low. So I have concentrated my energies on the pre-Hispanic past because I want to discredit everything foreigners have said about us—because it is all false. It's only natural that a German like Humboldt would come here, that North Americans come, to study our cultures but not understand them. They say, "this is this and that is that." So I have written my studies in an effort to destroy their opinions. I have three or four books on these subjects. I will show you an example. It's incredible how such misreadings come into being. At some moment or other, it occurred to one of your countrymen to state that a small Olmec figure had the face of a jaguar. Everyone since that time has repeated that the Olmec face has jaguar features. When you examine the figure, however, it is clear that it has absolutely nothing to do with the jaguar, yet the error continues even after another North American scholar conceded that the jaguars are far from realistic.

Q. So these scholars are creating new myths.

R.B.N. Exactly. Totally false mythologies—totally isolated, totally without value. I take up this point to demonstrate their error, hoping to offer an interpretation of the Olmecs that will have meaning. I admit that with my theory I cannot aspire to absolute truth. I aspire merely to create a sense of dignity. If what I write is true, so much the better. If North Americans can invent, then we can invent as well. If you make a guess, I will make my own.

Q. With better reason, and a greater sensibility for the subject.

R.B.N. I grew up among those stones. I am not frightened by them. When I look at them, I say to myself, why am I so fond of these stones?

Bonifaz Nuño's thesis in approaching a new reading of pre-Hispanic icons is that the Spanish misread indigenous symbols from the time of their earliest contact with them. In his *Imagen de Tlaloc*, he argues that the Aztecs consciously misinformed the missionary priests to safeguard their

old gods from the new Christian god. Tlaloc himself, he believes, the principal topic of this study, was greatly misrepresented by ill-informed Europeans who classified him as an agricultural deity responsible for bringing rains to the fields, when in fact he is a "representation of the power of the god at the very moment of the inception of that power." Since that first confusion, Bonifaz continues, misunderstandings have proliferated and interpretations of pre-Cortesian figures have been tailored to fit flawed historical accounts. This rigorous scholar pleads for a methodology that discards interpretations based on lies and inaccuracies and returns to the original archaeological sources, the figures themselves, for the truth. Applying that methodology, Bonifaz Nuño theorizes from schematized drawings of many representations of Tlaloc that the so-called jaguar face is actually composed of two serpent heads, snake figures that play a major role in the Aztec story of the origins of the earth and are, as a result, prominent in pre-Columbian art.

In the same study, Bonifaz Nuño examines the provenance of a statue he believes has been misidentified as Coatlicue, the principal female god in the Aztec pantheon, which has been called terrifying, monstrous, macabre, and "the most formidable model of terror and fear ever created by humankind." "What," Bonifaz questions, "are the images that have created such horror?" The list includes serpent parts—head, body, tail—and also human body parts: hand, shoulder, arm, female breasts, back, blood, heart, and skull. There are, in addition, feathers, shells, braids, and rattles. Bonifaz Nuño suggests that these objects be considered independently of the statue. The female form has been adjudged as endowed with grace and beauty. The heart is the object of purest veneration in Christian iconography. The skull represents meditation and wisdom. He divests each symbol of the sinister connotations that have been attributed to it. Even snakes, he ratio-

nalizes, are not considered horrible in the hands of bare-breasted Cretan women or in the crown of Egypt or twining around the caduceus. "In fact," he concludes, "I believe that from the moment in which art theorists renounce their Western vision and cease to reject the essence of our ancient art, they will have found the basis on which to integrate a system that has the potential for truth."

Those views on beauty and the eye of the beholder are fundamental in appreciating Bonifaz Nuño's poetry. The scales of Occidental percep-tion have dropped from his eyes, and in many of his poems he proposes a new, non-Western vision of beauty that has created no little difficulty to his readers. We see the presence of that unfamiliar world, for example, in the 143 seven-line poems that compose *Siete de espadas* ("Seven of Spades"). In these lines we hear the singing of the Indian blood Bonifaz Nuño says flows in his veins. In his scholarship and his poetry, ancient and modern Mexicos have found a rare voice that coalesces the dualism of its Western and indigenous elements.

The chosen one descends, and upon my shoulders
—she-goat's hoof, broom of incantation—
she folds her wings of shriveled leaves.
And in the sluggish maws of carnivorous
flowers, in the cleft of shriven sheets
—crossroads, chrism, fever—
uncertainly, she bones and hallows me.

[poem 1]

Lying in the field of maize, fecund
in her horrific joy, howls
the young queen, the eternal bride,
of man; my lady, mother
of all death. And in the nuptial
blood spilled in birth throes, she
unites voices and sheaves the chorus.

[poem 143]

Teeth red with the blood of apples, arms
of tender sheaves, and I inhale the
copal, maned smoke streaming from your
lustful fire; and I seek the captious
purple of incest, and I am received,
from years annulled, into the dancing
patios of the body of she who loves me.

[poem 66]

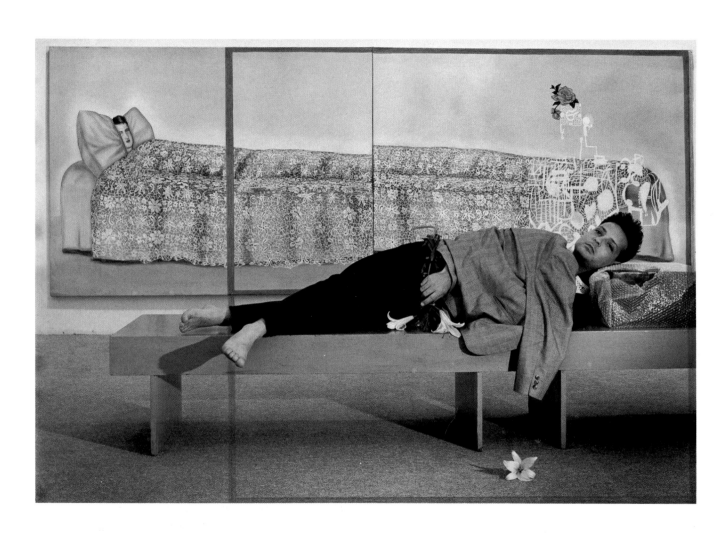

35. Julio Galán

JULIO GALAN

Múzquiz, Coahuila · 1959

In 1984 Julio Galán moved to New York to live and paint. Later he returned to Monterrey, where he lives most of the year, but he owns an apartment in New York, and in May 1990 he is in New York for an exhibition. It is here, not in Mexico, that we chat about his life and work. His English is much better than he believes, but he speaks most naturally in Spanish.

Questioner When did you begin painting?

J.G. I always painted.

Q. Your mother tells you that you were always drawing? In the dirt? On the walls? Always?

J.G. Yes, but when I decided to paint as a career, well, that was more difficult, because my parents wanted me to study for a profession. Since I could see they were not going to leave me in peace, I studied architecture for seven years. I finished the course, in Monterrey, and then I came to New York.

Q. To work as an architect?

J.G. No, to paint. But there was never a time I wasn't painting. I'm always painting.

Always painting. And always returning in his painting to the time he was always painting—a spiral into memories that flows, like a waterfall or artery from one of his paintings, against chronology, against nature, to the present, a present often portrayed through the figure of a sometimes in-fant, sometimes boy, sometimes youth. In each manifestation, however, is the same unmistakable persona: wan, doleful, pouting red lips, small but protruding ears.

Q. The recurrent figure in your paintings—is he memory or invention?

J.G. Oh, memory.

Q. Your youth, your childhood? Then it is you?

J.G. Or people from my childhood, my brothers and sisters.

Q. I'm wondering whether this persona who appears in your paintings is a little like Frida Kahlo. How do you feel about Frida?

J.G. I'm enchanted by her—too much.

Q. Is this a kind of self-analysis, a way to know yourself better?

J.G. Yes, I'm—every painting is like a therapy, a self-analysis, but it's not conscious. When I look at photographs of my paintings, it's as if each one were a new chapter, or as if it were a mirror in which I'm looking at myself. In my painting, I can see what is happening to me.

Q. So the knowledge comes later?

J.G. Yes, later.

Q. Do the paintings come from dreams?

J.G. No. Many people say my paintings are like dreams; they imagine dreams. But I've never painted dreams. No, I've never painted dreams.

197

At one time, inscriptions were a prominent feature of Galán's paintings. Some were simple and direct. A purple vase holding a bouquet of large purple and yellow pansies is outlined by a thick black line that traces a heart. A small placard at top center of the painting reads, "Ya no te quiero," ("I don't love you anymore"). Or an inscription may be more cryptic. In a large oil, a black-haired woman in an elaborate, full-skirted native costume holds a guitar, as if strumming a folk ballad. She might be standing on a stage with a painted backdrop. She might be standing on the lawn of a hacienda with real mountains in the background. The inscription on this painting reads, "Mientras el cielo rie, la tierra llora" ("When the skies laugh, the earth cries"). The only overt indications of earthly distress are two bare trees and the fruit falling from the branches of a limón tree.

One of the most baffling inscriptions is found in a surreal-realistic painting of a *charro* and his horse, *Los Cómplices* ("The Accomplices"). The horseman in his elaborate riding costume stares toward the viewer; he is holding a brilliantly striped saddle blanket. We recognize the pale skin, the red lips, the protruding ears. A round table in the foreground holds unknown objects, three of which float freely in the air. The objects are almost recognizable; they are whatever the viewer sees in them—perhaps receivers from old wall telephones that have acquired the rubbery life of monstrous mutations. The charro's horse stands in profile, his head intersecting a painting of a tranquil landscape: lake, shore, and sky. Nothing, other than the brilliant oranges, yellows, and reds of the striped wall paper and rug, hints of the content of the inscription that covers the wall to the charro's right. Starting from the floor and reading to the ceiling, the upside-down capital letters, at times obliterated by the floating objects and a general disintegration of both writing and patterned paper, read:

I want to burn down a museum I want to set fire to my heart I want to burn green firewood and break you in little pieces I want to burn everything I want to burn . . . I want to take a match and burn your white . . . in order to . . . deny I want . . . a match that can . . . I want burning . . . I want a can of gasoline and a lighted cigarette that will blow everything up I want you out of this world and for you to tell me whether or not I have to feel bad about all this I want to look long and hard love and hold you in my arms and then have my heart blaze so yours will blaze too and for you . . . and for you to die.

The more recent paintings in the New York exhibition—which bears the significant title *I, Galán, My Own Icon*—do not incorporate written inscriptions. The implicit vocabulary is frequently one of fragmentation and disjunction. The persona remains, and the childhood memories now are translated into scraps of the past: pasted-on bits of paper, stickers and seals, painted medallions. A lovers' tryst is overlaid with a semi-obscuring pattern of joined circles. A head against a pale blue background is split and imperfectly rejoined. Nearly all the images are fractured or severed or broken up—a cryptogram veiling an unseen inscription?

Galán freely confesses his fascination for costumes. "I am Mexican. I paint what I see—the Tehuana [woman], the charros, all that. I love disguises." "Masks?" "Yes, masks." And riddles and games. A major painting in the May exhibition is titled *The Black Pearl*. The Galán persona, a boy or girl of about six, kneels on a board miraculously afloat on a brown-yellow-green sea; the line of the horizon rises impossibly upward from left to right. Luminescent pearls encircle the neck and wrist of the child, whose right hand is outstretched toward, but at the same time pushing away, an enormous white pearl larger than the child's body.

"Where is the black pearl?" For anyone who has studied the painting, the question is inevitable.

"It's hidden somewhere in the painting. Can you find it?" Galán responds. He is obviously enjoying this moment. He can wait only to the count of three. "Behind the white pearl!" He laughs.

The charros and Tehuanas are absent from these paintings. Recently, a critic commented that unless one knew that Galán lived in Monterrey, he would not know Galán was a Mexican artist. It is true that Galán's newest self-explorations do not call upon specifically Mexican metaphors and motifs. One wall-sized diptych (which a reviewer in the *New Yorker* called "an absolutely original instant classic") portrays the Galán persona in bed, head nearly buried in the pillow put palely recognizable. The elongated bed extends through both frames of the diptych; its planes are split, like the two halves of the face in the self-portrait, and, like the face, imperfectly rejoined. The bed is covered by an intricately crocheted bedspread, which begins to unravel toward the end of the second panel, splitting into threads that seem to turn into stick figures, or occult signs. Nothing here, if we did not by now recognize the persona, identifies this painting as Mexican. Possibly the stick figures recall the flawed wooden men in the Popul Vuh, the Maya story of man's origins, although that idea follows only upon recognition of the painter. As Galán spends more time in New York, it will be interesting to see what of Mexico remains in his work—perhaps very little, like another obsessive self-portraitist, Alfredo Castañeda. Rufino Tamayo, however, never lost the pre-Columbian influences in his work, despite the years he lived in New York. Perhaps without a recognizably Mexican icon, Galán's personal metaphors—as telegraphed in the title of his most recent show—will be his trademark.

Q. Are you interested in La Guadalupe?

J.G. The Virgin of Guadalupe?

Q. Yes, has she ever appeared in one of your paintings?

J.G. She hadn't, but in fact I've just finished a painting of the Virgin of Guadalupe.

Q. As a good Mexican?

J.G. No, I never wanted to paint her. But they're building an important museum in Monterrey. They'll be bringing exhibitions of all the internationally known artists. And to raise money—they want to finish by December—they're having an auction this month, and they asked artists to paint something on the theme of the Virgin. I didn't want to, because I was working on my paintings for the exhibit, but I made time to do the painting, even though it bothered me.

Q. Because of the interruption or because of the Virgin herself?

J.G. Both things—the interruption, and because I didn't feel inspired to make the painting. But once I finished it, I liked it very much and said to myself, I'm really glad they pushed me.

Q. What was it like?

J.G. It's, well, it's difficult to describe, but it's a portrait painted on glass, on the reverse of the glass. And in the background is a collage of all the images connected with the Virgin of Guadalupe.

Galán is sensitive to images. As he is being photographed, we tell him that in his black shirt and trousers and white lace collar, and with his direct gaze into the eye of the camera, he will look like the subject of a Velázquez painting. "Oh," he says with some pleasure. "I had Velázquez in mind all the time I painted this." He nods toward the Velázquez lace of the diptych. Perhaps this is what is Mexican about Galán: the coincidence that is so natural it is no longer coincidence. "Mexico," he said earlier in the day, "is a naturally surreal country." And the surreal metaphor of this Mexican's art may be the black pearl.

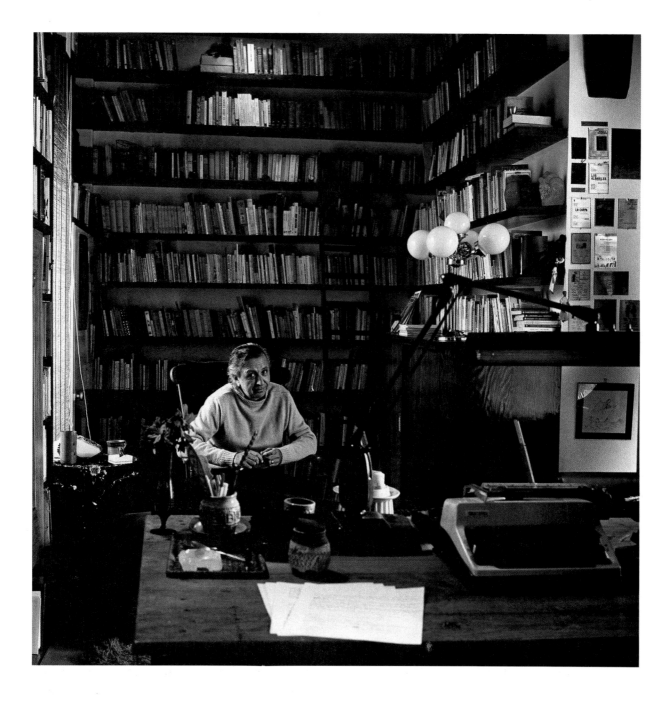

36. Vicente Leñero

VICENTE LENERO

Guadalajara, Jalisco · 1933

If you had asked me when I was thirteen what I wanted to be, I would have answered, I want to be a writer. I want to spend my life reading and writing books.[1]

Vicente Leñero is a fortunate man. He reads, by his own definition, "chaotically"—and writes, and writes. Novelist, playwright, essayist, journalist, editor, author of short stories, film, television, and radio scripts, "writer" is properly the word to encompass the breadth of his talents. And, yes, there were love poems, although those lie forgotten in the ashes of youthful ardor. We arrive bearing a printout of Leñero's work listed by the OCLC (the on-line catalogue of the major libraries in the United States, to which the Library of Congress is the principal contributor)— forty-nine entries; not bad for a foreign author, especially since, by one of those imponderable quirks of destiny, Leñero is one of many Mexican writers whose works are not as yet translated into English. He believes, actually, that contemporary theater cannot be translated, but that is a topic for another day. Sitting in the sunlight reflected from a tiled, rooftop terrace dotted with brightly blooming azaleas, Leñero reviews U.S. holdings of his publications. "Oh, this is just a prologue.

This is a novel. A novel. Short stories. Yes, theater. What! *Medusa?* I didn't write *Medusa.*" No, he did not write this play. *Medusa* was written by Emilio Carballido, a fellow playwright who happens to live directly across the street from Leñero. Mexican implausible plausibility invades the computer network of the OCLC, a viatic virus. This bibliographic blooper affords a moment's amusement, and then the conversation turns to more serious topics.

Like many of the French authors he reads and admires, Leñero has written and been interviewed extensively on questions of literary philosophy. Some of his positions are slightly surprising. He is strangely reluctant, for example, to concede that his work revolves around ethical and moral issues, an observation that occurs to even the casual reader of his works. One might propose, in fact, that Leñero is essentially an investigator of the conflicts that arise in social, religious, and political arenas between ordinary man and an oppressive establishment. Still, Leñero is hesitant to assume the cloak of moralist.

Questioner It's difficult to generalize, but one constant in your writing appears to be an ethical concern, a probing of responsibilities and principles. Can you comment on that?

V.L. (long pause) I think that any such effect is really a result of what I write. Those questions, as such, never concern me. No, I never think about theme or ideology. I believe that emerges from the writing. The writer's primary concern is formal. The how, the how.

Q. But you are talking about *how* you write, not *what* you write.

L.V. But what concerns me is how to write.

Q. And I'm referring to content: problems of the times, morality, justice.

L.V. Justice, you say.

Q. Well, the lack of it.

L.V. Exactly, that's the problem. But in the end, the writer concerns himself with things other than themes. The real problem, I repeat, is how to create tension, mystery, logic, how to write well—but not theme.

Q. Many of your works begin with facts from newspaper reports, things you then fictionalize as novels or plays.

L.V. The truth is that if I don't see it, I can't write it. It's a problem of mine. I don't have much imagination.

Q. Yes, that statement is well recorded. But I must doubt it.

L.V No, I feel that lack of imagination is a strong limitation in my writing. Almost everything is the result of a visual experience. That's why I often turn my novels into theatrical works—translate the same story into a different language. Because I find it very difficult to construct a story. It isn't my forte, not my skill. With other writers, it's just the opposite.

Much of this conversation must be read in the light of Leñero's modesty. Most authors agree that it is difficult to write. Most authors concur with Leñero that one writes best what he sees and knows. Leñero's "lack of imagination" is more logically a natural inclination to write in a style that Truman Capote made popular in the United States in *In Cold Blood*. Leñero has a similar work of

New Journalism entitled *Asesinato* ("Murder"), an account of the machete murder, allegedly committed by the couple's grandson, of two prominent Mexico City figures, a politician and his author wife. *Asesinato* is novel, reportage, and documentary. Leñero's preferred genre is the novel, and he professes special fondness for his *Garabato* ("Scrawl") and *Estudio Q* ("Television Station Q"), works notable for the "formal rigidity" and "iron discipline" that inform all his writing. In popular perception, however, it is his documentary plays and novels that define Leñero's literary image, plays such as *Los hijos de Sánchez,* commissioned by Oscar Lewis and based on his *Children of Sánchez; Martirio de Morelos* ("Morelos's Martyrdom"), a revisionary reading of a mythic hero of the Mexican Revolution, José María Morelos; *Compañero* ("Comrade"), which found its inspiration in the last days in the life of Ernesto "Che" Guevara; *El juicio* ("The Trial"), an account of León Toral's trial for the assassination of President Álvaro Obregón; and *Pueblo rechazado* ("Rejected People"), which follows the polemic aroused by a priest's attempts to introduce psychiatric treatment into a Catholic monastery in Cuernavaca. Leñero's best-known work is *Los albañiles* ("The Stonemasons"), for which he won the prestigious Biblioteca Breve prize. First a novel and then a play, *Los albañiles,* like much of Leñero's writing, is on one level detective or mystery fiction; at a deeper level, it is once again a meditation on morality. In this unflagging attention to ethical and social issues, Leñero's fiction dovetails perfectly with the journalistic, essayistic side of his writing.

Vicente Leñero is an assistant editor of *Proceso,* a bimonthly magazine with strong antiestablishment leanings. In Mexico, "antiestablishment" means "anti-PRI." Although in its infancy PRI was a revolutionary party, for almost seventy years now it has functioned as the one-party monopoly of a power elite. In the presidential election that takes place every six years, the election of the PRI

candidate, known as the Candidate, is but a formality. Only during the last years of the eighties were there notable cracks in the monolithic unity of this institutionalized "democratic" process. In a collection of columns from various magazines entitled *Talacha periodistica* ("Pound 'Em Out Reporting"), Leñero describes an invitation from the current president of Mexico to accompany his party on a week-long campaign swing through the provinces. "Invitation From Carlos Salinas de Gortari" is a long, humorous, and satirical account in the tradition of the *New Yorker* "Profile." In it, Leñero describes the hallowed invitation as well as, following a series of superficially comic mishaps, his disinvitation, summary dismissal from the presidential party, and strongly protested transmittal home. Beneath the parodic account of the author's bumbling brush with power lies a cool indictment of the hypocrisy and vacuity of the political process, and of the men who sustain and profit from it. It is well worth noting that the incidents Leñero describes might just as easily have taken place during a North American political campaign. He details his early hesitation about accepting the Candidate's invitation; his nervousness at such proximity to the blinding center of power; the events that lead to his missing sleep, missing dinner, missing connections with the presidential party; his (in retrospect) overly independent participation in programmed events; and, finally, his frenzied rush to catch the bus for the next scheduled event.

"This is your bus, Don Vicente."

There were very few passengers. . . . I was surprised to hear snatches of "how long to the airport," "hope it's not a long flight," and "I have an appointment on Reforma at 7:00."

Strange.

I walked back toward the driver. A young woman with the air of a stewardess stood in the well of the front steps, smiling as if she had been hired to do nothing but smile.

"Excuse me, señorita, this bus..."

"This bus goes to the airport," she replied automatically. "It's for people returning to Mexico City."

"Oh, but I'm not going to Mexico City," I said. "I'm having dinner with the Candidate."

The girl's smile widened, and she squeezed aside so that I could tranquilly descend before the bus shot off like a rocket.

The minute my foot touched the ground, I found myself face to face with Torres.

"I made a mistake," I said, apologetic.

"This is your bus," said Torres.

"No, this bus goes to the airport. The señorita just told me."

"This is your bus, Don Vicente," Torres repeated. He barred my way. He stared

without blinking. His voice had risen, sharp, cutting, as if he, too, were Army. . . . His face softened. Slightly.

"Please get on the bus. I'll explain."

"What's to explain?"

"Get on."

Guided by the palm of Torres's hand I reboarded the bus. . . . Before I could sit down, the bus was moving.

"How about a whisky?" Torres asked. . . .

"Whisky?" I repeated.

"Right."

Torres himself walked to the back of the bus and returned with two whisky and sodas. . . .

"So what happened?"

"Nothing happened, Don Vicente."

"You're sending me home, aren't you? Why are you sending me home?"

"There was a misunderstanding."

"But you're sending me *home*."

Because there was a misunderstanding, Don Vicente."

"I don't understand." . . .

"You see, the Candidate just wanted to change your itinerary. Since you couldn't make all the stops on the swing, he wants you to accompany him in mid-February instead. On a different tour. Or later, when he goes to Jalisco. You're from Jalisco, aren't you, Don Vicente? That would be a better time, don't you agree?"

Torres was not a very intelligent fellow, but he was trying to seem so. He was trying to smooth things over and sell me a bill of goods. It was pointless to argue. More than pointless, it was awful. Everything was so awful it made me want to yell *I want to stay. Please.* Stay here close beside the honorable Candidate, on his tour, with his people, basking in his warmth, in his smile, in the light of his intelligence. I was furious, but I decided, out of pure pride, to put on a good face in front of Torres. . . .

The first thing did when I got back to the city was telephone the oh-so-cordial Moreno Cruz who had called me in the first place. He was surprised to hear my voice.

"I thought you would be in San Luis," he said.

"I thought so, too."

I gave him a brief account of what had happened.

"That can't be, Señor Leñero. That can't be." He was upset, alarmed, amazed, annoyed, and very apologetic, and he swore he would track down the reason for such inexcusable discourtesy and then call me back and give me the full explanation along with the apologies I clearly deserved.

Of course, Moreno Cruz never telephoned again.

Proceso, May 1988

37. Rufino Tamayo, *Self-portrait*, 1949,
drawing, *Tamayo*, Ediciones Mexicana,
Mexico City, D.F. Permission of the
artist.

RUFINO TAMAYO

Oaxaca, Oaxaca · 1899

In November 1989, Rufino Tamayo suffered a heart attack and was flown to Houston, Texas, for heart surgery. Although subsequently he was strong enough to fly to Russia for a symposium in his honor, at the time of our appointment in March 1990 he was not well enough to leave his bed. We have, therefore, chosen to reproduce here an essay on Tamayo written by one of Mexico's finest poets, Xavier Villaurrutia, who died in 1950.*

Tall. Dark. Expressive eyes and large mouth sensual as a ripe fruit. Broad nose with flaring nostrils that absorb the air in one sustained inhalation. Large hands, at once strong and slender. As time has lightened Rufino Tamayo's skin, it has also sprinkled his dark hair with the cold ash of age.

Silent and laconic, reserved and enigmatic. Explosive as the volcano that suddenly erupts and then, almost in the same moment, cools to silence and solitude.

Rufino Tamayo was born in Oaxaca in 1899. His parents were Zapotec Indians. He spent his childhood in the tropics that—in the words of Carlos Pellicer—"filled his hands with color." Orphaned at an early age, he moved to Mexico City to live with relatives. He worked in a market in the city, selling tropical fruit—fruit from the tropics he had carried within him to the high plateau of Mexico City. The same fruit that would appear in his paintings as an insistent, recurrent motif, in all the geometry of its form and magic of its color.

*The following essay by Xavier Villaurrutia is translated from the Mexico City newspaper *Excelsior*, September 24, October 1, and October 8, 1950.

Rufino Tamayo's artistic vocation became evident at an early age; it was not, however, the precociousness that sparks for an instant and then dies forever.

One day painting students at the Academy of San Carlos noticed a new pupil, humble in appearance, but proud and introspective. . . . The Academy of San Carlos was a necessary phase that Tamayo accepted with the natural submissiveness of one who attends a preparatory school that can offer a true artist no more than the basic grammar he must later surpass if, as in the case of Tamayo, he has a personality to be discovered, cultivated, and projected in art.

After the Academy of San Carlos came the years of crisis: the rebellion against what he had learned and practiced in school at a time when the maestros were mired down in an academicism in which the examples of modern art were the worst of the turn-of-the-century Spanish painting. Years of freedom and curiosity. Years of feverish searching, during which, alone or in the company of the painter Agustín Lazo, Tamayo set out to know and study, by every means at his disposal, modern French painting from the Impressionists and post-Impressionists to the Cubists, the only painting that had the vitality to nourish and stimulate him, to serve as example or point of reference.

Soon—not by mere chance but, rather, by affinities of taste and similarity of goals—Rufino Tamayo found himself associated with a group of modern poets who had, consciously and by their own consent, formed a generation. I am referring to the group called the Contemporáneos, who at that time were struggling to redirect Mexican lyric poetry, turning it back to its true channel, firmly rejecting anecdote, eloquence, and prosaism—in a word, restoring to poetry its essential values. Rufino Tamayo's ambitions and intentions, as an artist, were the same.

Tamayo's first one-man show opened in 1926 to a surprised and disconcerted public. It was held in a gallery on the Avenida Madero, and in only a few oils already contained many of the qualities that were to make him such an individual and unique painter.

The firm, consciously rigid drawing of figures and, especially, the daring primary colors already indicated the great colorist he would become. At the same time, the absence of any touch of the picturesque, decorative, or folkloric made clear Tamayo's decision not to follow the easy road but to strike off down the unexplored paths on which one must lose himself if he is to find himself.

The tropics were the principal, almost the only, theme of this painter who, to interpret and express that theme, allowed neither the indolence nor languor of the

37a. Chairs for señor and señora in Tamayo's garden.

tropics. Rufino Tamayo's tropics have never been a simple, external sensuality; they are, rather, the tropics that—like an internal sun—he had brought with him from his birth-place and carried always within him like a precious heritage, the ineradicable heritage of his immediate and remote ancestors.

The asceticism and rigor he has so often imposed upon his painting, the intellectual tests to which he subjected it, and the mixture of influences and similarities with other painters such as Picasso, Braque, and Miró have only matured to the point of the exquisite that ancestral legacy. Rufino Tamayo did not accept that inheritance until he

had demonstrated he deserved it. That gift, the coveted colorist harmony of his race, is legitimate only in the hands of one who has worked hard to deserve it.

In that same year of 1926, Rufino Tamayo held his first exhibit in New York, where he stayed to live for two years. Mexico City and New York attracted him equally. He would return to Mexico City and briefly devote himself to teaching and to painting a mural in the National School of Music. He returned in 1938 to New York to live, but continued to obey the attraction of his native land, where he spent nearly every summer.

Because of his travels and his residence in New York, Tamayo has been accused of being uprooted from his country. Nothing more inaccurate or unjust. If the branches of Rufino Tamayo's spirit were intentionally exposed to changes in intellectual and physical climates, the deepest and most secret roots of his spirit and his art continue to be supremely Mexican. It is precisely this element of fidelity to the innermost essence of his race and his spirit that sets Tamayo's painting apart and makes him both a universal painter who can compete with the most avant-garde Europeans and a painter replete with such personal and individual qualities that we can say without exaggeration that his spirit defines his race.

Drawings, engravings, watercolors, and tempera and oil paintings. Rufino Tamayo has also yielded to the temptation of the mural, perhaps not his primary form, but one in which he has left evidence—on the walls, for example, of the National School of Music—of his ability to ally to monumental and sculptural drawing a lyricism in color and idea that strongly differentiates him from Diego Rivera and José Clemente Orozco. Rivera's interest lies in using the wall as a vehicle for expressing a historical, political, or social dialectic. Orozco's concern is to represent an existential drama in which destruction and horror are the protagonists.

The mural Rufino Tamayo painted in 1943 for the Smith College Library confirms his lack of bias. For Tamayo, the chosen theme—Nature, the Work of Art, and the Artist—was simply a pretext for achieving a composition in which geometry and, have no doubt about it, color are the true ideas and authentic protagonists. And what of Tamayo's project for a mural on the theme "The Conquest of Mexico"? What is it but the poetic version, like his mysteriously colored watercolors and gouaches, of a subjective and poetic concept in which emphasis, doctrine, and anecdote are conspicuously absent.

Tamayo abolished eloquence, rhetoric, drama, melodrama, and proselytizing from his work. And politics as well. His painting serves no political or religious creed. And when, rarely, the figure of a Benito Juárez or Emiliano Zapata appears in his paintings, it

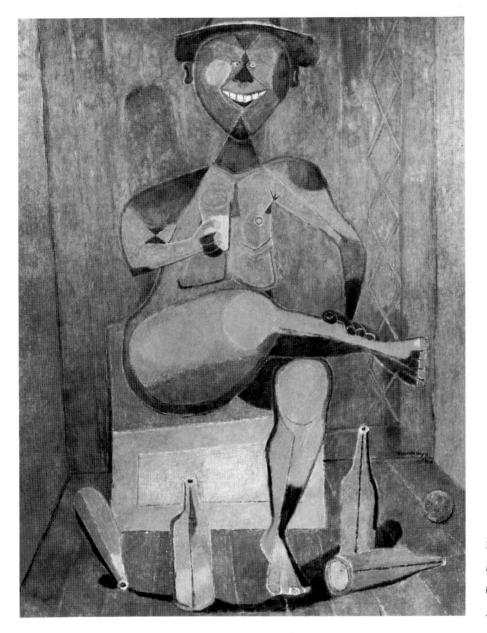

37b. Rufino Tamayo, *The Happy Drinker*, 1946, oil on canvas, 44 × 34 inches. Photograph courtesy of Mary-Anne Martin/Fine Art, New York.

is accurate to see nothing more than an elemental and ingenuous desire to render homage to two men the artist finds sympathetic because of their humility and accomplishments. The paintings in which these two figures appear are works in which any doctrinaire intent has been discarded to make room for a strictly pictorial composition; Tamayo uses deliberately naive motifs to imbue these paintings with popular savor and ingenuous and apolitical meaning. His is a poetic and plastic expression of admiration for two persons who represent two important historical periods in the history of Mexico.

Mallarmé said, wisely, that poems are made not with ideas, but with words. We can say of Tamayo that his paintings are made not with ideas but with lines and, especially, color.

Tamayo's drawings and engravings do not refute but, in fact, confirm, with their decisiveness and strength, what we could call a sculptural preoccupation. With the sobriety, solidity, and love of volume shown in many of these drawings, the pre-Cortesian tradition of art seems once again at work through the spirit of this modern Mexican master. Some of his woodcuts remind us that Tamayo could have been a magnificent sculptor had he wished. Some of the line drawings resemble sketches for sculpture, in which his personal and modern line coalesces with the most refined creations of ancient Mexican sculpture. Tamayo has indeed demonstrated his talents in sculpture. A clear and concrete example is *Cabeza de mujer,* a bronze sculpture executed in 1940.

Consciously, lucidly, deliberately, Tamayo chose to express his poetic intuition and sensibility, and his sensuality as a great colorist, in the artist's most intimate mode: easel painting. Following a progressive order of intensity, first in drawing, then watercolors and gouaches, finally in oil, Tamayo realized a work so prolific and fecund that he has established himself, beyond argument, as the most individual and unique painter in oils in all of Mexico.

If the true poet succeeds in selectively removing from his lexicon all words foreign to his sensibility, crystallizing his own personal language, the true painter does exactly the same with objects and colors that will allow him to express himself fully in his painting.

In the work of Tamayo, one discovers with delight his favorite colors and objects. The latter appear and reappear, sometimes as objects in and of themselves. At other times they surface as manifestations and symbols of the subconscious, in the same way that objects laden with magical symbolic power appear in our dreams. One example among many, and not the least eloquent, is the frequent presence of fruit in Tamayo's paintings. The geometrical architecture and intense amber of the tropical pineapple, the strange and bloody watermelon slices slightly reminiscent of entrails, are, at the same time, the excuse for the painter to employ with characteristic power the dominant colors of his palette: reds, crimsons, white, black, and greens. At other times it may be grapes "filled with dark essences." Or mangoes and bananas through which—in the same way the poet Góngora used a word not for its sense and logical content but as mere

colorist allusion—the painter plays the magical note necessary to achieve a symphony of color. . . .

Along with tropical fruit, one finds in the small vastness of Tamayo's still lifes and figure paintings other favorite objects: clocks, wine glasses, bottles, balloons, and the guitars that are not the guitars of Cubist paintings but shapes translated from popular Mexican toys to the ambience of Tamayo's paintings, now converted into ciphers and signs. A new and modern Joseph standing before the dreams painted by this pharaoh would also have the opportunity to interpret and decipher the constant, rhythmic recurrence of cages, railings, and grilles that obsessively appear like dimensional metaphors, like mysterious and melodic lines.

In the work of a painter who has eliminated the picturesque and who has closed his painting to the rhetoric and literary themes in which an entire segment of contemporary Mexican painting takes its pleasure—weakening it in the process—the human figure has strictly compositional value and is conceived and executed in the service of the painting's unity. Tamayo's paintings, therefore, are not characterized by groupings of human figures. One, two, three figures are sufficient. This painter composes through selection, not accumulation, and he is not intimidated by blank spaces—which in any case are never blank; through Tamayo's masterful brush work, color continues to vibrate in those spaces, creating a visual feast and, at the same time, an ambience that bathes figures in a complex and enduring poetry.

If there are few figures in Tamayo's paintings, these figures are also fairly uniform. Deliberately, the men and women, Tehuana Indian women, fruit eaters, flutists and musicians who appear in his paintings are drawn following an internal model. Faces and bodies are reduced to a geometry that supercedes immediate reality to become invention and personal creation.

If to this conscious and original concept of form we add the unexpected but always harmonious color of Tamayo's paintings, we find in them a magnificent theory of reinvented human figures, a universe of human nudes and zoomorphic figures that are in some way frightening and spectral.

Contemporary Mexican painting has no colorist of Tamayo's power and boldness. To find a rival to his harmonies of color we must look to contemporary French painting.

The colors of Rufino Tamayo's palette seem to have been squeezed from the rind or pulp of Mexico's most characteristic fruits. In his hands they have a magical power and effect. No one, as well as he, knows how to contrast them, and then join them in the

creative unity of the painting, in a daring and harmonic concert. The chords he achieves among warm and cold tones are extraordinary. In Tamayo we find the living example of Baudelaire's assertion, referring to the true colorist: "Everything is permitted him because since birth he has known the range of hues, the strength of tones, the results of combined colors, all the science of counterpoint that allows him to achieve a harmony of twenty different reds."

Few Mexican painters can pride themselves in having succeeded, to the degree Tamayo has succeeded, in blending subject, drawing, color, and medium, to achieve a work of art with a life and destiny independent of its creator.

If to all the qualities of this universal Mexican painter who has imposed such a unique seal upon his work we add the deep knowledge and sensual pleasure of the craft of painting itself—so ignored, so disdained, so forgotten in our milieu today—the result will be the totality of Rufino Tamayo's work.

Evolved slowly but intensely, "without haste but without respite," the work of this great modern painter has now attained—although, fortunately, the future is open to continued production—the moment of its richest, most fertile, and most exquisite maturity.

Tamayo obviously lived on after Villaurrutia's fine essay was published, and his work continued to evolve. It gives us pleasure, however, to honor in this way these two major Mexican artists and, as an additional tribute, to add a few lines from a poem by Carlos Pellicer alluded to early in Villaurrutia's essay.

Wishes

Tropics, why have you filled
my hands with such color?
Everything I touch
is saturated with sun.
In the subtle dusk of other lands
I move with the tinkling of iridescent glass.
Let me, if only for a moment,
cease to be scream and color. . . .
Oh, let me cease for a single instant
to be aide-de-camp to the sun!
Tropics! Why did you fill
my hands with such color![1]

GUILLERMINA BRAVO

Chacaltianguis, Veracruz

It is November. The company of the Ballet Nacional de México is disbanding for a two-month recess. They are a "family." They travel, rehearse, create, perform, and live together. Now, however, they are looking forward to a respite, but before that release there is one last meeting scheduled for 4:00 p.m. The preferred color among these handsome, restless young people is black. A sylph in black jersey has just passed us on the marble stairs to this fourth-floor studio and school. Young men in black T-shirts and trousers, many of them barefoot, are sitting in the hallway, unconsciously (one wonders) forming sculptural groupings. Their feet proclaim that they are dancers. We are waved to a rectangular room ringed with sofas and settees. From among the clusters of people engaged in animated conversation, we have no difficulty recognizing the grande dame of this family, Guillermina Bravo. The queenly carriage is anticipated. The aquiline profile is recognized by generations of modern dance devotees in Mexico, Latin America, and Europe. (It is less familiar in the United States, another example of north-to-south nearsightedness.) What is immediately striking when Bravo speaks, however—a surprise not augured by any visual cue—is the baritone voice. Tallulah Bankhead

might have studied at the feet of this doyenne of dance. Again, the feet—that is the second impression, one that comes only after we are led into the shabby rehearsal hall, and only after Bravo sits down. She is dressed in a silk shirt, a jersey cardigan, and jeans. A chiffon scarf, marbleized like the end papers of a rare book, is looped casually around her neck. It is only when she crosses her ankles that the phenomenally arched instep, incongruously clad in white socks and laced oxfords, identifies the professional dancer.

Guillermina Bravo began her career as a dancer under the direction of a North American choreographer named Waldeen, who had come to Mexico at the invitation of the Mexican government to found a dance company. From that group, Bravo moved to the theater branch of the all-powerful center for the Mexican arts, the Bellas Artes complex, where she served as director of dance. It is established fact that from that moment, Bravo has been a primary force in the dance world. In 1948 she founded the Ballet Nacional, which not only has been a premier performance company but also has discharged the indispensable function of training dancers and choreographers of modern dance. And now, we have heard, after years of creating dance in less than perfect

215

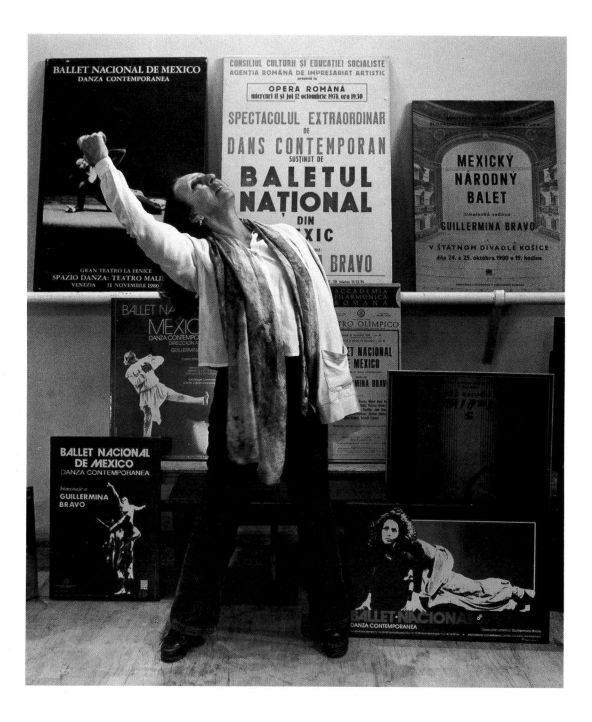

38. Guillermina Bravo

conditions, the Ballet Nacional is acquiring a permanent space in Querétaro, a city north and slightly west of Mexico City.

Questioner Is it true that the ballet is being presented a building in Querétaro?

G.B. No. A building is being *constructed* for us. Querétaro is a city in which appropriate buildings are hard to come by, so ours is being built from the ground up.

Q. Will it be on the outskirts, then?

G.B. No, in the center of town, close to the historical heart of the city.

Bravo's satisfaction is evident, and well-earned: "A building just for the ballet."

Bravo's art is always in transition. Mexico's major dance critic Alberto Dallal has called her "a choreographer in constant evolution." In this aspect, the repertoire of her company is at the opposite end of the spectrum from that of the Ballet Folklórico of Mexico, which, by its very nature, performs dances that have been canonized through tradition. Bravo's first influences were rooted in the years of social and political commitment defined by the muralists Rivera, Siqueiros, and Orozco. Later, her compositions explored expressionism, lyricism, oneiricism, narrative, and the abstract. Recently, all anecdotal qualities have been erased from her work; what remains is a concentration on pure movement and image. Bravo is articulate on how ballet is created.

G.B. I always begin with the body. Directly. With a dancer.

Q. You don't begin with notes, ideas, an overall vision?

G.B. No, I begin with a dancer, using the intrinsic components of dance.

Bravo's knowledge of the human body in general and of the potential of her own dancers specifically explains in part the tribute paid Antonia Quiroz, the stunning premiere danseuse, by one of the ballet's most dedicated fans: "What most enchants me about her dancing is that her body tells me what she is feeling before I look at her face." It goes without saying that this is a compliment to the balletic finesse of Quiroz. It also speaks to a consummate communication between choreographer and dancer.

Guillermina Bravo is undeniably a stern taskmaster. She requires impeccable technique from her dancers. She demands similar expertise from other professionals who contribute to her performances. Stage design is but one example. There are many excellent young artists in Mexico. They may paint brilliantly, she says, but unless they know the idiom of dance, they fail as designers. Bravo has high praise for Marta Palau, however, one of the few contemporary artists who asked to be instructed on the utilization of theatrical space. Bravo likes to illustrate her point with an anecdote about Jean Giraudoux. He was already a recognized author when he decided to write his first play. When it was completed, he called a friend in the theater, Louis Jouvet, and asked him to produce it. Jouvet insisted that Giraudoux bring it to him personally and then made Giraudoux climb to the stage and read the first act. He got no farther than the first speech, which was more than four pages long. Admiring dance, Bravo makes clear, is different from living and breathing it, as she has for fifty years.

Although anecdotal and narrative qualities are nearly nonexistent in Bravo's current repertoire of dances, something of the literary remains. In speaking of the structure of a composition, she resorts to literary terms. Her formula sounds simple: a piece must have a beginning, middle, and end. The beginning and middle come easily, she says—although "easily" is a relative term. At times she does not know what the ending will be until the dancers' bodies communicate that knowledge to her. To refine her formula even more, she explains that she thinks in terms of a "postulation, a counterpostulation, and a synthesis." Con-

sciously or unconsciously, she has adapted to dance the Hegelian precept of thesis, antithesis, synthesis. Bravo states that perfect costuming is another of her requirements, but her dancers often wear only leotards—or nothing—again focusing every perception on the corporeality of dance. Music sometimes inspires a ballet—the *Sobre la violencia* ("Variations on Violence") for example, based on a score by Philip Glass.[1] But more than any other contributing element, the potential of lighting excites Bravo. The stage in Bellas Artes has "exceptional" lighting, specifically a system of sidelighting the Ballet Nacional has developed, one she finds sadly lacking in European halls. The emphasis on lighting seems slightly disproportionate but may stem from its function as a visual element that the choreographer uses in sketching her ballet, in much the same way the painter floods a canvas with light and shadow to heighten the drama of the composition. That interpretation is substantiated by Oscar L. Cuéllar's review of the 1987 *Constelaciones y danzantes* ("Constellations and Dancers"), a ballet that was offered in homage to Rufino Tamayo.

> Among constants in the Tamayo aesthetic, Guillermina Bravo isolates opposing and complementary elements: cosmos and earth, light and matter, man before the vertigo of the universe and man performing his earthly rituals . . . ocher, maroon, cobalt, silver.
>
> The curtain, designed by Tamayo himself, and its fleeting celestial bodies, with its gray fringe serving as neutral backdrop, shelters the evolution of the other, the earthly bodies. . . . The dance of the human dancers continues independently of that of the constellations; each, nonetheless, reflects and contemplates the other. *Materials of light and clay* converge into human form, are resolved into a continuity that only a few like Guillermina Bravo can perceive.[2]

The photography session is nearly complete. Dancers wander in and out, entertained by the attention focused on this materfamilias and nervous that it is past the hour for their farewell meeting. Only now the predominance of male over female dancers becomes obvious. What are the reasons for this imbalance? Bravo has several, primarily cultural explanations. First, Mexico is a Catholic country, and there is still societal resistance to dance as a career. But within that reluctance, if a young man chooses to become a dancer, modern dance is more acceptable than classical ballet. Perhaps an even subtler and more ancestrally rooted reason is that Bravo searches for her dancers in the provinces, preferring to find untrained young people who are then offered scholarships to join and be formed by the company. In the country, traditionally, it has been the men who dance. Even female roles are danced by men. Modern dance, Bravo believes, has rediscovered the male body. At last men have been rescued from their roles as accompanying dancers.

If her concepts are to be realized, the choreographer, like the playwright and the composer, must entrust her performance to others. Although the choreographer—unlike authors in sister performing arts—may herself control her work during the time between its inception and its presentation, she is usually denied concrete evidence of its existence after the fact; the play may be published (admittedly, an imperfect reproduction), the symphony recorded, but the ballet exists only as it is danced. It is true that notations have been made of compositions by renowned choreographers, and ballets may be filmed or recorded on video. Bravo roundly rejects those simulacra. "Dance is an ephemeral art," she repeats more than once. She is not disturbed by the knowledge that her creations are evanescent. It is enough that they existed—and that the next ballet is already germinating.

MANUEL FELGUEREZ

Zacatecas, Zacatecas · 1928

Begin with a few simple geometric concepts, like the circle, the triangle, and the square. Organize them until they result in a form-idea. Then, take pencil and sketch this form-idea on paper, and give it order.

Think of the color silver, and surround it with a few cold colors; think of the color gold, and surround it with a few warm colors. In both cases, organize the color, give it order, and logic. Take brush in hand and apply color to the drawing, thus creating a design formed of various planes.

Every plane contains potentially infinite volumes. Opt for one, and create a relief; color will also assume dimension. Then take the volume and develop it in space, demonstrate that the concept painting-relief-sculpture is obsolete, exhausted, that form-color is one within relative spaces.

I want not to create form in space but form that creates space, movement that creates space, the multiplication of scale or the multiplication of the object, in order to penetrate multiple spaces, to permute forms, apply combinations, utilize displacement. In short, to discover, invent, demonstrate living form within multiple space.

That credo accompanied a 1973 exhibit by Manuel Felguerez entitled "Espacio multiple"

("Multiple Space"), in which his works are described as a "counterpoint of circles and rectangles" following a "purely chromatic rhythm." Progressions in individual pieces—paintings, sculptures, reliefs, serigraphs—suggest music or mathematics. It is not surprising then, in his home, to find that Felguerez collects musical instruments, or to read in the proceedings of a 1975 symposium on the arts in Latin America remarks that suggest a theoretical mind at work:

I want to quote a few semiotic concepts. Every work of art has as its goal the transmission of a message, and therefore must be constituted beneath a system of probabilities we call a code, that is, an element of order that makes possible the transmission of a language. In visual art, that code is composed of the syntactic organization of, principally, form and color to form a meaningful cultural text based on acquired expectations and habits.[1]

One has only to scan that text, and the credo, to appreciate what a rational artist Felguerez is, how analytical and self-appraising—"geometric," "organize," "order," "logic," "system of probabilities." In more ways than one, Felguerez might easily be taken for a professor: ubiquitous pipe,

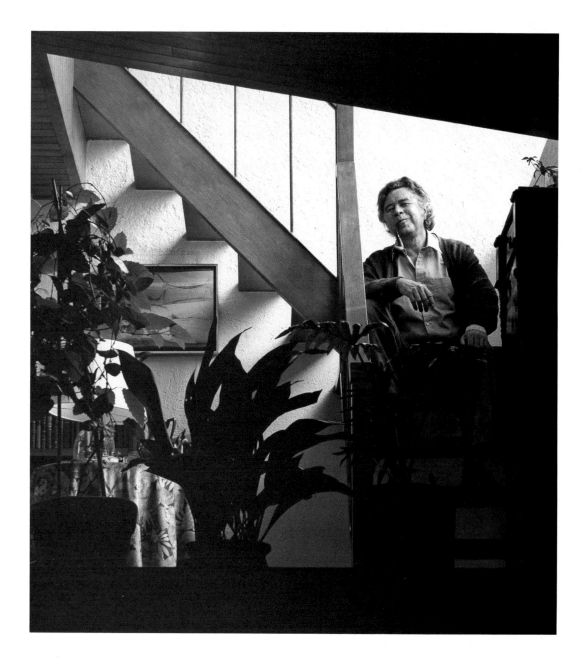

39. Manuel Felguerez

Henry Higgins sweater, quizzical expression, intelligent if slightly sad eyes, reflective pauses following questions. But the word "color" must also be drawn from his formula to prevent giving a false impression of coldness. Felguerez is serious, yes, but not without humor and warmth.

It is the analytical professor who organizes and orders a tour of the *sala* of his home in the Colonia Olivar de los Padres in Mexico City. All the space on the high-ceilinged walls is covered by Felguerez's work, offering a miniretrospective of his forty-year career. He begins with his art, omitting biographical references, skipping over the drama of his youth, the apportionment of family estates during the agrarian reform following the Mexican Revolution, the early death of his father, a year in the Academy of San Carlos, and a similar period in La Esmeralda, where he was apprenticed to Francisco Zúñiga.

"This is my earliest work, these figurative sculptures. I was a disciple of [Ossip] Zadkine, his student for a time in Paris, so I began by making slightly Cubist sculpture. Then I dropped figuration and took up abstract sculpture; that was after 1956. And from then on, actually, after 1957, I painted as well. At the beginning, I was still searching, so the changes are very rapid. . . . Yes, most of these were painted in Mexico. I was in Paris only during the time I was a student. In sculpture during this period, around 1959, I was making murals, sculptural murals. This (he points to a maquette of one of his best-known pieces) is in the Cine Diana. It's thirty meters. I'm sorry to say it's not very well cared for there in the movie theater. Then I began working with larger spaces, with texture. You understand, incidentally, that this is not a perfect selection; it's just what I ended up with. Then you see that I began working in black and white, with more emphasis on texture. . . . Yes, then white alone, more informalist. That was in 1961, and due in part to a trip to New York, to action painting, which influenced me in the sense of liberating form. But my formation is more geometrical, more constructivist. So in 1966 I returned to more organized form. These three were painted while I was teaching at Cornell—very free, but at the same time organized. From time to time you see a recollection of the female body. . . . That's right, here you see a torso, there a face—recollections of bodies, but bodies condemned to geometry. Then, gradually, the geometric part becomes more pronounced. Afterwards, geometry still, but more material, more substantial. I began to delve deeper into this geometry. I even painted with an airbrush in order to avoid any suggestion of texture. And along with these paintings, I made reliefs and sculpture."

That was the period of the "Espacio multiple" show at Mexico City's Museo de Arte Moderno, the same period during which Felguerez earned one of his major awards, the Gran Premio de la Bienial de São Paulo, Brasil. Still more change and exploration lay ahead, however.

"Since I was collaborating with a scholar at Harvard University, I began working on the possibilities of using the computer in problems of design. That's what I did on the Guggenheim. That was 1975. I began with small squares. You can tell from these small areas that my apartment in Boston was very small! Sculpture also came out of this project. Then I left the computer behind, but I used the designs—and there were a lot of them—and began painting large canvases. Once again with matter, seeking matter, combining action and geometry."

That work was exhibited in a second show in the Museo de Arte Moderno, "Superficie imaginaria" ("Imaginary Surfaces," 1979). The cool blues and grays and greens of the canvases reflect the rationalism of their origins. Their titles, however, communicate a mysticism that Felguerez does not enunciate: *Kabala, Intermediate Zone, Libra, The Cube's Doubt, The Rhombus's Enigma*. Felguerez continues.

221

39a. Manuel Felguerez, *Teorema Lunar*, 1989, lacquered metal. Photo: Carlos Contreras.

"This geometry led me to the organic, which is itself geometric and has the same combinations of circles, but as you join half-circles with circles you begin to get an organic appearance."

"A shell for example?"

"Yes, a shell for example. And within that, which we still see as absolutely geometrical, there is again a recollection of bodies, a recollection of the organic. This work has texture, you notice, and is on a larger scale. So what I'm doing now is setting geometry aside and constructing free form. In between, in these pieces from the early

eighties, are the same geometric designs but with found objects, assemblages. My sculptural murals are rather directly connected with this work, which in a way is a recuperation of the period of the murals. Since I was in Paris during this time, all these things, the forceps, the gears and clockworks, are from the Marché des Puces."

The retrospective is complete. We have arrived at a recessed cove containing a different kind of collection, small tin and iron figures, primarily soldiers. They are not unrelated to the small metal figures Felguerez's nephew pointed out the day before in the Bazaar Sábado in San Angel, one of the best crafts markets in Mexico City, explaining that his uncle was the originator of many of the designs, but by chance, really, Felguerez explains. During a period when he was creating many of the forty-five large sculptures and murals he has installed in buildings around the world, he maintained a number of assistants. As commissioned works of public art are sporadic at best, he had to do something to support the workshop. His solution was to design small figures of children and athletes and soldiers that were produced and sold under the rubric "Artesanías Felguerez." Over the years, the works were copied and since have become a staple among local artisans.

It seems that Felguerez is always designing something, building, creating. He designed his home-studio, for example, in the vein of the best of Mexican architecture: angles and planes of light and shadow, walled spaces sheltering cool greenery, stairways that play Escher tricks with perspective. In the early fifties he created ceramic pieces that, like the metal figures, are now standard in popular art. As a boy he practiced taxidermy, learning the intimate configurations of mammalian anatomy. Later, he collected and studied pre-Columbian pieces, absorbing the lessons of the indigenous past. And in the large stu-

dio behind the house there is a maquette of the multi-multilevel home Felguerez and his vivacious wife, Meche, are building in Puerto Vallarta. It will be a triumph of Felguerez ingenuity: one room wide, it cascades down a cliffside from the top level—for parking—past rooftop swimming pool, then bedrooms, past studio and living and kitchen areas to the beach below. One of the serendipitous pleasures of the project is that the home is constructed on a lot sandwiched between the properties of two North American millionaires who thought the land between them unusable and who now resent the intrusion of the enterprising Mexican utilizing the space they thought forever safe.

The studio itself—by now, no one could be surprised—is very orderly. Shelves of materials fill one end; the other is furnished with an assortment of tables and shelves and stools with twisted wire legs. Two objects capture the eye immediately. One is a large canvas on a heavy easel, the other an enormous and slightly scruffy armchair. The chair is so hospitable it seems almost to speak.

The painting is a revelation. Burnt oranges shading to deep carmine, golds, browns, fill the phantasmagoric space of the thickly textured canvas. Truly, Felguerez is "constructing form." One circle of many has closed. He has returned to a beginning, a time when geometry is not absent but complaisant, not severe but seductive. Perhaps it is possible to represent Felguerez's career as a constant tension between the circle and the square, a play between the severity of straight line and angle challenged by the siren song of the curve, and all permutations in between: the compulsive urge to square the circle and to round the square. The experiments with the computer are, at least for a while, some distance behind, but the orderly, sensitive brain of Felguerez continues to compute the infinite geometry of his art.

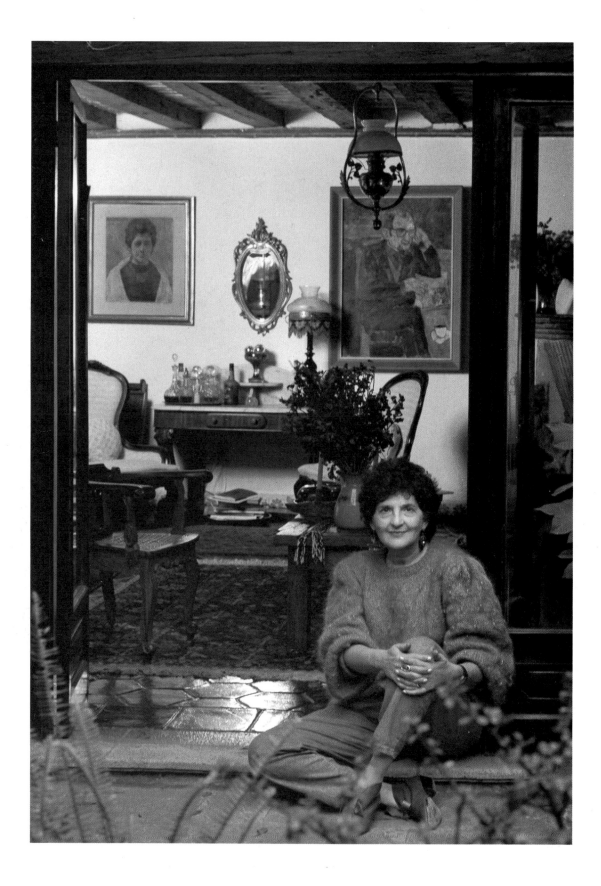

40. Margo Glantz

Margo Glantz [signature]

MARGO GLANTZ

Mexico City, D.F. · 1930

Mercury is Margo Glantz's sign. Not the Mercury of astrology but rather Mercury, the god of travel; mercury, metal in flux. Glantz is an inveterate traveler of both physical and metaphysical spaces. Her writing, creative and critical, is like quicksilver: gleaming, fascinating, a flashing play of words and ideas that resist familiar categories. Her criticism is the more easily described. She has written on Tennessee Williams and North American theater, and on José Agustín and La Onda; she had edited nineteenth-century travel accounts by foreign visitors to Mexico and published books of essays on Mexican literature. She is a professor and a successful administrator and has served as director of publications of the Department of Public Education, literature director of the National Institute of Bellas Artes, and as Mexico's cultural attaché in London. She is a creative critic, illuminating her subjects with the light of her intelligence. It is when she gives rein to her own beguilingly quirky writing, however, that one approaches the essential Glantz, the true original. For want of a better term, it may be said that she is a poet-essayist. She writes out of her personal experience, imagination, and anxieties. She exhausts the legends, myths, and truths of a familiar object and makes it shine like a new dis-

covery before our eyes. In *El día de tu boda* ("Your Wedding Day"), based on a collection of nostalgic hand-colored postcards, Glantz examines the romantic mores of the Mexican middle class of the early century: "The postcard is a genre in itself. It gives a rapid and concise idea of a journey, a panorama, a city, a sentiment. Among its four walls it contains a reality that demands an immediate, usually not profound, reading." Her *Mil y una calorías* ("A Thousand and One Calories") is a "dietetic novel." *Síndrome de naufragios* ("Shipwreck Syndrome") is an impressionistic observation on the perils of the life voyage, drawing from the adventures of such famed voyagers as Columbus, Virginia Woolf, Sinbad, Magellan, the Marx brothers, Marco Polo, and Baudelaire.

A number of years ago, Margo Glantz made a lecture tour in the States, reading, from among other pieces, excerpts from *Doscientas ballenas azules* ("Two Hundred Blue Whales"). Who was this tall, attractive woman, her audiences wondered, proclaiming her love for cows and whales and turtles, lauding fleshy, bovine, antediluvian animals over more traditionally emulated larks and gazelles and panthers? Her fondness for whales was certainly tempered by the threat of their extinction, but there was something exceedingly more per-

sonal about her affection than a humanitarian championing of endangered species.

I like the whale because it is not like a pelican, and because unlike the birds that nest along the coast it returns its nutritive excrement to the sea.

Algae and sargasso gleam on its glistening back. Whales are beautiful even when they are reduced to bone and become stays in corsets or splendid white brooches bleached by the salt spray and sea that Joseph Conrad concentrated in the typhoon of his words. I like whales for their intelligent silky skin and for their battered, perfumed substance and their oblique humorous eyes. I like them for their voice, for it was they who were the invisible sirens who lured Jason and Ulysses. I like them because they disdain even the sea, and guard it as their tomb when they commit suicide, leaving afloat their white bones—dazzling rafts, asylum for shipwrecked sailors.

Another of Glantz's fascinations is evident in *No pronunciarás* ("You Shall Not Speak"), which reads the profound messages written in names, in handwriting, and in signatures. Names define a genealogy. And it is *Genealogías* that contains the kernel for all Glantz's writing. It is the central book in the Glantz canon, for it is in the search for origins, the quest for identity, for knowledge of ancestors and self, that we find the germinal thrust of her twenty-five books. Much of the text is spoken in the voice of her father, Jacobo Glantz, a poet from the Russian Ukraine who wrote primarily in Yiddish. Both of Glantz's parents emigrated from Russia following the pogroms that accompanied the First World War. They intended to settle in the United States, where Jacobo's family had migrated and where he had spent a few years. Just as they arrived in this hemisphere, however, immigration quotas were changed, and the young Glantzes found themselves instead in Mexico (in itself, cause to ques-

tion fate). There Jacobo sold bread in the morning and shoes in the afternoon, studied dentistry, and wrote poetry. And there four daughters were born. One of them was a voracious reader, a loner who identified with Flash Gordon and Christopher Columbus. Her name was Margo (a name "given to beauty salons, unisex stores, carnivals, cleaners, restaurants, North American screen stars, provincial boutiques . . . and a fast-drying paint"). A first-generation Mexican, a Jew in an overwhelmingly Catholic society, a woman in an overpoweringly male-oriented culture, it is not surprising that in *Genealogías* she writes of a sense of alienation.

I have always been amazed by how I identify with the changeling, and have never been able to explain it to my satisfaction. Sometimes I think it is simply an impression left from one of the many houses we lived in during my childhood, the one at number 13 Niño Perdido [Lost Child Street]. Other times I think it had to do with the color of my hair; that is, mine was black to dark chestnut, while all my sisters (three more) have always been blond. And my eyes aren't blue. My sister Susana's were blue (and still are), and my sisters always used to wash their hair in manzanilla soap to keep it from turning dark. My hair was as tightly curled as a black's or as sheep's wool, and therefore I always associated myself with the black sheep in the fable (not Monterroso's but the one in the Bible). Maybe my feeling came from hearing my sister repeatedly yell that I was not my parents' child and they should throw me in the dustbin, but that sensation and those yells have been heard by many second children, and there is a Freudian explanation for that. . . . Maybe these genealogies will help me understand this feeling. It may date from the day my father brought Susana a Shirley Temple doll from the United States; she was dressed in an orange-and-white silk pajama with an embroidered dragon. Envy drove me from my paternal home.

Today Margo's home is in Coyoacán, one of the colonial neighborhoods of Mexico City. It is filled with folk objects, ornamental mercury balls, drawings by Toledo, a watercolor by Luis García Guerrero, and nineteenth-century chandeliers and beaded-shade lamps. The sitting room is dominated by a portrait of her father. Her literary family portrait and autobiography is part of our conversation.

Questioner One of the interesting aspects of your writing is its scope. You're a creative writer; you're a critic; in your most recent work on Bataille and other French theorists, you're edging toward philosophy; you've written your autobiography. How do you move from thing to thing? What impels you toward one genre or the other? Can you describe that process?

M.G. I believe that one of my problems is that I have too many ideas, and every time I come across something, every time I have a new idea, I think it is the most important I have had, and I abandon everything else. For example, the book of the whales, the one on being shipwrecked, and the book on names all began as a single book and only gradually divided into three. I think I ought to confine myself more, to a specific theme. But these are interests I have had since I was very young. And if you look closely, you will find that they are obsessive themes that all meet and converge.

Q. In sexuality and the body, no? And in the intellect. Can you really say you are most interested in the body, in corporeal subjects, when mind is your center?

M.G. It is, but what fascinates me most is the problem of the body. My thesis is always focused on the body. That is the recurrent theme.

Q. That's true, through all your work. Can yours possibly be an obsession similar to Frida Kahlo's, and to a number of young painters who take her as their inspiration: a way of expressing everything through aspects of your own person?

M.G. In my view, Frida was obsessed with her body because it was a mutilated, an injured body—a body she wanted somehow to recompose. Perhaps the same is true of me, that on some level there is a problem of fragmentation, and I write about different parts of the body to effect a kind of reintegration. Because although I have no profound wound, I always fancy myself fragmented. And writing is a way of putting the body back together—working on feet, or hands, or sometimes hair. And now I'm working—I have been for more than a dozen years—on the Conquest, the Discovery. I'm working through the problem of the body in the confrontation between the Occidental body—which is the clothed body—and the naked body of the Indian. This book will begin with the Conquest and span all the time to the present day—especially some aspects of colonial Mexico.

Q. But that's an enormous project.

M.G. Enormous, enormous.

Q. Going back to the quest of fragmentation—what you write in *Genealogías* suggests a strong sense of alienation. Does that also have to do with being a woman operating, acting, in a world of men?

M.G. I've been trying to find the answer to that all my life, but haven't as yet found it. I believe a kind of violence can result from a pre-established concept of one's body and that my own sense was determined by the decade of the thirties, from a time when movie stars were incredibly glamorous, like Greta Garbo, Jean Harlow, Joan Crawford, and Barbara Stanwyck. My mother dressed a little like them. And I saw their movies and collected albums of their photographs. And then when I looked at myself in the mirror, I felt terribly graceless.

Q. As we all did.

Glantz's most intense scrutiny of an aspect of the body is found in *De la amorosa inclinación a enredarse en cabellos* ("On the Amorous Inclination to

Become Entangled in Hair"). This is a complex book operating on many levels and involving figures as disparate as King Kong, Napoléon, Rapunzel, John Travolta, Mary Pickford, and Samson. Glantz's own words best describe the intent of the book:

> This book is, then, a beginning, a sample case, a loving object, which may reveal some of my predilections, my obsessions, although in an oblique way it also represents the predilections and obsessions of various past and contemporary Western cultures.
>
> In the first part, I propose a summary analysis of some of the relationships hair has to literature. . . . In the second, I join together two themes I consider fundamental: frivolity and death, the uncontrollable desire to be beautiful and murderous violence. I have used a number of clippings about beauty parlors and fragments from books in which the head is delivered to depredation: by guillotine, by hair removal, by shaving... I consider this theme important because, along with finger- and toenails, hair is what survives longest of the dead human body and because, at the same time, the way in which hair is dressed determines concepts of repression or liberation—as when hippies let their hair grow. The third section is simply a lock whose hairs have been plucked from different literary texts . . . leaving an open space for each to add the hair in the soup that most attracts or bothers him or, obviously, her. Or, to put it more poetically, for each reader to put her most beloved hair in its own locket.

Garcá Guerrero

LUIS GARCÍA GUERRERO

Guanajuato, Guanajuato · 1921

Your clay rings of silver

RAMON LOPEZ VELARDE

This phrase from *La suave patria* ("Beloved Land"), a cherished Mexican poem, might have been written of the soil of Guanajuato, García Guerrero's birthplace. This colonial city of steep cobbled streets, arcades, alleys, and underground thoroughfares was for three centuries the silver-mining capital of the world. The bare hills surrounding the city glow with the reds, ochers, and violets of García Guerrero's landscapes. More than any other contemporary Mexican painter, García Guerrero evokes place—from his brooding mountainscapes to the minutely detailed fruits, flowers, insects, and ores of his *patria chica* ("land of his birth"). García Guerrero's paintings are the visual equivalent of Pablo Neruda's *Elemental Odes,* a poem to his homeland, each work a paean to a specific representation of Mexican reality.

Like the photographer Manuel Alvarez Bravo, García Guerrero sampled many careers before finding his true métier. After completing his secondary schooling in Guanajuato, he traveled to Mexico City to study architecture, an experiment he quickly rejected. He returned home, where he earned a degree as a solicitor and notary from the University of Guanajuato. He never practiced law, but he did use his training to earn a living as a court clerk. Gradually, he began to spend more and more time painting. In the fifties, García Guerrero moved to Mexico City, installed himself in an apartment on Calle Amores, where he still lives, and began painting as an artist, not an aficionado. It is in that apartment that we learn more about his interests and his work.

"I have friends, but very little social life. I read a lot. And I am never bored." A fortunate state, we agree. "It's true that at this time of year I experience a little melancholy—more than on my birthday. Birthdays are, well, they are what they are. The end of the year is a kind of accounting. What have I done? What haven't I done? That always makes me a little— But I don't regret anything, not anything. Only the things I didn't do. Overall, I consider myself very fortunate. I don't want to go to the moon. I prefer to imagine it. It's so beautiful there in the sky. I prefer it that way, the image of *Clair de lune,* or a very romantic painting."

The reference to music is not casual. García Guerrero is passionate about music and paints only when music is playing. Shelves filled with

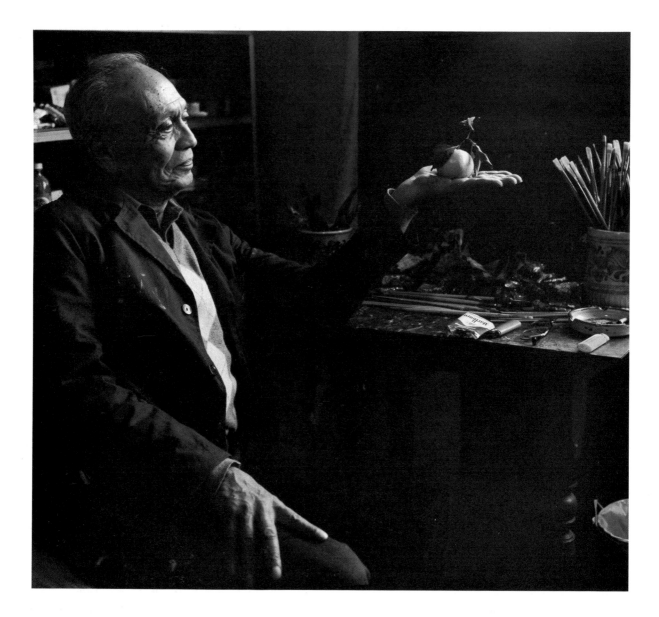

41. Luis García Guerrero

78-rpm records suggest a broad taste. He has no difficulty, however, in identifying his favorite composer. "Mozart. I think I am going to choose something different, but— There's no one like Mozart, Mozart, Mozart, and Mozart!" The meticulous order of García Guerrero's paintings reflects a Mozartean harmony; the minuscule *touches* are as intricately interwoven as a Mozart concerto. "I even included some divertimentos in a recent exhibition. You see, *me divierto,* I enjoy myself, painting, and as I don't take myself too seriously, I painted those divertissements for him." The paintings he refers to are joyous: blues, roses, yellows, whites—bouquets of dahlias, daisies, marigolds, and everlastings—one set against a background of lavender blues and another of golden yellows. And somewhere, invisible, Mozart. Smiling.

As he speaks, García Guerrero hums. His words are spaced with pauses filled with interjections that are more musical notes than words. "There was even one painting I (pause) *hmmm* titled *Les petites riens* (pause) *hmm hmm* for a ballet by Mozart. *Hmmm.* 'Little nothings.' *Hmm hmmm.* Because there was nothing, you see." The "nothings" here are four objects, a small piece of ore, a bivalve shell, a halved strawberry, and a *tomate,* its brittle husk just opening from around the green fruit. The four natural objects are arranged in Mozartean symmetry, like dancers poised to begin a minuet.

García Guerrero's career, following a traditional pattern, has evolved though several phases: from Cubist still lifes through portraits influenced by Picasso and Diego Rivera through abstractions (some with a markedly Oriental flavor) to the two modes of painting for which he is best known today, the landscape and studies of objects from nature. In many earlier paintings, small objects are foregrounded against a distant landscape, combining the two forms. A pomegranate dwarfs yellow-green hills, a pale yellow quince similarly dominates ocher and violet peaks, a pale brown mamey, its glossy brown pit exposed in a triangle of orangy pink flesh, balances on one end like a huge fleshy football amid the greens and browns of a receding series of mountain ranges. Later— although the combined form does not entirely disappear—landscape and object tend to be portrayed independently of one another: landscape and sky filling the entire canvas, fruit—a mandarin orange, a lime, a pear—placed prominently on a brilliantly rendered block of wood. One variation is a fruit floating above the landscape. Those suspended objects are a step on the way to García Guerrero's now-familiar unplaced object, one that may seem to have support although the underpinning is invisible.

That mode is so prevalent in García Guerrero's portfolio that it is laughingly proposed that he might himself obligingly float for the camera, like the priest in *One Hundred Years of Solitude* who, in the course of raising funds for his parish, would levitate briefly after drinking a cup of chocolate. Our discussion leads naturally to the question of magical realism. García Guerrero's work has been included in a show of Mexican surrealists, yet there is something incongruous in calling this superrealist, who details every shadow on the surface of a fuzzy chayote, every vein in the transparent wing of an insect, a surrealist. On the other hand, perhaps García Guerrero is an excellent example of the magically real, the absolutely factual floating eerily in a nondefined space. His explanation is uncomplicated. "I think something must be left for the viewer's imagination."

García Guerrero is an artist's artist. In home after home of Mexico's leading visual and literary artists is a centrally displayed García Guerrero shell, or pear, or tangerine, the mandarin orange that so often sunnily lights this artist's canvas. Luis Cardoza y Aragón, a prominent art critic equally enchanted by the magical mandarin, composed a prose poem to its image:

To paint a mandarin orange is to capture its totality.

Meticulously delving into sleeping substance, beyond the vigilance of roots, García Guerrero deciphers his subject in the eternal energy of his mirror, in which objects are elucidated as they dissolve in self-reflection.

To sink into the thousand and one nights of the pulsations that sculpted it, into the primeval light that reconstitutes it, I contemplate this jewel exploded into an infinity of facets.

Mandarina, juicy with vowels; the sorcerer's passion poises his orange on the summit of being.

In its planetary system, more orange than the orange itself, its gravity rules reality.

The portrayed orange has not taken the place

41a. Luis García Guerrero, *Mandarina,* 1966, oil on wood, 26 × 18.5 centimeters. Collection Luis Cardoza y Aragón.

232

of the intolerable model. This hallucinatory image flourishes on the tree of life: incendiary intensity.

I listen to the internal fervor, the golden gurgling, of the tiny belly that digests me and cloisters me, until I blaze exalted in its minimal, spherical fire, in the impetuous paradise of a planet held in a hand.[1]

García Guerrero enjoys his quiet life and the sanctity of his "little world." A small studio is dominated by a work in progress, one of the landscapes of his "bald" Guanajuato mountains. The record player is prominent among hundreds of records, as are a dozen or more half-filled ashtrays tucked everywhere about the room. The remainder of the apartment, as is so often the case in the homes of Mexican artists, is a small gallery. The walls display Toledo graphics, a Gerzsó, a Zúñiga, along with works by other Mexican artists. And then there are the treasures in the entry hall, two glass-fronted cases filled with beautifully arranged objects. One is nothing but seashells— "These are my models." The other displays geodes and crystals and ores. "This is raw silver. Who would think it was silver? It looks like something I would throw into the street." And there is a marvelous collection of *láminas*, the naïf paintings on tin that portray a moment of supernatural intervention, a favor granted by a saint or the Mexican Virgin of Guadalupe. "These are the saints you used to find in miners' homes. When colored prints became available, they threw these out. Insane, wasn't it?"

On the professional plane, too, García Guerrero's life is characterized by a certain withdrawal. "I don't speak out much—only rarely. And when I do, I need someone to zip my lips. It's my belief, though, that painting, or writing, or any art, is not accomplished at a roundtable. It is accomplished in studios, in theaters—and a little, in solitude, working."

When García Guerrero has something to say, however, he is serious about it. Carlos Monsiváis, in his introduction to a book tracing the trajectory of García Guerrero's career, recounts just such a moment in the life of the young artist. García Guerrero was twenty-eight. He was lecturing in León, Guanajuato, on the subject of modern art. *El Sol de León,* the local newspaper, carried a report of the events that hastened García Guerrero's departure from the provinces.

In the course of the program, García Guerrero spoke of numerous painters, until he came to the work of Picasso, José Clemente Orozco, and others . . . all of whose work presents revolutionary and anticlerical sentiments. . . . In sum, the lecturer's comments traveled such tortuous paths as to express anti-Christian ideas.

A local priest "energetically" accused García Guerrero of seizing the pretext to attack "our social and religious ideals, to mock everything sacred." The man who had invited García Guerrero made a public apology. García Guerrero held his ground.

"I do not believe that sentiments have a banner, but I have almost been convinced that I was the devil's messenger, sent to upset the artistic attitudes of the dictators of bad taste. If that was the case, I accept the role, since, in fact, my lecture did have the terrible objective of intending to disturb.

"I did not, however, imagine that I would so deeply scandalize those incorruptible souls whose ideals of beauty attain—at their outermost limits—the asexual limbo of respectable tackiness. To speak of heaven, to speak of hell, in painting is beyond their limited capacities. . . . I regret nothing that happened."[2]

The quiet man had spoken. He is quiet-spoken to this day. He has not sought the notoriety some call fame. But his art speaks for him, quietly but powerfully.

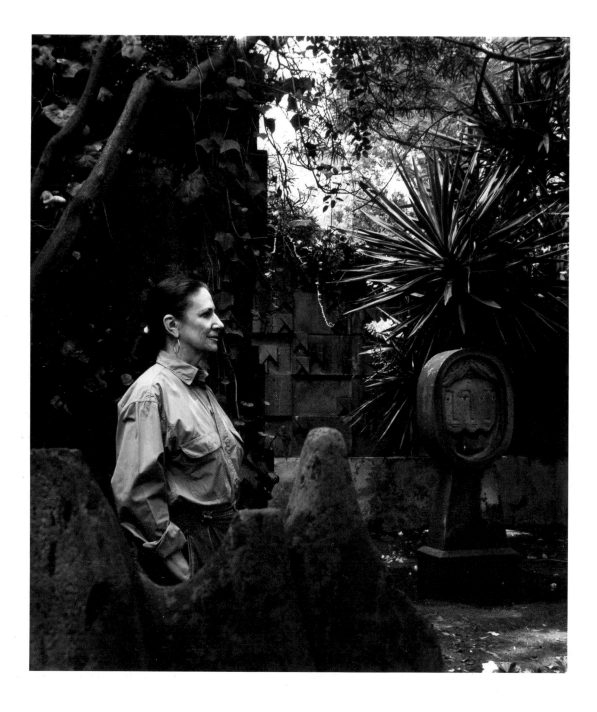

42. Angela Gurría

Angela Gurría

ANGELA GURRIA

Mexico City, D.F.

I should begin by pointing out that at the beginning I had no confidence at all in myself as a person and felt that I was fighting against everything; I do not know whether this was due to the fact of being a woman, but it is quite significant that I began by signing my work "A. Gurría," so that no one knew whether I was a man or a woman. All the people involved in competitions and the like were sure that I was a man, and were invariably surprised to find that the person in question was a woman sculptor. Once I felt more secure, I began signing "Angela Gurría" as I do now, and began living more fully both as a woman and a sculptor.[1]

It is not easy to be a woman artist in Mexico. A high percentage of those women who do succeed in what is at best an unwelcoming arts climate are first- or second-generation Mexicans such as Elena Poniatowska, Verónica Volkow, Angeles Mastretta, and Margo Glantz, or naturalized and adopted citizens like Marta Palau and Leonora Carrington. Even Frida Kahlo, now the symbol—if, sadly, only posthumously—of the Mexican woman artist, had one non-Mexican parent. It cannot be coincidence that even though these women identify absolutely with their native or adopted country some element of their foreign-ness allows them to escape the stereotypes of their culture.

It is an obvious absurdity, however, to suggest that only woman artists of foreign blood succeed. For proof, we need look no farther than the Mexican thousand-peso note and coin, which bear the image of Sor Juana Inés de la Cruz, the seventeenth-century nun who is one of Latin America's most famous artists, male or female. And in the twentieth century we find Angela Gurría, a woman who has succeeded in a field where, even today, throughout the world, the major creators are predominantly male: monumental sculpture. The most astounding example of sheer volume in Gurría's work is the project she directed in Valle de Bravo, _El corazón mágico de Cutzamala_ ("The Magic Heart of Cutzamala").

A.G. My work often involves the cooperation of many people. In this case there were at least two thousand workmen. Valle de Bravo is a very beautiful spot with many trees. A dam was built to form a lake—a lovely place. I was commissioned to create a monumental sculpture for a large open area there. The first stage of the Cutzamala project was truly impressive. It was designed to provide water for Mexico City. It was thousands of kilometers, cutting through hills, crossing moun-

235

tains. There are these huge pipes eighty meters high that measure the water as it descends. An ordinary sculpture would look ludicrous beside them, of course. So what I did, so the whole thing would not look silly, was integrate the pipe with the mountain. All the dirt that had been removed was graded, and from there, descending from the tower, I made a kind of pre-Cortesian temple. That was in turn integrated with the work camp, and the whole became a kind of, well, a kind of city: temple and observatory [in the mode of Chichén-Itzá]. So that was the idea, the concept, which worked out rather well. I painted the hill and the tower in blue and white, and it became a whole.

Questioner Do you have photographs of the project?

A.G. I have some horrid photographs. I will bring them, but it was on such a large scale it is impossible to capture it in its entirety. There was a town of workmen. Everything, even electricity, was down below. The tower was like a monument to Tlaloc, the god of water. So the tower became a sculpture, and the earth was landscaped behind it. I had two thousand men building steps.

Q. It must have looked like a scene from pre-Columbian times.

A.G. What was really phenomenal was that instead of working from the bottom to the top, in the normal order, we worked from the top down. The first of the steps was the top step. It was all done in reverse. You can see everything from a helicopter, but these pictures...

Q. It does look like a temple.

A.G. It really was like magic, all of us at the top, working down through the trees.

Q. The perennial magical realism of Mexico—it always seems to enter in.

As if on cue, a spider lowers herself into the middle of the conversation: Arachnida, creating her own intricate and ephemeral silken monument, she too working from the top down.

Q. That's what I was saying. There's always some presence in Mexico. She won't bother us.

A.G. Oh, no, I never touch any creature. I respect them all. And if I move them a little, like this, I ask their permission.

Q. I know that the one you call the *estrella,* the star, brings good luck.

A.G. They're much more afraid than we are. I'm afraid I just let them stay.

Q. To weave their magic.

A.G. In Mexico's culture everything, everything, is based on magic—all the pre-Cortesian culture and later. There were idols behind the religious icons. Even today, in the figures they make, you can find an idol inside. There's always something that transcends.

The majestic arachnidan descent was made in Gurría's studio in Coyoacán, an area of Mexico City in which one still may see the beauty of the colonial city. On the lower level of the studio, a large, white, slotted, wheel-shaped sculpture, *Comunión,* looks as if it were constructed especially for the conservatory where it stands among tropical greenery. The balcony railing overlooking this pleasant vista is lined with constructions of chunky glass set in metal, like huge, aberrant molecules—surely an offshoot of the large stained-glass sculpture Gurría fashioned for the Guadalupe Sanctuary in Monterrey, Nuevo León. A colorful Francisco Toledo tapestry warms the wall of the stairwell. A couch and a few chairs encircle an enormous slice of jasper or agate, a translucent swirl of rusts, browns and whites. These personal pieces viewed in the sculptor's workspace are easily identified. We realize that Gurría's public sculptures seen every day by thousands of passersby are a different matter. Near anonymity is, in fact, the lot of the creator of public art.

"In sculpture, one's work often becomes anonymous," Gurría agrees. "No one knows who made

it. Every person, architect, engineer, mason, workman—they all make it. I am the designer and director. It's my work, but at the same time it's the work of other people—Yes, like the dramatist or composer who turns the performance of her work over to others. But in the end, it is the work that matters."

How many hundreds of thousands have seen Angela Gurría's *Estación 1* ("Station 1"), one of a series of sculptures installed in 1968 along the *Ruta de la Amistad* ("Friendship Way") on the Periférico Sur, a section of the highly traveled beltway around Mexico City? Millions of automobiles have passed the twin black and white

42a. Angela Gurría, *Monument to Workers on the Deep Drainage System*, concrete and steel, five towers from 14 to 30 meters high, Tenayuca, Mexico. Photo: Kati Horna.

columns rising a graceful eighteen meters against the sky like two slightly curved and greatly elongated metronomes marking the beat of the pulsing city. Related in their monumentality, and in their elongated and truncated pyramidal bases, are the five 14- to 30-meter towers of the *Monumento al trabajador del drenaje profundo* ("Monument to Workers on the Underground Drainage System") in Tenayuca, Mexico. The smallest of the towers is unadorned; the sheared-off tops of the remaining four hold polished segments, open at the top, of grooved tubes that evoke the steel-drum markings of storm-sewer pipe. A sculpture necessarily viewed by fewer persons, since it stands in an interior space, but a piece that may be Gurría's most celebrated is the nine-meter steel *Homenaje a la Ceiba* ("Homage to the Ceiba Tree"), which fills the multistory lobby atrium of the Hotel Presidente Chapultepec in Mexico City. These large sculptures for public spaces are typical of designs executed from maquettes. Angela Gurría is also noted for large pieces carved directly in stone, often following nature motifs such as snails, seahorses, tadpoles, waves, and birds: her *Rehiletes* ("Pinwheels") and *Sirenas* ("Sirens") on the Paseo Tollocan in Toluca; *La nube* ("Cloud"), a marble displayed in the ground-floor central entry of the Museo de Arte Moderno; *Tepozteco*, the thrusting peaks of a moonscape weathered by millennia of cosmic particles; and *Estela* ("Stela"), a slim column on which geometric flights of butterflies have lighted like stone origami.

Only a few doors from Gurría's studio, in the back patio of her beautiful eighteenth-century home, is a courtyard walled in the same red stone as the *Estela*, on which a multitude of the origami butterflies have alighted. Two handsome golden-eyed weimaraners lope through the connecting patios, more interested in the flitting insects than those set by their mistress in the eternity of stone. We are drawn inside by glimpses of cool interiors, large high-ceilinged rooms that guard memories

one longs to share. This house has *duendes*, spirits, and the palpable but elusive quality that makes a work of art, a place, a person, unforgettable. Angela calls it—briefly, in English—"my House of Usher. She is beautiful, but she's falling down. I will die in her some day, but I love her so much." It is not difficult to understand why this warm and genial woman prefers to live quietly within the self-contained world of studio and home. She insists—despite a busily ringing telephone—that she lives a solitary existence and that her independence carries over into her professional life.

"I have not been considered part of any generation. I am the kind of person who, given a space, will fill it. I will fill it with whatever that space indicates to me. I am not obliged to make a figurative work, or a geometric work, because that is the style. I am not a part of any movement or style. I have never had a formula that I have repeated and repeated. It would disturb me very much to interject an element that is not within the context of the space. No, I am not a part of any group."

But Angela Gurría has left a part of herself, of her creative identity, on the public and private landscape of Mexico. She has *duende*. The spirit is with her.

MANUEL ALVAREZ BRAVO

Mexico City, D.F. · 1902

"I was born in Mexico City behind the Cathedral, in the place where the temples of the Mexican gods must have been built." Those lines from a personal letter written in 1943[1] convey a great deal about Manuel Alvarez Bravo's self-identity. Although his supposition about the location of the "temples of the Mexican gods" was not startling, since it is known that the Spanish capitalized on tradition by constructing their centers of worship on a site hallowed by ancient gods, it places his roots in the indigenous past. His sense of having been brought into the world in the invisible presence of those ancient deities was substantiated in 1978 when a worker laying an electric cable accidently unearthed evidence of the massive ruins of the Templo Mayor. Foreign artists such as Hugo Brehme, Tina Modotti, Edward Weston, and Paul Strand found rich inspiration in Mexico, but Alvarez Bravo was the first Mexican to capture international attention in his genre. He is Mexico's photographer par excellence, and his work will stand as one of the truly great national portfolios. Alvarez Bravo himself has stated that he has never been comfortable working outside Mexico, and it is tempting to speculate that jealous gods have bound him to the soil soaked in the blood of their sacrificial victims, his ancestors.

Two of Alvarez Bravo's most famous photographs can be read as allegories of the bloody rituals of that autochthonous past: *Obrero en huelga, asesinado* ("Striking Worker, Murdered") and *Sed pública* ("Public Thirst"). *Obrero* is Alvarez Bravo's most overt political statement. Early in his career, he divorced his art from his political philosophy, renouncing the propagandistic directions followed by his muralist contemporaries Rivera, Siqueiros, and Orozco. If we are to believe Alvarez Bravo, this photograph, like so many artistic experiences, was the gift of chance. He tells that he was in a market "watching the weaving of textiles," when he heard a noise like firecrackers. He ran to the nearby train station and found that a young striker had been shot by the police. His famous photograph contradicts the violence of the death. A young man lies on his back in a pool of blood, his open shirt stained, apparently, before he fell to the ground. His face, in death, is calm, not contorted. In a different light, the blood flowing from his head wounds might be long hair streaming in the wind. It is his arm, extended toward the camera, that most strongly conveys the eternal quiet

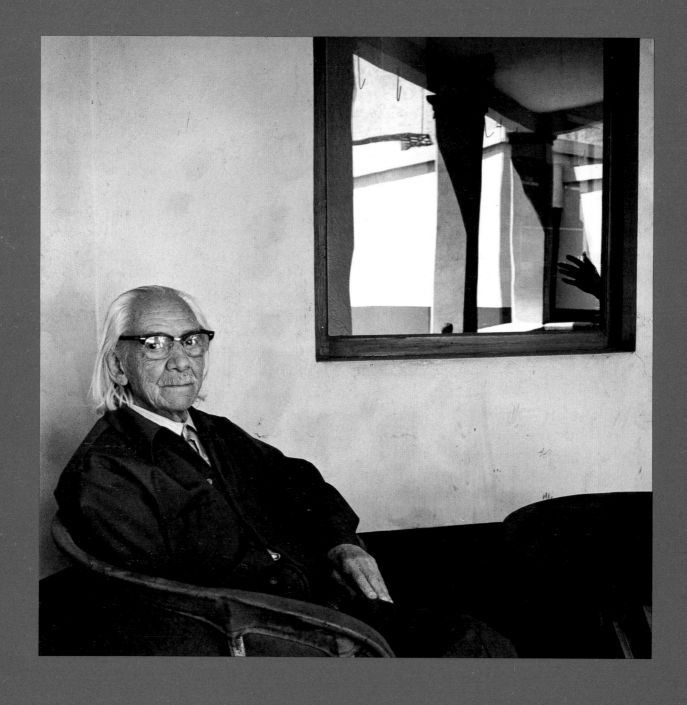

43. Manuel Alvarez Bravo

of death. The hand is a workman's hand, grimy, with gnarled fingers, but it is relaxed, as if the man were indulging in a pleasant siesta.

The normality of that scene is echoed in the photograph that Alvarez Bravo likes to display with *Obrero: Sed pública.* Here a young boy crouches on the lip of a public well. His white-clad body twists away from the camera toward a black wall, and he lifts his head to drink from a stream of water whose source is lost in the darkness. The boy's coal-black hair would also vanish in the shadows were it not for the sunlight that defines the crown of his head with a feathery halo. Workman and boy are but stages in the eternal cycle of life and death. Tlaloc, the rain god, quenches the boy's thirst. His blood, in turn, like that of the murdered workman, will return to the earth to quench the thirst of the ancient gods.

Viewers may read their own subjective appraisals into an artist's work, but skulls, graveyards, crosses, and coffins are too prevalent in Alvarez Bravo's oeuvre to deny his preoccupation with the eternal Mexican theme of death. One series of photographs, for example, depicts skulls: a ravaged skull from a pre-Columbian ruin, a skull that might have been used for an anatomy class, a skull photographed in Rouen, France, and one of the elaborately decorated candy skulls sold during festivities for All Souls' Day on November 1— *the* skull, universalized and demythologized. Not all the bloodiness is reserved for religious rites that predated the Conquest. One of Alvarez Bravo's most breathtakingly beautiful images is that of strikingly mortal Christ photographed in Oaxaca. The crown of thorns, the bloody wounds, are those of the traditional Christ figure, but He is made surreal and, at the same time, human by the white cotton, pin-tucked, and lace-edged pants that clothe his legs and hide the stigmata of his feet. An unforgettable detail: the lace on the right pants leg is badly ripped, in absolute contradiction to the loving attention evidenced in the jars of fresh daisies placed on the wooden dais on which this dejected and forlorn Christ is seated.

In the Alvarez Bravo canon, representations of death are countered by an equally important and pervasive theme, the female nude. These studies reflect a broad range of tonalities. In one photograph a young Indian girl sits on the floor, expressionlessly facing the camera, legs crossed, hands on her knees, in a direct quotation from pre-Columbian icons. Another, called *Xipe,* after the flayed god Xipe Topec, the image of regeneration, is portrayed from shoulder to knee. The model is standing with one arm doubled behind her back; the other hand holds a dark drapery that falls from her waist, suggesting the graceful folds of a strip of flayed flesh. Alvarez Bravo's most famous nude is *La buena fama durmiendo* ("Good Reputation Sleeping"), taken at the behest of André Breton, who praised the Mexican photographer in *Souvenir du Mexique,* a memoir of the nation he called surreal *"avant la lettre."* This nude reclines on a striped rug. She is naked except for the white bandages that swathe her feet, upper thighs, and lower belly but leave her pubis bare. Four prickly cactus are arranged beside her on the rug, the subject of much speculation in regard to their symbolic meaning. In a second photograph, the same model stands in a doorway closed by wooden slats like those in a rolltop desk. The bandages on her feet have been removed. In her left hand she holds the ends of the bandages of her lower torso, still present but now disarranged. This image is entitled *La desvendada* ("Girl with Bandages Undone").

In the catalogue for a major retrospective mounted in August 1989 at Mexico City's Centro Cultural de Arte Contemporáneo, Alvarez Bravo recounts how he became a photographer.

I was a student in Tlalpan, in a school run by Marist brothers. I never finished elementary

43a. Manuel Alvarez Bravo, *Los Perros Durmiendo Ladran* ("Dogs Bark While Sleeping"), *Milpa Alta,* 1966. Courtesy The Witkin Gallery Inc., New York.

school, for several reasons. The teachers were French; it was 1914; they had to go to war. In Mexico, we were having the Revolution.

I left school in 1915 to work and help my family. . . . I studied an advanced course in accounting in order to make more money. I wasn't there long. I took a few literature courses. I studied music for a while. Then I studied painting. After that, I tried to learn homeopathic medicine. That didn't last long, either. I've never lasted long at anything... a job, a situation.

Alvarez Bravo clearly understates his lasting power. Once he set out on his career—substantially aided by his friend Tina Modotti—he never turned back. In the sixty years of that trajectory, he has never lost his humility or his sense of humor, two qualities invariably noted by interviewers and critics and verified in personal conversation. After Alvarez Bravo fetches a feather duster and studiously sweeps the dust from a table in the courtyard of what he calls the little village

242

inside his studio gate, we talked about his craft. He is a patient and gracious man. He laughs frequently, a surprising "heh-heh" that often comes at an unexpected moment. He is rather tired, even though it is not yet noon.

Questioner When you began, photography was not considered as much an art as it is today.

M.A.B. No. In my time, it never was. The word "art" is very slippery. It really has no importance in relation to one's work. I work for the pleasure, for the pleasure of the work, and everything else is a matter for the critics.

Q. Can you trust the critics, have faith in them?

M.A.B. Well, that's their problem. (*He laughs.*)

Q. In the forties, when you and surrealists like Leduc and Varos and Leonora Carrington were all here in Mexico, did you know how important your work was going to be?

M.A.B. Well, a person is always submersed in his epoch. Only a few persons are interested in what you are doing. But in my case, absolutely no. I was simply living and working.

Q. You have been called a surrealist. I wonder whether it is more precise to say that you anticipated the mode of magical realism.

M.A.B. From Roh?

Q. Yes, Franz Roh. It seems to be such a common, even overused term today. But perhaps instead of surrealist, you are in fact a magical realist.

M.A.B. (*He laughs as church bells peal in the distance*) Well, "magic" is also a very slippery word.

The viewer, however, feels magic is not at all slippery when he sees the most ordinary objects transformed by Alvarez Bravo's eye: a way-weary dog before a listing wooden gate, circus horses, cacti, bark, laundry, posters, a dress draped over a chair. And walls—he seems to find a special magic in texture and shadows on walls, a hole in a wall, girls against walls, trees against walls, flags in sod atop walls, a mule and a girl behind a wall, and, combining two of his favorite motifs, a circus horse against a wall. One print eloquently conveys the mystery and magic in Alvarez Bravo's photography. A wall is bathed in lacy shadow. Across the bottom and up one side, at a slightly oblique angle, dark wood half frames the lighter wall. Slightly left of center, a quarter of the way up, is a dark handprint, fingers straight up, thumb to the side. It recalls the hand fetishes of Juchitán recorded in the photographs of Graciela Iturbide. It is an amulet, the hand of God, a careless workman's impudence. In Alvarez Bravo's caption it is simply *Pared con mano* ("Wall with Hand"). Whatever its source, its magic is not slippery.

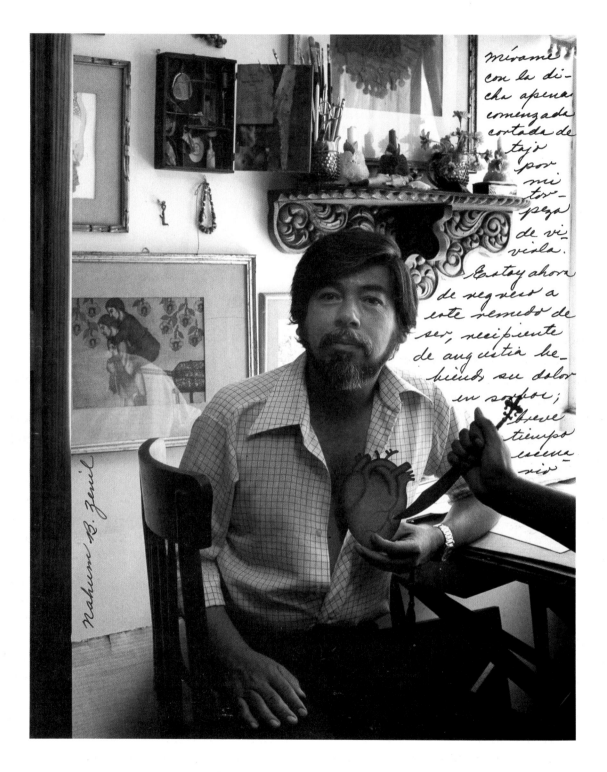

44. Nahum Zenil

NAHUM ZENIL

Chicontepec, Veracruz · 1947

"If I hadn't been a painter, I would have liked to be a writer or an actor, I like the theater, very much, most of all, the drama."

Although Nahum Zenil did make the decision—or the decision was made for him by his art—to become a visual artist, elements of literature and theater are prominent in his painting. For example, Zenil agrees that the power of literature to move him contributes to "the narrative line in my painting." And the actor-self is evident to anyone who has seen a Zenil painting, for the artist is the almost exclusive protagonist of his canvases—center stage, playing all the roles—an obsessive self-analysis and self-expression that will serve as the topic of critical papers for years to come. It must immediately be added that ego is much less apparent in the person of Zenil than in ninety-nine percent of creative artists. He is a gentle, quiet-spoken man who is generous with his time, hospitable, and sharing. He has, for example, organized an annual art show at his home on a *rancho* outside Mexico City, in which he provides an opportunity for lesser-known and emerging area artists to show their work. In March 1990, a typical contribution was his participation in the *Toma de Balmoral*, an art happening in Mexico City, in which the outer walls of an old building were divided into sections to be decorated with ephemeral art, providing a forum for emerging artists and notice of the destruction of historic buildings. Zenil, the major artist in this endeavor, assisted by his constant companion Gerardo, was there on a scaffold painting on brick a black-clad Zenil with the ubiquitous red heart.

Recurrent themes dominate Zenil's work—eroticism, identity, religion, pain—expressed through similarly recurring symbols: knife, mask, the Guadalupe, flag, Frida Kahlo, rope, heart, perhaps the heart especially. Zenil's hearts are anatomical, not Valentine representations. "There is little representation in form," he agrees, "in the human figure, in anything I paint." The Zenil heart is often violated in some way, sundered or pierced by a dagger or knife. At times hearts—entire bodies—are reintegrated, reunited by small lines like stitching.

Questioner What are these reparations, this stitching together? Repairing? Restoring?

N.Z. Precisely that: a repairing, a restoring, sometimes of an identity, or a pain. For example, in the case of the hearts. You see, there, in that portrait—the heart?

Q. Yes, I see.

N.Z. It's not whole. It's the pain you feel, the pain

245

that breaks your heart.

Q. But with love, is it made whole?

N.Z. With love—or pain.

Q. Pain?

N.Z. Yes, the pain itself can make it whole.

Zenil has expressed those same concepts in poetry. He reiterates that he would have liked to be a writer. "But I kept painting, I think it was more in line with my abilities." The unpublished poems he generously shares are, he says, "things I've written in times I wasn't painting—about things I might include in my work." It is easy to see relationships between the two media. One of his best-known paintings depicts Zenil before an image of the Virgin of Guadalupe, who is standing, as usual, above a crescent moon. (What is not usual is the head and shoulders of Nahum supporting, or hanging from, the foot of the statue of the Virgin.) A large heart in the lower center of the painting partly obliterates Zenil's bared chest; truncated veins and arteries rise toward the Virgin. The heart is pierced by a large knife wielded by the hand of an unidentified person whose arm alone enters the field of the painting. This composition follows the style of the traditional ex-voto and bears a typical inscription written in Zenil's careful hand. The words are a tribute to the Virgin from a faithful son who is *"muy agradecido por todo"* ("very grateful for everything"). The inscription also states, however, that its author was "brought into the world in difficult circumstances" and that he has suffered "deep wounds" during the course of his lifetime. Zenil writes of such wounds in one of his poems.

Look at me

with the happiness I scarcely knew

slashed

by my clumsiness in living it.

Here am I

back from this pretense of being:

a receptacle for anguish

sipping my cup of sorrow;

time is so short;

a scenario exposed

as a sham of sentiment.

Look at me,

with the long shadow of pain

glimpsed in my eyes.

Before devoting himself full-time to painting, Zenil was a teacher. There is a painting of one of his classes in his unique apartment in the Unidad Alianza Popular Revolución complex in Mexico City. In it, his students are portrayed as angels. A visitor may almost reconstruct Zenil's life within the walls of that apartment. The presence of his mother, for instance, is strong, in many paintings and in a *boîte*.

Q. Hmmm, December 21, 1987—what does this date represent? (The date is inscribed on a green box with glass sides. It is mounted on the wall and half-filled with small gravel-sized pieces of glass. A piece of something that looks like a broken slab of plaster lies atop the glass pebbles.)

N.Z. The date is December 21, when I had an automobile accident.

Q. What happened? Oh, I see. Is this what happened to your windshield?

N.Z. Yes, and I broke my hand. That was the same day my mother died.

Q. In the accident?

N.Z. No.

Q. Not on the same day?

N.Z. Yes. It all happened on the same day.

There is another construction in the room. It honors a second female presence in Zenil's life, Frida Kahlo. A glass-sided case resembling an antique bookcase contains an effigy in miniature of Kahlo; she is, as she was so often in life because of her crippling injuries, recumbent. Coils of thorns like barbed wire snake around her body, fill and

overflow the case. This is *Vida de espinas* ("Life of Thorns"). A second Frida appears in a painting larger than the average Zenil painting, again in her signature Tehuana Indian dress, menaced by a masked monster with a threateningly erect penis and blood-red fingernails. This is the room in which Zenil works. His modest worktable faces a window covered by lace curtains. Yes, the temptation is overwhelming to read the artist by his home, every room as an aspect of his soul, every object as an expression of his psyche—a reading given voice in his poems.

The hour has come for fasting,

for insomnia,

for mulling things over,

for baring your heart.

The hour has come for lamentation,

for feeling regret,

for self-pity,

for weeping inside.

The hour has come

to face the loss of happiness (three years!),

for realizing you were damned from the start,

for knowing yourself alone forever,

alone, from the first memory.

The hour has come

for fear

and trembling

for anguish

for pain

for hovering death.

The guest in Zenil's apartment is mesmerized, transported into a semisurreal world he might have dreamed. A dozen visits, a dozen years, are not enough to absorb the full impact of these small, treasure-laden rooms. Inside the front door, the eye is immediately drawn to a large crucifix on which Zenil's features seem perfectly natural. We move gingerly, as if in a trance, past a glass dome of the kind intended to display figurines or antique watches containing a nest with a broken bird's egg; half of the shell has fallen to the floor of the dome; a paper medallion imprinted with Zenil's face dangles from the top of the glass. It is entitled *Orígenes* ("Origins"). In a similar dome is the figure of a white-robed penitent wearing a crown of thorns; a real hummingbird is suspended from the top of this construction. A small china cabinet is filled with antique dolls, figurines, and china. A life-sized baby Jesus lies atop a wooden trunk. A square table in the center of the room, covered with a fringed, semitransparent shawl, displays a variety of sparkling cut glass. Above a wooden bench hangs a collection of nearly miniature paintings of Zenil by Zenil. With typical Mexican courtesy, he invites us to sit around the large dining table in the adjoining room, where handpainted dishes are displayed in a handsome sideboard. We are served strong, sweet coffee and *bocotones* fresh from the griddle, sweet tortillas made from the traditional masa, chopped cilantro, and black beans. The hall of the apartment is lined with figures and masks and *calaveras* from the Day of the Dead. One bedroom features a large painting of San Antonio at the head of the bed; it is hanging upside down. If he brings love, goes the legend, "he is turned right side up again." A closet in a second bedroom is filled with framed paintings and loose drawings. Zenil brings out the most important painting, a triptych: a self-portrait on a black background. The first panel depicts a nude Zenil, head to chest; a red silk cord is attached at the top of the frame and ends at the top of the head. The second panel portrays chest to genitals; from the genitals,

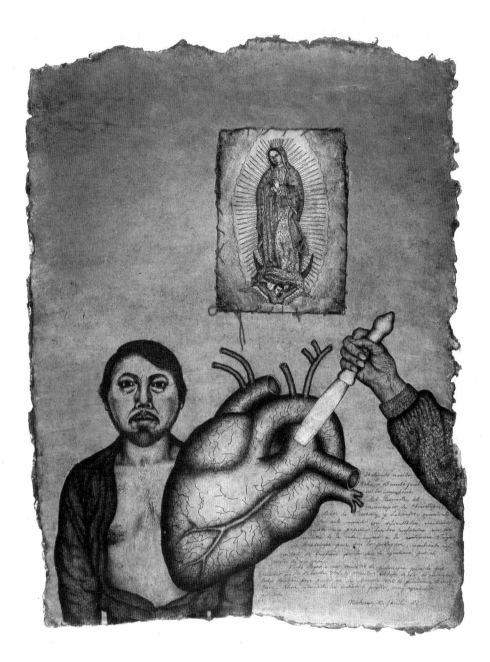

44a. Nahum Zenil, *Ex Voto (Self-Portrait with the Virgin of Guadalupe),* 1987, mixed media on heavy paper with collage, 20 ¹/₂ × 14 ¹/₂ inches. Mary-Anne Martin/Fine Art, New York.

the same red cord continues to the bottom of the frame. The third panel is entirely covered by three sections of fringed, maroon satin. When pulled, the first satin curtain reveals a black void; pulling the second section of the curtain, or the second and third, reveals the viewer's own reflection. Artist and viewer, reality and representation, are fused, joined in a playful-serious game.

At seven-thirty, I am a child again with you,

we play, hiding beneath the night,

we play on the beaches of our bodies,

in the woods of our bodies,

we play for time unlived,

for sorrow retained,

for tears unshed,

for struggle sustained,

for the father never known,

for plans unattained,

for justice unserved,

for love unexpressed,

for the song unsung,

for the cry repressed,

for affection unclaimed,

for the mother chagrined,

for rancor suppressed,

for birth without meaning,

for life without meaning,

for death without meaning...

but we play, you and I,

children, after seven-thirty, in the night.

Pain seemingly is where Zenil lives. A recent painting entitled *Fisura* ("Fissure") is yet another example. In this mixed media on amate paper the Zenil face is placed squarely in the center of a heart; intertwining veins and arteries wrap around the head like rolls of a bloody turban. Heart and face are divided in halves by a vertical tear, a literal ripping of the paper on which it is painted.

We walked without speaking

after so many times

of talking as we walked.

Your words were hidden

I know not where

and mine were caught in a knot

in my throat.

Cruel voice of silence!

You, on that side,

I on this

sensing your thoughts far from me,

unable to touch your hand as before.

Then and now,

distance that made us strangers:

the same road is a different road,

different, the trees along the shore.

Paintings and poems: Zenil is a haunting artist. For us the most wondrous memory of all is an extremely personal one. We arrive at the huge complex in which he lives—five or six hundred units—after an hour's drive. Only then comes the paralyzing realization that we have followed his directions for reaching the address but have left both the telephone and apartment numbers in the hotel. Zenil, along with nineteen million fellow residents of Mexico City, is not listed in the telephone book. No doorbell displays a name. No administrative office is open. We will have to knock on five hundred doors. With a shrug and a deep sigh, we each choose a direction, dive into a concrete corridor, march past several doors, turn, and knock. For the first of us to knock, the door opens immediately. Before our eyes stands Nahum Zenil, the ubiquitous self-portrait, full-length, framed now in his apartment doorway.

End of quest. Beginning of revelation.

ENDNOTES

Unless otherwise noted, translations are by Margaret Sayers Peden.

INTRODUCTION

[1]Christopher Columbus, "November 25, 1492," *The Log of Christopher Columbus,* translated by Robert H. Fuson (Camden, Maine: International Marine Publishing, 1987).

LEONORA CARRINGTON

[1]Carrington, "The Happy Corpse Story," in *The Seventh Horse* (New York: E. P. Dutton, 1988), p. 186.

[2]Bettina L. Knapp, "Leonora Carrington's Whimsical Dream World: Animals Talk, Children Are Gods, a Black Swan Lays an Orphic Egg," *World Literature Today* 51 (1977):530.

[3]*The Seventh Horse,* pp. 157–158.

[4]Whitney Chadwick, "Leonora Carrington: Evolution of a Feminist Consciousness," *Woman's Art Journal* 7, 1 (Spring/Summer, 1986):41.

[5]Sor Juana Inés de la Cruz, *A Woman of Genius,* translated by Margaret Sayers Peden (Salisbury, Connecticut: Lime Rock Press, 1982), p. 62.

EMILIO CARBALLIDO

[1]Carballido, "El mar y sus misterios" (unpublished play, performed in Spain, 1990).

[2]Carballido, *El Sol* (Mexico City: J. Mortiz, 1970), pp. 42–43.

[3]Carballido, *Yo tambien hablo de la rosa* (Mexico City: Editorial Novaro, 1970), p. 135.

GERMAN VENEGAS

[1]Samperio's comments are taken from an exhibition catalogue, "Ocultamientos, máscaras, rostros y risas" [Stealth, Masks, Faces, and Laughter], for a show held at the Museo de Arte Moderno, September through November 1987.

ELENA PONIATOWSKA

[1]Poniatowska, *Lilus Kikus* (Mexico City: Editorial Grijalbo, 1976), p. 38.

FRANCISCO TOLEDO

[1]Verónica Volkow's comments are from a brochure and invitation to a Toledo show, *Pintura y cerámica* [Painting and Ceramics], held in the Galería de Arte Mexicano, April 20, 1988.

VERONICA VOLKOW

[1]Volkow, *Los Caminos* (Mexico City: Ediciones Toledo, 1989), pp. 47–48.

[2]*El inicio* (Juchitán, Mexico: H. Ayuntamiento Popular, 1983), p. 10.

[3]*El inicio,* p. 10.

[4]*Diálogos* 23, 2 (marzo/abril 1977):3.

[5]*Los Caminos,* p. 31.

TEODORO GONZALEZ DE LEON

[1]*Contemporary Architects,* (Chicago: St. James Press, 1987), p. 338.

JOSE LUIS CUEVAS

[1]Cuevas, *Historias para una exposición* (Mexico City: premia, 1988), p. 30.

[2]Carlos Fuentes, *El mundo de José Luis Cuevas* (Mexico City: Galería de arte Misrachi, 1969), p. 6.

CARLOS MONSIVAIS

[1]*Días de guardar* (Mexico City: Biblioteca Era, 1970), pp. 347, 351–352, 363.

FERNANDO GAMBOA

[1]*México en el arte* 12 (November 1952), p. 64.

[2]*México en el arte* 5 (November 1948), n.p.

GUILLERMO SAMPERIO

[1]Samperio, *Gente de la ciudad* (Mexico City: Fondo de Cultura Económica, 1986), p. 137.

LUIS ARTURO RAMOS

[1]Ramos, *Este era un gato* (Mexico City: Grijalbo, 1987), pp. 18–19.

ENRIQUE DIEMEKE

[1]Alejo Carpentier, *America latina en su música* (Mexico City: siglo veintiuno editores, 1977), p. 7.

[2]Carpentier, p. 11.

[3]These instruments are defined by Nicolas Slonimsky in *Music of Latin America* (New York: Da Capo Press, 1972), p. 214.

ENRIQUE BARRIOS

[1]Alejo Carpentier, *America latina en su música*, p. 9.

JOSE AGUSTIN

[1]John Kirk, *José Agustín: Onda and Beyond*, edited by June Carter and Donald L. Schmidt (Columbia: University of Missouri Press, 1986), p. 9.

[2]Agustín, *Cerca del Fuego*, (Mexico City: Plaza & Janés, 1987), pp. 206, 311–12.

PATRICIA QUINTANA

[1]*Food and Wine* (American Express Publishing), March 1990: 65–68.

ISAAC VASQUEZ GARCIA

[1]R. A. Donkin, "Spanish red: An ethnogeographical study of cochineal and the Opuntia cactus," *Transactions of the American Philosophical Society* 67, part 5 (1977).

VICENTE LENERO

[1]Interview in *Teatro* (Mexico City: Editores Mexicanos Unidos, 1985), p. 16.

RUFINO TAMAYO

[1]Carlos Pellicer, "Deseos," in *La poesía mexicana del siglo XX*, edited by Carlos Monsiváis (Mexico City: Empresas Editoriales, 1966), p. 365.

GUILLERMINA BRAVO

[1]I am indebted to Alberto Dallal for the anecdotes recounted here and first published in *Fémina-Danza*.

[2]Oscar L. Cuéllar, *Siempre* (December 27, 1989), p. 61.

MANUEL FELGUEREZ

[1]Felguerez, *Artistas contemporáneos de América latina*, edited by Damián Bayón (Paris: UNESCO, 1981).

LUIS GARCIA GUERRERO

[1]Luis Cardoza y Aragón, *Ojo/Voz* (Ediciones Era, 1988), pp. 65–66. Cardoza's poem is abbreviated here.

[2]*García Guerrero* (Mexico City: Promexa, 1987), pp. 20–21.

ANGELA GURRIA

[1]Gurría, *Artes visuales*, a conference on feminine sensibility, Carla Stellweg presiding (January–March 1976), p. 60.

MANUEL ALVAREZ BRAVO

[1]Fred R. Parker, editor, *Manuel Alvarez Bravo* (Pasadena: Pasadena Art Museum, 1971), p. 48.

SUGGESTED READINGS

Ballet Folklórico de Mexico. Mexico City: National Institute of Fine Arts of Mexico, n.d.

Béhague, Gerard. *Music in Latin America: An Introduction.* Englewood Cliffs: Prentice Hall, 1979.

Brushwood, John Stubbs. *Mexico in Its Novel.* Austin: University of Texas Press, 1966.

Day, Holliday T., and Hollister Sturges, editors. *Art of the Fantastic: Latin America, 1920–1987.* Indianapolis: Indianapolis Museum of Art, 1987.

Espejel, Carlos. *Mexican Folk Ceramics.* Barcelona: Editorial Blume, 1975.

Girard, Alexander. *Encanto de un pueblo. The Magic of a People.* New York: Viking Press, 1968.

Grove, Richard. *Mexican Popular Arts Today.* Colorado Springs: Taylor Museum, 1954.

Harvey, Mariam. *Crafts of Mexico.* New York: Macmillan, 1973.

Images of Mexico (catalogue of an exhibition at Schirn Kunsthalle in Frankfurt). Dallas: Dallas Museum of Art, 1987.

Kandell, Jonathan. *La Capital: The Biography of Mexico City.* New York: Random House, 1988.

Latin American Art [magazine]. Publisher and editor Michael Marcelino C., Scottsdale, Arizona.

The Latin American Spirit: Art and Artists in the United States, 1920–1970. New York: Bronx Museum of Art, in association with Harry N. Abrams, 1988.

Oster, Patrick. *The Mexicans: A Personal Portrait of a People.* New York: William Morrow, 1989.

Reavis, Dick J. *Conversations with Moctezuma.* New York: William Morrow, 1990.

Riding, Alan. *Distant Neighbors: A Portrait of the Mexicans.* New York: Alfred A. Knopf, 1985.

Ross, Patricia. *Made in Mexico: The Story of a Country's Arts and Crafts.* New York: Alfred A. Knopf, 1952.

Slonimsky, Nicolas. *Music of Latin America.* New York: Da Capo Press, 1972.

Smith, Bradley. *Mexico: A History in Art.* New York: Doubleday, Gemini-Smith Books, 1968.

INDIVIDUAL ARTISTS

AGUSTIN, JOSE

Carter, June C. D., and Donald L. Schmidt, editors. *José Agustín: Onda and Beyond.* Columbia: University of Missouri Press, 1986.

ALVAREZ BRAVO, MANUEL

Parker, Fred R., editor. *Manuel Alvarez Bravo.* Pasadena: Pasadena Art Museum, 1971.
Perez, Nissan N., editor. *Dreams—Visions—Metaphors: The*

Photographs of Manuel Alvarez Bravo. London: André Deutsch, 1983.

CARBALLIDO, EMILIO

Carballido, Emilio. *The Golden Thread and Other Plays*. Austin: University of Texas Press, 1970. Trans. Margaret Sayers Peden.

——. *The Norther*. Trans. Margaret Sayers Peden. Austin: University of Texas Press, 1968.

——. "I, Too, Speak of the Rose," trans. William Oliver, in *The Modern Stage in Latin America*. New York: Dutton, 1971.

——. "Orinoco," trans. Margaret Sayers Peden, in *Latin American Literary Review* 12 (Winter 1983).

——. "A Rose by Any Other Names," trans. Margaret Sayers Peden, in *Modern International Drama (Fall 1988)*.

Peden, Margaret Sayers. *Emilio Carballido*. Boston: Twayne, 1980.

CARRINGTON, LEONORA

Carrington, Leonora. *The House of Fear: Notes from Down Below*. Trans. Katherine Talbot and Marina Warner. New York: E. P. Dutton, 1988.

——. *The Seventh Horse*. Trans. Katherine Talbot and Anthony Kerrigan. New York: Obelisk/E. P. Dutton, 1988.

——. "Down Below," as told to Jeanne Megnen, trans. Victor Llona, in *VVV* (February 1944).

Chadwick, Whitney. *Women Artists and the Surrealist Movement*. Boston: N.Y. Graphic, 1985.

CASTANEDA, ALFREDO

Ruy Sánchez, Alberto, and Edward J. Sullivan. *Alfredo Castañeda*. Mexico City and New York: Galería de Arte Mexicano and Mary-Anne Martin Fine Arts, 1989. English and Spanish.

CUEVAS, JOSE LUIS

Cuevas, José Luis. *El mundo de José Luis Cuevas*. Bilingual text by Carlos Fuentes. Mexico City: Galería de Arte Misrachi, 1969.

——. *Recollections of Childhood*. Los Angeles: Khantos Press, 1962.

FUENTES, CARLOS

Brody, Robert, and Charles Rossman. *Carlos Fuentes: A Critical View*. Austin: University of Texas Press, 1982.

Durán, Gloria. *The Archetypes of Carlos Fuentes*. Hamden, Connecticut: Archon Books, 1980.

Feris, Wendy. *Carlos Fuentes*. New York: Unger, 1983.

Fuentes, Carlos. *Aura*. Trans. Lysander Kemp. New York: Farrar, Straus and Giroux, 1975.

——. *Burnt Water*. Trans. Margaret Sayers Peden. New York: Farrar, Straus and Giroux, 1980.

——. *A Change of Skin*. Trans. Sam Hileman. New York: Farrar, Straus and Giroux, 1968.

——. *Christopher Unborn*. Trans. Alfred MacAdam. New York: Farrar, Straus and Giroux, 1989.

——. *Constancia and Other Stories for Virgins*. Trans. Thomas Christensen. New York: Farrar, Straus and Giroux, 1990.

——. *The Death of Artemio Cruz*. Trans. Sam Hileman. New York: Farrar, Straus and Giroux, 1964.

——. *Distant Relations*. Trans. Margaret Sayers Peden. New York: Farrar, Straus and Giroux, 1982.

——. *The Good Conscience*. Trans. Sam Hileman. New York: Farrar, Straus and Giroux, 1961.

——. *The Holy Place*. Trans. Suzanne Jill Levine. New York: E. P. Dutton, 1972.

——. *The Hydra Head*. Trans. Margaret Sayers Peden. New York: Farrar, Straus and Giroux, 1978.

——. *The Old Gringo*. Trans. Margaret Sayers Peden. New York: Farrar, Straus and Giroux, 1985.

——. *Terra Nostra*. Trans. Margaret Sayers Peden. New York: Farrar, Straus and Giroux, 1976.

——. *Where the Air Is Clear*. Trans. Sam Hileman. New York: Farrar, Straus and Giroux, 1971.

GERZSO, GUNTHER

Gerzó. With essays by Octavio Paz and John Golding. Neuchatel Suisse: Editions du Griffon, 1983. English, French, and Spanish.

GONZALEZ DE LEON, TEODORO

Heyer, Paul. *Mexican Architecture: The Work of Abraham Zabludovsky and Teodoro González de León*. New York: Walker and Company, 1978.

ITURBIDE, GRACIELA

Iturbide, Graciela. *Juchitán, a Town of Women*. Text by Elena Poniatowska, trans. Cynthia Steele and Adriano Navarro. Mexico City: Ediciones Toledo, 1989.

MASTRETTA, ANGELES

Mastretta, Angeles. *Mexican Bolero*. Trans. Ann Wright. London: Viking, 1989.

PACHECO, JOSE EMILIO

Pacheco, José Emilio. *Battles in the Desert and Other Stories*.

Trans. Katherine Silver. New York: New Directions, 1987.

———. *Don't Ask Me How the Time Goes By.* Trans. Alastair Reid. New York: Columbia University Press, 1978.

———. *Selected Poems.* Ed. George McWhirter. New York: New Directions, 1987.

———. *Signals from the Flames.* Trans. Thomas Hoeksema. Pittsburgh: Latin American Literary Review Press, 1980.

———. *Tree Between Two Walls.* Trans. Edward Dorn and Gordon Brotherston. Los Angeles: Black Sparrow Press, 1969.

———. *You Will Die in a Distant Land.* Trans. Elizabeth D. Umlas. Miami: Letras de Oro, University of Miami, 1990.

PAZ, OCTAVIO

Chantikian, Kosrof, editor. *Octavio Paz: Homage to the Poet.* San Francisco: Kosmos Press, 1981.

Chiles, Frances. *Octavio Paz: The Mythic Dimension.* New York: Peter Lang, 1987.

Fein, John M. *Toward Octavio Paz: A Reading of His Major Poems.* Lexington: University of Kentucky Press, 1986.

Paz, Octavio. *Aguila o sol? Eagle or Sun?* Trans. Eliot Weinberger. New York: October House, 1970. 2d ed. New York: New Directions, 1976.

———. *Alternating Current.* Trans. Helen Lane. New York: Viking Press, 1973.

———. *Blanco.* Trans. Eliot Weinberger. New York: The Press, 1974.

———. *The Bow and the Lyre: The Poem, the Poetic Revelation, Poetry and History.* Trans. Ruth L. C. Simms. Austin: University of Texas Press, 1973.

———. *Children of the Mire: Poetry from Romanticism to the Avant-Garde.* Trans. Rachel Phillips. Cambridge: Harvard University Press, 1974.

———. *Claude Levi-Strauss: An Introduction.* Trans. J. S. Bernstein and Maxine Bernstein. Ithaca: Cornell University Press, 1970.

———. *Configurations.* Trans. G. Aroul et al. New York: New Directions, 1971.

———. *Conjunctions and Disjunctions.* Trans. Helen Lane. New York: Viking Press, 1974.

———. *A Draft of Shadows and Other Poems.* Trans. Eliot Weinberger, Elizabeth Bishop, and Mark Strand. New York: New Directions, 1979.

———. *Early Poems 1935–1955.* Trans. Muriel Rukeyser et al. New York: New Directions, 1973.

———. *The Labyrinth of Solitude: Life and Thought in Mexico.* Trans. Lysander Kemp. New York: Grove Press, 1962.

———. *Marcel Duchamp: Appearance Stripped Bare.* Trans. Rachel Phillips and Donald Gardner. New York: Viking Press, 1978.

———. *Marcel Duchamp; or, The Castle of Purity.* Trans. Donald Gardner. London: Cape Goliard, 1970.

———. *The Other Mexico: Critique of the Pyramid.* Trans. Lysander Kemp. New York: Grove Press, 1972.

———. *Piedra de sol: The Sun Stone.* Trans. Donald Gardner. New York: Cosmos Publications, 1969.

———. "Piedra de sol: Sun Stone." Trans. Laura Villaseñor in *Texas Quarterly* 13, 3 (Autumn 1970).

———. *Renga: A Chain of Poems.* With Jacques Roubaud, Eduardo Sanguineti, Charles Tomlinson; trans. Charles Tomlinson. New York: G. Braziller, 1972.

———. *The Siren and the Seashell and Other Essays on Poets and Poetry.* Trans. Lysander Kemp and Margaret Sayers Peden. Austin: University of Texas Press, 1976.

———. *Sor Juana Inés de la Cruz; or, The Traps of Faith.* Trans. Margaret Sayers Peden. Cambridge: Harvard University Press, 1988.

———. *Sun Stone.* Trans. Muriel Rukeyser. New York: New Directions, 1973.

———. *Sun-Stone.* Trans. Peter Miller. Toronto: Contact Press, 1963.

———. *Selected Poems.* Trans. Muriel Rukeyser. Bloomington: Indiana University Press, 1963.

Wilson, Jason. *Octavio Paz.* Boston: Twayne Publishers, 1986.

———. *Octavio Paz, a Study of His Poetics.* Cambridge: Cambridge University Press, 1979.

PONIATOWSKA, ELENA

Poniatowska, Elena. *Dear Diego.* Trans. Katherine Silver. New York: Pantheon, 1986.

———. *Massacre in Mexico.* Trans. Helen Lane. Columbia: University of Missouri Press, 1991.

———. *Until We Meet Again.* Trans. Magda Bogin. New York: Pantheon, 1987.

QUEZADA, ABEL

Abel Quezada, El Cazador de Musas. Mexico City: Joaquín Mortiz/Peppi Bataglini, Milano, 1989. Text available in English.

QUINTANA, PATRICIA

Quintana, Patricia. *Mexico's Feasts of Life.* Tulsa: Council Oak Books, 1989.

———. *The Taste of Mexico.* New York: Stewart, Tabori and Chang, 1986.

RAMIREZ VAZQUEZ, PEDRO

Ramírez Vázquez. Preface by Robert Auzelle. Mexico City: García Valadés editores, 1989.

Ramírez Vázquez, Pedro, et al. *The National Museum of*

Anthropology: Mexico. Trans. Mary Jean Labadie and Aza Zatz. New York: Harry N. Abrams, 1968.

TAMAYO, RUFINO

Corredor Matheos, José. *Tamayo*. New York: Rizzoli Press, 1987.

Genauer, Emily. *Rufino Tamayo*. New York: Harry N. Abrams, 1974.

Paz, Octavio. *Rufino Tamayo*. Trans. Kenneth Lyons. New York: Rizzoli Press, 1982.

Rufino Tamayo: Fifty Years of His Painting. Introduction by James B. Lynch, Jr. Washington: Phillips Collection, 1978.

ZUNIGA, FRANCISCO

Francisco Zúñiga: An Exhibition of Drawings and Sculpture. Ed. Ronald D. Hickman and José Maria Tasende. San Diego: Arts and Crafts Press Printers, 1971.

Francisco Zúñiga: Sculptures, Drawings, Lithographs. New York: Brewster Editions, 1982.

Reich, Sheldon. *Francisco Zúñiga, Sculptor: Conversations and Interpretations*. Tucson: University of Arizona Press, 1980.

Zúñiga: The Complete Graphics. Ed. Jerry Brewster and Burt Chernow. New York: Alpine Fine Arts Collection, 1984.